JOHN MARIN

JOHN MARIN

RUTH E. FINE

NATIONAL GALLERY OF ART · WASHINGTON

ABBEVILLE PRESS · PUBLISHERS · NEW YORK

Editor: Nancy Grubb
Designer: Alex Castro
Production manager: Dana Cole

Front cover: Detail of *Movement, Sea and Sun*, 1921. See plate 184.
Back cover: *Related to Brooklyn Bridge*, 1928. See plate 123.
Frontispiece: Detail of *Woolworth Building, No. 28*, 1912. See plate 112.

Published on the occasion of the exhibition *Selections and Transformations: The Art of John Marin* at the National Gallery of Art, Washington, January 28–April 15, 1990.

A Note about the Captions
A ° preceding the plate number and title indicates that the work is included in the exhibition *Selections and Transformations: The Art of John Marin*. Catalogue raisonné numbers appear at the end of captions for oil paintings, watercolors, and etchings. A number preceded by R refers to Sheldon Reich, *John Marin: A Stylistic Analysis and Catalogue Raisonné* (Tucson: University of Arizona Press, 1970). A number preceded by Z refers to Carl Zigrosser, *The Complete Etchings of John Marin* (Philadelphia: Philadelphia Museum of Art, 1969).

Library of Congress Cataloging-in-Publication Data

Fine, Ruth, 1941–
 John Marin/Ruth E. Fine.
 p. cm.
 Includes bibliographical references.
 ISBN 1-55859-015-3 ISBN 1-55859-069-2 (pbk.)
 1. Marin, John, 1870–1953—Catalogs. I. Title.
N6537.M37A4 1990 89-17520
760'.092—dc20 CIP

CONTENTS

FOREWORD

The art of John Marin, produced during a career that spanned half a century, is both distinctively beautiful and intellectually challenging. A revered member of the circle surrounding the great connoisseur Alfred Stieglitz and greatly admired by artists and critics alike, Marin produced a large body of watercolors, oil paintings, drawings, and etchings that is one of the major achievements of American art and central to the development of our modernist vision.

This study and the exhibition it accompanies celebrate Marin's distinguished career. Much of the work shown here has been drawn from the important Marin holdings of the National Gallery of Art. These date from a 1949 gift made by Georgia O'Keeffe of three watercolors from the Alfred Stieglitz Collection. Another gift, in 1967, from Eugene and Agnes E. Meyer added, among other works, a group of the Woolworth Building watercolors that brought great acclaim to Marin in 1913. Our Marin collection was further enhanced by gifts of individual works from Frank and Jeanette Eyerly and a number of other donors.

The most important contributions to the National Gallery's role as a center for studying the art of John Marin were two magnificent gifts, in 1986 and 1987, from Mr. and Mrs. John Marin, Jr. Included were works in all the media Marin employed, including sixteen sketchbooks. Spanning the artist's career, they contain more than four hundred drawings and watercolors. The Marin family also gave the National Gallery important personal correspondence and unique research materials that had been gathered by the artist himself and that have considerably expanded our ability to understand Marin and his work.

Sadly, John Marin, Jr., did not live to see his father's accomplishments celebrated here. We are enormously indebted to him, as we are to his widow, Norma Boom Marin, and to their daughter, Lisa Marie Marin. They have been most supportive of our undertaking, as has Lawrence A. Fleischman, president of Kennedy Galleries, Inc., who was instrumental in placing the Marin Archive collection at the National Gallery.

The exhibition has been organized by our curator of modern prints and drawings, Ruth E. Fine, who has also written the text for this volume. We are grateful to the many other members of the staff who contributed significantly to the project, as indicated in her acknowledgments.

Finally, we want to express our warm gratitude to the lenders. All of us connected with this undertaking deeply appreciate the enormous sacrifice made by owners of Marin's works who have agreed to share their treasured objects with us. They have made this exhibition possible.

J. Carter Brown, *Director*
National Gallery of Art

JOHN MARIN

1. *White Mountain Country, Summer No. 29, Dixville Notch, No. 1,* 1927. Watercolor, graphite, and black chalk on paper, 17⅞ × 22¼ in. (including mount). Dorothy Norman. R.27.49.

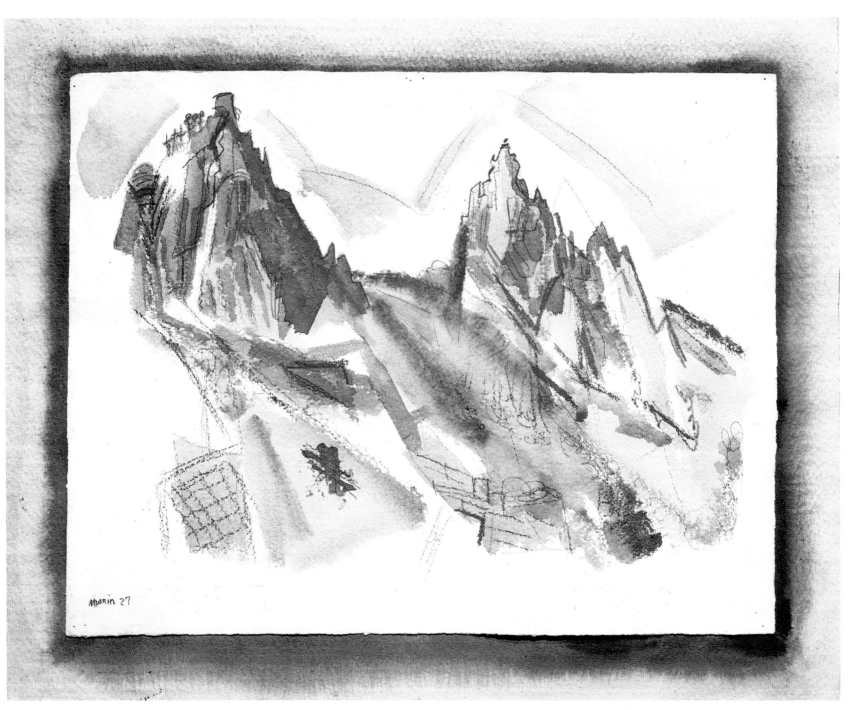

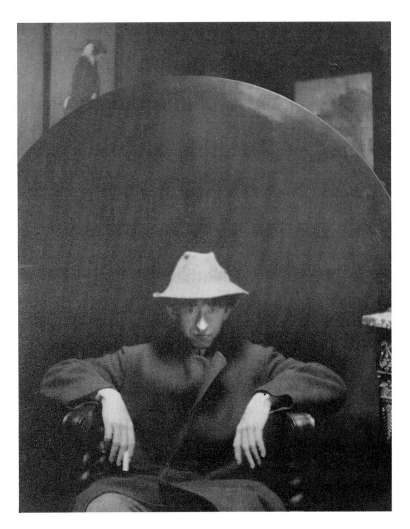

2. Alfred Stieglitz and Edward Steichen. *Portrait of John Marin*, 1911. Platinum print, 9⁷⁄₁₆ × 7⁵⁄₁₆ in. National Gallery of Art, Washington, D.C.; Alfred Stieglitz Collection.

INTRODUCTION

For is not a work of art the most tantalizing—here—there—where—yes and no—sort of thing on this Earth—the most vital yet to all a mystery—to not too many a mysterious reality—it cannot be understood, *it can be felt.*

—John Marin, "Marin Writes," 1947

John Marin's acclaim during his lifetime surpassed that of any of his contemporaries. In December 1948 critic Clement Greenberg wrote, "If it is not beyond all doubt that [Marin] is the best painter alive in America at this moment, he assuredly has to be taken into consideration when we ask who is."[1] Indeed, earlier that year Marin had, in fact, been selected as the number one painter in the United States by a *Look* magazine survey of museum directors, curators, and leading art critics.[2]

Marin's career was a long one, with one-man exhibitions virtually every year from 1910 until his death in 1953, a few months before his eighty-third birthday. Throughout this period his art was admired profusely not only by professionals but by laymen as well, and no American connoisseur

with a taste for advanced ideas could have ignored him. Major collections of Marin's work, now in the public domain, were formed by Ferdinand Howald in Columbus, Ohio, by Duncan Phillips in Washington, D.C., and, most important, by Alfred Stieglitz in New York.[3]

Marin's professional career can be said to date from 1905, when at age thirty-four he traveled to Europe, a journey then considered essential to the training of American artists with aspirations to sophistication. He remained abroad for five years, with one return visit to America in 1909–10. The artist's extant works date from considerably earlier than this European venture, however. Sheldon Reich's catalogue raisonné of Marin's oil paintings and watercolors includes a group of watercolors from as early as 1888, when Marin was eighteen, depicting the White Lake region of Sullivan County, New York.[4] Among his paintings from the 1890s is *Delaware Water Gap* (plate 3) of 1894, in which Marin's lifelong interest in the mountain landscape and the reflective qualities of water is already evident.

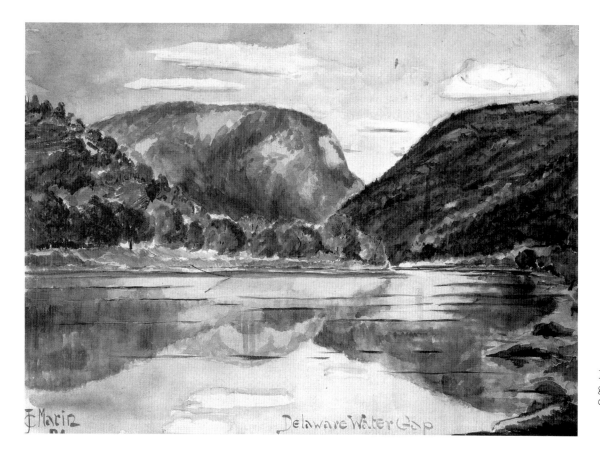

3. *Delaware Water Gap*, 1894. Watercolor and graphite on paper, 8½ x 11¾ in. Private collection. R.94.1.

Marin was extraordinarily prolific. Reich's catalog includes more than three thousand entries; approximately twenty-five hundred of them document watercolors and the rest, oils. In addition to this impressive body of paintings, Marin completed approximately 185 etchings and a single linoleum cut.[5] This last was one of several Merry Christmas–Happy New Year greetings that Marin sent to friends between 1935 and 1945. That he took up the unfamiliar linoleum-cut process at the age of

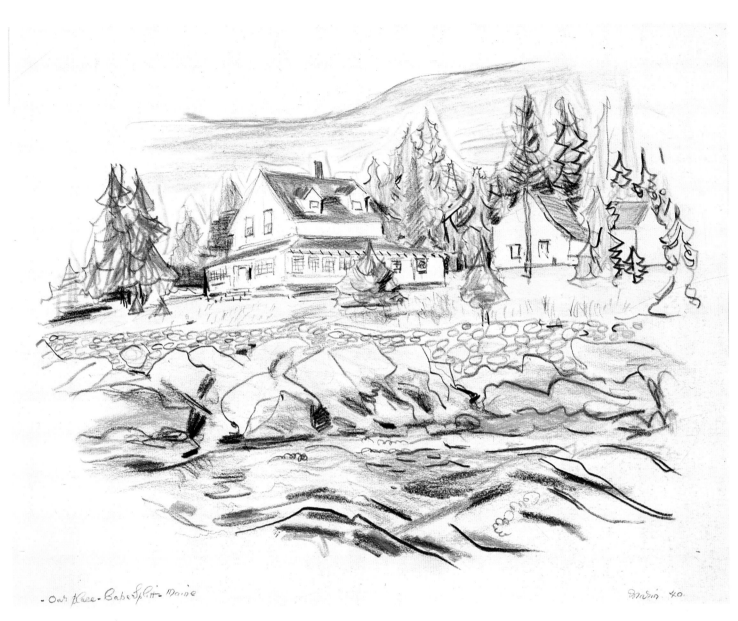

Our Place - Cape Split - Maine

Marin. 40.

4. *Our Place, Cape Split, Maine*, 1940. Crayon, colored
pencil, and graphite on paper, 10⅜ × 13⁵⁄₁₆ in.
Private collection.

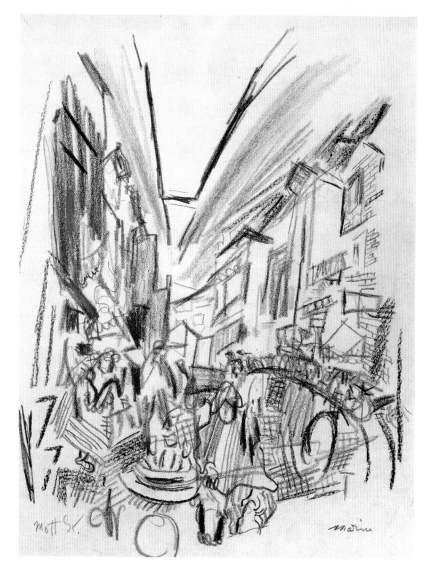

5. *Mott Street*, c. 1920. Graphite and black crayon on paper, 10 x 8 in. Leo S. Ullman, New York.

sixty-five, even if only once, is a telling indication of his experimental temperament. Marin's greeting cards also reveal his lighter side, depicting with great warmth and intimacy his Christmas tree, his family, and his beloved Maine house, which was also the subject of several drawings, including *Our Place, Cape Split, Maine* (plate 4).

Drawing seems to have been as natural to Marin as breathing; and the hundreds of sketches that survive suggest that he was almost never without pencil and a notebook or loose sheets of paper on which to record whatever caught his fancy. With the exception of some of the early European sheets and some colorful late works devoted to the circus, almost none of Marin's drawings is elaborately finished. They tend to be small sketches, such as *Mott Street* (plate 5), which would often be used in developing his paintings, watercolors, and etchings.[6]

Following the direction set by his earliest works, the landscape motif remained Marin's foremost interest throughout his life. More specifically, his name—like that of Winslow Homer before him and of Marsden Hartley, his contemporary—seems inseparably connected with the state of Maine, where he worked part of each year almost annually from 1914 until his death. Marin's paintings of Maine vary greatly, from woodland landscapes to misty views of picturesque towns—such as *Red and Blue, Maine* (plate 6)—to seascapes, which became an increasingly important motif over the

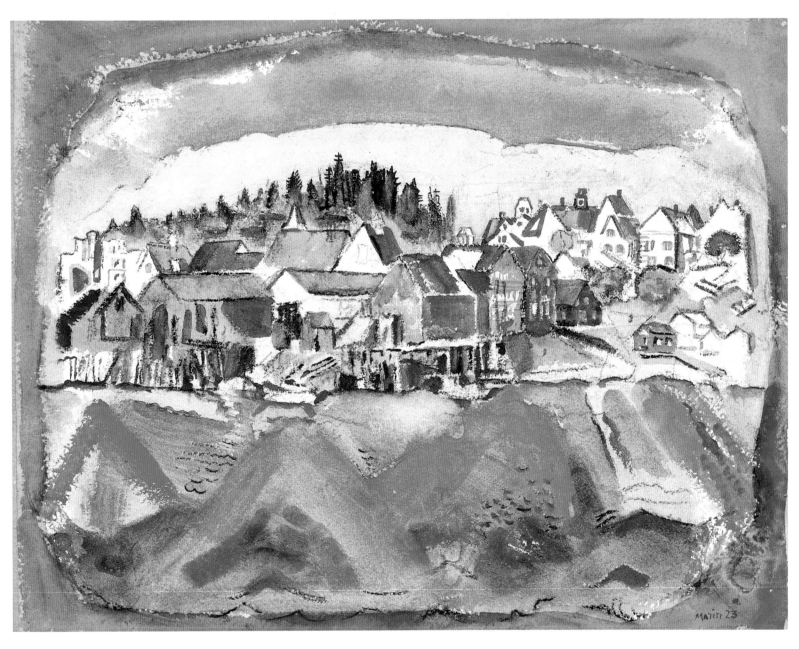

6. *Red and Blue, Maine*, 1923. Watercolor, graphite, and charcoal on paper, 13⅝ x 17¾ in. Alfred Stieglitz/Georgia O'Keeffe/Private collection. R.23.54.

years. Despite this strong association of Marin with Maine, his interest was hardly limited to it. He did beautifully delicate landscapes during his early years in Europe, and both before and after that sojourn he worked directly on site, year after year, at various points in New England, such as the

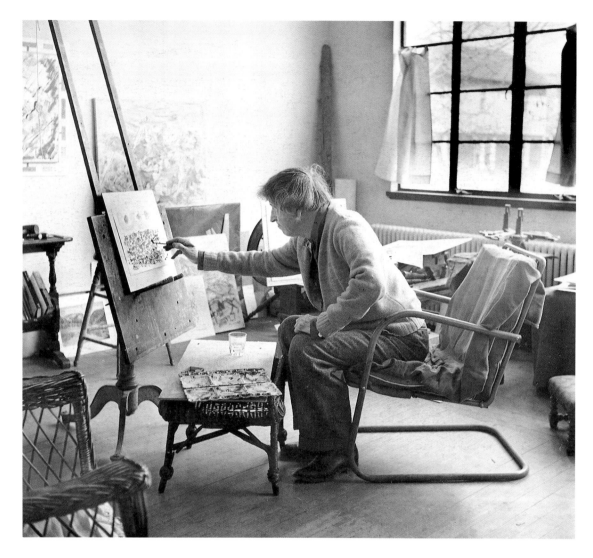

7. George Daniell. *John Marin, New Jersey* (working in his Cliffside studio on a Maine painting), 1951. Gelatin silver print, 10¹³⁄₁₆ x 10¹³⁄₁₆ in. Collection of the photographer.

White Mountains (plate 1), New Jersey, New York State, Pennsylvania, and, during two brilliantly prolific summers, in the region of Taos, New Mexico. Although there are many photographs of him painting outside, especially in Maine, it is clear that Marin worked not only on site but also from his sketches and from memory. Some of his paintings of Maine were surely done in New Jersey.[7]

New York City provided the second motif with which Marin is closely associated. The tempo of the city and its role as a center for modernist thinking were key to Marin's immersion in its atmosphere. He did not live there, apparently preferring to intensify the impact of the city's activity by the repeated process of entering and leaving. While using the city as a source of inspiration, he must have sought the quiet necessary to prolonged concentration in suburban New Jersey, where he had grown up and where, as an adult, he established his winter base. Indeed, many of Marin's

views of New York were made from the town of Weehawken, across the Hudson River; others could have been seen only from the ferry as he commuted to and from the city—for example, *West Forty-second Street from Ferry Boat* (plate 8).

8. *West Forty-second Street from Ferry Boat,* 1929. Watercolor and black chalk on paper, 21⅝ × 26¼ in. The Art Institute of Chicago; Alfred Stieglitz Collection, 1949. R.29.71.

Marin's interest in the figure is most apparent in the work of his last two decades, when he painted several portraits of family and friends as well as groups of female nudes cavorting in a number of "fantasy" seascapes, to adopt the term used by Marin in his titles. From the early 1930s the circus captivated his attention: sketchbooks are filled with incredibly abbreviated notations that account for ringmasters and trapeze artists, lions, elephants, and the encircling audience (plate 9).

John Marin was prolific as a writer as well, and his staccato verbal style, often more poetic than proselike, is closely linked to his visual style. The artist's letters, articles, and essays reveal much about himself, his art, and his times.[8] He was a central figure in the circle of the great photographer, connoisseur, and entrepreneur Alfred Stieglitz, whose importance to the dissemination of modernist ideas in American art is unrivaled. The painter's association with Stieglitz and with his three exhibition spaces—the Little Galleries of the Photo-Secession (best known as 291), the Intimate Gallery, and An American Place—lasted nearly forty years, having started even before the two men met in the

9. *The Circus,* 1940s. Sketchbook page, graphite on paper, 9 x 12 in. National Gallery of Art, Washington, D.C.; Gift of John Marin, Jr.

summer of 1909. Stieglitz's support of Marin's art, in both philosophical and financial respects, was obviously crucial to the painter's extraordinary productivity over half a century, and to his enormous and diverse popularity as well.[9]

For the last few years of Marin's life Edith Gregor Halpert, owner of the Downtown Gallery in New York, represented his work. In November 1950 she announced the opening at her gallery of the John Marin Room, "an informal and intimate place where a retrospective selection of oils and watercolors by America's leading contemporary artist may always be seen."[10] Marin died three years

10. Dorothy Norman. *Alfred Stieglitz Spotting Portrait of Dorothy Norman (with Paintings by John Marin and a Stieglitz Photograph in the Background), An American Place, New York,* 1936. Gelatin silver print, 3 x 4 in. Philadelphia Museum of Art; Collection of Dorothy Norman.

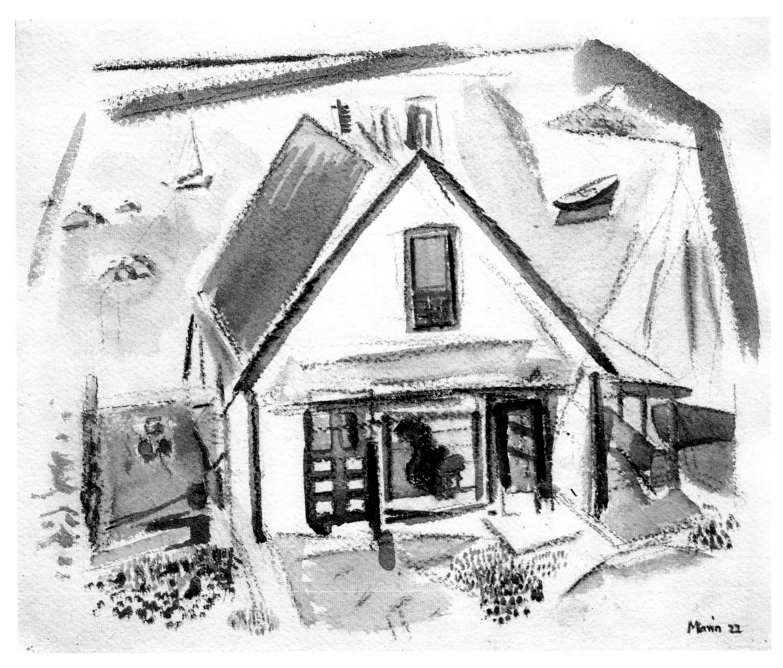

11. *Little House, Stonington, Maine, No. 2,* 1922. Watercolor, graphite, and charcoal on paper, 14 x 17½ in. Dorothy Norman. R.22.26.

later, and within months of his death a memorial exhibition was on view in New York at the American Academy of Arts and Letters; the following year the University of California organized a traveling retrospective.[11] Critic Robert Rosenblum's review of the New York show suggests the admiration accorded Marin's work at that time: "Seen in retrospect, Marin demonstrates a breadth of scope in both his personal creative achievement and his historical position." Rosenblum went on to comment on Marin's

> initial excitement with the recording of kinetic impressions which lies at the basis of [his] work . . . [in which] unfailingly, he also grasps the flavor of the experienced moment without losing the larger, more abstract rhythms. . . . He stands in full center of the major currents of American art . . . he parallels, even prophesies, abstract-expressionist trends. . . . The formal analogies with, say, de Kooning or Tomlin, are striking, and one is again pressed to pay homage to this master, who, throughout an artistic career of 50 active years, could continue to investigate pictorial problems with such experimental daring.[12]

Despite this great acclaim (or perhaps even partly in response to it), Marin's reputation dwindled in the decades following his death. One can suggest many possible reasons for this. His relatively small paintings must have seemed diminutive in comparison with the work of the Abstract Expressionists and the generation that followed. The dynamic expressiveness of his style was in marked contrast to the coolness of the Pop and Minimalist tendencies that dominated the 1960s and '70s. Moreover, as interest in early twentieth-century painting grew during the 1970s, Marin's distinctive approach set him apart even from the other painters of his generation, so different were his energetic paintings from the more polished works by painters such as Georgia O'Keeffe and Arthur G. Dove. Now, as the end of the century approaches, the clarity and complexity of Marin's work have been attracting renewed interest and admiration, perhaps as part of a more general acceptance of an expressionist figurative art. Whatever the reasons, it is a welcome turn of events.

> Leave it to the true creative artist—he'll find a place for the stones and weeds of life in his picture and all so arranged that each takes its place and part in that rhythmic whole—that balanced whole—to wing its music with color, line and spacing upon its keyboard.[13]

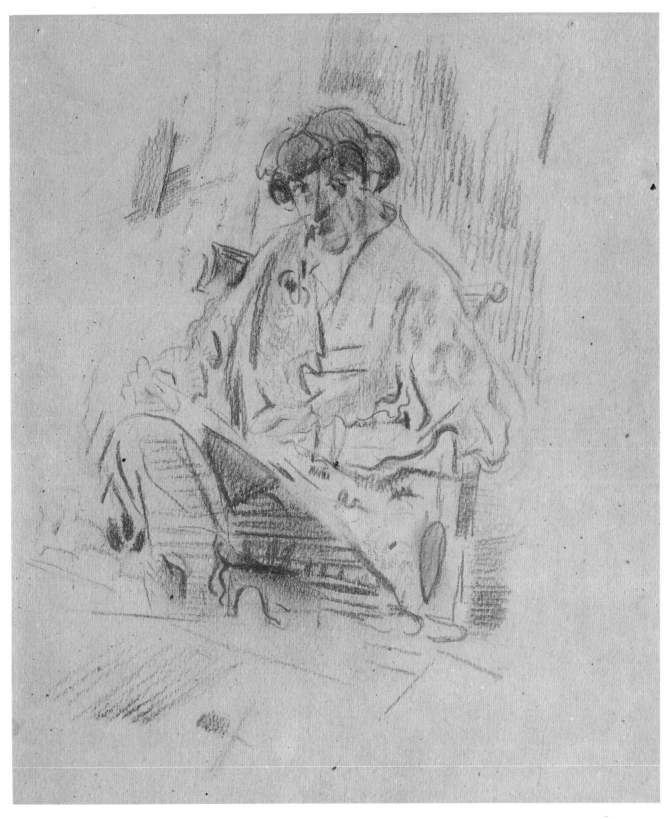

12. *Self-Portrait,* c. 1915–20. Blue pencil on paper,
12⅜ × 10⅝ in. Private collection.

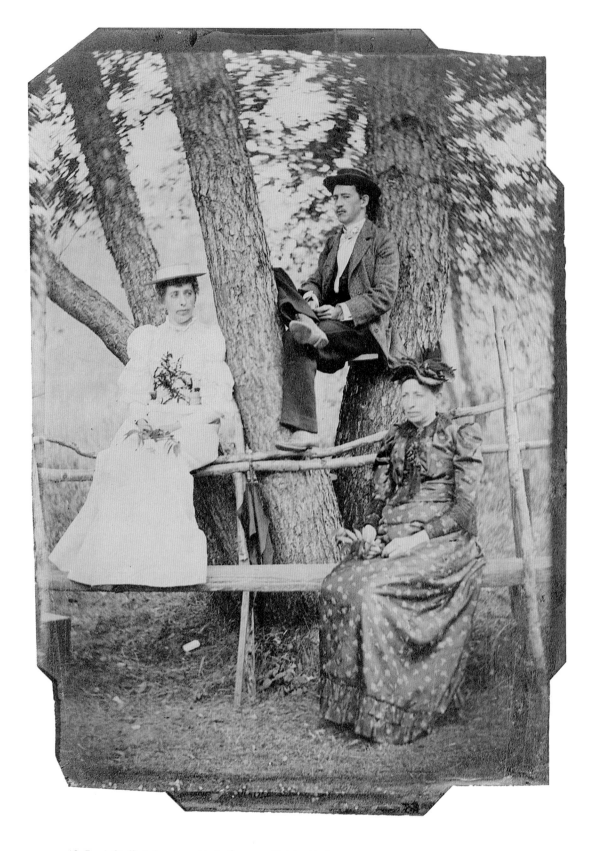

13. Frank Stofflett. Jennie and Lelia Currey with John Marin,
c. 1888. Private collection.

14. Annie Louise Currey, c. 1865.
Private collection.

15. John Chéri Marin, c. 1865.
Private collection.

MARIN'S YOUTH

John Currey Marin was born in Rutherford, New Jersey, on December 23, 1870, into a family that he described as "of the best English Ale, Dutch Bitters, Irish Gin, French Vermouth and plain Scotch."[1] His mother, Annie Louise Currey Marin, died within days of his birth. His father, John Chéri Marin, was on the road much of the time, working as what has been variously cited as an investor, a textile merchant, and a public accountant; he placed his young namesake in the care of the boy's maternal grandparents in Weehawken.[2]

A number of family letters and diaries survive from several periods of Marin's life, early through quite late. They suggest that true warmth, friendship, and easy communication linked the various family members. Writing in early 1875, when John would have been four years old, his grandmother Eliza Currey reported to other members of the family, "Johnnie is getting more fond of play than ever he does not have one minute to spare of anything else it is warm today and it is hard to keep him in."[3] Considerable affection was showered on John not only by his grandparents but also by two maiden aunts, Aunt Jennie Currey and Aunt Lelia Currey, who were living in the family home. Jennie Currey was a highly educated woman and an exceedingly popular teacher who became first a vice-principal and then a principal in the Union Hill, New Jersey, school system. Lelia Currey, who taught piano for a living, was also an amateur painter; a few of her oils remain with the family today.

16. *Stevens Institute*, 1925. Watercolor, graphite, and black chalk on paper, 15 x 18¾ in. Courtesy of Kennedy Galleries, Inc., New York. Not in Reich.

Intellectual stimulation was no doubt a factor in young Marin's upbringing, and the family took advantage of rainy days by going into New York, with stops at the Metropolitan Museum of Art.[4]

Time spent on a peach farm in Delaware owned by his grandfather Currey, in the woods and wild places along the Hackensack River in New Jersey, and on the Palisades overlooking the Hudson all contributed to Marin's pleasure in the outdoors, an enjoyment that stayed with him until the end of his life. "He developed the quick, observing eye, the loping outdoorsman's swift gait, [and a] sense of kinship with birds, trees, animals and country people."[5] As a teenager he enjoyed hunting as well: "Johnnie is most wild over shooting this fall: yesterday morning he was off bright and early and came home proud as Cuffy with a hawk and five other birds. He exchanged his treasures with the taxidermist for twenty cents, which was in a few minutes in Schneider's till, and a fresh supply of ammunition was in his pocket."[6]

The elder Marin seems not to have been around much, though he kept in sporadic contact by mail. Letters among the other family members suggest that he was less attentive to his son than they would have liked. For example, in October 1886 Jennie wrote to Lelia: "John promised to come up today, but there is no John here and it is three o'clock. I promised Johnnie if he did not come to take a walk and it is too late now for him, so I think I shall start for the walk."

The previous month, however, a letter from Jennie to Lelia had reported that the elder Marin had unexpectedly turned up, apparently to discuss his son's education:

[Guess] who was here today? . . . It was John, true enough. When we came home from church there he sat as meek as Moses on the piazza. Had it been a cold day I do not know what the frozen turnip would have done, but it is excessively warm today. We talked and talked about what Johnnie was to do, and John at last decided that he better go to the Institute. I hope he will not forget the bills. I wrote him a pretty plain letter week before last in regard to it. He says he is not making very much, and it looks like quite an undertaking, but he thinks it is a very bad thing for a young man to have no definite business; he is very much opposed to have him become a clerk or bookkeeper.

I shall miss his help very much for now he will have to be away all day and study in the evenings.[7]

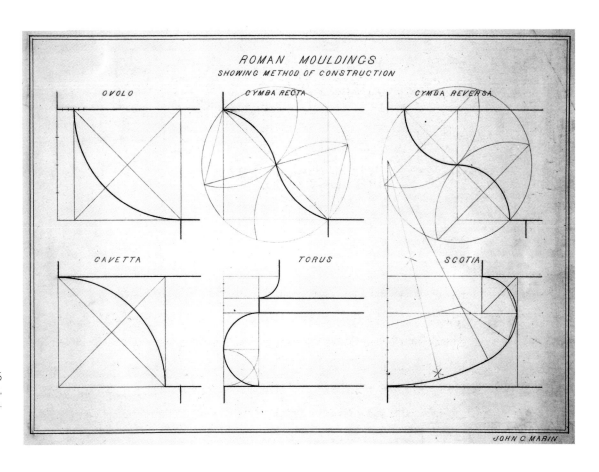

17. *Roman Mouldings,* c. 1888. Ink on paper, 15 x 21 1/16 in. National Gallery of Art, Washington, D.C.; Gift of John Marin, Jr.

The "Institute" was the Stevens Institute of Technology, where Marin completed half a year of a three-year program. The school offered only one degree at the time, in mechanical engineering, and as a first-year student Marin would have taken classes in mathematics, mechanical drawing (plate 17), languages, physics, belles lettres, and shopwork.[8] After abandoning the institute, the artist is said to have worked as a draftsman for various architects, among them a "well known office, that of Messr. Tubby, in [New York],"[9] before setting up his own firm.

In 1922 Marin published a pointedly brief account of his life thus far. Titled "Notes (Autobiographical)," it devoted a few lines to the years between his studies at the institute and his enrollment at the Pennsylvania Academy of the Fine Arts in Philadelphia:

—1 year business not much chance at the gamebag

believe I was fired

4 years Architects offices

not much class

otherwise they'd have discovered my—(Wondership)

2 years blank [10]

It seems odd that Marin didn't mention his own architectural firm, but many important aspects of his life are omitted from this highly eccentric summary. Documentation on Marin's independent architectural career indicates that in February 1892 he had contracted with James Pattison and Henry Van Roy to build a home for his aunts Jennie and Lelia "agreeably to the Drawings and Specifications made by J. C. Marin Jr. architect."[11] The time frame in his autobiographical notes indicates that his architectural work ended sometime in 1897, leaving "2 years blank" before taking classes at the Pennsylvania Academy.

It is provocative to consider how Marin's work as an architect affected his paintings, drawings, and prints. One constant throughout his career was Marin's exhaustive exploration of draftsmanship and the importance of a strong linear scheme. Some of the systematic rather than meticulously descriptive line structures in his earliest drawings may well relate to his architectural interests. Exemplary are some of the sketchbook drawings (plate 18), including many landscapes and cityscapes captured during Marin's youthful travels to Minneapolis, Saint Paul, Milwaukee, and other cities. Even as the

18. *Landscape,* c. 1890. Sketchbook page, graphite on paper, 5 x 7 in. National Gallery of Art, Washington, D.C.; Gift of John Marin, Jr.

years passed, the influence of his architectural experience may have remained forceful—for example, in the ways he was actively involved with structuring movement through space, and in the ways he tended, especially in later years, to enclose various segments within a work, as if establishing separate rooms to house individual elements.

Allusions to architectural structuring are often found in reviews of Marin's work. For example, in 1916 the critic Charles Caffin suggested: "In the best examples of his recent work one can feel that the washes of color, notwithstanding their impalpable suggestion, are actually built together into a structural whole. The various planes and surfaces of the transparent edifice are locked together with the logic of the builder who makes provision for the stresses and strains of his assembled material."[12] And eight years later another critic, Guy Eglington, continued the theme: "Now it is a green, now a blue, now a red, now a purple . . . [but] his preoccupation with color vibration was never such as to cause him to forget his function as a builder . . . he has always been mindful that a picture . . . is a house for the human spirit."[13]

Marin's architectural career, however important, delayed him a bit in pursuing his true aspirations. As the artist pointed out in his "Notes (Autobiographical)," drawing had always been vital to him:

Early childhood spent making scrawls of rabbits and
things (my most industrious period)
Then the usual—public schooling where as is usual
 was soundly flogged for doing the
 unusual
 drawing more rabbits on slate
 After enough flogging
one year at Hoboken Academy where the usual
was the keeping in after hours—I qualified
—a few more rabbits and a smattering of the
 now obsolete German language
Stevens High-School discovered me next and next
the Stevens Institute—went through the High-School
went to—not through Institute
 Of course a few bunnies were added to my
 collection but the main thing I got
there was mathematics for the which I am
duly grateful as I am now an adept at
 subtraction . . .

Reich lists fewer than forty paintings completed prior to Marin's departure for Europe in 1905, but it is important to realize that the artist completed an enormous and as yet uncatalogued body of drawings during this period.[14] Mainly in graphite or ink, they make us aware of Marin's early interest in landscape and of his youthful attention to the city and to shipping scenes. Two sheets of sketches, possibly from the same day, confirm that even at this early stage Marin was exploring the

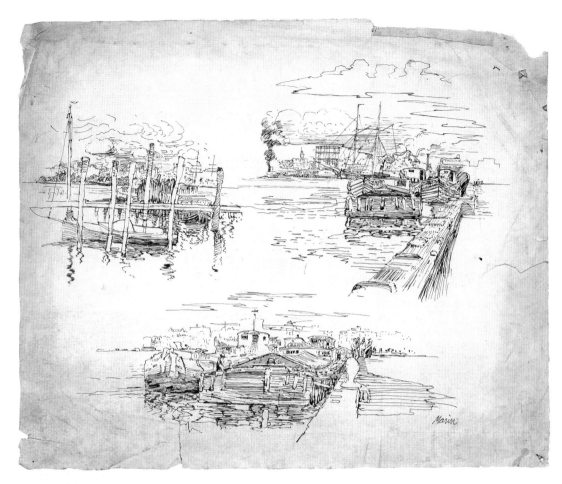

19. *Sketches of a Harbor,* c. 1890–95. Ink on paper, 13¹³⁄₁₆ × 16 ⅞ in. Private collection.

20. *Sketches of a Wharf,* c. 1890–95. Ink on paper, 13¾ × 16⅞ in. Private collection.

two parallel paths that would continue throughout his oeuvre: selecting visual elements from nature and transforming those selections into plastic compositions. One (plate 19) treats his harbor subject with a delicate hand, featuring its most picturesque aspects; the other (plate 20) moves in close to the boats and, with a more rugged hand, explores their abstract formal properties.

Marin was enrolled at the Pennsylvania Academy of the Fine Arts, the oldest art school in America, for both the 1899–1900 and 1900–1901 school years, when he lived in the heart of downtown Philadelphia.[15] No drawings or paintings from any of Marin's classes at the Academy seem to have survived. In fact, one wonders just how much time he actually spent in class. He may well have taken the night class to leave his days free, and he apparently spent countless hours roaming the city and sketching. These efforts were rewarded when he won a prize in 1900 for outdoor sketches of wild fowl and riverboats, subjects he loved even then.

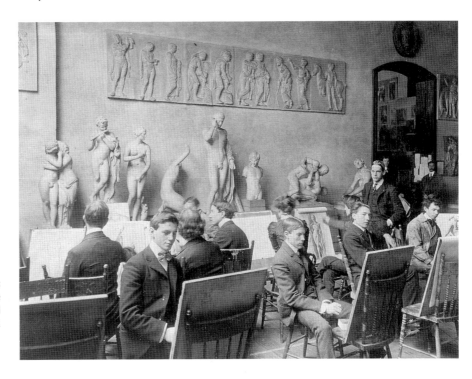

21. J. Liberty Tadd. *The Academy School, Large Antique Class (No. 3)*, 1901. Archives, The Pennsylvania Academy of the Fine Arts, Philadelphia. Arthur B. Carles is seated second from left at front, and Marin is at the far right.

Marin's view of his education was made clear in a 1935 letter to E. M. Benson, his first biographer:

As for what I got
in tutelage————not a damned thing
that I can remember
for often when the instructor
came around I mostly
played sort of *Hookey*
but if you say what did
you get in tutelage from
the great instructor nature
well I got anything I got
quite a lot yes quite a lot . . .[16]

Students at the Academy were exposed to much more than classroom instruction. The institution's galleries provided them with ready access to the paintings in the permanent collection, and special temporary exhibitions were regularly mounted.[17] The school also organized frequent trips to New York, including visits to the Metropolitan Museum of Art, which Marin may have taken.

Marin left Philadelphia in 1902 and continued his studies at the Art Students League in New York. From Frank Vincent DuMond he took classes in "Life Drawing" and "Drawing, Painting, and Composition." Despite the academicism of his work DuMond seems to have been something of a rebel, as he was apparently the only instructor at the League to allow students who had not completed their studies of the antique to enroll in a life-drawing class. School records show Marin in attendance during 1902–3, when Arthur Wesley Dow, whose ideas on modernism became an important force in the following decade, was an influential member of the faculty.[18]

Marin must have been a maverick, uncomfortable with formal education. His report in "Notes (Autobiographical)" in respect to art school couldn't have been much briefer:

2 years Philadelphia Academy
could draw all the rabbits I wanted to
therefore didn't draw many
While there shot at and captured prize for
 some sketches
 1 year blank
1 year Art Student's League, N.Y.
 Saw—KENYON COX—

 2 years blank

4 years abroad

Letters from Aunt Jennie offer insight regarding Marin's plans for his trip to Europe:

[John] has had letters from both his father and Charles [Bittinger, his stepbrother] telling him that he ought not to wait later on account of getting started at his work and it is hard to get a studio later in the season. . . . He expects to live in his studio and therefore ought to be provided with many comforts and Mrs. M. says with bedding. . . . John does not seem very enthusiastic about going away. I suppose he realizes more and more how he shall miss the comforts of home. He has secured his stateroom for Sept. 9, but he keeps putting off getting his trunk and the things he needs to put into it. I try not to think about him going away.[19]

But go he did, to start the career that brought him considerable fame almost from the beginning. The artist always contrived, however, to present himself as a simple, homespun man, as the end of his "Notes (Autobiographical)" makes clear. After a brief account of his European years, he went on to say:

Since then I have taken up Fishing and
Hunting and with some spare time
Knocked out a few
 water-colors
for which in former years I had had
 a leaning

Oddly enough, among the important things that Marin omitted from his terse autobiography was his meeting with Alfred Stieglitz, surely one of the landmark events of his life. His reference to Kenyon Cox, one of the more conservative artist-writers of the day, suggests no small amount of irony on Marin's part, so certain more serious items may have been too important for inclusion. He also omitted any reference to his great love of music, although he played the piano throughout his life, a matter of considerable comment among those who knew him best. His good friend Herbert Seligmann reported Stieglitz's opinion that

> it was a toss-up whether [Marin] would be a musician or painter and his musical feeling played a dominant part in his paintings. . . . Marin's beautiful Steinway grand piano [was] in the corner of his living room in Cliffside, New Jersey, and there was a grand piano on the wide, glassed-in porch at Cape Split. He spent hours playing Bach, Beethoven, Mozart, Handel, and early English and French clavecinists. His playing altogether lacked technique. He never practised scales nor had he been taught in youth to limber his fingers with exercises. His playing was as peculiar to himself as his painting.[20]

22. Herbert J. Seligmann. *Marin Playing the Piano*, n.d. Ink on paper, 11 × 8½ in. National Gallery of Art, Washington, D.C.; Gift of John Marin, Jr.

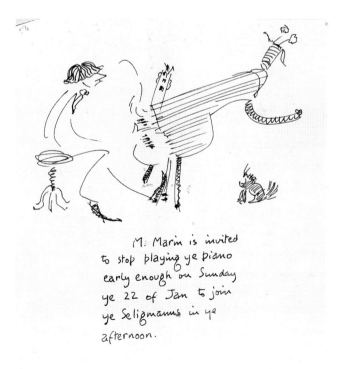

M: Marin is invited
to stop playing ye piano
early enough on Sunday
ye 22 of Jan to join
ye Seligmanns in ye
afternoon.

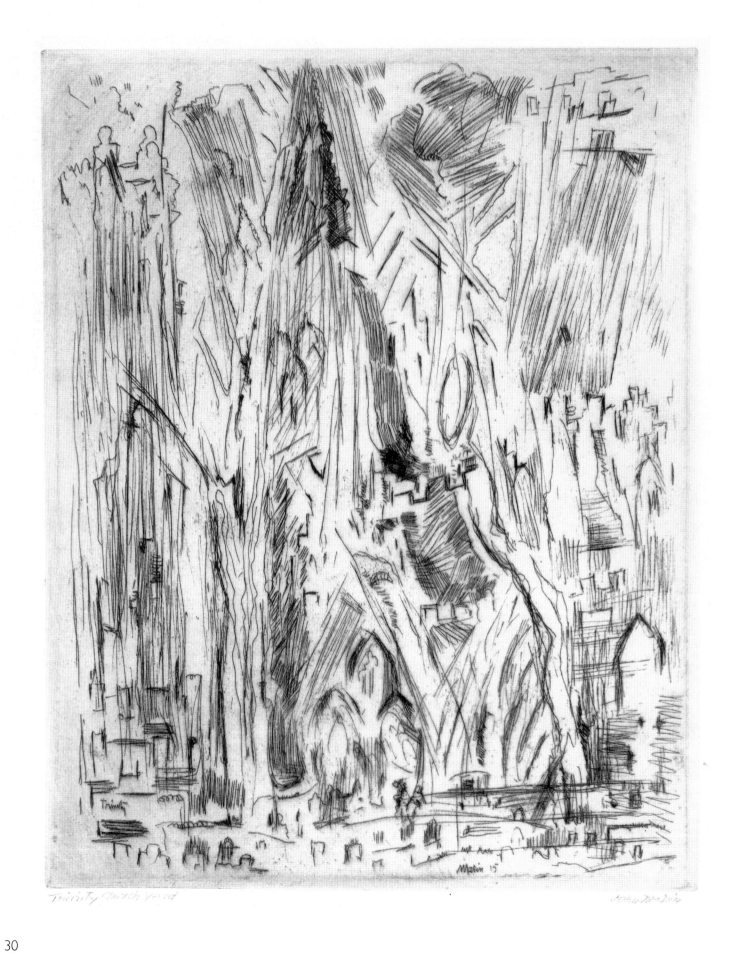

Trinity Church Yard John Marin

30

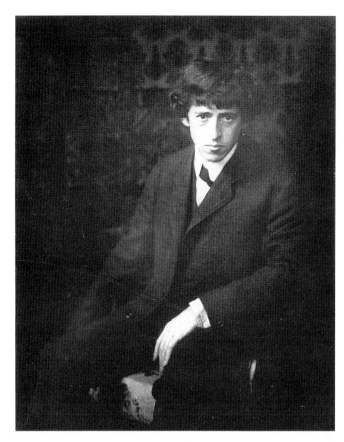

24. John Marin, c. 1910. Private collection.

OVERTURE: THE ETCHINGS

°23. *Trinity Church Yard*, 1915. Etching, 9¹³/₁₆ x 7⅞ in. The Art Institute of Chicago; Gift of Georgia O'Keeffe, 1956. Z.120.

Marin's etchings provide a microcosm of his art as a whole, moving from a romantic lyricism to a tough modernist vision. An accomplished etcher almost from his first efforts, Marin would have made an important mark on the history of twentieth-century American art if he had completed nothing but this substantial body of work—approximately 185 prints.[1] He received his earliest recognition for his etchings of European city scenes.[2] Between 1905 and 1910 such views provided inspiration for more than half of his total etched oeuvre. The earliest of Marin's prints display the extraordinary skill that was at the artist's disposal, but by 1909 he was making evident his great reluctance to allow his manual facilities to rule his imagination.

Marin could have learned the methods of etching during his student days in Philadelphia or New York, etching societies having been long established in both cities. We have no evidence that he did so, however, and it appears that not until his arrival in Paris did he begin working with the etcher's needle. Nevertheless, his interest in prints apparently was whetted in America. Having earned money from the sale of some drawings, he purchased several volumes of Charles Blanc's catalogue raisonné of Rembrandt's etchings, through which he came to especially admire the landscapes; he also bought a copy of Maxime Lalanne's *Treatise on Etching*. Lalanne's book, first published in French in 1866, had been translated into English by S. R. Koehler in 1880 and was extremely useful to artists and other print enthusiasts eager to learn about the complexities of etching techniques.[3]

Charles Bittinger, Marin's younger stepbrother and also a painter, was in Paris with his wife, Edith, at the time of Marin's arrival in late September 1905. Their welcome was instrumental to his relatively easy acclimation to his new surroundings; Marin's father, whose financial support was crucial to these early years of his career, was also there to help him set up house. Bittinger seems to have taken Marin under his wing. Among the most fortunate aspects of this was that Bittinger's interest in etching was waning, and soon after Marin arrived, his stepbrother helped equip him with a press and all the materials necessary to start making prints.[4] He also introduced him to George C. Aid, an American etcher of some note at the time, who was living in the same building as the Bittingers. It seems most likely that Marin learned to etch by a combination of means—by reading Lalanne, by looking at works of art, by talking to Bittinger, and by observing Aid and perhaps others. However he learned, he was almost immediately at remarkable ease with the medium. The artists most influential on Marin's etchings were Charles Méryon and, more important, James McNeill Whistler. Marin might have known Whistler's work, and specifically his etchings, from exhibitions held in New York from the 1880s. He also might have seen them in the Pennsylvania Academy's own collection, access to which was cited as one of the benefits of holding a student ticket.[5]

Paris, his home base, was the subject of many of Marin's European prints. Among the other places he visited and depicted in etchings are sites throughout France and Germany, including Laon, Rouen, Chartres, Nuremberg, and Strasbourg. Whistler's role is especially evident in Marin's depictions of the two cities that evoked some of his predecessor's most beautiful graphic works: Amsterdam, where Marin traveled on several occasions, and Venice, where he spent six weeks in 1907. The artist was a prolific correspondent, and his letters from Europe are filled with marvelous, spontaneous responses to the places he visited, like his report to his Aunt Jennie about Venice:

> There is the large canal or grand canal they call it with all the little canals running in and out and the narrow little streets where you can touch the walls on either side and the curious little bridges spanning the canals and the gondolas plying in all directions and the city of little or no noise and where the horse and trolley car is unknown and where there is one horse kept on exhibition for the children and where you have no fear of being run over. . . .
>
> Then there is St. Marks Place of large dimensions surrounded by buildings chief of which of course is the noble pile of St. Marks far famed not without reason for when you see its domes its countless minerets and pinicles [sic] airily poised its curved gables filled with mosaics splendid in coloring its deep arches filled with the curious and quaint and all gilded upheld by columns the capitals of which no two are alike but all fancifully formed; leaves where pop out toads lizards and curious little people and on everything each column different in coloring.
>
> Then way into the interior where the great domes all of beautiful gilt surrounding beautiful frescoes of gorgeous coloring everything is leaning this way and that and the flooring all of mosaic pattern is as uneven as a plowed field. . . . It is one of the things that one would [like] to carry home with them put up in the back yard and look at first thing every morning to see if it was there and didn't move away like the some curious phantom it seems to be.[6]

Marin completed some twenty etchings in Venice, which tend to be exceedingly delicate and in

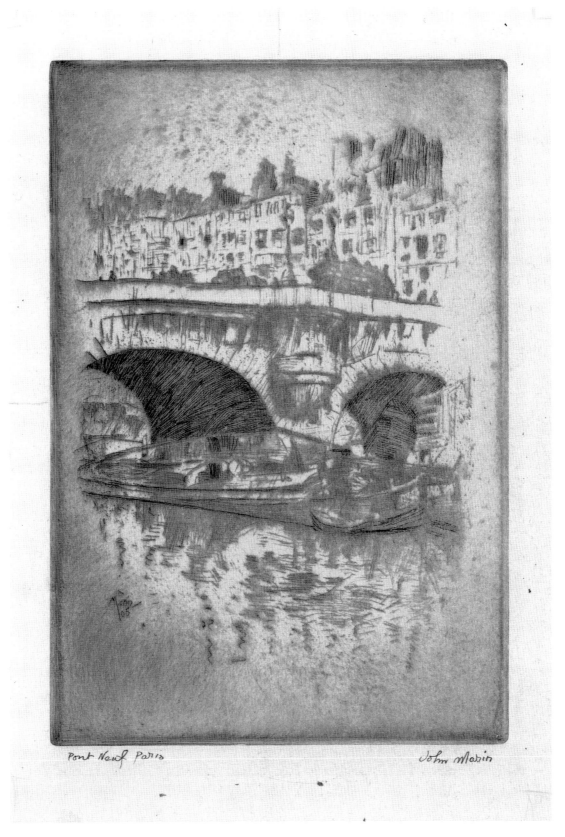

Pont Neuf, Paris

John Marin

°25. *Pont Neuf, Paris*, 1905. Etching, 7⅞ x 5⁷⁄₁₆ in.
Private collection. Z.11.

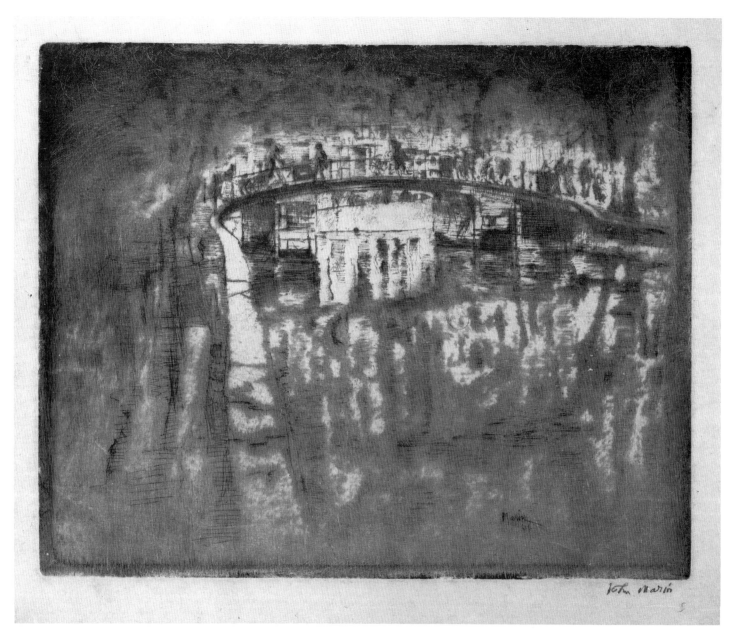

°26. *Bridge over Canal, Amsterdam*, 1906. Etching, 5¹⁵⁄₁₆ x
7½ in. National Gallery of Art, Washington, D.C.; Ailsa
Mellon Bruce Fund. Z.13 ii/ii.

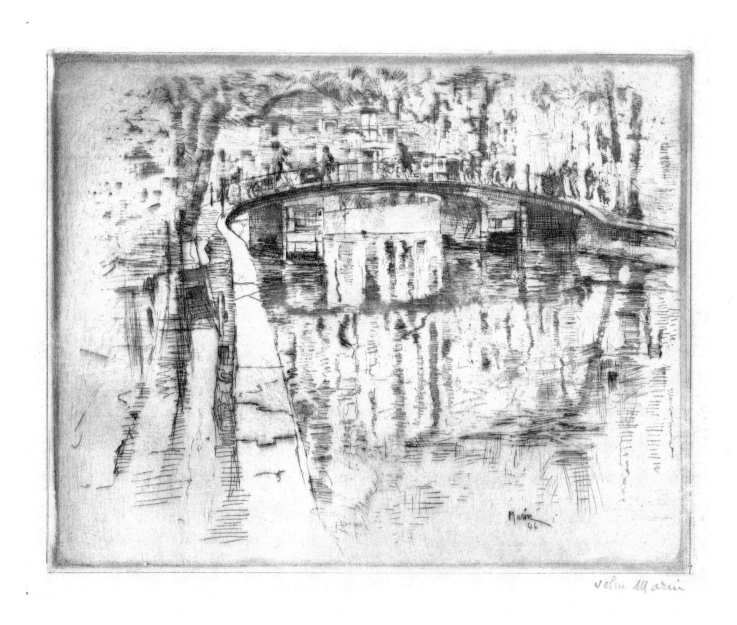

27. *Bridge over Canal, Amsterdam*, 1906. Etching, 5⅞ × 7½ in.
Private collection. Z.13 i/ii.

some respects the least personal of all of his prints. One senses that the unique beauty of the city was somewhat daunting. Perhaps the ghost of Whistler, here more than anywhere else, hovered over him.[7]

Aspects of the Whistlerian mode are generally apparent in these European etchings regardless of city. They include Marin's choice of subject: densely packed street scenes dominated by architecture but dotted with clusters of figural activity; and places where land and water meet, both waterfront scenes and bridges bustling with activity, as in *Pont Neuf, Paris* (plate 25). Whistler's etchings might have inspired Marin's use of a centrally focused, vignetted image; his delight in the decorated façades; his evocative rather than descriptive linework; and his use of selective tonal wiping to achieve images that varied radically from impression to impression, though printed from the same plate.

One of Marin's earliest uses of this painterly printing method (commonly referred to today as monotype printing) was in *Bridge over Canal, Amsterdam* (plates 26, 27). The process enabled him to evoke "the wonderful reflections in the water where buildings, trees, people, boats, and everything in fact the whole face of the street is turned upside down in the most beautiful and softest manner."[8] The etched drawing on the plate is very spare, as seen in plate 27; and much of the articulation, not only of the reflections but also of the architecture and the path along the canal, is dependent upon the silvery tone of the ink left on the plate. The black quality along the upper edge of plate 26 reinforces the suggestion of a "nocturne," to borrow a Whistlerian phrase.

Marin wrote to his father that "Amsterdam is the spot for etchings,"[9] elaborating in another letter that the city was the place he

> like[d] the best of all the places I have visited. . . . Every other street is a canal . . . and you should
> see the quaint old gabled roof brick dwellings which rear themselves up from the waters from
> them one sees other parts of the city where are laid out parks and handsome residences then
> the streets have brick pavements somewhat like in Philadelphia also I must not forget the
> galleries where of course I saw Rembrandt's "night watch" and many others "Franz Halls" then
> the modern dutchmen [Anton] Mauve and [Willem and/or Matthijs] Maris also an important
> Whistler I think this Rix gallery in some respects rivals the Louvre—I made some few etchings.[10]

Marin's sense of humor comes through in his description of one of the city's less attractive aspects: "They do have mosquitos here and this house is full of them but they have nets over all the beds this is very good as it don't allow the pests to get outside the nets."[11]

Marin's European prints not only reflect the artist's admiration for Whistler but also suggest some of the subjects he had already made his own, subjects that would engage him in a very personal way throughout the decades to follow. Particularly prophetic was Marin's interest in buildings that stretched high, the towers and spires that dominated the picturesque towns he visited—for example, the tower seen in *St. Germain-des-Prés, Paris* (plate 63). In retrospect, one readily views these as forerunners of those buildings that "scraped the sky"[12]—the subjects of several etchings completed after Marin's return to America. Some of the European etchings—for example, *Notre Dame, Seen from the Quai Celestins, Paris* (plate 28)—feature the dramatic, active skies that became one of

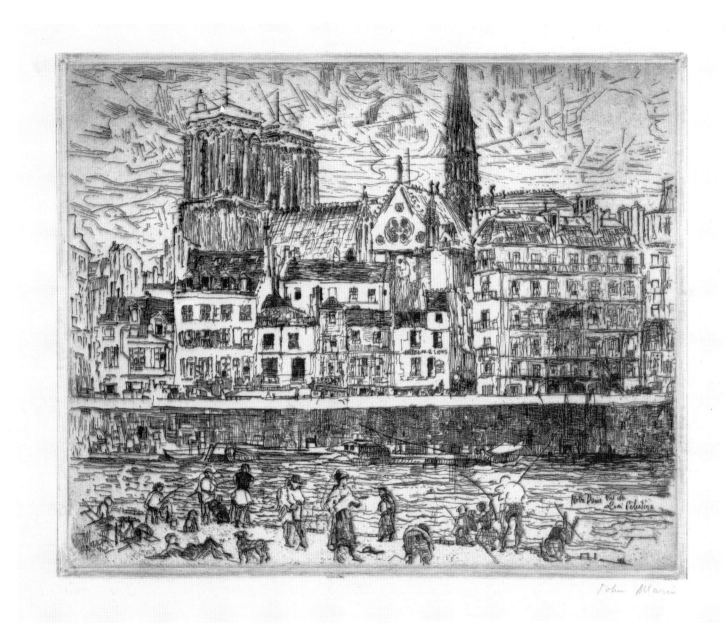

°28. *Notre Dame, Seen from the Quai Celestins, Paris,* 1909.
Etching, 7⅞ x 9¹³⁄₁₆ in. Private collection. Z.97.

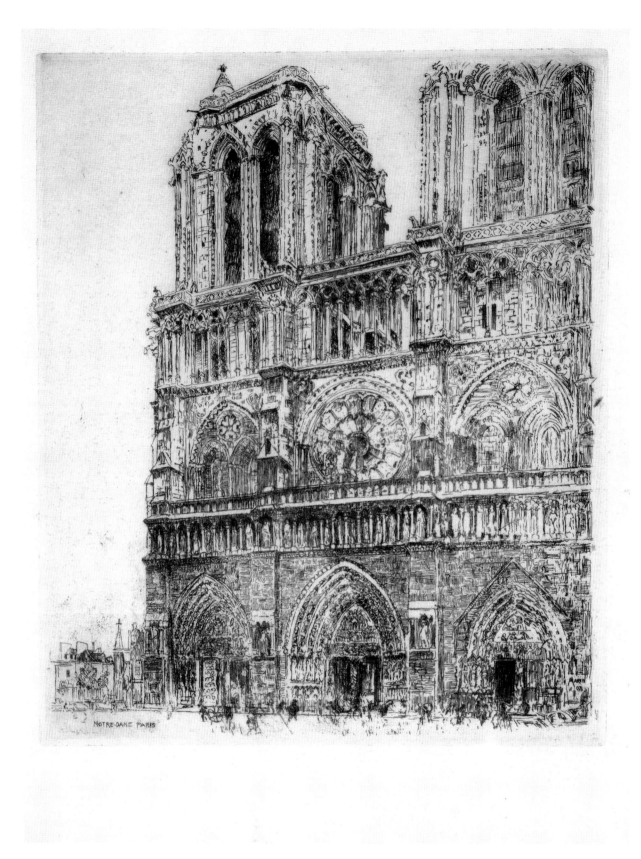

°29. *Notre Dame, Paris,* 1908. Etching, 12⅝ x 10¹¹/₁₆ in.
National Gallery of Art, Washington, D.C.; Gift of John
Marin, Jr. Z.79 v/v.

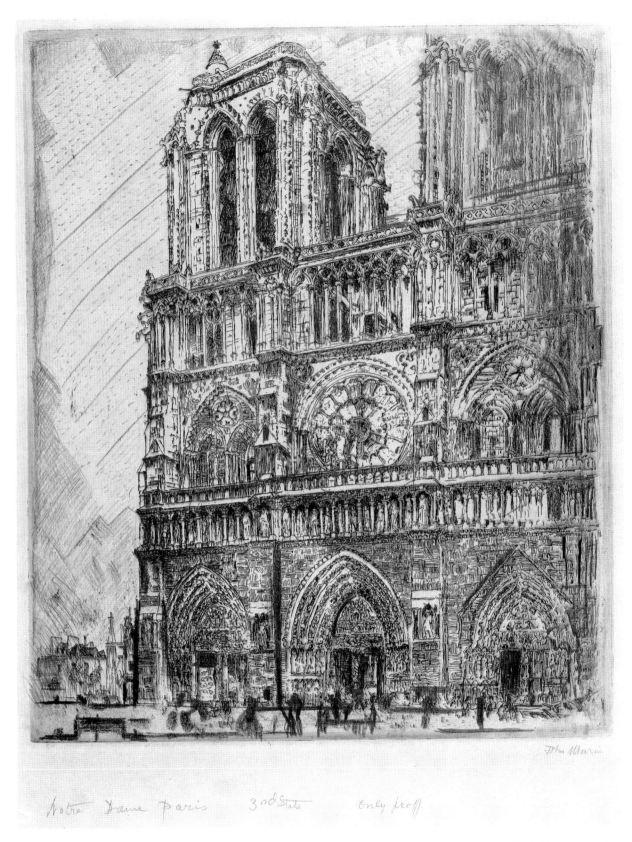

Notre Dame Paris 3rd State Only proof

°30. *Notre Dame, Paris,* 1908. Etching with graphite annotations, 12⅞ × 10¾ in. The Metropolitan Museum of Art, New York; The Alfred Stieglitz Collection, 1949. Z.79 iii/v.

Marin's hallmarks. This etching also expresses Marin's fascination with effects of light, from the soft and flickering atmosphere to the clarity with which light structures the urban geometry. When shown at 291 in Marin's 1910 exhibition, the print was singled out by critic Elizabeth Luther Cary as having "in particular that movement and sparkle that is the very life of an etching."[13]

Marin's etchings are small, intimate objects. The four largest, measuring approximately 13 by 11 inches, depict major Parisian tourist spots—Notre Dame (plates 29, 30), the Opéra, the Madeleine, and Saint-Sulpice. All of Marin's other etchings are considerably smaller, measuring approximately 8 by 10 inches. The tourist views were apparently undertaken with the encouragement of the New York printseller Louis Katz. According to Charles Bittinger, Marin greatly disliked working on commissioned subjects instead of those of his own choosing, and he had so many problems with the large plates that he vowed he would never again work at that size.[14] Indeed, apart from approximately twenty watercolors and a few oils, the year 1908 seems to have been consumed by these four meticulously worked prints, for which Marin occasionally drew proposed changes and additions onto proofs. An example is plate 30, which is heavily annotated with graphite.

Just as Marin's major themes are introduced in his European etchings, so are his formal concerns. His approach to line in many of the etchings was vigorous and staccato rather than delicate and gentle, as Whistler's tended to be, showing that even this early in his career Marin had developed a handwriting of his own. As Carl Zigrosser has suggested in *The Complete Etchings of John Marin*, Marin's response to Whistler may have been as much one of recognition or kinship as of emulation.[15] Marin's clear appreciation for the power of line and his urge to select, or abstract, the salient aspects

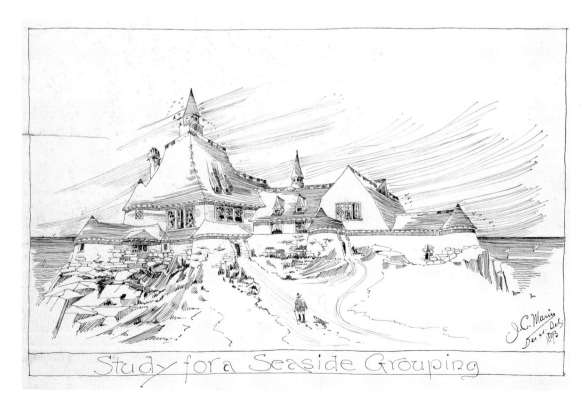

31. *Study for a Seaside Grouping*, 1893. Ink on paper, 10⅝ x 16 in. National Gallery of Art, Washington, D.C.; Gift of John Marin, Jr.

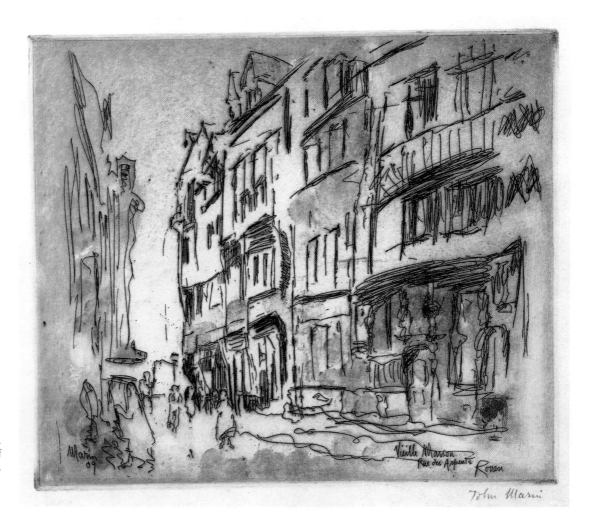

°32. *Old House, Rue des Arpents, Rouen, I*, 1909. Etching, 6⅞ × 8½ in. Cleveland Museum of Art; Dudley P. Allen Fund. Z.90.

of a place are among the most marked characteristics of the European etchings. The artist's strong emphasis on draftsmanship may be rooted in his career as an architect. Zigrosser has suggested that his choice of architectural subjects might have stemmed from this as well, but subjects of that sort are so pervasive among prints of the period by various artists that Marin's previous career seems of less importance in this regard.[16]

There is evidence, however, that Marin's broad knowledge of prints had some origins in his architectural career. An 1893 pen-and-ink drawing, *Study for a Seaside Grouping* (plate 31), which was executed during the time Marin was working as an architect, is inscribed "J. C. Marin / Des. et. Del. / 1893." He could have learned this manner of signifying artistic credits—"Des." and "Del." might stand for "designed" and "delineated"—by studying engravings of architectural subjects. In addition, the closely drawn parallel strokes with which the artist suggested tone could stem from that tradition as well. That Marin may have studied architectural prints is nonetheless only conjecture, and the freedom of his etched line bears virtually no resemblance to the pragmatic draftsmanship of architectural engravings. Rather, Marin's line suggests the directness and spontaneity characteristic of prints rooted in the late nineteenth-century painter-etcher revival, espoused in the United States

soon after it emerged in Europe. This approach gave line a plastic function similar to the one that color serves in painting—suggesting spatial shifts that establish pictorial structure.[17]

Marin's art encompasses both his delight in nature and his immersion in the modern age. In his case, one component of the latter was a kind of nostalgia for an earlier, simpler era, a time that seems to be signified in Marin's work by the recurring image of a horse and wagon. From his very first prints, such as *Hansom Cab, Paris* (Z.5),[18] through *Brooklyn Bridge—On the Bridge, No. 1* and *No. 2* (Z.163, plate 65), from the last decade of the artist's life, the horse (usually drawing a carriage or cart) reappears in the work. A poignant, old-fashioned sort of image, the horse is found not only in the etchings but in many drawings, watercolors, and paintings as well; and it seems pertinent that in his description of Venice quoted earlier, Marin mentioned the horse that was kept on exhibition.

Marin's use of the etched line changed dramatically during these important years in Europe. His desire to break free from whatever limitations he perceived in his earliest prints was rewarded in his 1909 etching, *Old House, Rue des Arpents, Rouen, I* (plate 32). The print is drawn with a freely worked, meandering line that was enhanced with selective tonal wiping, manipulated differently for each impression. As in *Bridge over Canal, Amsterdam* (plates 26, 27), Marin used the tone with a sense of great exploration. "Every Print Different" is the inscription on plate 32, and its surface is distinctively marked by the artist's fingerprints. That the print was an enormously important one for Marin is indicated by another inscribed impression in a private collection: "A Departure—Freedom," it practically shouts from its margins.[19] While a similarly loose style of drawing is seen in other prints of 1909—among them, *Cathedral, Rouen* (plate 33)—nowhere else is it so expansively manifested.[20]

Other prints from about this time are exploratory in other ways. *St. Ouen, Rouen* (plate 34), for example, shows the range of Marin's line from the fairly descriptive, in some of the cathedral's details, to the radically abbreviated, especially along the street leading back into space. A conscious quest for change, in both his watercolors and etchings, was on the artist's mind: "Some of the etchings I had been making before Stieglitz showed my work already had some freedom about them. I had already begun to let go some. After he began to show my work I let go a lot more, of course. But in the watercolors I had been making, even before Stieglitz first saw my work, I had already begun to let go in complete freedom."[21] Yet Marin's development never followed a straight path. The prints of 1910, his last year in Europe, embrace not only the breakthrough style of *Old House, Rue des Arpents, Rouen, I,* but that of all his other earlier linear approaches as well. Not until his return to America did his freer approach fully blossom.

Starting in 1908, with only the four elaborate tourist views completed, Marin's output in etching diminished. Only sixteen prints were completed in 1909 and a half-dozen in 1910, compared to thirty-seven in 1906 and twenty-nine in 1907, Marin's most prolific years as an etcher. There undoubtedly were a number of reasons for this. The artist may have lost some of his enthusiasm for the medium while working on the large commissioned subjects. In correspondence with his father Marin often expressed his desire to be painting as well as his correlation of making etchings

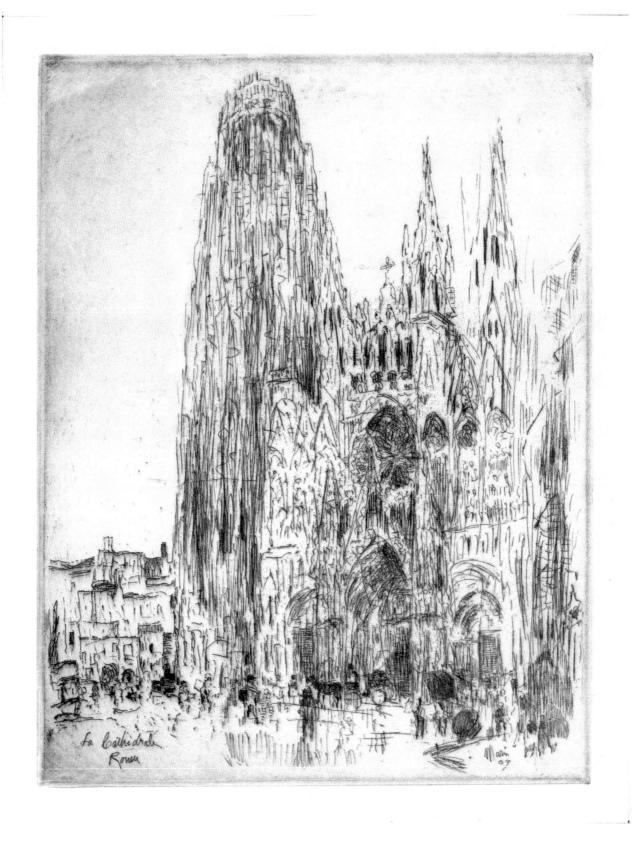

°33. *Cathedral, Rouen*, 1909. Etching, 9¹³⁄₁₆ × 7¹¹⁄₁₆ in.
Private collection. Z.85.

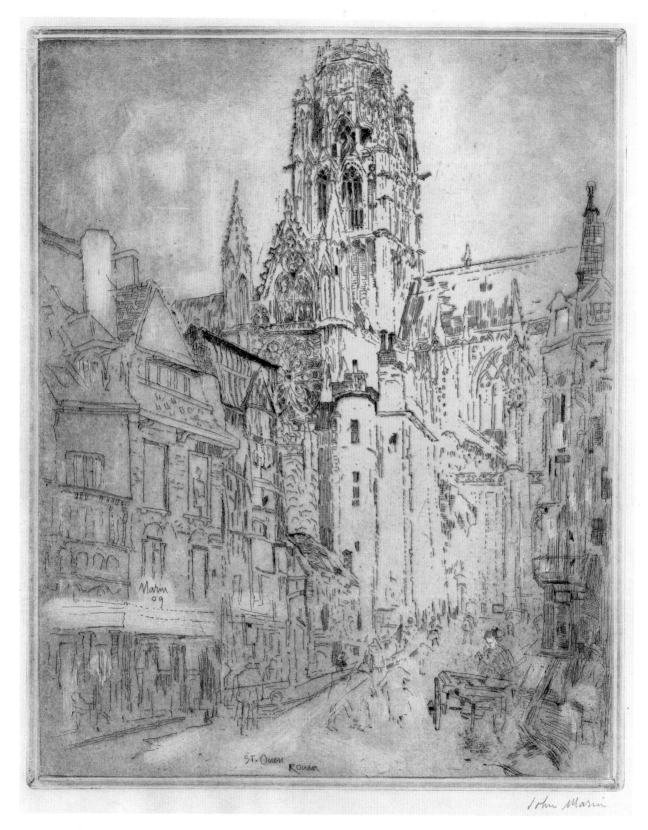

John Marin

°34. *St. Ouen, Rouen*, 1909. Etching, 11⅜ x 9 in. The
Metropolitan Museum of Art, New York; Harris Brisbane
Dick Fund, 1923. Z.89.

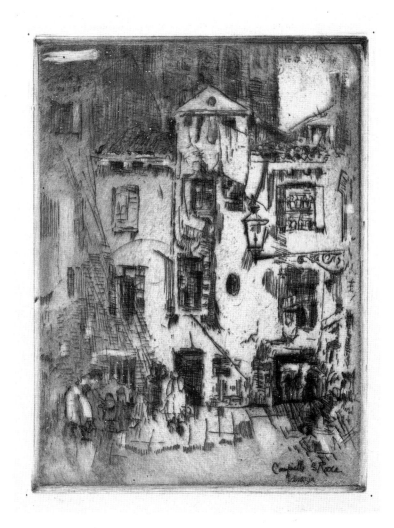

°35. *Campiello San Rocco, Venezia,* 1907.
Etching, 6¼ x 4¹¹/₁₆ in. Private collection. Z.50.

with the need to make money.[22] But the freer style he was developing may have made his work less generally acceptable to the conservative print-collecting audience.[23]

At the same time, Alfred Stieglitz's interest in Marin's work in general would have reduced the pressure on him to produce traditional prints. Stieglitz had begun showing Marin's work in New York in the spring of 1909, having been sent a group of his watercolors by Edward Steichen (who was to introduce the two men in Paris later that year). From that point until the end of Stieglitz's life, he vigorously represented Marin's work, instructed visitors to his galleries on its distinctive merits, sold it to an appreciative public, assured Marin enough funds to live on, and acquired for himself an extraordinary collection of the artist's work. Although it is difficult at times to separate legend from fact, Stieglitz's commitment to the full range of Marin's work is suggested by an anecdote about the day the artist showed him his highly individualistic new etchings, and Stieglitz asked why he didn't do more of them. To Marin's response that dealers had called them unsalable Stieglitz is said to have replied, "If I were you and could do things like that, I'd tell off the dealers and do what I wanted."[24] Marin responded to Stieglitz's encouragement, a development that caused Marin's father considerable consternation. Worried that the artist would have no source of income if anything happened

to Stieglitz during World War I, the elder Marin apparently suggested to his son's mentor that Marin do salable etchings in the mornings and his crazy watercolors in the afternoons. Stieglitz's response was, reportedly, that Mr. Marin ask his new wife whether a woman could be a prostitute in the morning and a virgin in the afternoon, the equivalent of what he was wanting his son to do.[25]

Marin worked entirely in the linear etching processes. The soft tonal effects in his prints were achieved not by etching into the plates but from the manipulation of ink on the surface during printing. Sometimes this meant using tone to establish compositional details, as in the Whistlerian *Campiello San Rocco, Venezia* (plate 35); at other times it meant simply leaving an even haze of ink all over the plate to add warmth and density to the image. At yet other times, especially in his earliest prints, Marin's manner of wiping the plate with a circular hand motion is clearly evident, with the central area of a subject wiped most cleanly and the edges and corners decidedly gray. This method provides some of the earliest suggestions of Marin's framing enclosures, a formal approach that came to be closely associated with his art. The framing strategy did not play a serious role in Marin's paintings until the early 1920s, but he was enclosing images within his prints as early as 1907. The wide beveled edges of his etching plates themselves occasionally served this function: ink was intentionally left on the bevel in making impressions of several subjects—as in *St. Germain-des-Près, Paris* (plate 63)—contrary to the more usual practice of cleaning a plate's edges to prevent their interfering with the image.[26] After Marin's return to America, he began to draw an actual border within the main body of the plate, creating a stronger enclosure than the darkened bevel provided —for example, plates 37 and 39. These drawn borders were often intensified in the printing, sometimes by being wiped especially clean, sometimes by being left darker. Marin often used his fingers to smear the ink in the border.

Although Marin completed a large number of watercolors, pastels, and other drawings as well as several oils during his years in Europe, his etchings constitute the most accomplished and distinctive body of work from that stage of his career. His interest in making prints continued after his return to America in 1910, albeit with only intermittent intensity. The subjects were related closely to his other work, mainly in watercolor, which became his primary medium for the next two decades. In watercolor, however, both landscape and city engaged Marin's attention, whereas in the etchings he focused on New York City and its environs, at least until late in life. One reason for this may have been that his etching press was set up in his New Jersey house rather than in Maine.

The Brooklyn Bridge is the subject of two vigorously worked etchings dated to 1911, one horizontal (Z.105), the other vertical (plate 36). Neither was printed in more than a few proof impressions.[27] Though related in spirit to the last of the European prints, they are stylistically very different from them. Instead of being drawn with the meandering line seen in *Old House, Rue des Arpents, Rouen, I* (plate 32) and other of the 1909 subjects, the 1911 etchings were worked in a rather scratchy manner, with a jagged back-and-forth, or up-and-down, motion. These earliest of Marin's Brooklyn Bridge prints are a watershed in the development of his etching style. Their use of

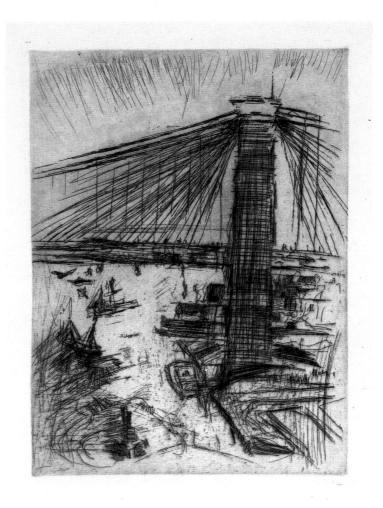

36. *Brooklyn Bridge*, 1911. Etching, 11 × 8½ in.
Lee G. Rubenstein. Z.104.

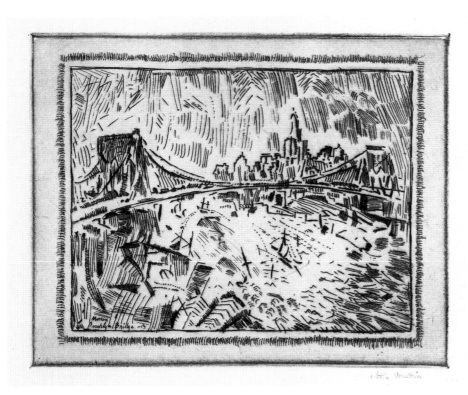

°37. *Brooklyn Bridge and Lower New York*, 1913.
Etching, 6¹³⁄₁₆ × 8⅞ in. Private collection.
Z.106.

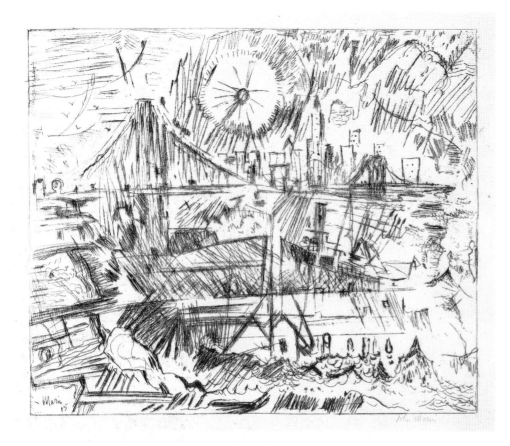

°38. *Brooklyn Bridge from Brooklyn (The Sun)*, 1915. Etching, 10¾ × 12¹³/₁₆ in. The Cleveland Museum of Art; Gifts of Mr. and Mrs. Lewis B. Williams Collection, Leonard C. Hanna, Jr., The Print Club of Cleveland, Mr. and Mrs. Edward B. Greene, L. E. Holden Fund, Ralph King, and Bequests of James Parmelee and Charles T. Brooks by exchange, 1981. Z.122.

line is very different not only from his European prints but also from the more staccato approach of the prints that followed.

None of Marin's prints is dated to 1912, but 1913 was a splendid year for Marin the etcher. The Woolworth Building and the Brooklyn Bridge dominated his efforts to evoke the dynamic life of the city he was learning to know again and coming to love in a new way. Settling back in America with the comfort of Stieglitz's support, Marin responded to all the forces now separating the New World from the Old, the modern from the traditional, the world he had always known as home from the one he had just visited. In his etchings, as in his watercolors, Marin was attempting to explicate the energy that was surging upward, in the shape of the new skyscrapers, and that was connecting vast distances, as new technologies and materials facilitated the building of expansive bridges.

The Brooklyn Bridge appears in Marin's etchings from 1911 to as late as 1944. His earliest etched views of the bridge encompass aspects of the city's skyline and river life as well. Exemplary is *Brooklyn Bridge and Lower New York* (plate 37), in which the sky and the river embrace the city's structures, reflecting the planes of the buildings as they move in all directions until caught by the short strokes of the framing border, one of the first Marin actually drew on a plate. In a similar view from two years later, *Brooklyn Bridge from Brooklyn (The Sun)* (plate 38), the bridge and the spaces between the artist and the span are the artist's primary subject.

Several other views feature Brooklyn Bridge itself, with little attention paid to the city. *Brooklyn Bridge (Mosaic)* (plate 39), the most descriptive of the group, is similar to the earlier *Brooklyn Bridge*

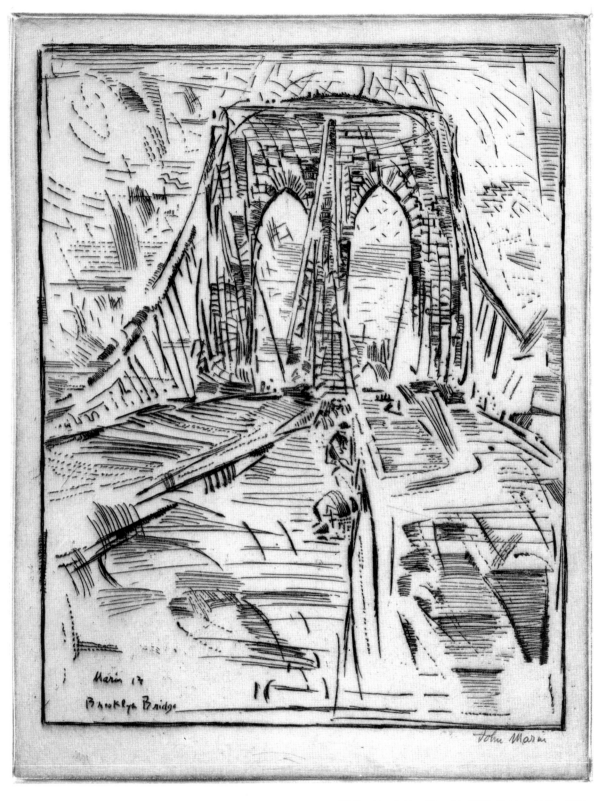

39. *Brooklyn Bridge (Mosaic)*, 1913. Etching, 11⅜ x 8¾ in.
Private collection. Z.107.

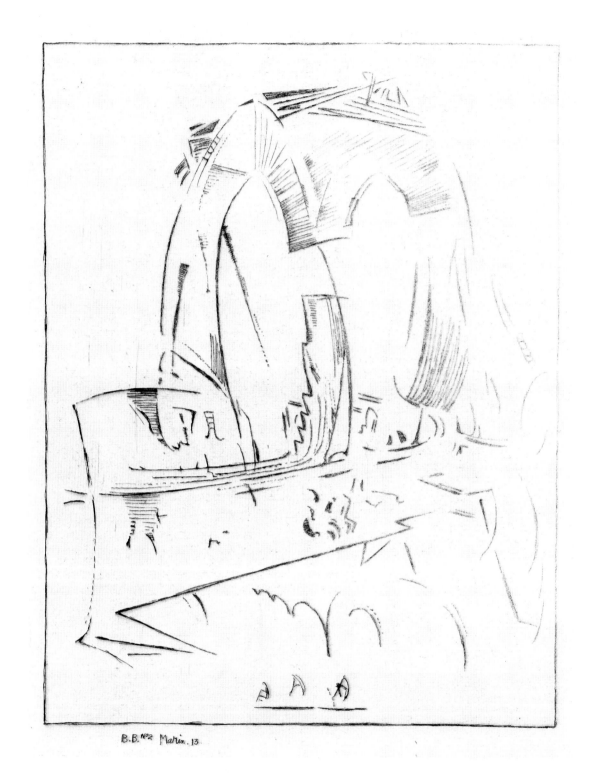

40. *Brooklyn Bridge, No. 2 (Song of the Bridge),* 1913.
Etching, 10¾ x 8⅞ in. Philadelphia Museum of Art; The
J. Wolfe Golden and Celeste Golden Collection of Marin
Etchings. Z.109.

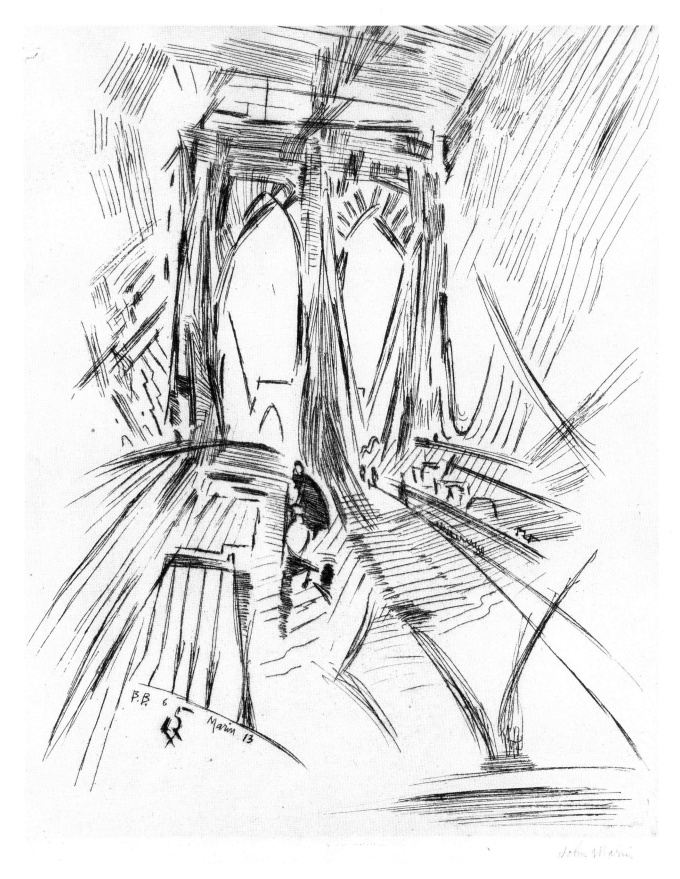

°41. *Brooklyn Bridge, No. 6 (Swaying)*, 1913.
Etching, 13¼ × 10¾ in. Amon Carter
Museum, Fort Worth. Z.112.

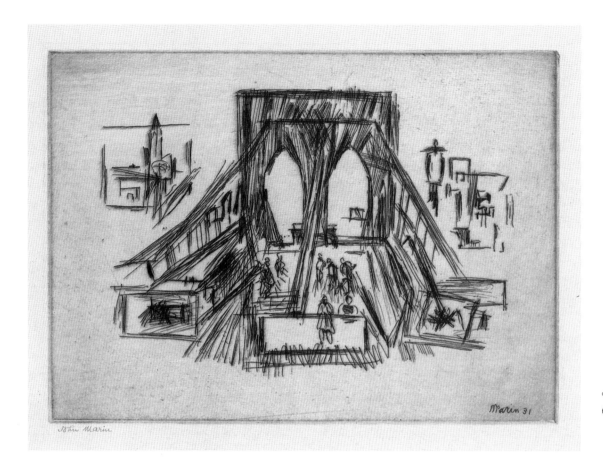

°42. *Approach to the Bridge*, 1931. Etching, 6¹³/₁₆ × 9¾ in. Private collection. Z.154.

and Lower New York in its combination of dot-dash strokes with series of parallel lines. Both prints look explosive, as if fireworks had been set off over the city. In contrast, *Brooklyn Bridge, No. 2 (Song of the Bridge)* (plate 40) is more slowly rhythmic and incredibly spare in its selective use of line.[28] *Brooklyn Bridge, No. 6 (Swaying)* (plate 41)—with its clear suggestion of the bridge's moving off in the distance and with the structure actively integrated into its surroundings—is the most dramatic of the group, equal in visual power to the Woolworth Building etchings of the same year. Marin made drawings and paintings of the bridge off and on for years. In etchings he took it up again in 1931 and 1944. The earlier of the two motifs, *Approach to the Bridge* (plate 42), relates to those of 1913, but it is horizontal in format and features a more incisive line and the use of various formal enclosure elements that Marin had since incorporated into his work. There are four preliminary etched studies for the work (Z.150–53), all of which exemplify the kind of segmented image that Marin explored increasingly in his painted city scenes of the 1930s (see, for example, plate 148).

Marin's interest in the Woolworth Building was more contained than his interest in the Brooklyn Bridge. Four Woolworth etchings were done within a single year, 1913, with only one reappearance of this specific subject four years later, in one of the artist's most experimental prints, *Woolworth from the River* (plate 50). Other soaring structures play an important role in the New York etchings, however, as in *Trinity Church Yard* (plate 23). This etching is of particular interest because it clearly served as a source for a watercolor painted a few years later (plate 44). The church also appears in

43. Trinity Church seen from Wall Street, n.d.

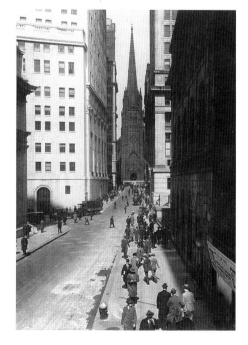

44. *Trinity Church,* c. 1921. Watercolor and graphite on paper, 10 x 8 in. Private collection. Not in Reich.

45. *Trinity Church, Downtown, New York,* c. 1919. Graphite and wash on paper, 9¹⁵⁄₁₆ x 7³⁄₁₆ in. Private collection. Not in Reich.

a spare, curvilinear graphite-and-wash abstraction (plate 45), in which the cross configuration at the bottom emphasizes the nature of its subject.

Many drawings of the Woolworth building exist, too, with varying degrees of fidelity to the building and with varying relationships to the prints and watercolors based on the subject—for example, plate 46. Impressions of *Woolworth Building, No. 1* (plates 47, 48) vary greatly, as much as in any of Marin's subjects. Much of the detail was brought out by the handling of tone on the surface of the plate, very different from *Bridge over Canal, Amsterdam* (plate 26), in which the use of plate tone to create atmosphere emulated Whistler. By 1913 Marin had moved worlds away from Whistler, and while his use of tonal wiping did yield atmospheric effects, its major function was structural, suggesting both details of the architecture and shifts in pictorial space.

Plates 47 and 48 both vividly convey the sense of the artist's fingers swiftly dabbing away areas of ink in the sky and in some of the broad planes of the buildings. He might have drawn the more linear markings with his fingernail, or a blunt tool, or with a stiff cloth twisted into a point. One notes here, too, the margin, drawn as an integral part of the image and, in these impressions, wiped fairly clean. While the two impressions are similar, the precise gestures and planes that are set down— or, to be more precise, lifted out—are distinctly different.

46. *Woolworth Building,* c. 1913. Graphite on paper, 11 x 8½ in. Courtesy of Kennedy Galleries, Inc., New York.

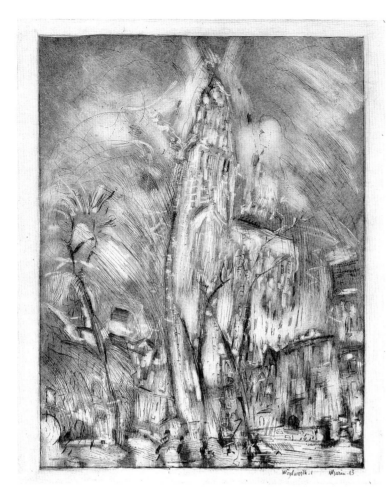

°47. *Woolworth Building, No. 1*, 1913. Etching, 11⅞ × 9¹⁵/₁₆ in.
National Gallery of Art, Washington, D.C.; Avalon Fund. Z.113.

°48. *Woolworth Building, No. 1*, 1913. Etching, 10⅞ × 8¾ in.
Amon Carter Museum, Fort Worth. Z.113.

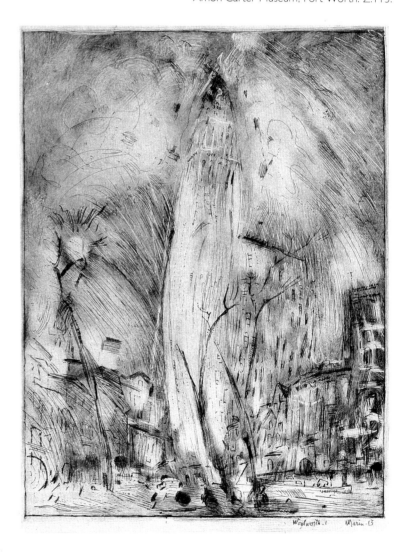

°50. *Woolworth from the River*, 1917. Etching with monotype
surface shapes, 11⁵⁄₁₆ × 9 in. Philadelphia Museum of Art;
The J. Wolfe Golden and Celeste Golden Collection of
Marin Etchings. Z.131.

°49. *Woolworth Building (The Dance)*, 1913. Etching, with
inscription to Alfred Stieglitz, 13 × 10½ in. The Art Institute
of Chicago; Alfred Stieglitz Collection. Z.116.

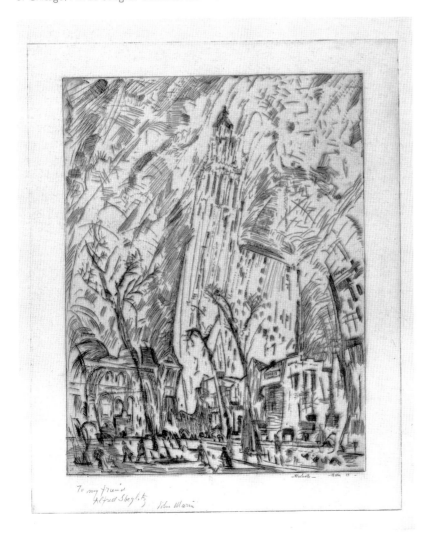

Woolworth Building (The Dance) (plate 49) was more consistently printed: the impressions are generally wiped with an even film of plate tone overall, at times slightly darker in the margin. The basic activity is dependent on the etched line, with considerable specificity in the figural activity along the street. Marin's last etched Woolworth Building, *Woolworth from the River* (plate 50), incorporates clearly defined shapes of surface tone applied by offset and is a far more abstracted version of the structure than any of the earlier etchings. It is closely aligned with several spare, linear abstractions of 1916 and 1917. *Movement—Grain Elevators, No. 2* (plate 51), for example, shows a linear "movement," as Marin termed it, juxtaposed with areas of tone unique to each impression. At times

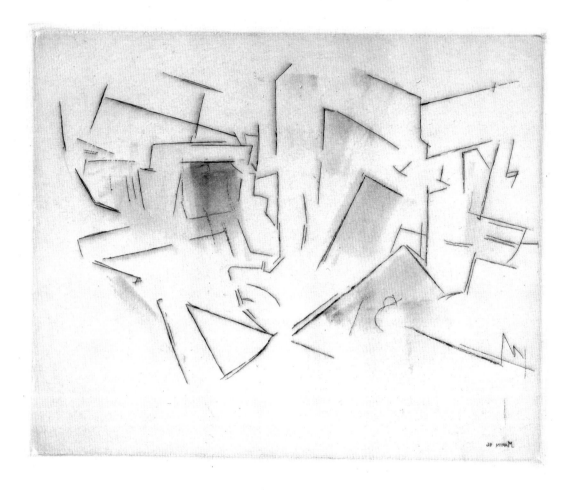

°51. *Movement—Grain Elevators, No. 2*, 1916. Etching with monotype surface shapes, 9 x 11⅛ in. Private collection. Z.128.

this tone may have been set down with rubber pads, as Zigrosser suggested; in other instances, however, small pieces of sponge were clearly used.[29] Zigrosser also indicated that several prints from this period, including plate 51, are engravings. Indeed, Marin annotated one impression with that term. The character of the line, however, is that of etching, and it seems possible that his annotation suggests how he wanted the work to look rather than how it was made.[30]

The spare vision exemplified in these etchings of 1916–17 is close in character to that of Marin's watercolors at this time. Like the watercolors, they are active in gesture, although they tend to be far more placid than two explosive earlier etchings, *Weehawken, No. 1* and *Weehawken, No. 2* (plates 52, 53), and the highly faceted *Grain Elevator, Weehawken* (plate 54), all three from 1915. In this last,

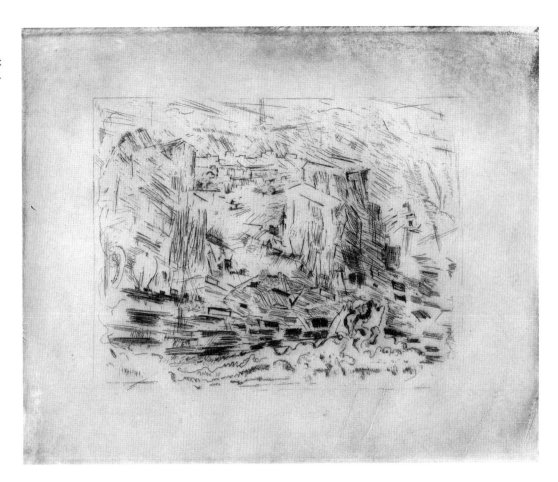

°52. *Weehawken, No. 1*, 1915. Etching, 9¹/₁₆ ×
11¼ in. Private collection. Z.123.

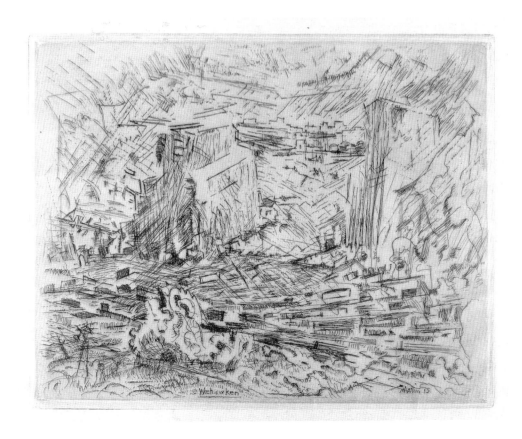

°53. *Weehawken, No. 2*, 1915. Etching, 6¹¹/₁₆ ×
8½ in. Philadelphia Museum of Art; The Lola
Downin Peck Fund. Z.124.

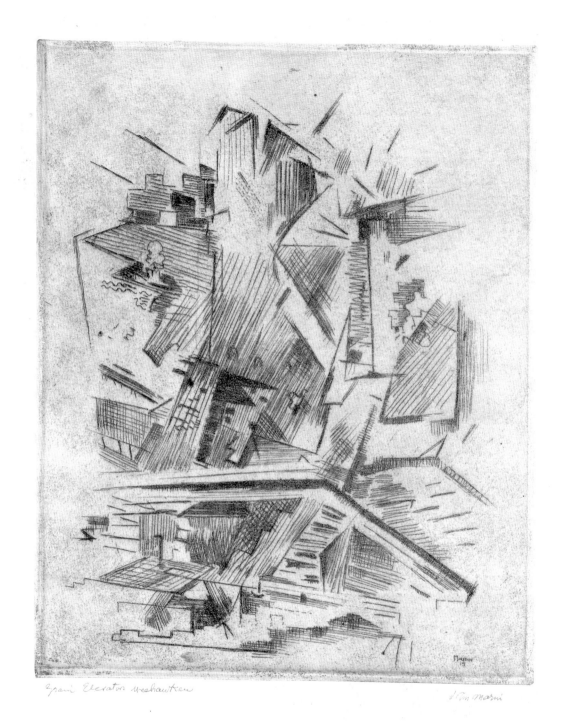

Grain Elevator, Weehawken

°54. *Grain Elevator, Weehawken*, 1915. Etching, 11¼ x 9¹⁄₁₆ in. Collection, The Museum of Modern Art, New York; Given anonymously. Z.125.

the planes of the structure overlap in various directions, suggesting as strong an impulse toward Cubism as can be found in Marin's art.

Almost foretelling the composition of the Brooklyn Bridge prints of 1944 (Z.163, plate 65), although in reverse, is *Downtown, The El* (plates 55, 56); it is known in three versions, the first and third of which are seen here. As usual for Marin, the first version is closest to the scene, with the others moving toward greater abstraction. The etching is also closely related to one of Marin's most

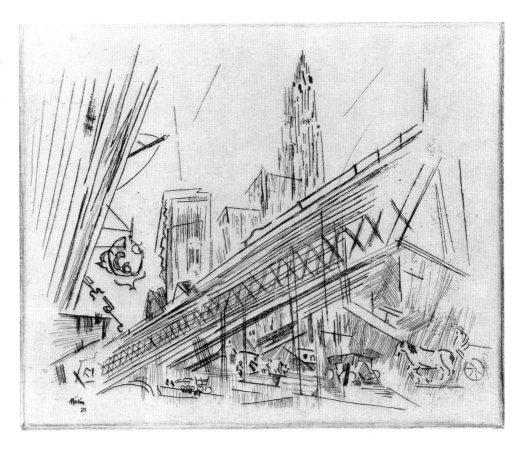

°55. *Downtown, The El* (first version), 1921. Etching, 7⁷⁄₈ × 9¹³⁄₁₆ in. Philadelphia Museum of Art; The J. Wolfe Golden and Celeste Golden Collection of Marin Etchings. Z.132.

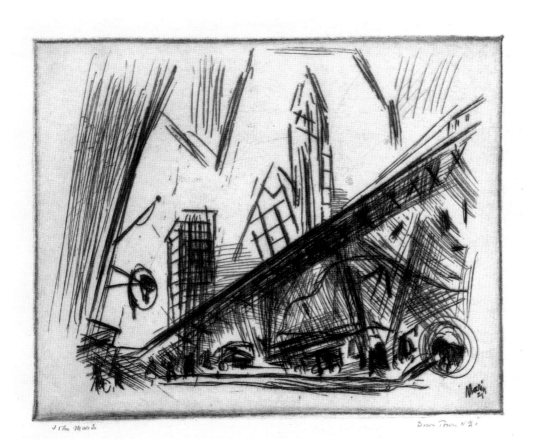

°56. *Downtown, The El*, 1921. Etching, 6¹⁵⁄₁₆ × 8¹³⁄₁₆ in. Private collection. Z.134.

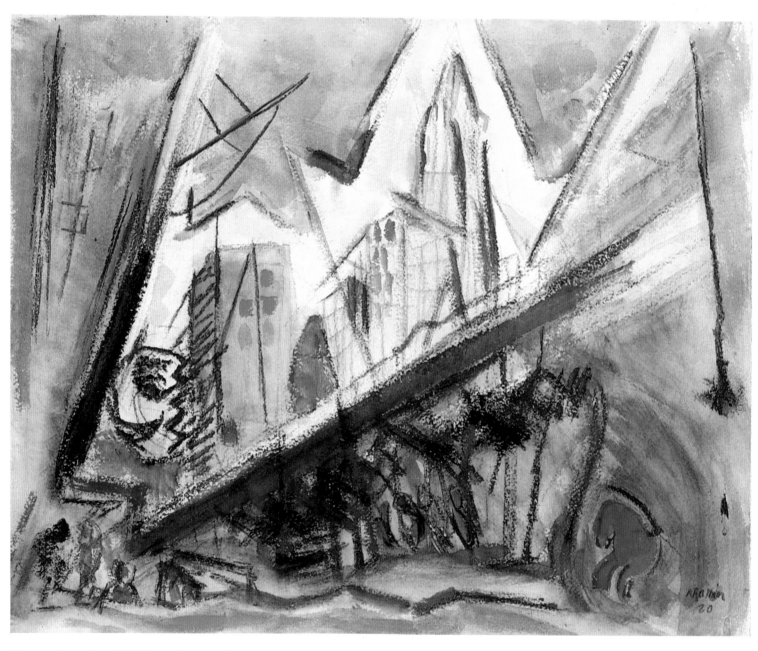

57. *Lower Manhattan*, 1920. Watercolor, graphite, and charcoal on paper, 21⅞ x 26¾ in. Collection, The Museum of Modern Art, New York; The Philip L. Goodwin Collection. R.20.12.

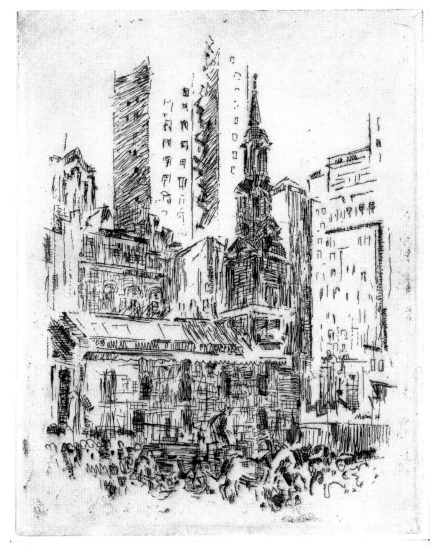

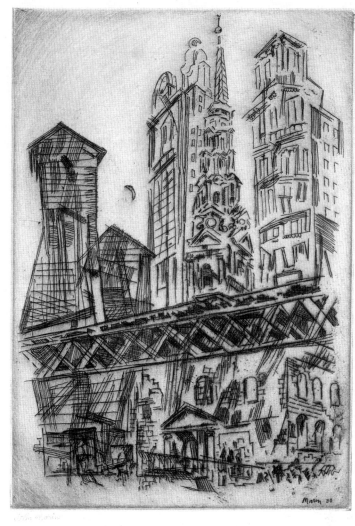

°58. *St. Paul's at Broadway*, 1914. Etching, 9¾ x 7¾ in. Private collection. Z.119.

°59. *St. Paul's against the El*, 1930. Etching, 9¹¹⁄₁₆ x 6¹³⁄₁₆ in. Private collection. Z.146.

dynamic watercolors of the period, *Lower Manhattan* (plate 57), and comparing the two gives a clear indication of how the artist's work in various media interacted.

In 1914 Marin had undertaken three somewhat generalized, densely packed city scenes, the most finished of which is the rare *St. Paul's at Broadway* (plate 58). The artist picked up the subject again the following decade, and during the 1920s and '30s his etchings, approximately twenty-five in all, focused on street scenes in New York City. He explored the interaction of the city's inhabitants, the cars that were growing in number, and the lower buildings that hugged the ground and structured the human activity. *Street Scene, Downtown, No. 3* (plate 60) is exemplary. The artist also combined the city's towers with aspects of street life, completing such works as *St. Paul's against the El* and *Downtown Synthesis, No. 3* (plates 59, 61), marked by areas of monotype surface printing, and he also introduced more distant views, such as *Lower Manhattan from the Bridge* (plate 62), a horizontal rather than vertical view of the city, which implies the Brooklyn Bridge without actually showing it.

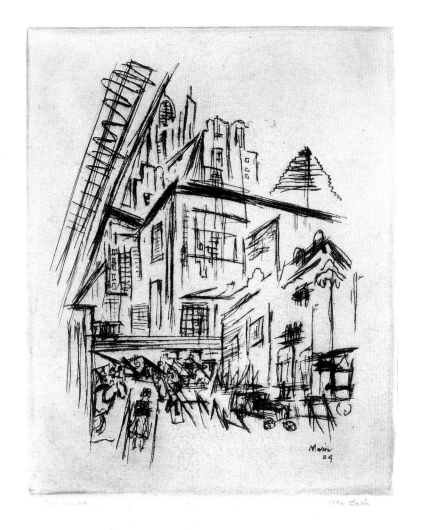

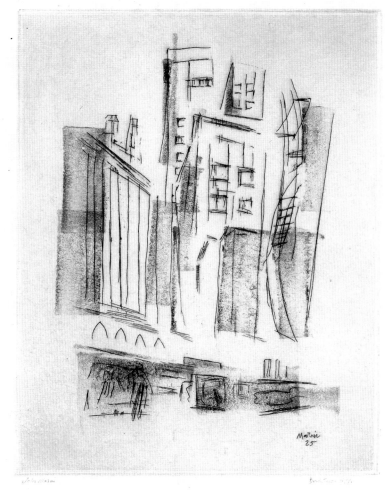

In 1932 Marin broke away from the urban environment and etched two prints of sailboats (Z.155, Z.156). His work in etching continued until almost the end of his life, albeit with decreasing frequency. The late etchings, printed in only a few proof impressions, reflect new motifs of interest to him, many of which were worked in more than one version. They comprise several figure compositions, including one circus scene (Z.165), which was etched during the period when circus subjects were important to Marin's paintings and drawings.

°60. *Street Scene, Downtown, No. 3*, 1924. Etching, 9⅞ × 7⅞ in. Philadelphia Museum of Art; The J. Wolfe Golden and Celeste Golden Collection of Marin Etchings. Z.138.

°61. *Downtown Synthesis, No. 3*, 1925. Etching with monotype surface shapes, 9⅝ × 7¾ in. Private collection. Z.140.

The artist's working methods varied over time but even within a single period his approach to etching was not consistent. At times he worked directly, as he described in one of his letters from Amsterdam: "I pass most of the time sauntering along the canals with etching plates in my hand and I have only two more plates left.... About next Friday we start for Paris & I will have my hands full biting and printing etchings & I hope they will turn out better than the Laon stuff did."[31] Back in Paris the following month, Marin continued his saga:

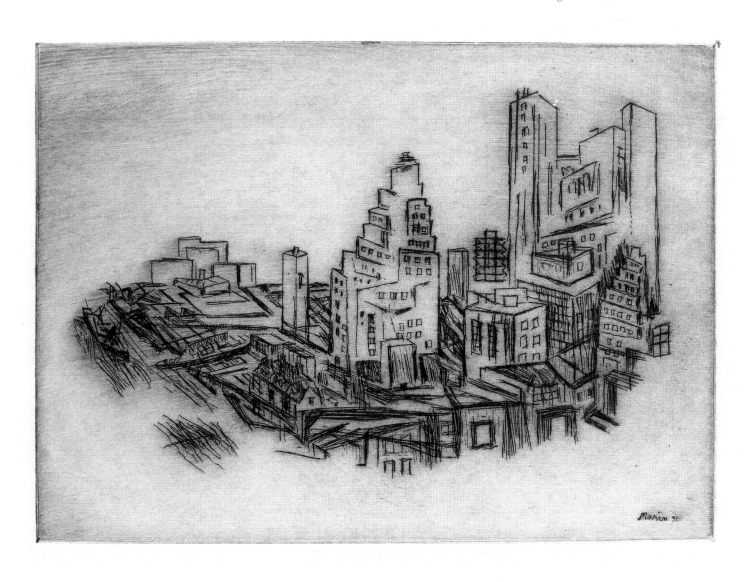

°62. *Lower Manhattan from the Bridge*, 1931.
Etching, 6¾ × 9½ in. Private collection. Z.149.

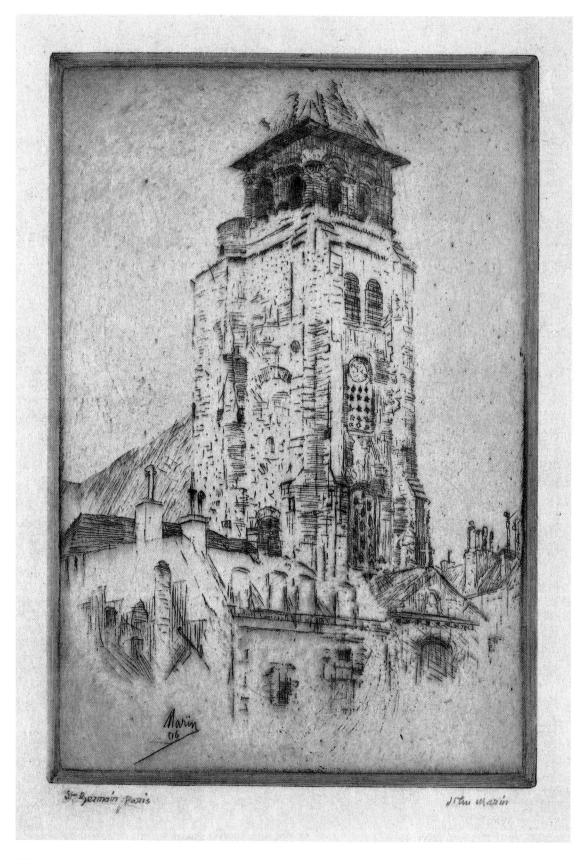

St. Germain-des-Près, Paris

John Marin

°63. *St. Germain-des-Près, Paris,* 1906. Etching, 8 x 5½ in.
Private collection. Z.47.

I am worrying over a lot of etchings that I made in Amsterdam. . . . I should have bitten them on the spot—but—I was afraid of carrying acid about with me however with corrections here and there hammering out & etc. I may have a half dozen good ones out of the dozen. . . . I am just beginning to learn the ways of etchings and now know that by biting you cannot make a good etching out of a bad drawing and that if you make a bad drawing don't bite it but repolish the plate which cost me lots of money until now I think I have all the parapharnalia [sic] for doing it my self. . . .[32]

This correspondence from fairly early in Marin's career suggests his commitment to technical accomplishment, which is vividly evident in the prints even from this time. Certain of Marin's etchings were drawn on the site, but a graphite drawing for *St. Germain-des-Près, Paris* suggests that from the

64. *Study for "St. Germain-des-Près, Paris,"* c. 1906. Graphite on paper, 14¹/₁₆ × 11¼ in. Private collection

very start of his career he also worked some of his prints from drawings (plates 63, 64). A fuller view of the scene than the one Marin eventually used for his etching, the drawing is in reverse of the print, in the direction it would have appeared on the plate had the plate been worked from it.

That so many of his etched images exist in several similar versions, a testament to Marin's care and concern for detail, suggests that reworking an idea entirely was one way to get what he wanted and also to maintain a sense of directness and ease. In the earlier works one finds several variations on a given theme, whereas in the works of the 1940s and '50s one is more apt to find several

65. *Brooklyn Bridge—On the Bridge, No. 2,* 1944. Etching, 6½ × 7⅞ in. Philadelphia Museum of Art; The J. Wolfe Golden and Celeste Golden Collection of Marin Etchings. Z.164 i/ii.

66. *Drawing for "Brooklyn Bridge—On the Bridge,"* 1944. Graphite on paper, 6¼ × 7⅞ in. John Marin Collection, Colby College Museum of Art, Waterville, Maine; Gift of Mr. and Mrs. John Marin, Jr.

versions of virtually the same image. This working and reworking, albeit on different works rather than for a prolonged time on only one, suggests that the association of spontaneity with Marin's art sets up a false notion. What is extraordinary is that he was able to work and rework and rethink as much as he did and yet manage each time to retain the glow of immediacy and the excitement of discovery.

Marin made many drawings related closely to the subjects of his prints. Sometimes, as with his sketches of New York street scenes of the mid-1920s, they are close to but not precisely the same images as the etchings, making it difficult to demonstrate that specific sheets actually functioned as sources for specific prints. Less speculative is the relationship of certain drawings on paper or plastic to some later prints—for example, *Brooklyn Bridge—On the Bridge, No. 1* and *No. 2* (Z.163, plate 65) of 1944. For them, one finds numerous drawings and tracings (such as plate 66), in essentially the same size but usually in reverse, showing the development of the image and demonstrating the enormous pains Marin would take to be precise in his spontaneity. The search for precision prevailed to the end of his life. Marin's last etched subject, *Ye Old Dutch Church, Upper Saddle River* (Z.174, Z.175), is a spare and simple composition constructed of few lines. It was etched in two versions, and again there are numerous transfer drawings related to them.

Marin was an expert printer. The European etchings brilliantly demonstrate this point, traditionally printed as they are in rich impressions with extensive use of *retroussage*, a method by which ink is lifted out of the lines, enriching the surrounding surface and yielding more velvety effects. After the artist's return to America he continued to be an expert printer, but entirely on his own terms. In fact, these prints forcefully defy generally accepted notions of quality in several respects. First, they tend to be somewhat silvery and spotty, with lines not fully inked and the broken lines enhanced by his elegant use of plate tone. The consistency of these unusual linear qualities throughout Marin's later oeuvre makes it apparent that they reflect the artist's intentions. By these means Marin achieved in his etchings atmospheric effects that paralleled those he was exploring in other media.

Second, in many impressions of later subjects a double line is evident, creating a shadowy, blurred effect that suggests that the paper shifted, either as it was set onto the plate or during printing. Again, this happens often enough to establish that it was intentional rather than accidental and that Marin saw this effect as one that enhanced his staccato drawing style. Supporting this idea is an impression of one of Marin's last prints, titled by Zigrosser *Sea with Figures, No. 1* (plate 67). The title *Sea Fantasy* was inscribed by Marin on the original backing board of the frame, indicating that the print was readied for presentation by the artist himself, who presumably liked the impression. It is pale and fuzzy by conventional standards, standards that Marin could easily have met had they been of any interest to him; but the double line throughout the composition adds a level of animation to the already highly gestural image. While this is a fairly extreme example, the same sort of personalized printing occurs throughout Marin's oeuvre. Marin's own views of the success of individual

67. *Sea with Figures, No. 1*, 1948. Etching, 6½ x 7¹⁵⁄₁₆ in.
Private collection. Z.166.

impressions are often inscribed right on them: annotations such as "A-1," "A-1 Plus," "Best Print," or "Approved Marin" frequently are found on the sheets.

For the most part Marin printed his own etchings, although only a few subjects are so inscribed. Prime among these is *Woolworth Building (The Dance)* (plate 49), impressions of which often indicate "Printed by John Marin / sent out by 291." There were exceptions, however, to Marin's functioning as his own printer. In the 1920s the artist Ernest Haskell, whom he had met during his Paris days, printed a few of Marin's earlier European plates, apparently to satisfy the needs of E. Weyhe Gallery, which represented the etchings at this time.[33] Several large editions that were commercially published were professionally printed as well. These include two European subjects: *Through the Window, Venice* (Z.60), printed by L. Fort in Paris and published in the January 1908 issue of *L'Art décoratif* to accompany an article about Marin, and *Meaux Cathedral II* (Z.76), by an unknown printer, which was published in the November 1908 issue of the *Gazette des Beaux-Arts* in an article on the Salon d'Automne.[34] In America, an impression of either *Brooklyn Bridge and Lower New York* or *Downtown, The El* (plates 37, 56) was issued in 1924 by the *New Republic* magazine as part of the *Folio of American Etchings,* in a combined edition that exceeded five hundred, according to Zigrosser. *Sailboat* (Z.155) was published in an unsigned edition of approximately two hundred by the American Artists Group in 1932; and *Lobster Fisherman* (Z.172), completed in 1948 and one of Marin's last etchings, was formally published in 1950 by Twin Editions with the portfolio *John Marin: Drawings and Watercolors. Brooklyn Bridge and Lower New York* and *Downtown, The El* were printed by Peter Platt, the others by Charles White and David Strang, respectively.[35]

Zigrosser recorded many of Marin's plates as printed in fewer than ten impressions, but his information on both states and edition sizes, now more than twenty years old, is due for revision. Except for plates from which only a few proofs were pulled, and the six subjects mentioned above as printed in editions larger than a hundred, the usual edition size for Marin's etchings appears to be twenty-five or thirty. They were generally, but not consistently, dated and inscribed with titles within the plates; most edition sizes were not recorded. The sheets apparently weren't signed until well after they were printed, presumably when they were about to be sold; some were sold without signatures.

Marin's early etchings clearly were meant to be a source of income for the artist, and several letters to his father from Europe indicate that success with the etchings would leave him free to paint.[36] This correspondence also shows that Marin was actively seeking dealers in London and Paris. One in Paris might have been Charles Hessele, who furnished the illustrations accompanying the article about Marin's prints in the January 1908 issue of *L'Art décoratif.* Marin's letters from the fall of 1906 provide an ongoing report of his commercial progress:

> As regards etching again I have been putting off writing to you in hopes I would have something
> definite to tell you in regard to that dealer they begin by talking big and then gradually pulling in
> their horns or putting out their chorus now he only wants to take immediately 6 etchings and he
> doesn't want them mounted which he might have told me at first I have been almost running my

legs off to him finding him most generally not in Saturday before last he told me to come again this Saturday called twice not in however it might all come out right he doesn't want to give more than 10 francs a piece. . . . I expect to leave for London & make some etchings there besides going around to all the dealers for the last time before I leave for London I am going around to this dealer's here and take 2 or 3 new etchings he promised to take 6 a come down we will see he is a great fellow all full of promises at first but may be when he hears from me that I am going to London he will know he is not the only man who can give me a *reputation*.[37]

It remains unclear whether Marin actually did make a productive dealer contact in Paris, but he had better luck in other places. Zigrosser suggested that the work was represented by a printseller in London, although he did not identify him. Back home in America, Marin's prints were taken on by Louis Katz in New York (who may have been introduced to the work by Marin's stepmother) and by Albert Roullier in Chicago, who may have heard about Marin from George C. Aid.[38]

Marin met Roullier in Paris in 1907. The artist had numerous etchings, little cash, and a burning desire to go to Venice, and the printseller agreed to purchase the etchings at Marin's price, although he apparently was so successful with them that he doubled the payment later.[39] Roullier is credited by Zigrosser as having published several of Marin's prints, starting with *Pont Neuf, Paris* (plate 25), which had been executed in 1905. It is difficult to know precisely what "publish" means in this context other than that he included them in the gallery's catalogs. They appear in those of 1909 and 1913, the latter of which focused on Marin and listed forty-nine European etchings, but not one of the more recent American views.[40]

In May 1911 Kennedy and Co. in New York held an exhibition of thirty-three of Marin's European etchings. The introduction to the catalog describes him as having spent his time in Europe "painting and etching out of doors at every opportunity. . . . He has an instinct for selecting the picturesque point of view, and as his etchings are nearly all architectural subjects, his early training assists in making his execution firm, forceful and vigorous."[41] Marin's etchings had been well received when exhibited during his years in Europe, and the Kennedy catalog notes that in 1908 he had been elected to the Salon "in recognition of the excellence of his exhibit of water colors, pastels and etchings."

Throughout his career, etchings were included in the exhibitions of Marin's work at Stieglitz's galleries. All of the New York etchings were seen there; according to Zigrosser, sometimes several were gathered together and sold as a set titled Six New York Etchings: *Brooklyn Bridge and Lower New York* (plate 37), *Brooklyn Bridge from Brooklyn (The Sun)* (plate 38), *Brooklyn Bridge (Mosaic)* (plate 39), *Brooklyn Bridge, No. 2 (Song of the Bridge)* (plate 40), *Brooklyn Bridge, No. 6 (Swaying)* (plate 41), and *Woolworth Building (The Dance)* (plate 49). Zigrosser, who was working during the teens for the conservative printsellers Frederick Keppel and Co., recounted how he first saw Marin's etchings at Stieglitz's gallery. He responded vigorously to their innovations, considering them unique in American etching and able to hold their own with European graphic art.[42] For a period in the 1920s E. Weyhe Gallery, one of the foremost supporters of modern American graphic arts and Zigrosser's employer

by 1919, represented Marin's etchings with Stieglitz's blessings. Among the public exhibitions in New York devoted solely to Marin's prints during this period were one in 1921 at Weyhe and another three years later at J. B. Neumann's Print Room. Most often, however, his etchings were included in shows of his works in various media.

Marin's own pride in his etchings, even his early ones, seems to have been sustained throughout his life. In 1948 he selected a group of seventy-seven prints spanning his career to be on view at An American Place. In referring to that show as an "unexpected exhibition," a reviewer for the *New York Herald Tribune* wrote: "Visitors will receive this show with kindly eye, and perhaps with some astonishment over the fact that, looking back upon a period of intense and successful printmaking, Marin himself regards fondly his early role as an impressionist and is as confident of the enduring merit of this attainment as of this more advanced work in tipsy-tilted skyscraper abstractions and cavernously simplified city-street scenes."[43]

In 1953 *John Marin: Prints and Drawings* was mounted at the Adele Lawson Galleries in Chicago (courtesy of the Downtown Gallery, New York); and starting that same year *John Marin Etchings*, composed of thirty prints, was circulated by the American Federation of Arts, opening at the J. B. Speed Art Museum in Louisville, Kentucky, six months before the artist died.[44] A review of the A.F.A. show indicates that impressions of *Lobster Fisherman* (Z.172), printed in a large edition from a steel-faced plate, were available for $15. Prices for the few other prints for sale ranged from $75 to $150.[45]

Marin's empathy with the etching medium, his respect for its intimacy, and his pleasure in its possibilities are obvious. In a 1911 letter to E. A. Taylor, who was writing an article featuring American artists in Paris, Marin summarized his thoughts about etching at that time. One doubts that he ever substantially changed them: "Do you want to know what I think about etchings and what they should be? Well, little letters of places. You don't want to write a volume to give tersely, clearly, with a few lines, each individual line to mean something, and there should be a running connection existing throughout. There you have it—lines, letters; letters, words; words, a thought; a few thoughts and you have your line impression of a something seen and felt."[46]

°68. *Hudson River at Peekskill,* 1912. Watercolor on paper,
15³⁄₁₆ × 18⅝ in. National Gallery of Art, Washington, D.C.;
Gift of John Marin, Jr. R.12.27.

69. Alfred Stieglitz. *John Marin at 291*, c. 1918.
Platinum print, 4½ x 3½ in. Private collection.

EUROPE
AND THE RETURN TO AMERICA

Marin's years in Europe, from 1905 to 1910, were of enormous importance to his career. A central figure of the expatriate art world then developing in Paris, he formed or reinforced friendships that would sustain him for the rest of his life. Like his friend from the Pennsylvania Academy, Arthur B. Carles, Marin frequented the Dôme, a café that served as a meeting place for artists and writers.[1] From their days in Philadelphia, Carles and Marin had shared an interest in billiards; they also shared a respect for each other's work.[2] In about 1908 Carles introduced Marin's watercolors and etchings to Edward Steichen, who in turn brought them to the attention of Alfred Stieglitz, thus initiating the most important professional association of Marin's life. The Dôme is also where Marin met the artist Ernest Haskell in 1910.[3] Years later Haskell was to print impressions for E. Weyhe Gallery from several of Marin's plates. Far more important to Marin, however, was Haskell's encouragement in getting him to visit Maine in 1914, a visit that was to have repercussions as important as those that resulted from Marin's meeting with Stieglitz a few years earlier.

Marin's own account of his European years in "Notes (Autobiographical)" was, like the rest of that document, rather compressed:

4 years abroad
played some billiards
incidentally knocked out some
batches of etchings which people
rave over everywhere
At this period the French Government was going to give me the
 Legion d'Honor I refused
they then insisted on buying one of my Oils
I ran away to Venice
they set up such a howl that
there was no escaping
 I let them have it[4]

Other accounts indicate that Marin, unlike many American artists in Paris at the time, avoided the now legendary evenings with Leo and Gertrude Stein.[5] As the letters Marin wrote home make clear, his activities included visits to the Rijksmuseum and the Louvre and, one can assume, other museums as well. Nevertheless, throughout his life he seems to have wanted to maintain and project a sense of his naïveté, and he tended to credit Stieglitz's introduction of modernist European art to America as the source of his own awareness of it. Writers during Marin's lifetime tended to believe him. E. M. Benson, his first biographer, wrote in 1935 that while in Europe, Marin "lived in comparative isolation, apart from cliques and especially from artists. . . . The museums and picture galleries saw little of him."[6]

There was a counterposition to this, however. For example, MacKinley Helm, in his 1948 biography, wrote that in 1918 Marin had spent "long hours analyzing from memory the work of old masters whose paintings he knew"; Herbert Seligmann suggested that the artist highly valued Tintoretto and the French marine painter Eugène Boudin; and Marin himself told Benson that (as distinct from Paul Cézanne and that generation) "it's the *ancients* who verify."[7] Two fascinating undated works bear out the breadth of his interest: one a study of the Madonna and Child with Saint John after Raphael and the other a study after a Flemish tapestry (plate 70). In addition, scrapbooks of papers left in Marin's studio when he died include reproductions of works by such diverse artists as Cézanne, John Constable, Jules Pascin, Rembrandt, Tintoretto, J.M.W. Turner, Rogier van der Weyden, and Whistler, as well as Egyptian and Greek sculpture, Byzantine mosaics, and Persian miniatures. Yet Marin intermittently perpetuated the notion of his disdain for earlier art: "I take off my hat to the Old Masters, but if anyone asks me, have I seen a real painting, I wonder. They used paint. But what I am looking for is a painting by one who loved paint itself. Maybe Vermeer combined the ability to render what was before him with the feeling for paint. Even the old Chinese Masters with their washes on silk—that was stain rather than paint."[8]

Marin's claims to have known little of the Parisian art world while he was there, and specifically nothing about the work of Cézanne and Henri Matisse, seem especially disingenuous given that his own work was in several major Salons where work by these artists was on view.[9] One can believe neither that he missed the opportunity to see his own paintings in such august surroundings nor that he refrained from taking note of the competition. Of great importance would have been the Salon of 1907, which featured a Cézanne memorial exhibition, and the Salon of 1908, in which Matisse's paintings were strongly represented. Marin's work appeared in both.

70. *From an Old Flemish Tapestry*, c. 1940. Watercolor and graphite on paper, 6¹⁵⁄₁₆ × 8⁷⁄₁₆ in. Private collection. R.40.14.

The connections to be made between Cézanne and Marin are, for the most part, rather tenuous, but a description of the Cézanne memorial exhibition written at the time by Rainer Maria Rilke seems to predict the complexity and conflict of the spiritual if not the methodological course that Marin was to take:

> While painting a landscape or a still life, [Cézanne] would conscientiously persevere in front of
> the object, but approach it only by very complicated detours. . . . I think there was a conflict, a
> mutual struggle between the two procedures of, first, looking and confidently receiving, and then
> of appropriating and making personal use of what has been received; that the two, perhaps as a
> result of becoming conscious, would immediately start opposing each other, talking out loud, as it
> were, and go on perpetually interrupting and contradicting each other.[10]

°71. *Middle of Atlantic,* 1909. Watercolor on paper, 14³⁄₁₆ x
16¾ in. National Gallery of Art, Washington, D.C.; Gift of
John Marin, Jr. R.9.21.

In 1908 Marin became part of the New Society of American Artists in Paris, along with Alfred Maurer, Max Weber, and others. One of the purposes of this "new" society was to challenge the more conservative thinking of an earlier society with a similar name. Hardly the action of a man indifferent to the currents of his time, Marin's participation in the society affirms his integration within the artistic community.

Marin's claims of indifference to the Parisian art world were accompanied by his offhanded suggestion that billiards occupied as much of his time as anything else. Perhaps it did, but it is clear that he was an extremely productive artist. It was during this period that he firmly established the subjects he would deal with for the rest of his life—the landscape and the cityscape. Moreover, watercolors completed during an Atlantic crossing touched the third of his most important motifs— the sea. Precisely when Marin's ocean voyage took place and how long the artist remained in America are unclear. Several of his ocean watercolors are titled *Middle of Atlantic* (plate 71). Some are dated 1909, suggesting the possibility that Marin returned to America in the fall or winter of that year, having met Stieglitz in Paris the previous summer. Marin seems to have remained in the United States until May 1910, well after the first one-man exhibition of his work at 291 that February.[11]

Many drawings survive from Marin's years in Europe—for example, the crowd scene (plate 72) that foretells the street views to come in the late 1920s and '30s. Drawings may be related to

72. *Street Scene,* c. 1905. Graphite on paper, 11⅛ x 14¾ in. Private collection.

individual prints, as we have seen, but few seem to relate specifically to paintings, certainly not at all to the extent that would be true after his return to America. A group of pastel drawings are as finished, in the sense of being completed works rather than studies, as any drawings he was ever to do. Most of them appear to have been done in Venice.[12] Drawn on gray or brownish sheets very similar in tone to the papers used by Whistler in his Venetian pastels, these drawings pay homage to the earlier artist more directly than any other of Marin's works. Done with a soft, crumbly pastel, they have an extraordinary delicacy and luminosity. Tiny touches of pigment laid adjacent to each other are remarkably suggestive of form, though hardly anything is there. Exemplary are two views of Venetian canals, one (plate 73) in which the scene is fairly filled with overlapping touches of color, and another (plate 74) in which very few marks establish structure.

Marin's European paintings include fewer than ten oils and a substantial body of watercolors numbering more than one hundred. The canvases are ambitious in size, among the largest he ever painted, some measuring as much as 31 by 25 inches; he lamented during this period that he was unable to paint because he had so little room where he lived.[13] That there are fewer oils than watercolors is consistent with the pattern the artist maintained throughout his career.

The subjects of Marin's canvases include both street scenes and views of the French countryside. *Mills at Meaux* (plate 75) is one of the more luminous of the European canvases, which tend to be gray in hue and darker in tone than the artist's watercolors of the time. Perhaps Marin was unconsciously sustaining the tradition of oil painting he had seen practiced at the Pennsylvania Academy—the sort of dark Impressionism that was adopted by the followers of William Merritt Chase and the Munich School.[14] As Benson put it, "He had been trying to graft his unspoiled way of seeing on somebody else's color sense, and the result didn't satisfy him."[15]

Marin had worked in oils prior to going to Europe and continued to do so, with lapses, throughout his career, providing considerable evidence of a far greater interest in the medium's possibilities than his reputation as a great watercolorist has acknowledged.[16] However, it seems likely that he found working in watercolors to have fewer binding traditions, fewer established rules. It proved a liberating medium, one with which he not only was comfortable but that enabled him to explore form with a greater sense of abandon. In writing on Marin's art, Benson suggested that "watercolor is as sensuously exciting as semi-precious jewelry. It is to oil paint what jade and coral are to granite and brick. And its artistic use as a fluid wash of color on semi-absorbent paper, defying revision of any kind, demands a sureness of touch and spontaneity of handling that most nearly approaches Chinese script."[17] The fact that one of his oils, another canvas titled *Mills at Meaux* (plate 292), was purchased by the French government in 1907 would surely have encouraged him to focus on that medium, so nothing but his personal artistic needs must have steered him toward watercolor.[18]

By Marin's time there was a strong watercolor tradition in the United States, especially among painters of landscape and seascape. Whistler, John Singer Sargent (who, like Marin, worked in the Tyrol), and Winslow Homer (who, like him, worked in Maine) come immediately to mind as

°73. *Venetian Canal*, c. 1907. Pastel on paper, 9⅜ x 12⅜ in. National Gallery of Art, Washington, D.C.; Gift of John Marin, Jr.

°74. *Venetian Canal*, c. 1907. Pastel on paper, 9⅜ x 12⅜ in. National Gallery of Art, Washington, D.C.; Gift of John Marin, Jr.

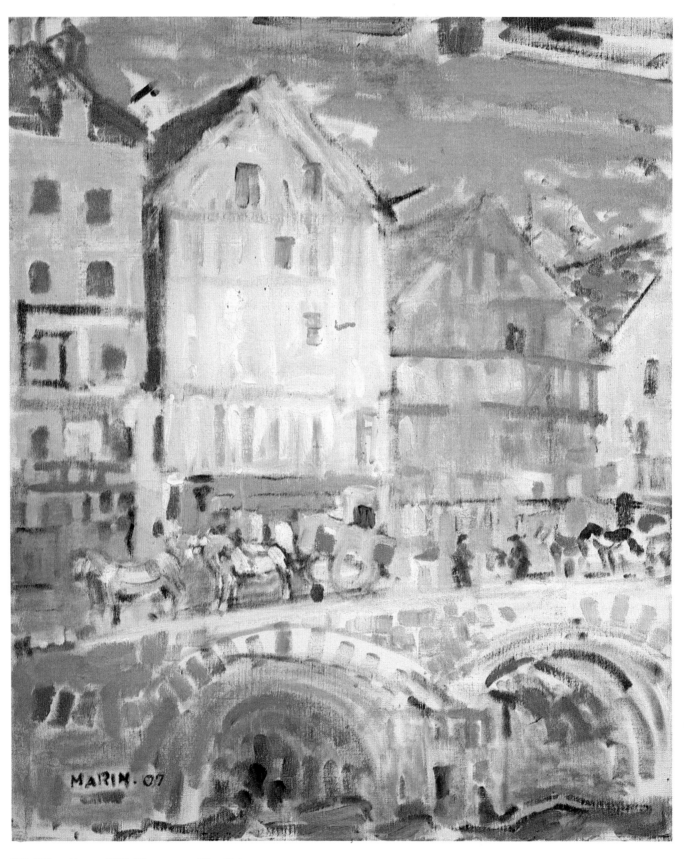

°75. *Mills at Meaux,* 1907. Oil on canvas, 31 x 25 in.
Courtesy of Kennedy Galleries, Inc., New York. R.7.3.

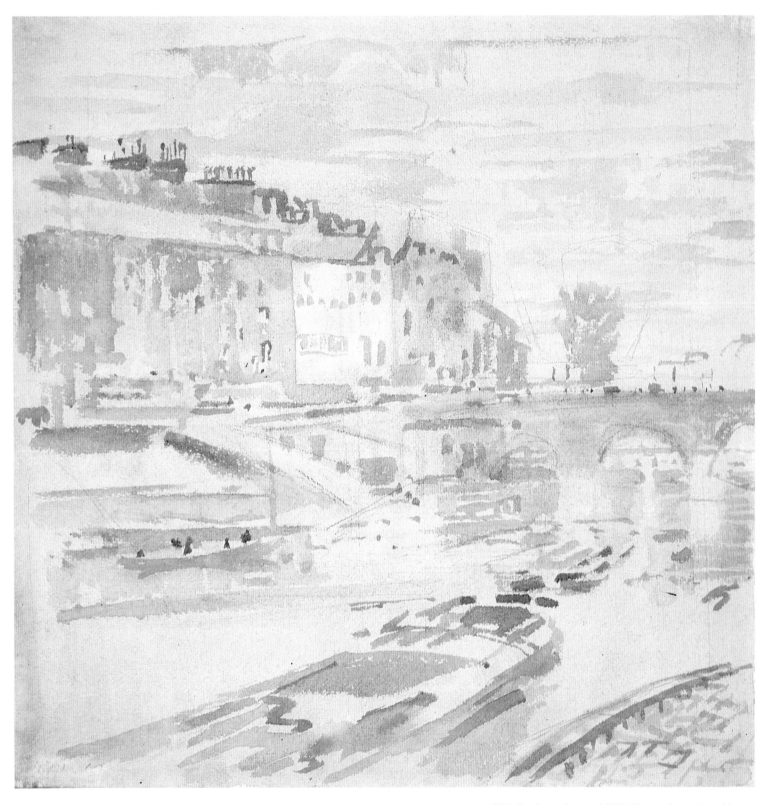

°76. *The Seine, Paris,* c. 1907. Watercolor and graphite on paper, 13⁵⁄₁₆ x 13½ in. National Gallery of Art, Washington, D.C.; Gift of John Marin, Jr. R.7.7.

significant watercolorists in the generation immediately preceding Marin's. In particular, Homer's success in using watercolor to portray rugged, heroic imagery undoubtedly paved the way for Marin's singular commitment to the medium and his accomplishments in it.[19]

The watercolors that Marin had made prior to his student days are exceedingly picturesque. His handling of form is more conventional in them than in his drawings; in the latter he tended to invent formal means that are as important as the subject, an approach that ultimately became central to all of his art. It is unfortunate that no watercolors or oils remain from his days at the Academy and the Art Students League, though given the large number of drawings that survive, these may actually best represent his work of the period. In any event, once in Europe, Marin revived his interest in watercolor, working not only from landscape but also the city, the primary subject in his etchings.

Marin's determination to visualize air characterizes his work of all periods; and most certainly he was a painter of environmental moods even at this early time. To find the means to suggest flickering, dappled sunlight; to evoke dense, heavy skies before storms; to portray the falling rain as it obliterated the structural clarity of buildings and bridges were among his greatest challenges.

For *The Seine, Paris* (plate 76), Marin laid a pale gray wash on the entire sheet and then, with incredible delicacy, he set down strokes and patches of deeper grays and browns, blues and violets, pinks and yellows. Within this muted framework dabs of tame red-browns and red-violets supply notes of great vibrance. Marin's evocative use of watercolor to imply rather than describe form is a great leap from the descriptive linework of etchings such as *Notre Dame, Paris* (plate 29). *The Seine, Paris* is close in effect to Marin's pastels, especially in its use of a painted gray ground that simulates the toned papers on which Marin was setting his jewellike touches of powdery color. Very different is *Notre Dame* (plate 77), of approximately the same time, worked with great fluidity and economy in broad washes, the individual marks almost totally submerged.

French Landscape (plate 80), of two years later, is worked with no preliminary drawing at all; patches of watercolor develop into a flickering landscape with gray clouds off in the distance. The color in general is soft and gentle, often muted, enhanced by bright touches. By contrast, other watercolors of 1909 express a strong sense of drama—for example, *River Effect, Paris* (plate 78), in which a brilliant light infuses the scene. Some, such as *Outside Paris, France* (plate 79), push drama almost to a suggestion of menace. The forceful use of black seen here was not to recur until Marin's paintings of the 1920s.

Marin's brief trip back to America seems to have had a powerful effect on his work. One clear result was that his approach to the landscape changed radically. Rather than the intimate scenes of France that had engaged him, he began to paint the Tyrol, thus embarking upon his first serious exploration of the mountain landscape, a subject that was to be of great importance to his work. "Communing with the colossal, but comparatively stable, phenomena of mountains, forests, and valleys,"[20] he completed a group of paintings that convey not only his intense response to the majesty of the mountains but also a vivid sense of atmosphere and mystery unprecedented in his

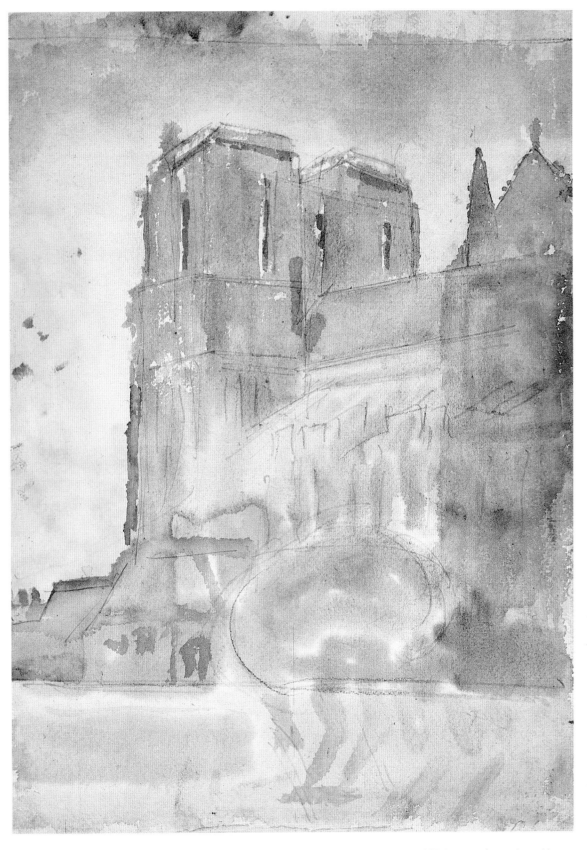

°77. *Notre Dame*, c. 1907. Watercolor and graphite on
paper, 15½ x 11 in. National Gallery of Art,
Washington, D.C.; Gift of John Marin, Jr. R.7.6.

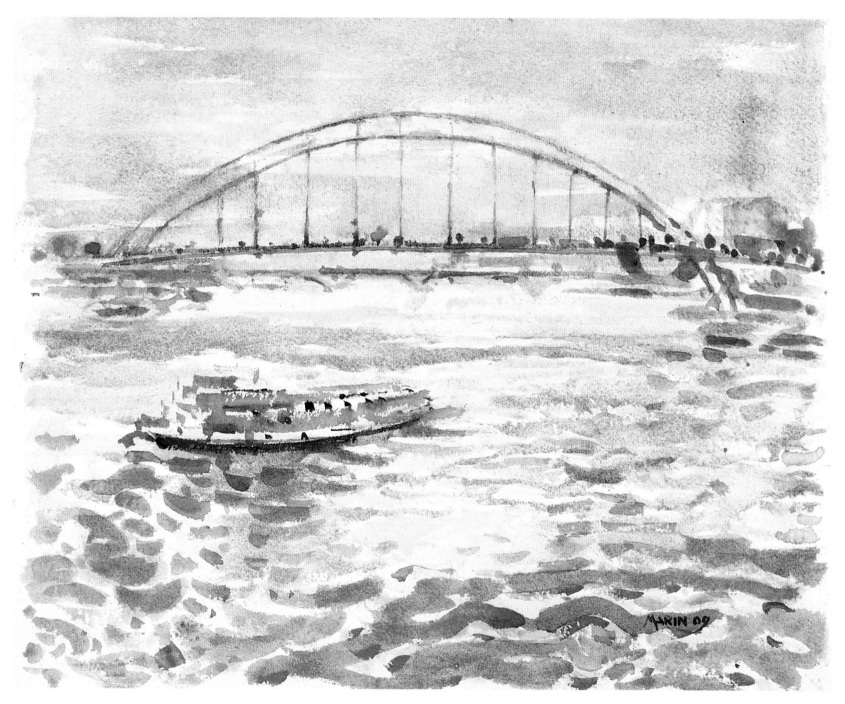

°78. *River Effect, Paris,* 1909. Watercolor on paper, 13½ ×
16⅜ in. Philadelphia Museum of Art; A. E. Gallatin
Collection. R.9.32.

°79. *Outside Paris, France*, 1909. Watercolor on paper, 9½ x
12 in. Courtesy of Kennedy Galleries, Inc., New York.
R.9.27.

°80. *French Landscape*, 1909. Watercolor on paper, 12⁷⁄₁₆ x
14¹⁵⁄₁₆ in. National Gallery of Art, Washington, D.C.; Gift of
John Marin, Jr. R.9.11.

work. He pitted "his imagination and his technical resources against the problems of big nature. It was not views he was studying, but sensations. He sought to render his impressions of the vastness and the power."[21] And he succeeded masterfully.

Grandeur and sensations of great distance are established in these paintings. In *Tyrol Series* (plate 81), worked with no underdrawing at all, the drama of the distant peak pressing its way through the clouds is enhanced by the dense foliage close in. Violets dominate, as is true of many of the Tyrol Series mountains. Not all of the Tyrol scenes are about the heroic landscape, however; several, like *Tyrol Series* (plate 82), portray free-flowing rocky streams. Movement was enhanced by Marin's manner of painting layer upon layer of wet pigment into wet pigment and then washing much of it out again to achieve a soft lushness.

The watercolors done in the Tyrol were his most freely worked to date. Some, like plate 82, are marked by an incised skeletal underdrawing (in this case probably drawn with the tip of the paintbrush handle) that sets out the basic composition. Marin was to use this method for a while but then abandoned it in favor of a more active drawn or painted line. It seems likely that the methodology of making the incised framework evolved from Marin's work as an etcher. The incised lines in the watercolors created an indentation in the sheet; this, in turn, held a pool of paint that appears somewhat darker than the surrounding field. There is a feeling of great abandon in the way these watercolors were painted. A sense of elation abounds, the painterly qualities handled with a broad gesture. They have a feeling of "Freedom—A Breakthrough," to quote the annotation on that proof of *Old House, Rue des Arpents, Rouen, I* from the previous year. The watercolors function much as that etching had, heralding the extraordinary changes that were soon to take place.

Writing a decade later about Marin's mountain paintings, with reference not only to these early Tyrol works but also to later ones done in the Adirondacks and the Berkshires, one critic commented, "The light plays about the hills, the whole is covered with air and the scene is almost miragelike in its transparency."[22] In no works was this ever truer than in these, Marin's first important group of mountain landscapes.

In the summer of 1909, a few months after Marin's work had first been on view at 291, Steichen introduced the artist to Stieglitz, who was then in Paris. The meeting changed the lives of both men. After returning to America later that year, Marin sailed back to Europe but stayed only briefly. It seems likely that once Marin had spent some months in America, buoyed by Stieglitz's offers of friendship and support, he no longer felt drawn to the expatriate's unsettled life. He was, after all, forty years old by this time; the emotional and material comfort, and the independence from his family, that Stieglitz offered must have been most welcome.

Upon his return to America, Marin established the working pattern he was to follow for the rest of his life. In winter he painted and made drawings and prints in the New York City area, focusing on scenes of the city, reworking and completing landscape ideas he had gathered outdoors in other seasons, and preparing for the exhibitions sponsored virtually annually, at one place or another, by

°81. *Tyrol Series,* 1910. Watercolor on paper, 18⁵/₁₆ × 15³/₈ in.
National Gallery of Art, Washington, D.C.; Gift of John Marin, Jr.
R.10.79.

°82. *Tyrol Series*, 1910. Watercolor on paper, 18⅝ x 15⅞ in.
National Gallery of Art, Washington, D.C.; Gift of John Marin, Jr.
R.10.78

°83. *From the Window of 291 Looking Down Fifth Avenue,*
1911. Watercolor and graphite on paper, 16 x 13⅛ in.
The Metropolitan Museum of Art, New York; The Alfred
Stieglitz Collection, 1949. R.11.11.

Stieglitz. During spring and fall Marin painted landscapes with sources in the environs of New York State and his New Jersey base. In summers (which often lasted well into autumn in terms of Marin's workplace), he traveled to the country, immersing himself in the distinctive characteristics of whatever region he was visiting.

His style from 1910 through 1912 closely followed his development in the Tyrol. Mostly he worked in watercolor applied directly, either with no underdrawing at all or with a skeletal structure incised, as in the Tyrol works, or sparsely drawn in graphite. This basic approach varied little, regardless of subject. The fluidity Marin used to describe the organic nature of the countryside was at first attached to the geometry of the city as well, as evident in *From the Window of 291 Looking Down Fifth Avenue* (plate 83). In the watercolors of the Woolworth Building that soon followed, Marin shifted to a more planar manner of structuring his city views. This became a dominant mode of his vision, and a sense of the activated plane was incorporated into his landscapes as well. Marin's color, by contrast, was responsive predominantly to the specifics of a given place as well as to the character of the times of day and year.

By 1911 Marin presumably was somewhat acclimated to life in a rapidly growing and changing United States. His watercolors of that year (no oils are known) show the artist exploring a variety of themes, including the still life and the portrait, which one doesn't readily associate with his oeuvre. Among these is *Flowers and Pot* (plate 84), and over the years Marin occasionally approached this sort of subject again in both watercolor and oil.

Portraits are a feature of Marin's late calligraphic work, but they also appeared much earlier, as exemplified by *Mrs. Haviland* (plate 85), a portrait of the wife of Marin's friend the photographer Paul Haviland.[23] *Mrs. Haviland*—like *Flowers and Pot, From the Window of 291 Looking Down Fifth Avenue*, and landscapes of the period—is painted directly, revealing only a spare graphite structure from which Marin departed considerably as work progressed. *Mrs. Haviland* is noteworthy for its profusion of color, perhaps as extravagant in range of hue and value as Marin was ever to get. Marin's watercolor technique is here more richly and variously evident than is the norm for this period: color flows into color—for example, in areas of the coat and in the variegated wall at the lower right; color is layered onto color, as at the left. Fairly meticulous details of decoration can be seen in the wallpaper, and the resulting sense of surface enhancement is reminiscent of the façades in Marin's Venice etchings. Areas are scrubbed out as well—for example, at the left of the figure, in what appears to be a floor-length window through which light is flooding the room, and in the upper left wall, where the paper is clearly abraded as a result of extensive reworking.

In the decade 1910–20, especially, Marin was actively defining the themes and methods he wished to explore within his painterly world. He moved far from the more traditional sphere within which his architectural etchings fit, shifting into a ground-breaking artistic milieu that he, in fact, was to help define for his generation. In a painting such as *Mrs. Haviland*, Marin not only undertook a great technical range, but he also seems to have been discovering the fact that exploring the methodology

°84. *Flowers and Pot,* 1911. Watercolor on paper, 16¼ x
13¼ in. The Farber Collection, New York. R.11.10.

°85. *Mrs. Haviland*, 1911. Watercolor and graphite on paper, 16⅞ × 14¼ in. National Gallery of Art, Washington, D.C.; Gift of John Marin, Jr. R.11.19.

86. *Palisades, Hudson River*, 1917. Watercolor and charcoal on paper, 16⁷⁄₁₆ × 19½ in. Private collection. R.17.25.

87. *Hudson River, Hook Mountain*, 1925. Watercolor and graphite on paper, 16½ × 20¼ in. Private collection. Not in Reich.

of painting (or etching, if that was the medium in use) was, in itself, an important aspect of his approach to making art. This experimental approach is evident in his landscapes as well.

Sites along the Hudson River, such as that in *Hudson River at Peekskill* (plate 68), repeatedly attracted Marin. Later views of the region include works as softly undulating and abstract as *Palisades, Hudson River* (plate 86), and as close to nature as *Hudson River, Hook Mountain* (plate 87);[24] in both, the land rather than the river is the focus. The earliest, *Hudson River at Peekskill,* is a meditation on reflections. The shapes seen upside down in the river have as much weight and solidity as the vessels and hills that stand upright against the blazing sky. Paint is applied without any sort of underdrawing, and it is worked wet into wet to achieve areas of mottled hue, juxtaposed with clearly articulated details such as the twigs and bushes in the foreground. Marin has captured here a brilliant moment at sunset. No matter how swiftly he wielded his brush, however, he had to be working from a memory of the moment, or a composite of many moments, for the specific effects of the light could not possibly have lasted long enough for him to observe them and simultaneously set them down.

In a watercolor of the Brooklyn Bridge made the same year (plate 118), a similar atmospheric brilliance suggests Marin's romance with New York City and makes clear that his method was not tied to any specific site. Some watercolors of 1912, however, are far more tightly structured, attending more to shape than to atmosphere. This is most apparent in a group done in the Adirondacks, including *Adirondacks, New York* and *In the Adirondacks* (plates 88, 89). Reviewers immediately responded to Marin's ability to capture the specific sense of place:

> One needs no catalogue to know that No. 23 is the Adirondacks, any more than one needs to
> be told that the rolling, dipping hills and hollows of No. 18 is the heart of the Berkshires [where
> Marin had also worked that year]. The solitary grandeur, the cool, keen air and frost-bitten color
> is of the essence of the first, as much as the soft, friendly undulations and warm color is typical of
> the latter and one is as consummately suggested as the other.[25]

In 1913 Marin traveled with his new wife, Marie, and his Aunt Jennie to Castorland in New York State. Jennie's letters to other members of the family offer a vivid picture of their situation:

> Yesterday, John took a walk of about twelve miles to visit Beaver Falls and was caught in a
> healthy rain. He was soaked and was glad to find a good warm fire with a tank of hot water....
>
> This town is really very pretty. The houses are all pretty and in fine condition, beautiful lawns,
> and no fences. There is a grocery, butcher and all round store less than a good city block from
> here. There are no really big farms anywhere near. The men around just keep their gardens in
> order, but the women are working to have their houses in fine order. The piazzas are kept spic
> and span, easy chairs; tables and carpets on the floor. A doctor lives about one hundred feet
> away and there are three churches in town.

A week later, in what seems to be her Sunday letter-writing mode, Jennie went on to "Dear Everybody":

> Sunday has come around again, and if ever you got into a real Sunday place, this is that place.
> Everything is about as quiet as possible.... Friday, the Adams' family and we hired an automobile
> and went for a long drive, through Denmark, Copenhagen, and Lowville. John wanted to get all

°88. *Adirondacks, New York,* 1912. Watercolor and graphite
on paper, 18¾ x 15¾ in. Courtesy of Kennedy Galleries, Inc.,
New York. R.12.2.

°89. *In the Adirondacks*, 1912. Watercolor and graphite on paper, 14⅛ x 16⅜ in. Harvard University Art Museums, Cambridge, Massachusetts; Anonymous gift. R.12.28.

the views of the country possible. Some of the places are very old. . . . We were shown many fine residences in Lowville by Mrs. Adams, who was born here, and her mother before her. . . .

John is quite taken with reading a history of this part of the country written by Mr. Hough's father. . . .

The neighbors seem as if they were inclined to be sociable, but we keep pretty well to ourselves and the woods. Marie likes to go with John so when he is not going far we go too.

About all that one can do here is to enjoy the trees and grass. Marie says she wishes a circus or moving picture show would go through. . . .

Another letter from Jennie, from the following month, gives a few details about Marin in particular:

When John and Marie are alone, they expect to take brief trips around, one to the Thousand Islands, etc.

A piano came Aug. 1, he had given it up, but it arrived in the morning before we were up. As there is not so much chance to paint here, he will enjoy it very much. His stomach is giving him much trouble and this is a poor place to feed it what is best. There is no lamb or mutton sold in the place. Marie telephoned to a butcher at the next station to send her a pound of mutton for broth. When delivered, the bill called for seventy-five cents. He thinks he will get along without mutton. The only cheap things here are milk and eggs, but one tires of those. We have had beans, peas, lettuce and squash which were very nice.[26]

Though he produced mainly watercolors in Castorland, a few oils date from this session as well, such as *Castorland* (plate 90). The paint is thinly applied, almost like a watercolor in its delicacy, although the forms are different from those in his Castorland watercolors. In the oil, pigment was laid in, then sometimes washed out to establish clearly defined shapes similar to those in some of the Adirondacks paintings of the year before.

Most of the Castorland watercolors have a light graphite underdrawing. They are marked by the coordination of line gestures with color areas, an approach Marin was later to push quite forcefully. Bright and pure in hue, their primary colors presented a considerable change from the cool, often muted colors of the Tyrol works and many of those done immediately after Marin's return to America. Exceptionally beautiful is *Castorland, New York* (plate 91), with its brilliant blue sky radiating a glorious light; the multihued strokes along the bottom, typical of the Castorland series, suggest an unusual spaciousness.

One senses that the Castorland landscape, with its pastoral rolling farmland and rounded trees dotting gentle hills, did not present Marin with great dramatic challenges. His paintings there were made a year later than some of his most dynamic early views of New York, yet they seem at first glance surprisingly tame. However, it was in the Castorland watercolors that Marin broke away from the seductive watery washes he had used since his work in the Tyrol. Seeking new ways of handling his medium, he reintroduced line as a strong visual element. Indeed, line in some form remained crucial to his work, with few periods of exception, for the rest of his life.

By the time of the Castorland paintings, Marin was already an admired figure in American art. His meeting with Stieglitz in 1909 had resulted in a friendship and a professional commitment of

°90. *Castorland*, 1913. Oil on canvas, 30 × 26 in.
Private collection. R.13.22.

°91. *Castorland, New York*, 1913. Watercolor and graphite
on paper, 16 x 19 in. Mr. and Mrs. Frank A. Ladd, Amarillo,
Texas. R.13.38.

extraordinary warmth and effectiveness. Stieglitz handled all of Marin's professional affairs—scheduling exhibitions, placing his paintings in appropriate collections, and assuring that the artist, if not wealthy, did not suffer from financial worries. In addition, Stieglitz's passion for photography and the specifically American motifs of his own work, as well as his interest in rain, snow, fog—atmosphere—would certainly have had an impact on Marin.[27] Their association lasted almost four decades, until Stieglitz's death in 1946.

> The relationship from the first [was] distinguished by an extraordinary mutual confidence and common integrity. If Marin has never lightened Stieglitz's material burden by, of his own accord, interesting possible collectors in his work, he has also never questioned any act of Stieglitz's relative to his affairs, and what is even more remarkable, apparently persuaded his own wife to see eye to eye with him. . . . [Stieglitz] early advised Marin to "concentrate on the bread and forget the butter." And Marin has contented himself with the means to a relatively austere existence.[28]

Marin's first exhibition at 291 had been held while he was still in Europe, from March 30 to April 17, 1909, in conjunction with fifteen oil paintings by Alfred Maurer, another young American then working in Paris. Twenty-five of Marin's watercolors were on view, and the show was generally well received. One critic called the artist "the master of mists."[29] Another described the paintings as "harmonies of indescribably delicate tonalities wrought on the Japanese principle of the *Notan*, a balance of dark and light, of the intimate relationship of contrasted values," suggesting that Marin's art was the latest product of the influence that oriental art had begun to have on the occidental in the 1860s. Briefly stated, the critic saw the work as "a more abstract way of receiving and of rendering the impression of the scene. It is not so much a visual as a spiritual impression, eliminating as far as possible the consciousness of the concrete. . . . The consciousness of facts disappears in a spiritualized vision of form and color, that I can best explain to myself by the way in which a composer will expand a motif into an elaborated harmony."[30] And yet another writer said of Marin's watercolors that "all have an originality that will draw to them the attention of those who would see something in the medium which departs radically from conventions."[31]

The following year, 1910, Stieglitz mounted Marin's first one-man exhibition. Forty-three watercolors, twenty pastels, and ten etchings were shown,[32] and some of the reviews, once again, bordered on the rhapsodic. For example, William D. MacColl noted: "Veil beyond veil, and mist beyond iridescent mist, rise these tearful images, transfiguring all things within their reach, till heaven and earth, the sky, hills, lakes, the contours of all nature, seem compounded into one measureless and exhaustless film."[33] By contrast, Elizabeth Luther Cary, while enormously enthusiastic herself, was somewhat cautious in her prediction of the more conservative viewer's response: "Watercolors, pastels and etchings by Marin, many of them exquisite in color [were] too much influenced by the theories of Matisse to please a public or critics not yet advanced to that stage of 'up-to-dateness.' . . . One or two of them look as though they had been stained with the very dyes of the spring grass

and the rain-washed heavens. The painter's instinct for recognizing the possibilities of structure by color alone is extraordinary. . . ."[34]

Critics continued to express their sense that Marin's art required an appropriately responsive viewer. J. Nilsen Laurvik, making an early reference to the unconscious in relation to Marin, commented two years after Cary:

> [Marin's watercolors] repel or attract according to the imaginative power of the spectator. The literal minded find nothing but absurdity in them, as though the flights of man's soul may not be as reasonable as that of an aeroplane. . . . His best work is characterized by a playful spontaneity that has something of the infectious charm of the natural, unconscious movements of children whose naive simplicity it approaches more nearly than any work being produced today deserving to be called adult art. And when the crying and the tumult cease, that now rages in the world of art, it will be found I am sure that the unpretentious John Marin was one of the few authentic personalities in an age whose chief figures are distinguished by their bold assumption of unearned authority.[35]

Marin's New York exhibitions, held in some form almost annually after 1909, came to be events that were awaited with great anticipation by the gallery-going public. A review of the 1930s suggests that "as usual [a Marin exhibition] forms the first important date in the new season's counting, and like other years, provides a feast of uncommon beauty for the initiated."[36] Over the years Stieglitz presided over three exhibition spaces. The first of them, located on the top floor of an old brownstone house, was opened in 1905 and named the Little Galleries of the Photo-Secession, although it has come to be known as 291, the number of its address on Fifth Avenue, between Thirtieth and Thirty-first streets. World War I placed great pressures on the enterprise, and it was closed in 1917. From that year until 1925 Stieglitz represented Marin by other means, most importantly by setting up exhibitions in other places, including the Daniel and Montross galleries. In 1925 he opened the Intimate Gallery with a Marin exhibition; and four years later the Intimate Gallery was succeeded by An American Place, again opening with a Marin show. This was the space over which Stieglitz was to preside until his death.

Stieglitz's galleries and the publications he sponsored (the most famous being *Camera Notes* and *Camera Work*) are legendary in the history of American art. Much has been written about them. Lamenting 291's demise, Paul Rosenfeld wrote in 1921:

> The spirit that reigned in the two little burlap-hung rooms up under the skylight was one of the few wholly clean and lovely things in New York. . . . 291 showed for the very first time in this land, the washes of Rodin, the oils and water-colors of Cézanne, Matisse and Picasso both as painters and sculptors, the *douanier* Rousseau, Picabia, Brancusi, Nadelman, de Zayas, Hartley, Marin, Weber, Bluemner, Dove, Walkowitz, Steichen, negro and African sculpture, children's work, Strand photographs, all in the effort to exorcise the American devil with the truth of present-day life, the call to the inner room, the impulse to self-knowledge. The small picture-buying public, so it was hoped, would learn to purchase works of art out of love for the thing itself, in recognition of the fineness of feeling in which good work is done, and not in a spirit of personal vanity. The

artist, in turn, freed from the commercial game of the galleries, was to be set free to live out his life and develop his art. Quality was to be loved. . . . America was unready for the orientation. . . . it seems as though 291 was but a light carried along by a stream in the night that showed in which direction the stream was moving.[37]

The energy of the place must have been riveting: "Here, in a center of exhibitions and discussion, painters and thinkers and writers, while they warmed their feet by the stove in the back-room, battled over plastic form and feeling and content as they never had done before in America."[38] Forbes Watson, reminiscing about 291 when the Intimate Gallery opened, recalled: "so excited were the voices that emerged from the inner sanctum that it required the keenest concentration to keep one's mind upon the pictures in the little, front gallery, which was seldom silent except at the hour when Mr. Stieglitz had led his little cohort of revolutionists over to the then existing Holland House."[39]

Stieglitz provided early and staunch support to American modernist artists, not only Marin but also Arthur Dove, Marsden Hartley, Alfred Maurer, Georgia O'Keeffe, and Max Weber. His support of an American vision in literature was manifested in his friendships with Hart Crane, Waldo Frank, Paul Rosenfeld, and others. As part of the Stieglitz inner circle, Marin would have been engaged by the important intellectual and artistic currents in New York at this time.

In February–March 1913 the *International Exhibition of Modern Art*—best known as the Armory Show—was held in New York, introducing European, mainly French, modernism to America.[40] The show's impact was enormous, but even while artists in America were seeking to absorb the advances in art rooted in Europe, they were simultaneously seeking a uniquely American approach, one that would encompass their country's vigor and youth and its freedom from the burden of European elegance and tradition. Artists were feeling the impact of the speed of the modern world, of technology, and they were exploring new methods of constructing visual space that developed from the awareness of Cubism, Futurism, Orphism, and so forth that the Armory Show reinforced.[41] Interest was high in exploring color as an expressive vehicle, an idea that had evolved from Fauvism as transmitted by Matisse. "Divisionist" color theories stemming from the writings of Michel-Eugène Chevreul, first translated into English in 1854, had been much under discussion in Paris, and although Marin may not necessarily have read Chevreul, he certainly would have been aware of his ideas.[42]

Marin's view of contemporaneous studies regarding the role of the unconscious is difficult to pinpoint. His naïve persona obviously masked a keen intelligence and vast knowledge; and he would undoubtedly have been aware of writings by Sigmund Freud and others on creativity and the unconscious. The unconscious was referred to by various reviewers of Marin's art, including Paul Rosenfeld: "The unconscious mind has selected for Marin his medium. . . . He applies his wash with the directness of impulse that is supposed to be discoverable only in the work of small children. . . . The Chinese only seem to have been as freely, as singingly spontaneous in this particular medium."[43]

To be sure, not everyone was thrilled by the diverse intellectual activity that infused the American art world during the 1910s and early 1920s. Even among conservative critics, however, there were

those who expressed strong admiration for Marin as the great representative of American art:

> While the passing craze of Futurism, the epidemic of unintelligent distortion . . . and tough, sterile
> primitivism . . . have been sweeping over the field of our national art, Marin has forged ahead
> toward a goal of his own imagining . . . as his sensitivity develops along the lines of volumnear
> balance and three-dimensional poise, the comprehensiveness of his color will inevitably follow. At
> that time—and I predict that it is not far distant—we may expect to see some of America's
> most genuine expression delivered from the shackles of European snobbery and standing on
> the high pinnacle of personal achievement.[44]

Championing respect for an American vision was Stieglitz. Obviously enjoying the importance of his role, in July 1914 he published a special edition of *Camera Work* devoted to 291. For it, Marin set down in his own distinctive poetic style his thoughts on his spiritual home:

> I know a place
> where reason halts
> in season and out of season
> where something takes the place
> in place of reason
> a spirit there hovers roundabout
> a something felt by those who feel it
> here together and to those who come
> a place of comfort
> a place electric a place alive
> a place magnetic
> since it started it existed
> for those sincere: those thirsty ones
> to live their lives
> to do their do
> who feel they have
> yet cannot show.
> The place is guarded,
> well guarded it
> by He——who jealously guards
> its innocence, purity, sincerity
> subtly guarded it
> so that—it seems—not guarded at all
> no tyrant he—yet tyrant of tyranny
> so shout—we who have felt it
> we who are of it
> its past——its future
> this place
> what place?
> Oh Hell 291 [45]

92. Left to right: Paul Haviland, Abraham Walkowitz, Katharine Rhoades, Agnes Ernst (Mrs. Eugene) Meyer, Emmeline (Mrs. Alfred) Stieglitz, Alfred Stieglitz, Eugene Meyer, and John Marin, Mount Kisco, New York, 1912. Abraham Walkowitz Papers, Photographs of Artists, Collection I, Archives of American Art, Smithsonian Institution, Washington, D.C.

94. Bernard Hoffman. *John Marin Stands in New Jersey with Painting of New York, with New York City in the Distance,* 1950. Gelatin silver print, 10 × 8 in. *Life Magazine;* Copyright 1950 Time, Inc. Magazines.

°93. *Street Movement, N.Y.,* c. 1932. Gouache on paper, 24¼ × 20 in. Jean and Alvin Snowiss. Not in Reich.

THE URBAN LANDSCAPE

In December 1912, shortly before his forty-second birthday, John Marin married Marie Jane Hughes, the quiet sister of his aunts' ebullient seamstress, whom he had left behind in 1905 when he went to Europe. From all accounts she seems to have devoted the rest of her life to accompanying her husband on his daily painting trips and attending to the needs of her family. The couple's son, John Currey Marin, Jr., was born in 1914, and the following year Marin painted the first of several portraits of him (plate 95). For the first several years of the marriage the family lived a relatively unsettled existence, summering in various scenic places, most frequently Maine, and making last-minute decisions about where to spend the winter. In 1913–14, for example, they lived on the upper two floors of a house at the corner of Twenty-eighth Street and Fourth Avenue. "The studio at the top of the house was lighted by a row of opaque bull's eye windows which gave just enough light for work on the etchings." In 1914–15 they stayed with aunts Jennie and Lelia. The uncertainty of it all is captured in a letter from Marie to Lelia:

> We have seen very little sunshine since last Thursday, and it is very warm. . . . In regard to our
> plans for the winter we have nothing special in view the only thing which I can see is that we may

95. *Portrait of John, Jr.,* 1915. Watercolor and graphite on paper, 16¼ x 13¹⁵⁄₁₆ in. Private collection. R.15.32.

not be able to have a home of our own this winter. John must have a place for his things & to work so I am afraid we will not be able to pay so much rent—with the prospect of very few sales. Of course my sister will be glad to have us with her & we can be quite comfortable there but there is no place quite like ones [*sic*] own house.

Stieglitz has suggested that John use a room in the building at 291 Fifth Ave. & while that is very good in some ways it is not a good atmosphere for John to be in all the time & certainly will not be conducive to work. I had hoped he could find a room something like he had before and that we could find a place somewhere near so he could get home to lunch. Well, we shall see when we get home.[2]

In 1920, after years of camping out, the Marins purchased a house and settled in a quiet residential neighborhood in Cliffside, New Jersey, where Marin set up his winter studio, "a quite matter-of-fact place of work in the rear of his home. It's big, airy and of course has the invaluable north light exposure. Wide windows spread against the wall and through them you can see a lot of the sky over Cliffside Park as well as its nearby backyards."[3] This house and studio remained Marin's city base for the rest of his life. A longtime friend who interviewed the artist shortly before he died reported, "We found him still living in the same unpretentious seven-room house with one tree, a

96. Dorothy Norman. *John Marin House, Cliffside, N.J.,* 1940s. Gelatin silver print, 3¾ x 2¾ in. Private collection.

97. Arnold Newman. *John Marin—in His Studio at 243 Clark Terrace, Cliffside Park, New Jersey,* 1947. Gelatin silver print, 7½ × 9⅝ in. Private collection. Copyright Arnold Newman.

98. *Winter from My Back Window, Cliffside, New Jersey,* 1929. Oil on canvas, 27 × 22 in.; with Marin frame. Courtesy of Kennedy Galleries, Inc., New York. R.29.72.

garage, and a front porch on a quiet nondescript street in Cliffside, New Jersey. . . . We were talking in his second floor studio, a large white room (once two bedrooms), now all windows on one side. There were drawings, etchings, watercolors, oils on chairs, on the couch, on tables and shelves."[4]

Marin doesn't seem to have made any paintings of the house itself, but he did call upon its immediate surroundings for motifs. Two 1929 oil paintings, *From My Window, Cliffside, New Jersey* (R.29.12) and *Winter from My Back Window, Cliffside, New Jersey* (plate 98), together provide a splendid sense of the character of the neighborhood. The building in the lower left of *From My Window, Cliffside, New Jersey* suggests that this view is to the right of that depicted in plate 98. These rather straightforwardly descriptive paintings, dating from long after Marin had begun investigating abstraction, exemplify the fact that virtually every year he made paintings of close fidelity to their sources in nature as well as paintings in which formal or ideational notions prevail.

Marin's paintings of the regions surrounding his various winter residences—for example, *Hudson River at Peekskill* (plate 68) and the freely calligraphic paintings made in the 1940s and '50s in the Ramapo Mountains of New Jersey (plate 99)—have been overshadowed by his Maine landscapes. Several factors have contributed to this. The works from Maine are, in fact, far greater in number

than Marin's landscapes from other places; in addition, paintings of Maine, a beautiful and popular vacation site, carry an intrinsic nostalgic appeal. Nevertheless, the landscapes of suburban New York played an important role in the artist's development, and they were well received when exhibited. A 1939 review of a group of oils done in the Ramapos makes this clear:

> [The] present [Marin] show at An American Place is thoroughly unusual in that more than half of the paintings are oils. Unusual, too, is that they are the best oil landscapes he has done. . . . Thirteen small oils are an original contribution to one whole wall [the "Marin Spring" series]. They represent Marin's idea of the unfolding of spring. He motored to New Jersey to make these documents of nature. They are landscapes of distant hills, tilled farms, orchards, and highways and range at fortnightly intervals from March to July 1. It was really an inspiring conception, a sort of Monet's Haystacks in the modern idiom.[5]

The "Marin Spring" paintings were sequentially numbered on their backs by Marin, and they appear to have been painted four or so per day. *No. 1, Marin Spring* along with *No. 3, No. 6,* and *No. 9* (plates 100–103), convey a sense of the variety that Marin captured in two different days' work. The sequence is reminiscent of a larger sequence of oil paintings that he had done in the Weehawken area almost three decades earlier. Both groups were painted on fairly small canvas boards, rather than stretched canvas, allowing for easy portability into the out-of-doors.

By the time the Marin Spring paintings were executed, Marin had been working steadily in oils for more than ten years, following what was virtually a break with the medium from about 1916 through 1928. His approach in oils had become as controlled, as direct, and as respectful of the material as his work in watercolor. Surfaces range from raw canvas to juicy, heavily built-up paint strokes. Brush marks are more or less apparent, depending on whether they are dabbed, pulled, scrubbed, or otherwise applied. Marin's propensity for drawing is apparent in the linear application of paint as well as in his scratching, scraping, and incising the paint after it was laid down. This linear work is most clear in the foreground and central tree in *No. 1, Marin Spring.* In that work the gray tonalities tell of a lack of sunlight, and perhaps a lingering chill in the air. *No. 6, Marin Spring,* by contrast, with its brilliant white blossoms and distant ultramarine peaks against the sky's azure clarity, sounds a true celebration of the new growing season. Lovely as these and other New Jersey landscapes are, Marin made his mark on modernism less with his suburban landscapes than with his paintings of New York City. Marin's view of the city was shaped not only by his close attention to landmarks such as the Woolworth Building and the Brooklyn Bridge but also by less specific compositions emphasizing distance. From before he went to Europe through the end of his life, the city of Weehawken and its views of New York across the Hudson River were a constant source of inspiration. Some of Marin's most dynamic and abstract etchings of 1915 and 1916 are rooted in the heavy, blocklike industrial forms of the Weehawken grain elevators (plates 51, 54). His depictions of the city in watercolors vary from descriptive views—such as the brilliantly colored *Weehawken Railroad Yards and Grain Elevators* (plate 104), in which layers of paint and the paper itself were rubbed away as Marin vigorously developed the sky and foreground smoke—to others that convey

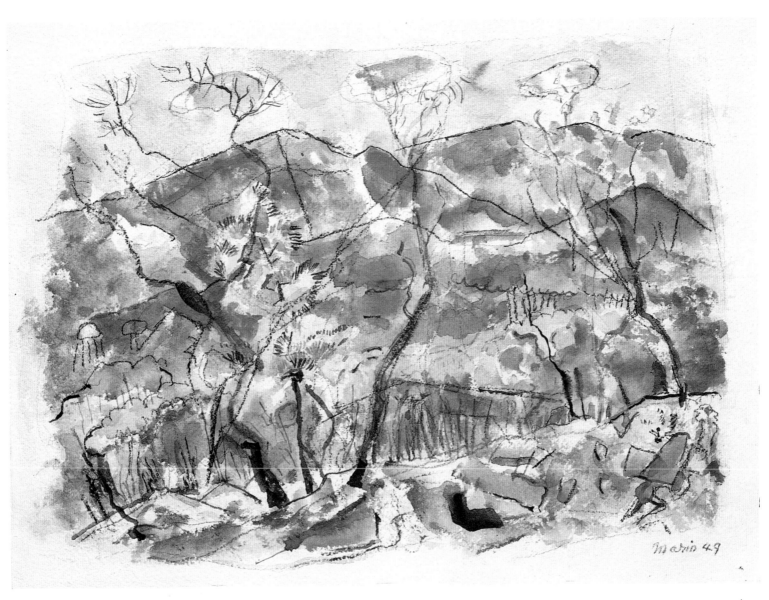

°99. *In the Ramapos, No. 2,* 1949. Watercolor, graphite, and black crayon on paper, 15¼ x 20½ in. Hirshhorn Museum and Sculpture Garden, Smithsonian Institution, Washington, D.C.; Gift of the Joseph H. Hirshhorn Foundation, 1966. R.49.12.

100. *No. 1, Marin Spring,* 1939. Oil on canvas board, 12 × 16 in. Private collection. R.39.27.

101. *No. 3, Marin Spring,* 1939. Oil on canvas board, 12 × 16 in. Private collection. R.39.29.

102. *No. 6, Marin Spring,* 1939. Oil on canvas board, 12 × 16 in. Private collection. R.39.32.

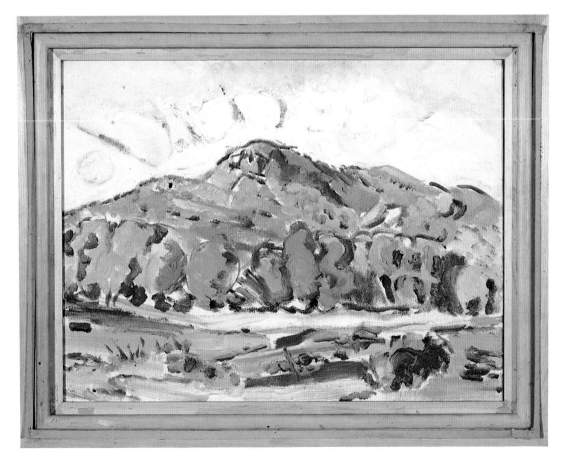

103. *No. 9, Marin Spring,* 1939. Oil on canvas board, 12 × 16 in. Private collection, R.39.35. To modify the commercially manufactured frame, Marin glued an orange paper strip adjacent to the outermost band.

°104. *Weehawken Railroad Yards and Grain Elevators*, 1910.
Watercolor and graphite on paper, 14⅞ x 13⅜ in. (sight).
Jean and Alvin Snowiss. R.10.89.

a sense of atmosphere while dealing with form in a more abstracted fashion. Exemplary is *Weehawken Docks, New Jersey* (plate 105), in which Marin's use of color and his sensuous manipulation of the watery paint transform an industrial site into a land of mystery and romance.

Among Marin's oils of Weehawken is a group of some one hundred small paintings, most of them measuring approximately 9 or 10 by 12, or 10 by 14, inches, that has been a subject of some controversy since it was first brought to the public's eye. It was initially known as the "Weehawken Cliff Sequence," although "Cliff" has since been dropped.[6] The Weehawken paintings are enormously varied in subject and formal direction, ranging from distant views of Manhattan, to Weehawken houses (plate 106), to woodland landscapes (plate 107), to scenes that focus on the riverfront docks, warehouses, and grain elevators (plate 108). Some are so abstract that it is impossible to identify their sources (plate 109). The Weehawken Sequence was first mentioned in print in Mac-Kinley Helm's essay for the catalog of the 1947 Marin retrospective organized by the Institute of Modern Art, Boston, but selections from the series were not on view until the artist's final exhibition at An American Place, *John Marin Oils: 1903–1950,* held in the spring of 1950. When the latter exhibition was reviewed, the Weehawken paintings were noted as being "particularly interesting . . . [an indication] not only that Marin had at that time an equal readiness to develop in that medium, but also, and more important, that even before his first contact with cubism he had established some of the essentials of his vision: an emphasis on the opposing dynamics of flat color blocks, and his familiar racing brush."[7]

Helm, expanding his discussion of the Weehawken Sequence in his 1949 biography of Marin, indicated that the artist told him that the series had been painted during the winters of 1903 and 1904. Helm went on to discuss some works that dated from the summer sandwiched between those "two crowded winters of painting," thus making clear his understanding that the Weehawken paintings had been done in two working sessions, not one. Curiously, this account has since come to be understood as describing the winter (singular) of 1903–4. Reich, while arguing against this early date, did lump the paintings into one prolific working session, cited in his catalog as 1916, in part on the basis of a larger oil on canvas, *Weehawken Grain Elevators* (R.16.48), dated to that year.[8]

Given that Marin was in his late seventies when speaking with Helm, it would hardly be surprising if he misremembered when the paintings were made, which would have been more than a quarter of a century earlier no matter which date was accurate. He did place them in two separate working sessions, however, and their diversity makes it possible that they evolved over an even larger number of working sessions or in two sessions that were further apart. Some of them, in their fidelity to nature, connect with watercolors from between 1910 and 1912, such as *Weehawken Railroad Yards and Grain Elevators* (plate 104). Others seem as abstract and explosive as Marin's Weehawken etchings from 1915 (plates 52–54), and as his watercolors of the teens based on a variety of sites—for example, the delicately colored *Echo Lake District, Pennsylvania* (plate 164).

°105. *Weehawken Docks, New Jersey*, 1912. Watercolor and
graphite on paper, 13⅞ x 14⅞ in. National Gallery of Art,
Washington, D.C.; Gift of John Marin, Jr. R.12.65.

Not only are the Weehawken Sequence paintings exceedingly diverse in their degree of abstraction, they are incredibly varied in their handling of paint and in their coloration as well. Marin retained an interest in oil painting throughout the early teens, as evident from landscapes he painted in oil in Castorland in 1913 (plate 90) and in Maine the following year (R.14.31–34). That he was so prolific in oil in the Weehawken region suggests that he found the heavy, dark forms of the industrial city most suited to dramatic possibilities of the oil medium. Some are painted with an effusive approach to the sumptuousness of oil, whereas others are more cautiously handled, the paint applied with less overt energy. Some are dominated by grays and browns, whereas others are marked by a sense of warmth, with grayed red-violets, for example, playing a crucial role. In trying to understand and organize the series, one cannot simply assign all of the sparely painted, descriptive panels with warm hues to one year and all of the richly painted, abstract, cool panels to another, with variants someplace in between. Marin would hardly have made it so uncomplicated. It does seem possible, however, to arrange the panels into groupings with affinities of style, paint manipulation, and color that distinguish them from others, and on that basis attempt to place them chronologically in association with Marin's work in other media during those crucial years between 1910 and 1916. Whatever the precise date, the Weehawken Sequence, or Sequences, remains a distinctive body of work within Marin's oeuvre. Not until the late 1920s and early '30s did the artist again approach the oil medium with such a strong sense of purpose. Then he tackled the landscape of Maine and the rigors of New York City.

The New York to which Marin had returned from Europe was drastically different from the one he had left:

> The Woolworth Building was under construction; two new bridges had been swung across the East River; horse and cable cars were now almost entirely replaced by electric ones; there was an elevated railway rattling overhead and a subway growling underfoot. Time seemed to be moving faster and more raucously. Even the tugboats in the river were more boisterous. The city was passing through a corporate convulsion, a frightening and bewildering kind of high-tensioned life. It was like watching the first days of creation.[9]

Marin's watercolors of the city were based on sketches made as he wandered around. Hundreds of these exist, many in sketchbooks that are still intact.[10] Others were done on loose sheets, and some have been taken from sketchbooks, often by the artist himself, probably to exhibit or to use as sources for more finished works.[11] Skyscrapers and the Brooklyn Bridge drew his immediate interest. His 1912 paintings of the Woolworth Building attracted extraordinary attention when seen at 291 shortly after completion. In the 1920s and '30s the artist shifted his focus to the street life of the city, to the interaction of moving figures with architectural spaces, and to the city's skyline as seen from the water and from across the Hudson River in Weehawken. Although the landscape and the sea dominated his attention toward the end of his life, the city still continued to engage him:

°106. *Weehawken Sequence*, c. 1915. Oil on canvas board, 9 x 12 in. Courtesy of Kennedy Galleries, Inc., New York. R.16.131.

°107. *Weehawken Sequence*, c. 1915. Oil on canvas board, 9 x 12 in. Courtesy of Kennedy Galleries, Inc., New York. R.16.113.

°108. *Weehawken Sequence*, c. 1915. Oil on canvas board, 12 x 9 in. Courtesy of Kennedy Galleries, Inc., New York. R.16.130.

°109. *Weehawken Sequence*, c. 1915. Oil on canvas board, 12 x 9 in. Courtesy of Kennedy Galleries, Inc., New York. R.16.134.

°110. *Woolworth Building under Construction*, c. 1911.
Watercolor on paper, 19½ x 15½ in. National Gallery of
Art, Washington, D.C.; Gift of Mr. and Mrs. John Marin, Jr.
R.13.81.

even when he was gravely ill and in his eighties, he made views from his bed in New York Hospital of the city he so loved (plate 288).

The Woolworth Building, located on the west side of Broadway between Barclay Street and Park Place, was under construction from 1910 to 1913.[12] When completed, it was the tallest building in the world and as such it provided an important symbol of the modern age. It certainly was this for Marin, a symbol he depicted over the years in several dramatic etchings (plates 47–50), in numerous drawings with various degrees of abstraction, and in a brilliant group of watercolors, four of which suggest the range of Marin's responses to this tower that altered the face of his city.[13] It is unwise to suggest that the chronological order of the Woolworth Building watercolors can be determined on the basis of how complete the building appears to be, since they may be based on earlier drawings. Nevertheless, on stylistic grounds (also problematic, given Marin's erratic shifts in style), these four Woolworth watercolors do seem to follow the chronology of the building's completion.

In the earliest of the four, *Woolworth Building under Construction,* c. 1911 (plate 110), which has another view of the city on the verso,[14] Marin focused not on the building alone but on the multistructured city. Blocklike form above blocklike form, it gives a sense almost of a jigsaw puzzle fitted together, with the shapes interlocking into a densely packed mass, man-made yet devoid of the human presence. The peak of the Woolworth Building, with its scaffolding in blue, is the brightest spot on the sheet. Insofar as it is visible, the base of the Woolworth, barely painted, is marked mainly by a suggestion of windows. Integrated here with other architectural forms, the building is less visually powerful than in most of the other watercolors that feature it, including *Woolworth Building, No. 28, Woolworth Building, No. 31,* and *Woolworth Building, No. 32* (plates 112–14), the last of which moves furthest from its subject.

The most elaborately worked is *Woolworth Building, No. 28.* Along the bottom of the sheet are suggestions of trees, figures, and an automobile, all of which figure more prominently in Marin's New York scenes after the mid-1920s. The focus here is on the peak of the tower, and the activity in the sky reinforces its importance. The complexity of color is quite spectacular, not only in the range of the hue but also in the richness with which surfaces are developed: a selection of delicate greens, yellows, and oranges suggests trees; rich browns, blues, and oranges indicate figures; and the full palette was used to establish the architecture. Broad washes are contrasted with pencil-thin brushstrokes. Areas of paint are not only washed out but also scratched out in places, a technique Marin was to use to a great extent a decade later.

The weight of color and form across the lower register allows the tower to soar. More meticulous in detail than *Woolworth Building under Construction,* it is, in its own way, faithful to naturalistic form; yet the dynamics, especially in the sky, seem to be moving toward the explosion that takes place in *Woolworth Building, No. 31.* In Marin's oft-quoted introduction to the catalog for his 1913 exhibition at 291, which included the Woolworth Building series, he wrote a few words to "quicken" the viewer's response to his "point of view":

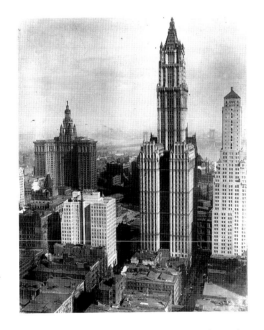

111. New York buildings seen from the Telephone Building, 1927. The Municipal Building is at left, the Woolworth Building at center, and the Transportation Building at right.

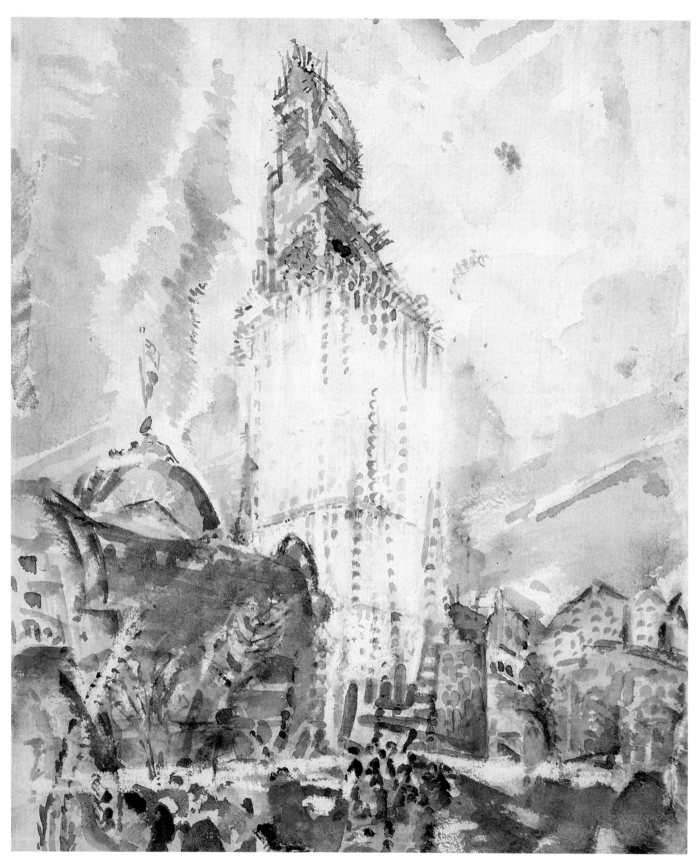

°112. *Woolworth Building, No. 28*, 1912. Watercolor and graphite on paper, 18⅜ × 15⅝ in. National Gallery of Art, Washington, D.C.; Gift of Eugene and Agnes E. Meyer. R.12.66.

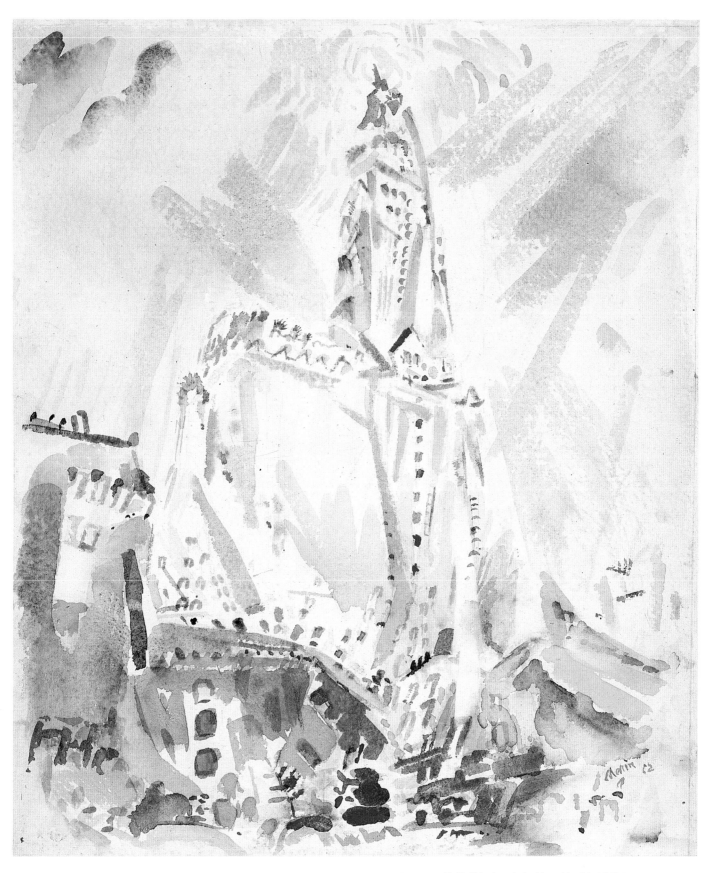

°113. *Woolworth Building, No. 31*, 1912. Watercolor and graphite on paper, 18¾ x 15⅞ in. National Gallery of Art, Washington, D.C.; Gift of Eugene and Agnes E. Meyer. R.12.68.

Shall we consider the life of a great city as confined simply to the people and animals on its streets and in its buildings? Are the buildings themselves dead? We have been told somewhere that a work of art is a thing alive. You cannot create a work of art unless the things you behold respond to something within you. Therefore if these buildings move me they too must have life. Thus the whole city is alive; buildings, people, all are alive; and the more they move me the more I feel them to be alive.

It is this "moving of Me" that I try to express, so that I may recall the spell I have been under and behold the expression of the different emotions that have been called into being. How am I to express what I feel so that its expression will bring me back under the spells: Shall I copy facts photographically? I see great forces at work; great movements; the large buildings and the small buildings; the warring of the great and the small; influences of one mass on another greater or smaller mass. Feelings are aroused which give me the desire to express the reaction of these "pull forces," those influences which play with one another; great masses pulling smaller masses, each subject in some degree to the other's power.

In life all things come under the magnetic influence of other things; the bigger assert themselves strongly, the smaller not so much, but still they assert themselves, and though hidden they strive to be seen and in so doing change their bent and direction.

While these powers are at work pushing, pulling, sideways, downwards, upwards, I can hear the sound of their strife and there is great music being played.

And so I try to express graphically what a great city is doing. Within the frames there must be a balance, a controlling of these warring, pushing, pulling forces. This is what I am trying to realize. But we are all human.[15]

In *Woolworth Building, No. 31,* the structure is completed, the scaffolding gone, and the "pull forces" between the tower and its surroundings are in place—a symbol perhaps for Marin's own delight in the extraordinary energy being generated around him. The paint was reworked very little. While there is some layering of hue, in general each patch of color has absolute autonomy. As in *Woolworth Building, No. 28,* but not in *Woolworth Building under Construction,* there are traces of a spare graphite underdrawing. Essentially, however, the painting is composed of rapidly set down color relationships.

The Woolworth Building paintings and other of Marin's renditions of New York were viewed as symbolic of the uniqueness of America: "[Man, in America] built his cities with such vigor that unlike most cities of the earth they went far up into the air. Marin has tried to show us this great force of America, the mighty industry of the land as it swirls like an angry torrent."[16]

When the Woolworth Building watercolors went on view at 291, Cass Gilbert, the building's architect, went to the Gallery, where he "sadly" confronted the work, "scarcely moving" until Stieglitz, not knowing who he was, approached him, commenting, " 'possibly this work startles you. But if you have acquaintance with Chinese or Japanese art, this should not be so very strange— even though it is not directly related to either. These Marins are inspired by the Woolworth Building —it's a passion of his.' Still the man looked sad, though he was immobile. And continued to gaze.

114. *Woolworth Building, No. 32,* 1913. Watercolor and graphite on paper, 18¾ x 15⅞ in. National Gallery of Art, Washington, D.C.; Gift of Eugene and Agnes E. Meyer. R.13.69.

'So this is the Woolworth Building,' he mused. 'Yes,' replied the commander of the moderns, 'the Woolworth Building. In all of its moods.' Shaking his head, the visitor echoed these words, '. . . the Woolworth Building . . . its various moods.' And so saying, left, descending by the wheezy elevator, never to reappear. . . ."[17]

Gilbert's presumably horrified response to Marin's Woolworth Building watercolors was not unique. One writer noted that New York had "withstood many stiff wallops from moralists, critics, and uplifters generally, but most of them were 'love-taps' compared with the rough treatment handed out by John Marin in his 'New York Series' of pictures"; another commented, "Mr. Marin's ideas seem to have spoilt a good artist in the making."[18] Many critics, however, recognized in Marin's New York watercolors a distinctive representation of the oft-pictured city, and they applauded the works' break with tradition. That break was emphasized in one article illustrating a Woolworth Building watercolor along with etchings of the city by Joseph Pennell (listed as John) and Herman A. Webster: "Some six or eight of [Marin's] New York paintings hang together. They reinforce one another as the rhythms of movement leap from picture to picture cruising through the series in a resistless exultation."[19]

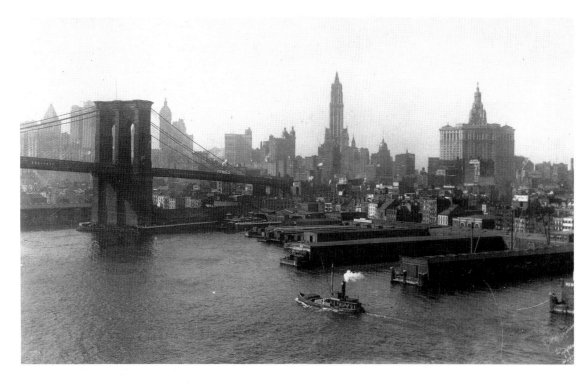

115. Manhattan from Brooklyn, 1916.

The relationship between Marin's work of this period, particularly the Woolworth Building paintings, and the art of both Robert Delaunay and the Italian Futurists is a topic of ongoing discussion.[20] It is unlikely that Marin would have yet seen any paintings by the artists involved with the Futurist movement, since none was exhibited in America until 1915. He may well have been familiar with various Futurist writings in English translation. However, the term *futurist* was often used loosely at this time to denote anything modern, suggesting that some contemporary references to the movement may have been very imprecise. Marin's knowledge of Delaunay's work—specifically, his 1910 paintings, drawings, and lithographs of the Eiffel Tower—is more likely. Marin may have seen some of the originals while in Paris, and he may have encountered impressions of the prints or reproductions of other works after his return.[21] Nevertheless, just as Marin's kinship to Whistler was one of empathy as much as of emulation, it seems that Delaunay would have reinforced, rather than inspired, Marin's own desire to dynamically alter form from a naturalistic scheme—a desire that had already been evident in Marin's 1909 etchings.

Initially less remarked upon than the Woolworth Building paintings were Marin's etchings and paintings based on the Brooklyn Bridge, which was of equal importance to him in denoting the modern era.[22] In this Marin was not alone, as Lewis Mumford has suggested: "Beyond any other aspect of New York, I think, the Brooklyn Bridge has been a source of joy and inspiration to the artist. . . . All that the age had just pride in—its advantages in science, its skill in handling iron, its personal heroism in the face of dangerous industrial processes, its willingness to attempt the untried and the impossible—came to a head in the Brooklyn Bridge."[23]

Construction of the bridge was begun about the time Marin was born, and it continued for more than a decade.[24] The artist was undoubtedly aware of its progress and of its opening in 1883, which was accompanied by a shower of fireworks. A prominent feature of the bridge was its pedestrian promenade, built fifteen feet wide and eighteen feet above the roadway. Intended as a "place to exercise, socialize, relax on a bench, and enjoy the view of the city and river," the promenade was "more like a park than a street." John Roebling, one of the bridge's chief engineers, wrote in his original plan that "in a crowded commercial city, such a promenade will be of incalculable value." Pedestrians were to have "an uninterrupted view of their surroundings. . . . The purest air and the brightest sunshine . . . the orator and the poet [were to] come for inspiration. . . ."[25] Among the poets who responded was Hart Crane, who also shared Marin's love for the sea. Crane's poem *The Bridge* is surely the most famous inspired by the great span.[26] Marin, responding twenty years earlier, had placed himself on a long list of visual artists who took advantage of the great structure's poetic potential, including Childe Hassam, Joseph Pennell, Max Weber, and Georgia O'Keeffe; more recently, Robert Indiana and Red Grooms have continued the tradition.[27]

In some of Marin's paintings—for example, *Brooklyn Bridge* (plate 116)—the towers of the bridge predominate. In others, such as *Brooklyn Bridge* (plate 118), the bridge is just one component in a city complex. In still others—for example, *Related to Brooklyn Bridge* (plate 123)—elements of the structure function less as identifiable aspects of the bridge than as a framing or screening device within the composition, a device that went back to Marin's European etchings. Plates 116 and 118 present the range in Marin's use of the Brooklyn Bridge within the first year he seriously explored it. As is usual with his favored compositions, both are known in several versions and can be related to a number of etchings as well—for example, plate 116 with *Brooklyn Bridge, No. 6 (Swaying)* (plate 41) and plate 118 with *Brooklyn Bridge from Brooklyn (The Sun)* (plate 38).

In plate 118 the towers of the bridge loom at the left and right edges of the sheet, but the structure is shrouded at the center in a dense, painterly fog. Marin here embraced the romantic aura of the city in much the same way that he had approached the vastness of the Tyrol two years earlier. In contrast is plate 116, distinguished by the dynamics of the open and closed design of the bridge's tower, the activity of the figures moving across its promenade, the flickering effects of the light filtered through the bridge's cables, and the compression of space established by the bending of the lampposts to meet the buildings swaying in the distance. The subject here is energy, not atmosphere.

In *The Red Sun, Brooklyn Bridge* (plate 119) the artist's handling of his materials is so spectacular that the subject is as much as anything the manipulation of paint. Brilliant color, especially touches of alizarin that act as reflections of the flaming red sun, is combined with subtle, gray-black charcoal lines. Strokes are laid in and left as freshly applied; marks are carved into the painted surfaces, as in the guardrail at lower left, above which unpainted patches of white paper suggest the choppy river. Some areas, like those at the lower center, are washed in and scrubbed out, leaving evidence of the

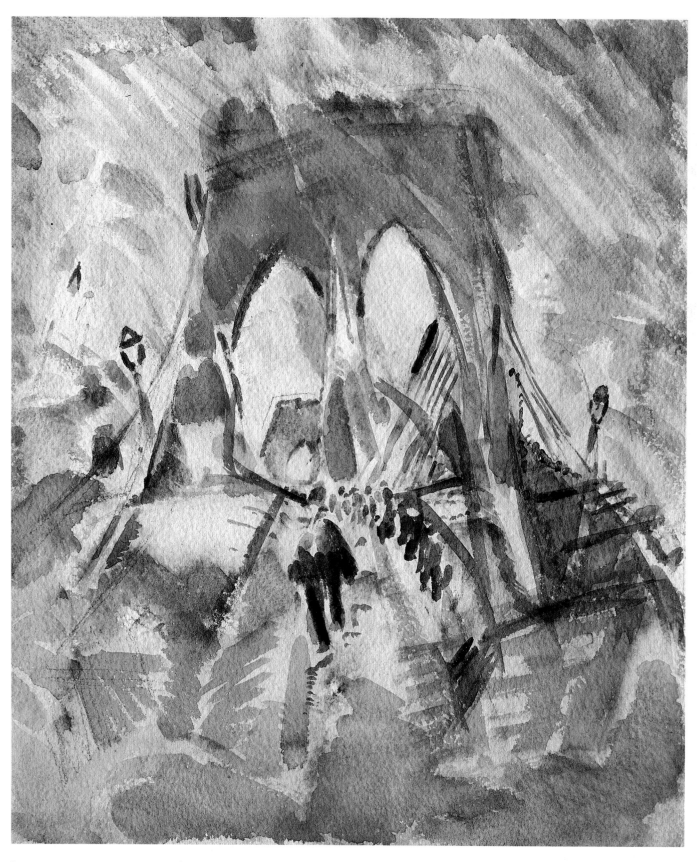

°116. *Brooklyn Bridge*, 1912. Watercolor and graphite on paper, 18½ x 15½ in. The Metropolitan Museum of Art, New York; The Alfred Stieglitz Collection, 1949. R.12.11.

artist's circular hand motion; fingerprint dabs stand for windows in the buildings at the right. Marin's use of his hand as a tool recalls his wiping of his etchings. It is likely that his recent attention to the brilliant sunsets in Maine (see plates 182, 183, and 185, for example) had focused his attention on that big round circle as it hovered over the city as well. The bridge itself serves as a framing screen, setting up parallel bands across the surface of the sheet, a structure seen in many of Marin's sketches of the subject.

The composition of *The Red Sun, Brooklyn Bridge* is one Marin rendered several times, in large-scale watercolors including *From the Bridge* (plate 121), as well as in smaller, more roughly conceived pieces. Important in all of them is a horse, which seems to stand in the shadow of an emerging America as an icon of an earlier, ephemeral world. *Brooklyn Bridge, On the Bridge* (plate 122), of several years later, conflates aspects of several earlier renditions: the towers are centrally placed and frontal in orientation; a figural element is incorporated along with the blazing sun, but there are few suggestions of the city in the distance. This limited palette, juxtaposing grays with pinks and yellows, is an unusual one for Marin. Reflective of his earlier bridges, this watercolor introduces concerns that were incorporated into etchings the following year (see plate 42).

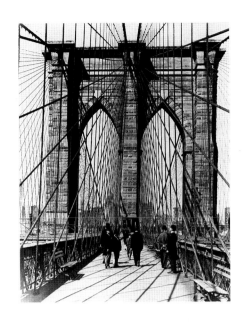

117. George P. Hall and Son. Men standing on the walkway of the Manhattan Tower of Brooklyn Bridge, looking toward Manhattan, 1898. The New-York Historical Society, New York.

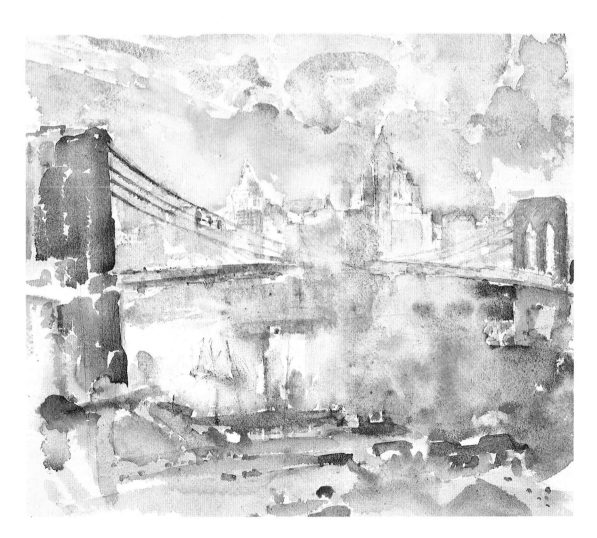

°118. *Brooklyn Bridge*, 1912. Watercolor and graphite on paper, 15½ x 18½ in. John Marin Collection, Colby College Museum of Art, Waterville, Maine; Gift of Mr. and Mrs. John Marin, Jr. R.12.12.

°119. *The Red Sun, Brooklyn Bridge,* c. 1922. Watercolor and charcoal on paper, 21⅜ x 26³⁄₁₆ in. The Art Institute of Chicago; Alfred Stieglitz Collection, 1949. R.22.109.

120. Elizabeth Street, New York, after St. Joseph's Celebration, October 1, 1927.

121. *From the Bridge,* 1931. Watercolor, graphite, black crayon, and charcoal on paper, 18½ × 22⅞ in. Private collection. R.31.7.

°122. *Brooklyn Bridge, On the Bridge*, 1930. Watercolor and
graphite on paper, 21¾ × 26¾ in. Daniel J. Terra
Collection, Terra Museum of American Art, Chicago,
R.30.51.

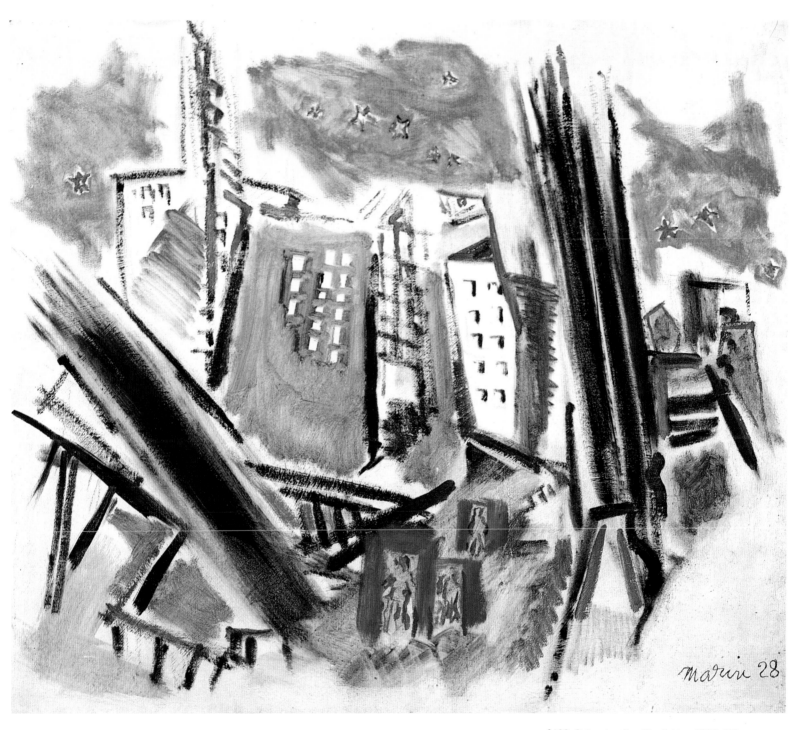

°123. *Related to Brooklyn Bridge*, 1928. Oil on canvas,
26½ × 30 in. Private collection. R.28.56.

Related to Brooklyn Bridge (plate 123), an oil, was painted in 1928, the watershed year when Marin began working with oils again after a lapse of several years. Presumably he was responding, at least in part, to the limitations of watercolor. This painting is among his largest ever and certainly one of his most expansive. It is relatively thinly painted, for Marin's more aggressive use of painterly impasto did not reappear in his work until the early 1930s. One senses that Marin intended to use his oil paints, even on this large a scale, as swiftly and directly as watercolor, while taking advantage of the oil medium's possibilities of manipulation and weight. It is possible to track Marin's hand as it worked the brush across the canvas, swiftly setting down the bridge cables in brown, moving with a more confined motion in laying in the green buildings and the red sky, and painting with relatively great deliberation in establishing the boxlike environments that enclose each of the pedestrians. These boxes are distinctive to Marin's work, and as a compositional structure they emphasize specific elements, such as the crouched figure in *Wall Street, Trinity* (plate 125). (This need to be emphatic is evident in Marin's writing style, too, where parentheses box in words and capitalization is liberally added, like darker lines in the drawings.) His painted boxes suggest a feeling of psychological aloneness that Marin might have been considering not only as a personal experience, but also as a growing characteristic of the modern world. Among Marin's oils, *Related to Brooklyn Bridge* is one of great importance in both symbolic and formal terms.

During the years of World War I, Marin painted mainly landscapes, though he did depict a number of other New York themes, apart from the Woolworth Building and the Brooklyn Bridge, and at

125. *Wall Street, Trinity,* c. 1924. Graphite on paper, 9¹³⁄₁₆ x 7⅞ in. Courtesy of Kennedy Galleries, Inc., New York.

least some of the canvases in his Weehawken Sequence date from the period as well. The war must have generated a sense of global upheaval within the city, and these were also the years when the Marin family had no settled winter base. Working in New York without a permanent studio would surely have been fraught with complications.

Starting in 1920, the year the Marins purchased their Cliffside house, Marin looked at the city anew. During that and the following few years he completed some of his most startling and most beautiful cityscape watercolors, many of them in a horizontal format, an indication that Marin's landscape paintings, which more often than not had a horizontal rather than a vertical scheme, had affected his frame of reference for the city. While adding the wide view to his way of portraying the city, Marin certainly did not abandon the vertical. Long after his famous Woolworth Building series, Marin depicted the Municipal Building, the Singer Building, and the Telephone Building in powerful watercolors that feature them as the central aspect of the scene.[28] News photographs from the 1920s, such as a view of the Telephone Building taken from the Woolworth Building (plate 127), give an idea how these buildings restructured the New York skyline.

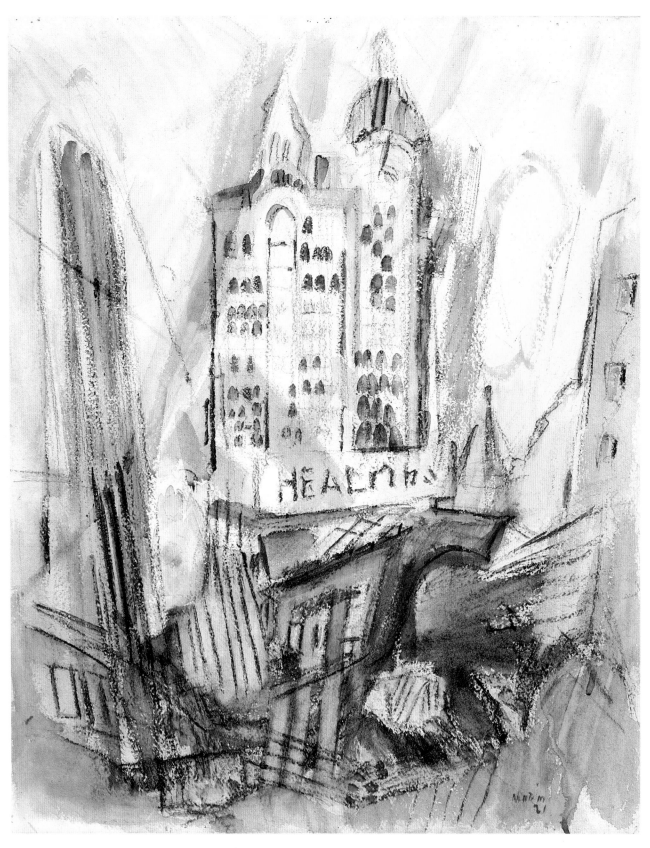

°126. *Singer Building,* 1921. Watercolor, graphite, and
charcoal on paper, 26⅜ x 21⅝ in. Philadelphia Museum of
Art; Alfred Stieglitz Collection. R.21.49.

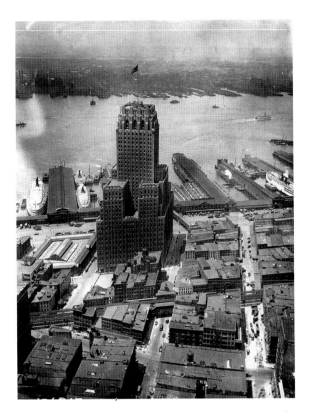

127. New York Telephone Building and wharfs seen from the Woolworth Building, 1927.

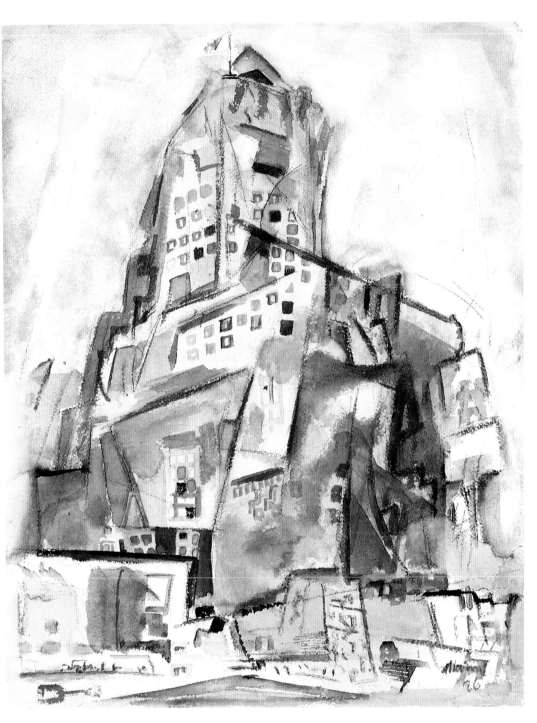

128. *The Telephone Building*, c. 1925. Sketchbook page, graphite on paper, 10¼ x 7 in. National Gallery of Art, Washington, D.C.; Gift of John Marin, Jr.

°129. *Telephone Building, Lower New York*, 1926. Watercolor, graphite, and charcoal on paper, 26⅞ x 20¹⁵⁄₁₆ in. Private collection. R.26.65.

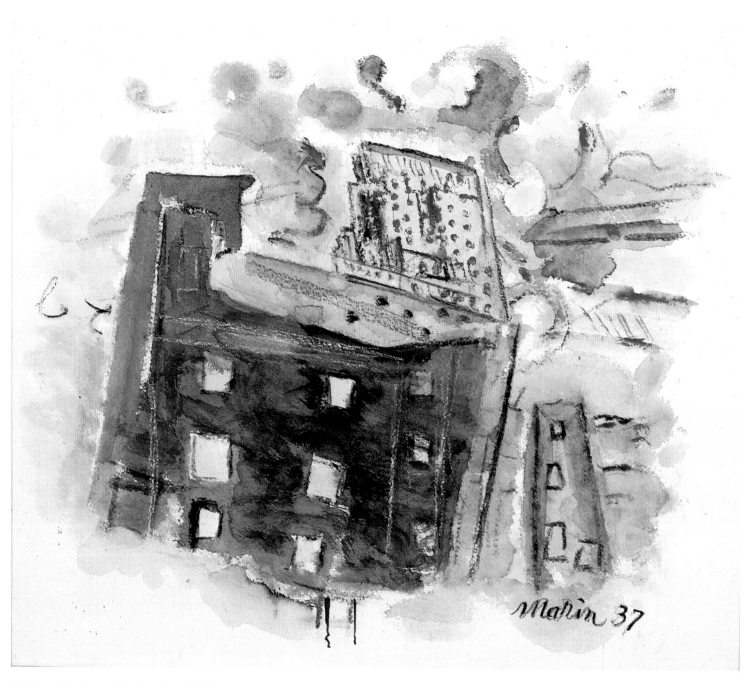

130. *Top of Radio City, New York City*, 1937. Watercolor, graphite, and charcoal on paper, 20¾ x 24¾ in. Jean and Alvin Snowiss. R.37.27.

Marin's 1921 watercolor of the Singer Building (plate 126), with its strong verticality, retains many of the characteristics of his earlier skyscraper paintings. The Telephone Building, by contrast, is presented as a blocklike, less elegant structure (plates 128, 129). In plate 129 attention is drawn to the windows organized into a small-scale block pattern that counters and enhances the large modules of the architecture. Tiny buildings and automobiles distributed along the ground are quite simply suggested, and visual space is radically compressed. The zigzags and squares show Marin's interest in this sort of patterning well before he emphasized it in some of his New Mexico paintings. Marin continued responding to the Telephone Building's boxy forms as late as 1936, when he painted it as one element in a wide view from the river (plate 152).

Lower Manhattan (plate 57), one of the important horizontal cityscapes of the early 1920s, introduces the elevated train in Marin's paintings and emphasizes a different aspect of his surroundings: "New York, with its frantic life, . . . the street a noisome cavern under an elevated railroad; the place where men toiled only a jumble of misshapen buildings . . . curbs littered with packing-cases and lined with yawning drays, of clatter of commerce. . . ."[29] This new emphasis on the street foretells one of Marin's concerns of the next two decades, although well into the 1930s he continued to look up at the "skyscrapersoup of the city"[30] (plate 130).

One of Marin's most splendid horizontal compositions is *Lower Manhattan (Composing Derived from Top of Woolworth)* (plate 131). From its sewn-on central sunburst radiates a semicircular explosion of streets and buildings. The streets echo the rays of the sunburst collage, and the triangular and zigzag enclosures suggest the repetition of forms within the façades of the buildings. It is Marin's most extraordinary rendition of the sounds, speed, and density of the city. Some sense of the view that triggered his response can be gleaned from a photograph taken a few years later (plate 127). From the mid-1920s on, Marin increasingly shifted his city scenes away from the skyscraper to denser street views. Those with a vertical format emphasize the cavernous effect of the spaces left by the buildings. His titles tell us his sites, centered on Nassau Street, Mott Street, and the region of Trinity Church (plate 43).

In 1925 Marin's recurring stomach problems kept him from traveling any distance for the summer months. At some point about this time, possibly when he was confined at home, Marin completed a distinctive group of small watercolors of the city. They were worked one next to another on large sheets, often recto-verso, and later cut down into separate images. *Downtown New York* and *Downtown New York, No. 5* (plates 132, 133) indicate the range within the group of forms and strokes, from the fairly delicate, as in the former, to the aggressively dark and heavy, as in the latter. All of them are extensively worked with graphite and charcoal lines, and their surfaces are often heavily abraded. They seem impatient, as if the artist was trying to get at something and not readily achieving it.

In addition to this group of watercolor sketches, at mid-decade Marin completed a number of watercolors of the New York Stock Exchange (plate 134). He also continued to extend the horizon-

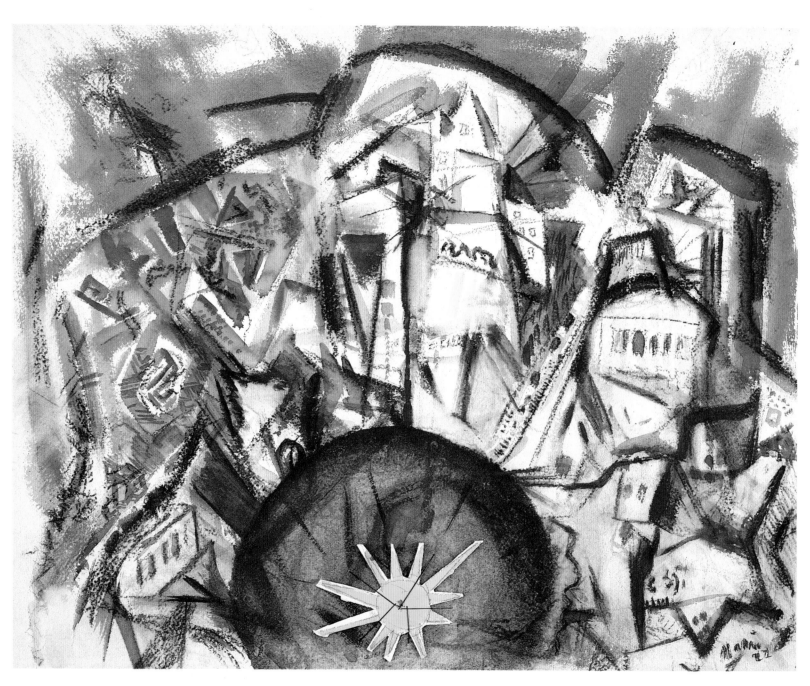

°131. *Lower Manhattan (Composing Derived from Top of Woolworth)*, 1922. Watercolor, graphite, and charcoal on paper with paper cutout attached with thread, 21⅝ x 26⅞ in. Collection, The Museum of Modern Art, New York; Acquired through the Lillie P. Bliss Bequest. R.22.28.

132. *Downtown New York,* c. 1925. Watercolor, graphite, and charcoal on paper, 11 × 9⅝ in. National Gallery of Art, Washington, D.C.; Gift of John Marin, Jr. R.25.28.

133. *Downtown New York, No. 5,* c. 1925. Watercolor, graphite, and charcoal on paper, 10¹³⁄₁₆ × 9⅞ in. National Gallery of Art, Washington, D.C.; Gift of John Marin, Jr. R.25.38.

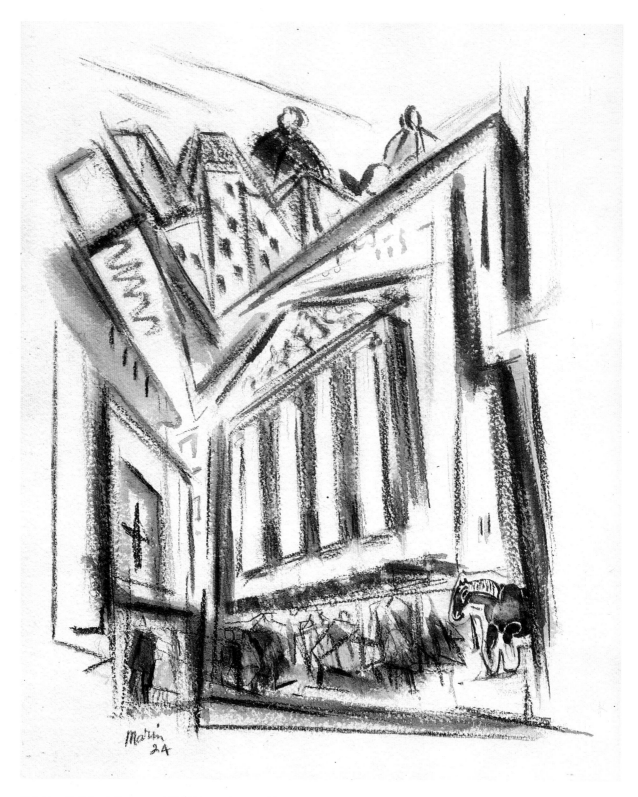

134. *New York Stock Exchange*, 1924. Watercolor, graphite, and colored pencil on paper, 22¼ × 18⅜ in. Mr. and Mrs. Herbert Hain. Not in Reich.

tal cityscape format, with one of the most dazzling examples being *Broadway Night* (plate 135). With its geometric, horizontal organization and its clear interest in the activity and the signs along the street, it incorporates many of the forms Marin had developed to evoke "the land of Jazz—lights and movies—the land of *the* moneyspenders"[31] in his cityscapes throughout the decade.

> He has apparently been studying the moving throngs of pedestrians and motors that color and clog the New York streets and has woven the elements of this ceaseless tide of form into hieroglyphic patterns of unusual richness and interest. Of all of these innovations the "Broadway by Night" with its lurid lights and blaring billboards fails to suggest the gorgeous cacophony of the scene. Perhaps it is beyond the reach of the pictorial arts to capture the blazing electrical panorama of such a scene, but if any man is entitled to have a try at it, it is John Marin.[32]

A number of undated drawings of New York street scenes may have been done during the mid-1920s, a time of assimilating and reviewing. There are many of them, and one senses that Marin roamed the city constantly, pencil and pad in hand, capturing the energy he felt pulsating around him. His keen interest in the figure became apparent in these drawings. Starting in the late 1920s, and increasingly in the 1930s, the figural motif took its place in the paintings as well. That he was a close observer of the shapes and spaces and rhythms created as people moved among the street vendors and parked cars below the El is evident in *Middle Manhattan Movement Abstraction, Lower Manhattan* and *Street Crossing, New York* (plates 137, 138), of 1928, both of which portray figures

Marin 28

°137. *Middle Manhattan Movement Abstraction, Lower Manhattan*, 1928. Watercolor, graphite, and chalk on paper, 21½ x 26¼ in. Munson-Williams-Proctor Institute Museum of Art, Utica, New York. R.28.37.

138. *Street Crossing, New York,* 1928. Watercolor and graphite on paper, 26¼ x 21¾ in. The Phillips Collection, Washington, D.C. R.28.73.

bustling across busy city streets. Their titles themselves tell much about Marin's approach. As always, the term *movement* suggests attention to rhythm, to gesture, often to repetition, whereas *abstraction* suggests a clear and conscious thrust away from the source. Sometimes the two are combined, as in plate 137. In these formal respects, *Middle Manhattan Movement Abstraction, Lower Manhattan* is more forceful than *Street Crossing, New York,* but there are obvious affinities in their overall structures. The former is more shallow, with an emphasis on the flattening of forms and a sense of their closeness to the surface of the sheet. In the latter, there is a greater distancing between the viewer and the scene. A radical painting of a similar subject was completed a few years later. *Street Movement, N.Y.* (plate 93) is extreme in its luminous color, in its highly abbreviated suggestion of form, and in its rough use of the watercolor medium (a small round piece of cardboard that stuck to the painting's surface suggests the speed with which Marin squeezed that paint directly from the tube, without bothering to remove the inner lining of its cap). The sun once again reigns supreme.

Groups of people crossing streets, at box offices, walking along the sidewalk became increasingly prominent in Marin's paintings and drawings as the 1930s progressed. Many are horizontal, such as *City Movement, New York* (plate 139), in which the figures act as a band of vertical stripes, marching across the center. Also in the 1930s Marin developed new strategies for enclosing segments of his images, as evident in *Building, New York; Region Trinity Church, N.Y.C.;* and *City Construction* (plates 140, 141, 143). *Building, New York* is one of Marin's most forceful hymns to the workmen who were transforming the city. As in *City Construction,* his subject is as much the act of building, the function of the laborers, as it is the structure being built. The ruggedness of the men's activity is echoed in the ruggedness of the brushstrokes.

In *Region Trinity Church, N.Y.C.* the kind of enclosure forms that surround the figures in the oil painting *Related to Brooklyn Bridge* (plate 123) are in full force, isolating and emphasizing. Marin's "26–36" date on the piece, which appears on related works as well (plate 142), undoubtedly indicates the years of his interest in the theme rather than that he worked on this one sheet over a decade. Considerable importance is given in both versions to the linear aspects of the compositions. For example, in plate 141 a delicate lightness of touch is conveyed by the graphite; in plate 142 the line, worked in ink, is more forceful in effect, providing precedents for the calligraphic emphasis in Marin's later work.

Writing in 1951 to Elizabeth S. Navas, who acquired the Trinity Church watercolor for the Murdock Collection at the Wichita Art Museum, Marin provided, first of all, his suggestions on how to look at pictures in general, and, second, a specific report on *Region Trinity Church, N.Y.C.*:

> Kindly look at the picture—and think of nothing else—give the picture that chance—let what comes after lookings come of itself—for—it should represent nothing but itself—being itself— being a creation in its own right——
>
> As for this particular picture titled—Region Trinity Church New York—it came into being together with five other variations—as the result of my wanderings there abouts—these seeings

139. *City Movement, New York,* 1940. Watercolor, graphite, and crayon on paper, 10⅜ x 14¹⁵⁄₁₆ in. Private collection. R.40.9.

°140. *Building, New York*, 1932. Watercolor, graphite, charcoal, and crayon on paper, 24½ × 19½ in. (sight). The Detroit Institute of Arts; Gift of Dr. and Mrs. Irving Levitt. R.32.11.

°141. *Region Trinity Church, N.Y.C.,* 1936. Watercolor and
graphite on paper, 24¼ x 19¼ in. (sight). Wichita Art
Museum, Wichita, Kansas; The Roland P. Murdock
Collection. R.36.26.

142. *Region Trinity Church, N.Y.C.*, 1936. Watercolor, graphite, and ink on paper, 25⅜ × 19¾ in. Private collection, Chicago. R.36.27.

143. *City Construction*, 1932. Watercolor, graphite, and black chalk on paper, 26 × 21¼ in. Albright-Knox Art Gallery, Buffalo; George Cary Fund, 1954. R.32.12.

—transposed into—symbol seeings—not losing the—core—of my seeing—Rhythm
throughout was looked for—balance and construction—a playing part with part—movements
of juxtaposition objects—certain objects framed as it were to beat attention to themselves—
each object taking its place—the whole—I repeat—to be a balanced construction.[33]

In 1932 Marin completed several expressive oils of the city, including *Mid-Manhattan, No.1; Mid-Manhattan, No. 2;* and *Bryant Square* (plates 144–46). In *Mid-Manhattan, No. 1* the skyscrapers retain a greater specificity than in the second version, in which a greater sense of overall schematic patterning prevails. The stream of figures along the lower band of the earlier version functions as a distinctly separate element; the figures in the later version, though proportionately smaller, seem more individually defined and more fully integrated into the composition. The painterly aspects of the two works vary significantly as well. *Mid-Manhattan, No. 1* is more densely worked and richer in color, its paint thickly applied with a variety of strokes and markings. *Mid-Manhattan, No. 2,* worked with a cool spareness, is more dependent on drawing for its definition of form, and tonal rather than coloristic differentiations are paramount. In moving toward a greater abstraction, Marin moved as well to a spareness in means. This approach came to mark the last works he completed.

Bryant Square is closely based on drawings of the scene (plate 147). It is characterized by a distilled representation of the architectural scheme and by neutral colors, as well as by an extensive linear activity, both incised and in black paint. The facture features a liveliness of surface and richness of handling. Primed but unpainted canvas is juxtaposed throughout with freely applied, luscious strokes by different-size brushes. Fields of smoothly applied hue are contrasted with dabs built up to create surface texture. Lines were sometimes dry brushed onto a dry surface, allowing the weave of the canvas to play a role. Other strokes were painted thickly into wet paint, the two colors mingling to create a softer edge. Marin was a master of gray, and its atmospheric properties were central to his art from his earliest watercolors. In *Bryant Square* a light tone provides a field for the darker grays and other neutrals. The mixture of tall and low buildings and the interlocking activity of figures and automobile traffic convey an effect of multiple viewpoints. Lines move, shapes hover, surfaces undulate, and tensions pervade the entire composition.

The critical response to Marin's oil paintings was mixed, but it did include considerable enthusiasm for his new work in the medium:

> No doubt in time the Marin idiom in oils will take its place as just as much an undeniable
> achievement as his idiom in watercolor. At the moment it is perhaps still in the making; but the
> power of the oils which constitute the chief part of the current exhibition cannot be escaped.
> Mood perhaps makes the oils stand apart from the watercolors; the somber tone of a mature
> vision, the resigned peace after tragedy is to be felt in them. The painting is austere, passionate,
> strong, as majestic as the watercolors but somehow sterner.... The 1932 exhibition is an
> answer to those who have said, "yes, he is a fine watercolorist, but his genius is limited. Why has
> he never worked in oils?"[34]

°144. *Mid-Manhattan, No. 1,* 1932. Oil on canvas, 28 × 22 in. Des Moines Art Center; Coffin Fine Arts Trust Fund. R.32.22.

°145. *Mid-Manhattan, No. 2*, 1932. Oil on canvas, 35 x 26 in.
The Regis Collection, Minneapolis. R.32.23.

°146. *Bryant Square*, 1932. Oil on canvas, 21½ x 26½ in.
The Phillips Collection, Washington, D.C. R.32.10.

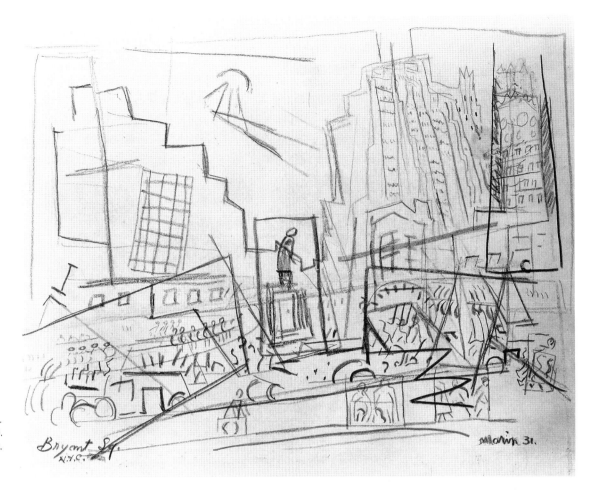

147. *Bryant Square, New York City*, 1931.
Graphite on paper, 10½ x 13¾ in.
Private collection.

Marin continued to paint in oils for the rest of his life, working first with increasing quantities of paint, thickly applied, and eventually with a spare touch that activated the surface of the canvas while barely applying any paint at all. In a small painting of 1934, *Sailboat, Brooklyn Bridge, New York Skyline* (plate 148), Marin compressed all of his favored motifs into individual enclosures, painted with splashy delight, and then surrounded them with one of his hand-painted frames. Another painting of approximately the same time, *Study, New York* (plate 149), is equally comprehensive in its collection of motifs but organized by an explosive structure of diagonals rather than enclosures, the explosion extending out to an elaborately painted border.

The year 1936 was a banner one for Marin. The Museum of Modern Art mounted a major retrospective of the sixty-six-year-old artist's work, containing 160 watercolors, 21 oils, and 44 etchings. By this time his use of oil had enhanced his approach to watercolor. He continued for the rest of his life to work in both media, his technical approaches and formal strategies in the one affected by the other. Earlier, his shifting back and forth between Maine and New York had had similar effects. For example, in the 1920s he increasingly started showing views of New York from the water, undoubtedly in response to his experiences in Maine, painting what he would have seen from his boat.

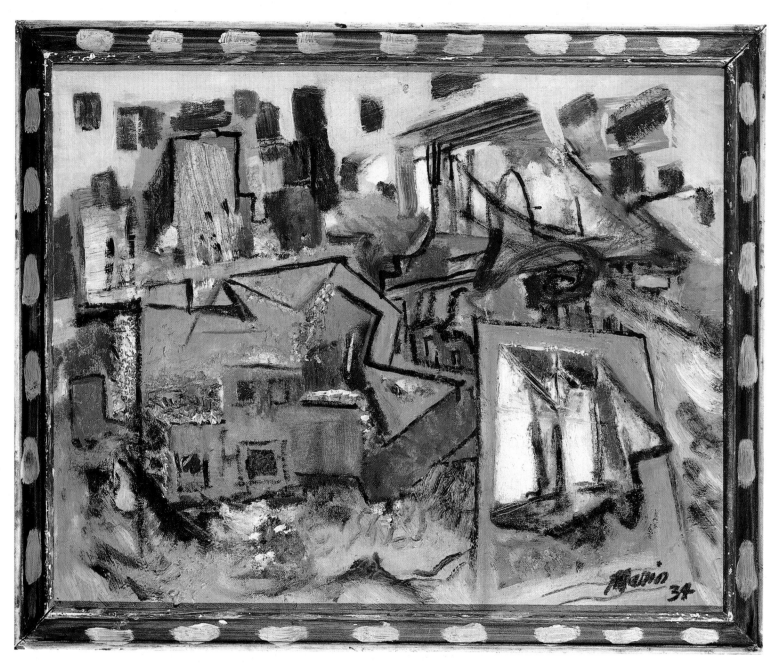

°148. *Sailboat, Brooklyn Bridge, New York Skyline,* 1934. Oil
on canvas board, 14 x 17¾ in.; with Marin frame. The
Farber Collection, New York. R.34.23.

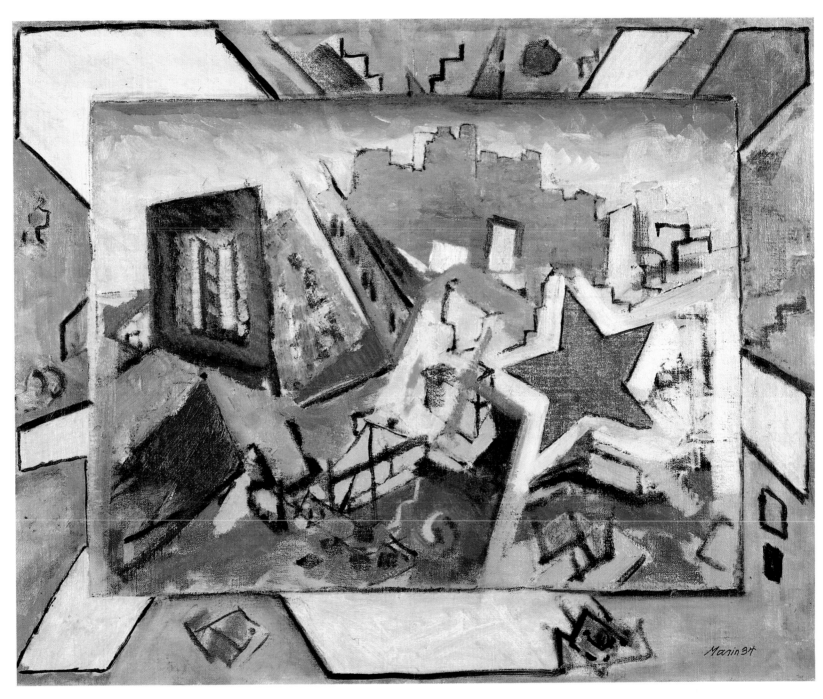

°149. *Study, New York*, 1934. Oil on canvas, 22 x 28 in.
Mr. and Mrs. William Janss, Sun Valley, Idaho. R.34.28.

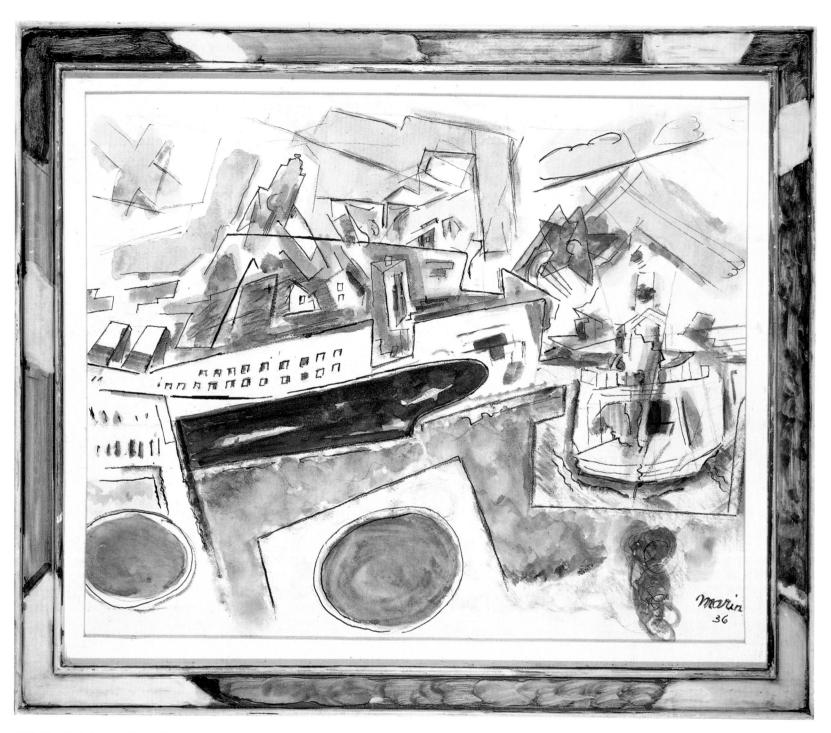

°150. *New York, Hudson River*, 1936. Watercolor, graphite,
and ink on paper, 19 x 24⅛ in.; with Marin frame.
Private collection. R.36.22.

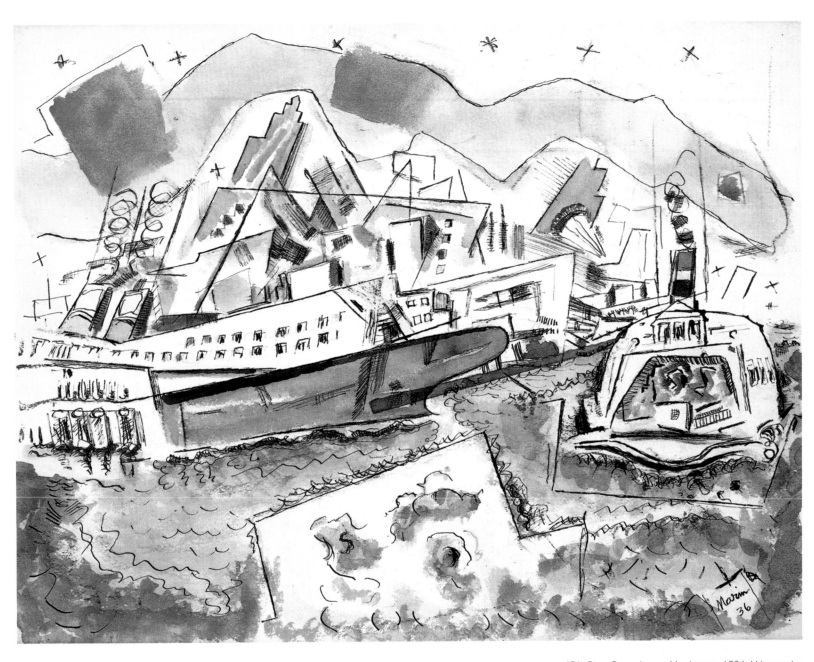

151. *River Front, Lower Manhattan*, 1936. Watercolor,
graphite, and ink on paper, 20 × 26 in.
Mr. and Mrs. Harry Spiro, New York. R.36.28.

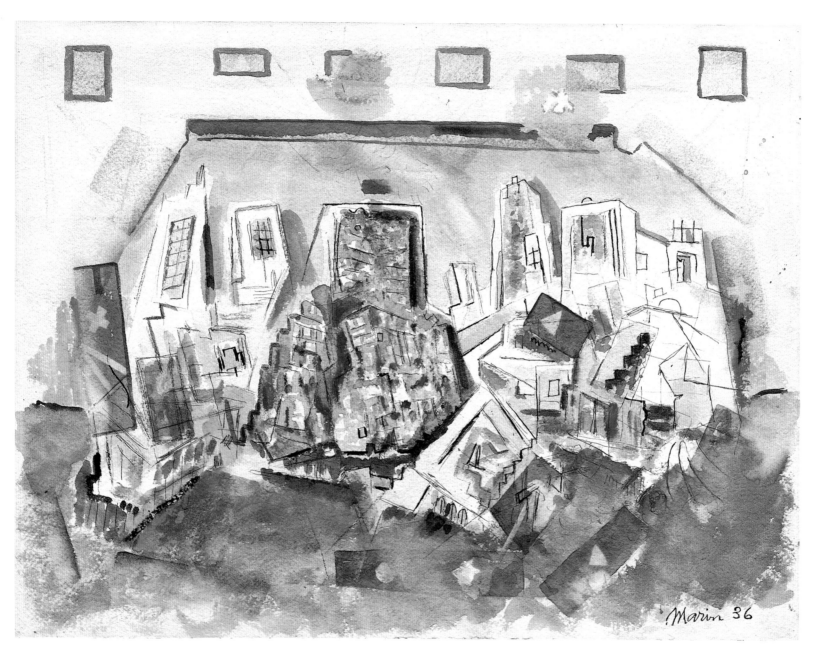

°152. *Motive, Telephone Building, New York*, 1936.
Watercolor, graphite, charcoal, and ink on paper, 20 x 26¼
in. The Metropolitan Museum of Art, New York; The
Alfred Stieglitz Collection, 1949. R.36.18.

Among the watercolors of 1936 are two radically different views that exemplify this aquatic perspective, *New York, Hudson River* and *Motive, Telephone Building, New York* (plates 150, 152). Both are enhanced with pen and ink, a method of delineation that Marin incorporated into his work about this time. *New York, Hudson River* and a related work, *River Front, Lower Manhattan* (plate 151), focus on shipping, suggesting the movement of boats back and forth along the river. Its light and bright coloration confound one's expectations of the industrial city. *Motive, Telephone Building, New York* is technically interesting: some areas are pounced or stamped, perhaps with a sponge; others, such as the circles, stars, and triangles at the lower right, appear to have been created by a masking procedure. While the Telephone Building is clearly given pride of place, the incredible activity in the water, sky, and surrounding structures can hardly be considered secondary. Repetitions of forms and rhythms abound, activating the painting's surface and conveying the glow of the city with an enthusiastic strength of conviction. The painting was immediately praised: "Seen from the waterside, he has given it to us a rich raspberry pile shot with flecks of heaven-sent blue and amplified with a strange burst of Marinesque shrapnel—a rich melange of inexplicable forms that could only come to pass at the hands of this painter who, at the age of sixty-odd, continues to startle even his closest friends and admirers."[35]

Marin's view of New York, although not always startling, was always quite apart from the chronicles of the human condition evident in New York scenes by, say, John Sloan and Reginald Marsh; from the despairing sense of profound psychological isolation explored by Edward Hopper; and from the brilliantly colored flattened spaces of Stuart Davis. Marin's view of New York had as much to do with the feel of the city as its looks:

> Fused with the inscrutable elements of race and place, there pulses in every one of Marin's
> spurts the tempo of the modern world. In each, through notations of rapid movement, there
> beats the frantically accelerated age, life flying onward through space with such rapidity we can
> scarcely glimpse it as it thunders by; . . . particularly in Marin's New York all is sudden upheaval,
> spasmodic earthquake from the abyss of society, a thousand maddening by conflicting tugs. . . .[36]

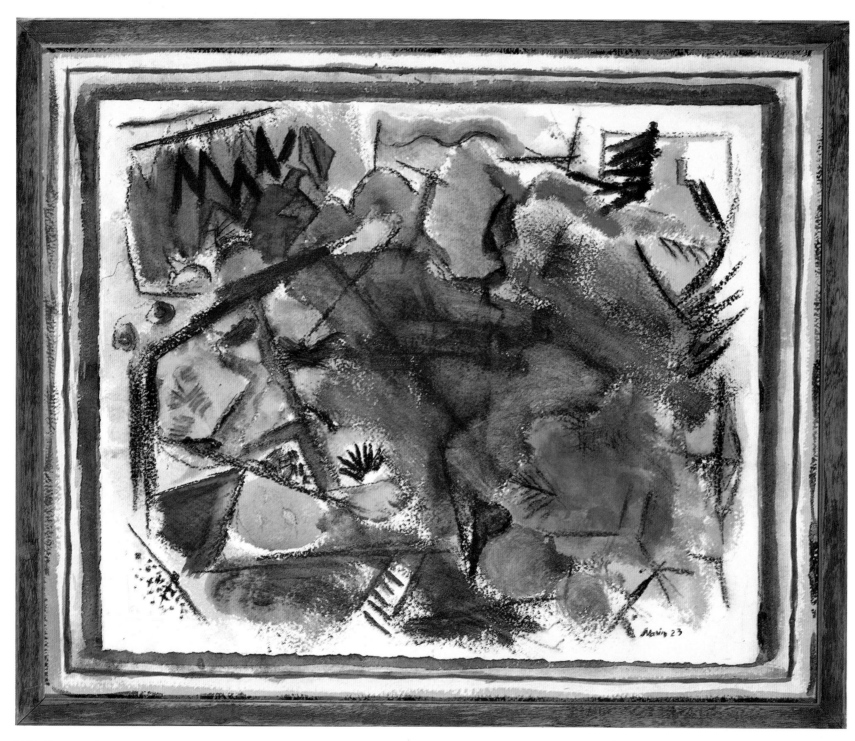

°153. *Movement Autumn,* 1923. Watercolor and charcoal on
paper, 22³/₁₆ × 22⁷/₁₆ in. (including mount); with Marin frame.
Private collection. R.23.43.

154. George Daniell. *John Marin at Cape Split,* 1952. Gelatin silver print, 6¹⁵⁄₁₆ x 6¹⁵⁄₁₆ in. Collection of the photographer.

MAINE:
WHERE LAND AND WATER MEET

In the summer of 1914 John Marin discovered Maine.

> Big shelving, wonderful rocks, hoary with enormous hanging
> beards of seaweed, carrying forests of evergreen on their
> backs. The big tides come in, swift, go out swift.
> And the winds bring in big waves, they pound the beaches
> and rocks.
> Wonderful days.
> Wonderful sunset closings.
> Good to have eyes to see, ears to hear the roar of the waters.
> Nostrils to take in the odors of the salt sea and the firs.
> Fresh fish, caught some myself.
> Berries to pick, picked many wild delicious strawberries.
> The blueberries are coming on.
> On the verge of the wilderness, big flopping lazy still-flying
> cranes.
> Big flying eagles.
> The solemn restful beautiful firs.
> The border of the sea.[1]

Before him artists as diverse as Albert Pinkham Ryder and Winslow Homer had painted in New England, helping to establish the American landscape tradition into which Marin moved.[2]

Critics often compared Marin with Ryder and Homer, as in this hymn to the power of a new American vision in which the distinctive qualities of the American landscape were set forth. It reads as a celebration of the rugged individual alone in the wilderness.

> As Winslow Homer's painting is full of force of the sea, so Marin's water colors have in them the strength of the mountains. We can feel the volcanic forces and think we see the rounded mounds left by the glacial period. . . . In the cold green-blue pine trees of Maine this wild natural force has been felt by Marin. His woods are almost primitive in their power. They command our respect not our love, and we feel our very presence an intrusion. . . . The pine trees are alone with their lakes and stand guard over their waters against the great north wind.[3]

As he had been in his youth, Marin as an adult was a hearty outdoorsman of the rough and tumble kind that calls to mind Nick Adams, the central figure in Ernest Hemingway's *Big Two-Hearted River*.[4] He liked to boat and to fish, and he was an avid hiker. He is said to have taken with him wherever he went his fisherman's wicker creel, in which he carried his supplies for painting, along with an easel and paper. He even developed a rotating easel, which facilitated his painting outside on uneven terrain.

Marin spent long periods in Maine from 1914 until the end of his life, often staying from early summer almost until Christmas. His very first year there, in the West Point–Small Point area by Casco Bay, was an extremely prolific one, and the work was of consistently high quality. The painter and Marie, who was pregnant with John, Jr., settled very near the home of his old friend the painter-etcher Ernest Haskell and his family. The Marins remained centered there for several seasons, spending considerable time with the Haskells. Marin went daily to his friend's barn to collect a pail of milk from the family cow, and the two artists often went boating and fishing, sharing an enjoyment of the rugged outdoor life.[5]

That part of Maine is marked by rocks and cliffs and windswept trees, and one senses that even the brusque air invigorated Marin's work. "He lived . . . on a promontory—a wild wonderful spot—a Marin spot—with the tree at the back of his cottage and the sea in front, and on shelving rocks that went down to the sea. . . . Once I found him painting on the limb of a tree—high up—painting with both hands."[6] The artist was so taken with his surroundings that he acquired a bit of it almost immediately. Stories about the transaction vary. According to Paul Rosenfeld, Marin informed Stieglitz that "$1200 would be adequate support for him and his [pregnant] wife for the year, [then] departed for Maine only to return six weeks later to announce that he'd bought a very beautiful island with the money Stieglitz had given him, the drawback being that there was no water on it." Stieglitz, however nonplussed he may have been, apparently found more money for Marin, who "returned to Maine, and resumed dining off clams and huckleberries, and painting the landscape."[7]

"Marin Island," as the artist called it, was the subject of many watercolors over the years, among them plates 155 and 156. Painted more than fifteen years apart, they vividly embody Marin's shift

155. *On Marin Island, Small Point, Maine,* 1915. Watercolor and graphite on paper, 13¼ × 18½ in. Private collection. R.15.26.

156. *Marin Island,* 1931. Watercolor and graphite on paper, 16 × 21½ in. Aaron I. Fleischman. R.31.21.

from a meticulous delicacy to a broader, more flamboyant approach. In his letters Marin wrote much about the trials of living in Maine: "One fierce, relentless, cruel, beautiful, hellish and all the other ish's place. To go anywheres I have to row, row, row. Pretty soon I expect the well will give out and I'll then be even obliged to go for water and as I have to make water colors—to Hell with water for cooking, washing, and drinking."[8]

Marin's paintings of 1914 and 1915, the years when he was introducing himself to the forms and spaces of Maine, encompass a wide variety of compositions and techniques. They range from rather picturesque vistas such as *West Point, Maine I* (plate 157), to fairly abstract structures such as *West Point* (plate 158) that suggest long-distance views, to intimate examinations—for example, of a mass of vegetation, as in *West Point, Maine* (plate 159), or a high cliff, as in *Ragged Isle, Maine* (plate 160.). These last two exemplify the extraordinary refinement of many of the works from 1914.

West Point, Maine (plate 161) foreshadowed works to come: the distant islands linking sea and sky, the foliage articulated in various schematic ways, the luminously reflecting water—all are elements the artist would return to repeatedly. Fascinating here, too, is how Marin framed the central area of blue water, an early example of the sort of enclosure that he would explore further in his paintings of the following decade. Marin's exuberant sense of discovery was remarked upon when the works were exhibited: "Noticeable, too, is the variety of expression. No formula is discoverable in choice of subject or treatment. Everything speaks of a liberation of spirit, working in harmony with its surroundings and actively alive."[9]

Virtually all of the 1914–15 Maine works are watercolors, except a lone oil dated 1914, *Seascape, Maine* (not in Reich), and a few that are undated but similar in style and size. In the oils many of the forms are delineated by a delicate line scratched into the field of paint, functioning in much the same way that a thin painted colored line does in many of the watercolors from 1914. Worked with great poise, in as rich a variety of colors as the underlying fields, these painted color-lines are reminiscent of the rivulets of paint that formed in the incised lines of some of the 1910 Tyrol watercolors. In *Ragged Island, Maine* the color-lines interact with the broad areas of wash, in great measure for mimetic purposes, although their function goes far beyond mere description. Nevertheless, by actually *drawing* the color-line, rather than having it take form more indirectly, via an incised skeleton, Marin may have become conscious of its descriptive properties, possibly one reason he abandoned this method of working.

There was a profoundly lyrical quality to the meandering line and delicate color of Marin's work during these first summers in his adoptive home. Henry Tyrrell expressed it precisely when he described these paintings as depicting "some enchanted solitude like Prospero's isle in *The Tempest*" rather than "the surging thundering Maine coast of Winslow Homer."[10] This thundering was to come later, beginning in the early 1920s.

Marin returned to Maine in 1915. Thanks to his wonderfully communicative Aunt Jennie, who spent some time with her nephew and his family at Small Point, we have a fairly full description of

157. *West Point, Maine I*, 1914. Watercolor and graphite on paper, 14¹⁵⁄₁₆ × 16½ in. Private collection. R.14.80.

158. *West Point,* 1914. Watercolor and graphite on paper, 16¾ x 19½ in. National Gallery of Art, Washington, D.C.; Gift of John Marin, Jr. R.14.83.

159. *West Point, Maine,* 1914. Watercolor on paper, 19⅝ x 16⁹⁄₁₆ in. Private collection. R.14.93.

°160. *Ragged Isle, Maine,* 1914. Watercolor and graphite on paper, 16⅜ x 19¼ in. The Art Institute of Chicago; Alfred Stieglitz Collection, 1949. R.14.60.

°161. *West Point, Maine,* 1914. Watercolor on paper,
15⅝ x 18½ in. Private collection, Iowa. R.14.98.

the environment and the life-style at Alliquippa House, the guest house where they stayed:

> We do not see much here but wild nature. There is a little sign of life. The sea gulls are quite
> plentiful, the big white ones and black ones that flap their wings and fly away over the water.
> Some are pure white and others are dark. Yesterday was a lovely day but to-day looks as if it
> was just ready to rain again. The weather is so unsettled. It is seldom willing to give us two days
> alike and it generally threatens several days before really doing what it promises. . . . John went
> out painting this morning, the first for this trip.[11]

In two letters written a little more than a week later, Jennie went on to say:

> We have six boarders just now but cannot tell when we shall have a house full or more. . . .
> We are in a house containing about a dozen rooms, all very cheerful. . . . There are very few
> trees near us. The ground is too rocky for very large trees. . . . We sit and watch the tides come
> and go and they are so noticeable here and we are within so short a distance of the water, not
> more than about a hundred feet. The tides must be about fifteen feet. John has a row boat that
> he keeps here. . . . It is a pretty place, but quite lonely. There will be a change of most of the
> people here again to-morrow. There will probably be some new people coming and several are
> going away. It seems quite gloomy to me, as there is so much fog.[12]

Marin clearly didn't find the place gloomy. One suspects, in fact, that he would have been rather
enchanted by the fog. His second visit to Maine yielded some of his most spare, oriental-feeling,
abstract images. Among these are the deep vista *Near Stonington, Maine* and the severely limited in
hue *Tree Forms, Maine* (plates 162, 163), the latter being among a number of highly abstracted
studies of trees painted during the course of the season.

162. *Near Stonington, Maine,* c. 1915. Watercolor and
graphite on paper, 16¼ x 18¾ in. Lydia Winston Malbin
Collection. R.15.29.

163. *Tree Forms, Maine,* 1915. Watercolor and graphite on paper, 16⅜ x 14³⁄₁₆ in. National Gallery of Art, Washington, D.C.; Gift of John Marin, Jr. R.18.61.

Like Marin's New York paintings, the Maine paintings signified the development of an "American" vision. His winter 1916 exhibition, which included not only watercolors but also oils, drawings, and etchings, was acclaimed as being of

considerable importance to those interested in the more individual and vital expression of American Art.... Marin's personality stands forth, healthy and strong, not dependent on the crutches of second-hand inspiration ... [and his art may lead to] some of America's most genuine expression delivered from the shackles of European snobbery and standing on the high pinnacle of personal achievement.... [Marin] in one short year [had] gone far toward conquering many of the deeper concerns of composition.... He has attained to a rhythmic conception of his subject-matter until it has become almost abstract....

164. *Echo Lake District, Pennsylvania*, 1916. Watercolor and
graphite on paper, 19¼ x 16¼ in. National Gallery of Art,
Washington, D.C.; Gift of John Marin, Jr. R.16.13.

165. *Tree Forms, Small Point, Maine,* 1917. Watercolor and graphite on paper, 16¼ × 19½ in. Courtesy of Kennedy Galleries, Inc., New York. R.17.48.

Both Chinese painting and "Cézanne's mental attitude" were invoked by critics in respect to work in which "objects, as such, have almost entirely disappeared, and all that remains is the salient line, or combination of lines, which to him expresses the plastic attraction of his natural inspiration."[13]

Marin's work triggered a great range of responses. Depending on who was writing, it was praised either for its realism or for its abstraction and spontaneity. Two other reviews of the winter 1916 exhibition exemplify the conflict, which continued throughout Marin's career. Forbes Watson's was decidedly mixed:

> On entering the exhibition it is necessary to leave reason behind and surrender to sensation, for logic receives but peremptory treatment at the hands of this artist.... [There is evidence,] in some of the pictures, of confused and undigested ideas which struggle to make themselves coherent. But if you are one who can, even for a moment, give up preconceived ideas, and receive a record of an artist's fleeting color impressions you may enjoy the more spontaneous of Mr. Marin's watercolors.[14]

Henry McBride, by contrast, wrote of the show:

> In almost every watercolor save those that look like Chinese hieroglyphics I get decided realism. It is realism to something rare, subtle, fleeting, dream-like in the actual scene, and facts and

measures have little to do with it. Even the Chinese hieroglyphics I "understand" ... [and] the Chinese feeling they suggest is continued in practically all of the landscapes. ... Chinese art gives one the sense of age, of vast knowledge, of the accumulation of thousands of years of resignation to the difficult facts of life, and to thankfulness, just the same, for the good moments here and there.

Mr. Marin's art seems old, too, this year; much older than ever before. The fact is the whole world is feeling its age at present, and it is no surprise to find one of our most sensitive artists swayed by it.[15]

In 1916 Marin went not to Maine but to Echo Lake, Pennsylvania, in the Kittatinny Mountains, near the Delaware Water Gap. Apparently he found it less visually stimulating than Maine: "Up here, it is woods and more woods smeared over the landscape. Mountains without much character? Until you find it."[16] Finding it, of course, was the challenge of every place. Marin's work of the two previous years had greatly expanded his visual vocabulary; and the notion of abstracting from the landscape rather than trying to describe it had become paramount. The Echo Lake paintings range from full, dense landscapes varying in their degree of fidelity to the site to several in which the overall character is delicate and spare. Exemplary of the latter is *Echo Lake District, Pennsylvania* (plate 164), a centrifugal composition that appears to be based on a garden viewed from above.

The Forum Exhibition of Modern American Painters was held in New York in March 1916 at Anderson Galleries. How broad the definition of "modern" was in this context can be gleaned from the fact that forewords to the catalog were written by both Robert Henri and Alfred Stieglitz, whose views of modernism were nothing if not divergent. Sixteen artists were represented, including members of the Stieglitz circle as well as Charles Sheeler and William Zorach. Each wrote an explanatory note on his work. Marin's illuminates why he returned to the same subject again and again and what he was looking for each time:

These works are meant as constructed expressions of the inner senses, responding to things seen and felt. One responds differently toward different things; one even responds differently toward the same thing. In reality it is the same thing no longer; you are in a different mood, and it is in a different mood.

If you follow a certain path you come to a something. The path moves towards direction, and if you follow direction you come to the something; and the path also is through something, under something and over something. And these somethings you either respond to or you don't. There are great movements and small movements, great things and small things—all bearing intimacy in their separations and joining. In all things there exists the central power, the big force, the big movement; and to this central power all the smaller factors have relation.[17]

This exhibition surely would have reinforced Marin's awareness of the tensions and crosscurrents within the modernist movement, tensions that presumably were instrumental at this time in his pushing his own work to explore several paths simultaneously. There were other conflicts and pressures as well. World War I was under way and of great importance and concern to everyone. Marin's sense of frustration at the madness of it all had earlier been expressed to Stieglitz in a letter

166. *Abstraction*, 1917. Watercolor and graphite on paper, 16¼ × 19¼ in. National Gallery of Art, Washington, D.C.; Gift of John Marin, Jr. R.17.1.

167. *Abstraction*, 1917. Watercolor and graphite on paper, 16¼ × 19¼ in. National Gallery of Art, Washington, D.C.; Gift of John Marin, Jr. R.17.2.

of 1914 in which he confirmed as well his belief in the importance of art in maintaining the eternal truths in such turbulent times.[18]

Marin's paintings of 1917, the year following the Forum exhibition, are pushed toward abstraction, in several directions. In *Tree Forms, Small Point, Maine* (plate 165) masses of color-shapes in a swirling configuration present as abstracted a view of what clearly remains a landscape as Marin was ever to undertake. Other paintings go further still, almost abandoning any reference to nature—for example, *Abstraction* (plate 166); others move toward hard-edge, flattened, nonreferential composition, such as *Abstraction* (plate 167). Never again did Marin veer so far from nature, and one senses that this distancing from the observed site was antithetical to his deepest feelings. At the end of his life, he commented: "The trouble is what the public calls abstraction is that which supposedly has nothing to do with the 'photographic' eye. But what I attempt to do in my own work is to put down objects —a kind of mind-picture in suspended motion—so that when one of my pictures is called *abstract*, it is only because I leave it to the imagination to supply whether what I have painted is a gull, or a ship, or a person. Let the onlooker supply anything he wishes."[19]

°168. *Study of the Sea*, 1917. Watercolor and charcoal on
paper, 16 x 19 in. Columbus Museum of Art, Columbus,
Ohio; Gift of Ferdinand Howald. R.17.39.

°169. *White Waves on Sand, Maine,* 1917. Watercolor, graphite, and charcoal on paper, 15⅞ × 18¾ in. John Marin Collection, Colby College Museum of Art, Waterville, Maine; Gift of Mr. and Mrs. John Marin, Jr. R.17.53.

In 1917 Arthur Wesley Dow published "Modernism in Art," in which he stressed the following characteristics of modern art: Less attention to subject, more to form. Line, mass, and color have aesthetic value whether they represent anything or not. The visual arts should be as abstract as music.[20] Dow's ideas echo in part those set forth by Wassily Kandinsky in *Concerning the Spiritual in Art*. A section of the latter about musical analogies with art had been published in translation in *Camera Work* in January 1912, and a full English translation had been issued in 1914, so Kandinsky's concepts would have been part of discussions within the Stieglitz circle. Whistler's analogies to music would have been well known to them as well.[21]

Marin's work of 1917 suggests that he worked his way through a variety of intellectual pressures that season, among them the ideas expressed by Dow. Another group of paintings with closer ties to nature than his few hard-edge abstractions seems more in line with Marin's temperament. These are seascapes in which "the Seas are piling up on the rocks," to use Marin's description of a similar sight he'd observed two years earlier.[22] Among these is *Study of the Sea* (plate 168), whose jagged rocks and curlicue waves contrast strikingly with the gentle undulations seen in *White Waves on Sand, Maine* (plate 169) of the same year.

Total abstraction was obviously antithetical to Marin's deepest impulses, but his approach to it in the 1917 paintings probably emboldened him to push away from the specifics of landscape and to investigate a wider range of pictorial problems. Marin's friend the photographer Paul Strand (writing about fourteen works by Marin in a 1921 exhibition of American watercolors at the Brooklyn Museum) considered the years between 1908 and 1917 crucial to Marin's struggle "to free himself from Whistlerian and Chinese influences. . . . Relegating 'aesthetic' formula of design, form and organization to their proper place as so much conventional twaddle, he has gone directly to the environment in which he is rooted to the immediate life around him, in a profoundly disinterested attempt to register the forces which animate it."[23] Strand went on to claim that the Marins made all but the Homers and Demuths pale and that "beyond question the greatest watercolorist living anywhere today, John Marin is one of the few whose work is the supreme proof of the actuality of an American painter, of the possibility of American painting."

According to MacKinley Helm, the Marins went to Rowe, Massachusetts, rather than Maine for the summer and autumn of 1918 because the Alliquippa House at Small Point, where they best liked to stay, was filled by the time Marin attempted to reserve room for his family.[24] In 1919 Marin traveled to Maine again, moving farther north and settling in the Stonington–Deer Isle area for the first of several summers. He found the place less intimate than the Small Point area, "not as lovable," at first, although some years later he referred to it as "this place of mine, a village, where clustered about you can see if you *look* dream houses of a purity of whiteness, of a loveliness of proportion, of a sparingness of sensitive detail, rising up out of the greenest of grass sward."[25] It was a year of synthesis in his work, as he explored how to coordinate his commitments to nature and to modernism: "Go look at the way a bird flies, a man walks, the sea moves. There are certain laws. You have

to know them. They are nature's laws and you have to follow them just as nature follows them. The bird soon senses when it has done the wrong thing. The flight is disturbed and the bird immediately counter-balances this disturbance to keep in flight. The bird is at once aware of the broken wing— the artist of the lifeless line."[26]

One aspect of the watercolors of 1919 is Marin's use of shape in a way that integrates its function as hard-edged compartments in the segmented paintings of 1917 with an atmospheric quality that appeared in the works from Rowe, Massachusetts, the previous year (plates 203, 204, 206). The abstract shapes often take their general character from a natural form, such as a tree, that they are surrounding or loosely framing, as in *Deer Isle, Maine* (plate 170). Later Marin's compartments became more expansive, as in *Deer Island, Maine* (plate 172), where the color and shapes establish broader segments that are enlivened by line—lines that are lyrical in the plant forms and dramatic in setting up a movement across the sky. In other works, including *Deer Isle (Birch Tree), Maine* (plate 173), shapes are more directly derived from the landscape and more sharply exaggerated. A similar emphasis on exaggerated shape is evident even in those watercolors whose subject is a deep picturesque vista, such as *Looking toward Isle au Haut, Maine, from Deer Isle* (plate 171), in which a transparent gray wash over the distant landscape bands sets them back and allows the golden

170. *Deer Isle, Maine*, 1919. Watercolor, graphite, and charcoal on paper, 16¹¹/₁₆ × 13⁹/₁₆ in. National Gallery of Art, Washington, D.C.; Gift of John Marin, Jr. R.19.5.

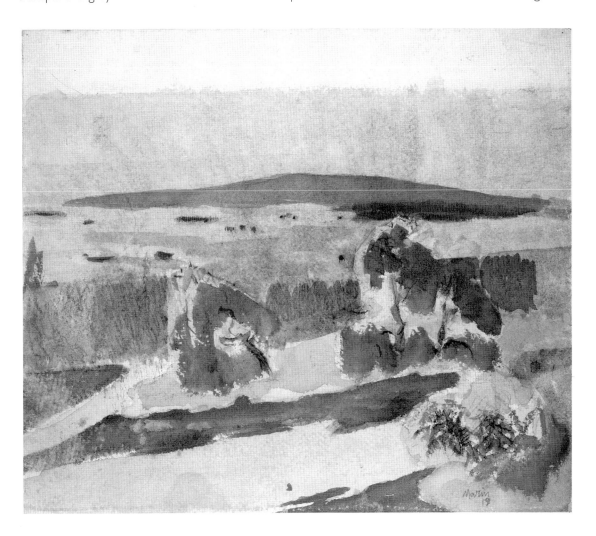

171. *Looking toward Isle au Haut, Maine, from Deer Isle*, 1919. Watercolor and charcoal on paper, 14 × 16½ in. National Gallery of Art, Washington, D.C.; Gift of John Marin, Jr. R.19.23.

°172. *Deer Island, Maine*, 1924. Watercolor, graphite,
charcoal, and colored pencil on paper, 14⅝ × 17⅝ in.
Alfred Stieglitz/Georgia O'Keeffe/Private collection. R.24.7.

173. *Deer Isle (Birch Tree), Maine,* 1919. Watercolor and graphite on paper, 16¹³⁄₁₆ × 13⅝ in. National Gallery of Art, Washington, D.C.; Gift of John Marin, Jr. R.19.4.

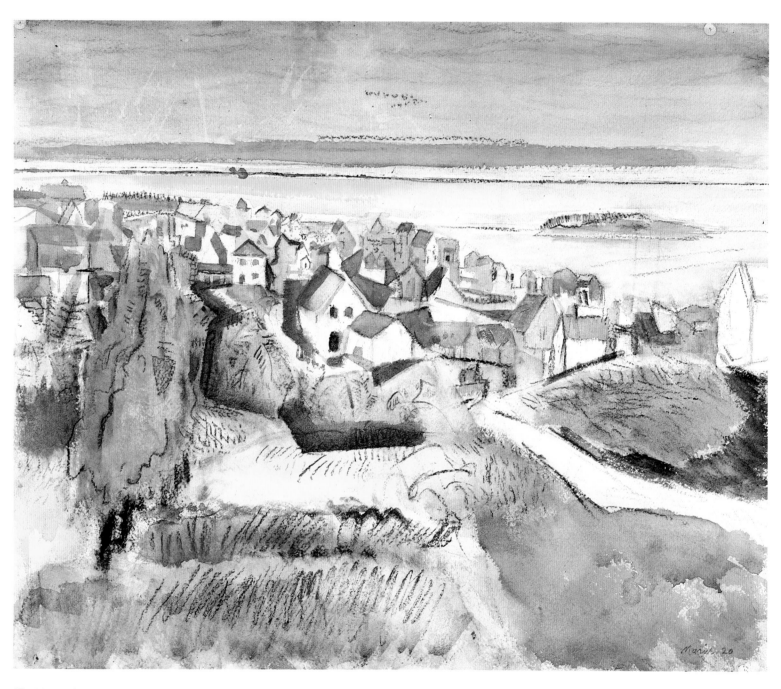

174. *Houses, Stonington, Maine.* 1920. Watercolor, graphite,
and charcoal on paper, 21½ × 26½ in. The Farber
Collection, New York. R.20.9.

foreground to sing. Marin expressed his enthusiasm for the new work in a letter to Stieglitz: "I did something I rather like, a disorderly sort of a thing, I am up on my haunches. I don't know just what to do. I sort of want to raise Hell in my stuff and don't know how to do it properly.... To paint disorder under a big order."[27]

Something else that the Stonington–Deer Isle watercolors introduce is Marin's approach to the town as distinct from the city. The little pointed white buildings are cubic boxes that define space and provide a geometric foil to the surrounding landscape and sea. In many of the Stonington watercolors the town and the water interact, as in *Houses, Stonington, Maine* (plate 174), perhaps a view from Marin's house, which he wrote was "a little higher up the hill than last year so we have better outlooks."[28] One suspects that Marin's examination of the low, tightly packed Maine villages is one of the factors that about this time shifted his attention away from the towers of New York City and onto the streets. Marin himself commented that he was "noticing these village houses more and more this year.... Maybe having purchased a house, I am kidding myself into an interest in houses."[29]

During the seasons Marin spent in Stonington he began the boat paintings that became one hallmark of his work. Even before the turn of the century, shipping had captured his interest, as evident in a sketch of a harbor that is marked by a Marinesque framing border (plate 176). The artist enjoyed reading sea adventures throughout his life, and he undoubtedly liked the fact that his name, in French, meant *seaman*. His love of sailing was reported by Ernest Haskell who, with Marin, "sailed to Ragged Island and Wallace Head—all over Casco Bay we sailed. He believed in sailing.... And now I see sailing, in his pictures of the sea—the very essence of sailing."[30]

In some watercolors, like *Pertaining to Stonington Harbor, Maine, No. 1* (plate 178), a boat is set against active, inhabited surroundings. In others, like *Schooner and Sea, Maine* (plate 179), the vessel

175. Unidentified newsphoto of a sailing vessel, n.d. From a scrapbook in the John Marin Archive, National Gallery of Art, Washington, D.C.; Gift of John Marin, Jr.

176. *Harbor Scene*, c. 1890. Ink wash on paper, 6¾ x 5⅜ in. Private collection.

177. Vintage postcard of Stonington, Maine, n.d. Maine Historic Preservation Commission, Augusta, Maine.

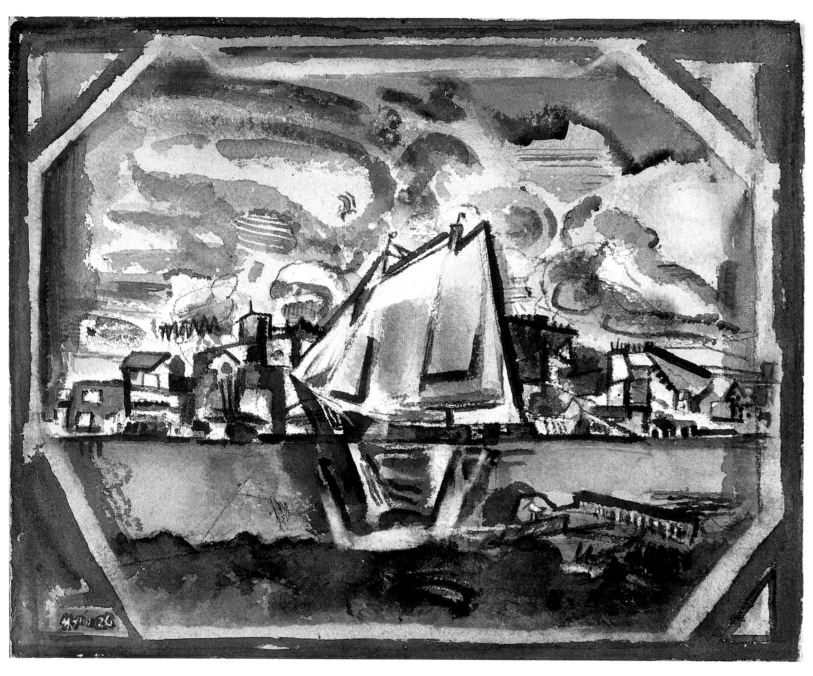

°178. *Pertaining to Stonington Harbor, Maine, No. 1*, 1926.
Watercolor and graphite on paper, 13 x 16¾ in.
Philadelphia Museum of Art; Alfred Stieglitz Collection.
R.26.50.

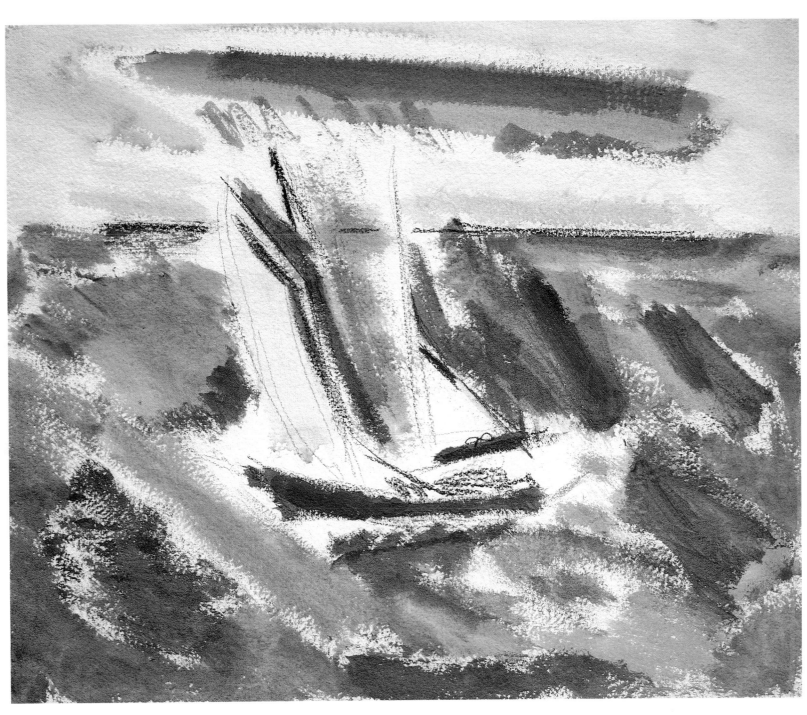

°179. *Schooner and Sea, Maine*, 1924. Watercolor, graphite, and crayon on paper, 16½ x 19¾ in. Dorothy Norman. R.24.44.

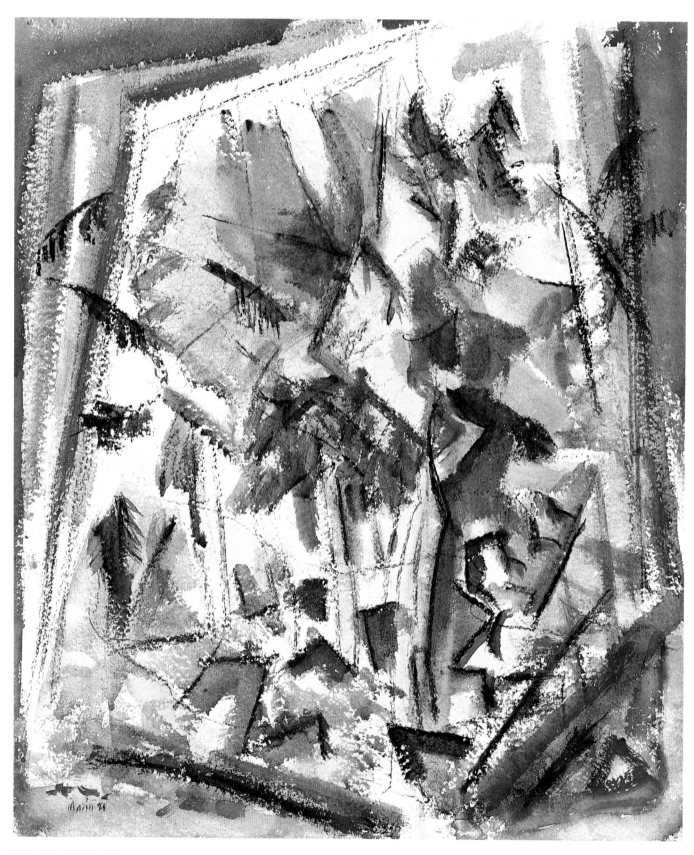

°180. *Woods*, 1921. Watercolor, graphite, and black crayon
on paper, 19½ x 16½ in. Vassar College Art Gallery,
Poughkeepsie, New York. R.21.68.

is more isolated, "lonely and dignified like solitary, self-sufficing individuals." [31] Jerome Mellquist, commenting on *The Little Boat* (perhaps the work by that title now in the Metropolitan Museum of Art, R.14.69), suggested: "Marin *is* that little [boat] out there; the rapt worshipper of nature; the gleeful one; the man whose feeling beats more wildly every time he looks at land or sea or sky." [32] One senses that the boat, especially the boat in stormy waters, functioned for Marin as a metaphor for inner travels, for existence. The lone tree may have signified this as well, and it is a subject of which Marin never tired. Often, as in *Woods* (plate 180), one tree becomes the hub of a complex; in others, such as *The Pine Tree, Small Point, Maine* (plate 181), an isolated example stands for "all the pine trees of our Eastern Coast." [33]

The landscapes from 1915–19 emphasize inquiry, pushing shape to abstraction and exploring ways of schematizing trees, surf, and other components of the landscape. About that time Marin seems to have been seeking new ways to communicate his respect for abstraction as an essential component of modernist thought while maintaining a sense of the landscape. Rather than flattening shapes across the flattened surface, he increasingly explored the activation of pictorial space. Among the subjects he mined were sunsets—what might be called "skyscapes." Between 1919 and 1922, especially, Marin completed several watercolors in which his focus was the flaming rays of the sun, their reflection on the sea, and the island dots that interrupted it. "Fireworks rather than sunlight," suggested Elizabeth Luther Cary, "would seem to be the obvious symbol to use for Marin's pyro-

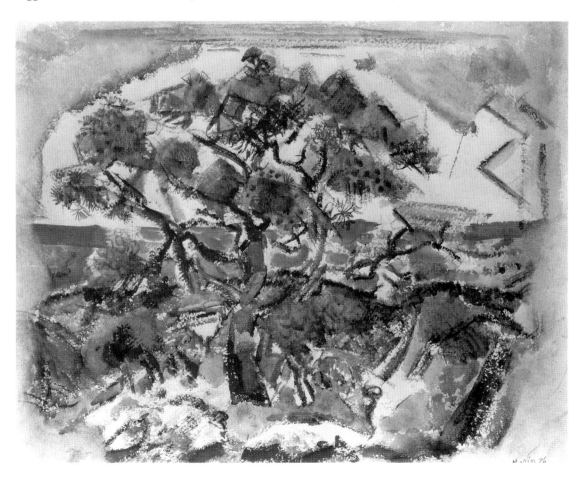

181. *The Pine Tree, Small Point, Maine*, 1926. Watercolor and charcoal on paper, 17¼ x 22 in. The Art Institute of Chicago; Alfred Stieglitz Collection, 1949. R.26.66.

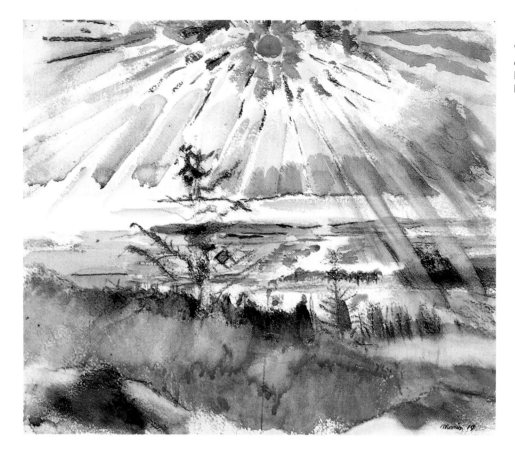

°182. *Sunset, Casco Bay,* 1919. Watercolor and charcoal on paper, 23½ x 26¾ in. Wichita Art Museum, Wichita, Kansas; The Roland P. Murdock Collection. R.19.40.

°183. *Sunset, Maine Coast,* 1919. Watercolor and charcoal on paper, 16¼ x 19¼ in. Columbus Museum of Art, Columbus, Ohio; Gift of Ferdinand Howald. R.19.41

technic later methods."[34] One senses the blinding glare, the dazzling color, the rapidly changing rhythms that Marin tried to capture.

There is a fidelity to the landscape in *Sunset, Casco Bay* (plate 182, formerly in the collection of Georgia O'Keeffe), whereas *Sunset, Maine Coast* (plate 183) was painted with greater abandon, responding more to painterly demands than to nature's. This is the seesaw that continued to characterize Marin's work in all of its phases. His selection of a site seemed to respond to his fluctuating inner commands to portray the site in some instances and to transform it in others. In *Movement, Sea and Sun* (plate 184), with its enclosure strokes all around, Marin appears to have been trying to contain, visually, the intensity of the coastal winds, which were a powerful factor in the sensations of many of his Maine Movements. The sun dancing across the sky, another motif that was to reappear frequently in Marin's art, suggests the passage of time. Perhaps the most coloristically complex of all of the Maine sunset watercolors of the period is *Sunset* (plate 185), with its brilliant sun reminiscent of *The Red Sun, Brooklyn Bridge* (plate 119), probably of the same year, 1922. The painting has a geometric tightness unusual among the landscapes; and enclosure forms lock in the individual elements, emphasizing the trees on the island off to the left and the schooners marching across the horizon.

In 1921 Paul Rosenfeld, writing with characteristic zeal, recognized a new energy in Marin's work:

Fused with the French delicacy, there has come to exist a granite American crudeness. So strong and rough has Marin's water-colour become, that the elders complain he has transcended the natural limits of the medium. What he has done, indeed, is to liberate the medium, and express through the liberation the nature-poetry he feels. . . . Nature is felt in her endlessness, her indifference, her vast melancholy fecundity. The conscious and the unconscious mind interplay in this expression. Flashes of red lightning, pure ecstatic invasions of the conscious tear through the subdued and reticent American colour of the wash. The deep blues and browns become strangely mystic. The realism turns very suddenly, inexplicably, into unrealistic, ghostly expressionistic art. Little complexes of colour, gold and red and yellow, little nucleii of painted jewels, appear poured out of the unknown regions of the mind. One is reminded again and again of Blake, a Blake unliterary and master of his prophetic medium. Nature has given her lover back again to himself, and permitted him·to develop in the strength of his spirit.[35]

Marin continued to alternate between works in which the picturesque prevailed and those in which the air and the space outweighed the trees and rocks. By the early 1920s line took on increasingly important roles, very different from the 1914–15 works, and Marin employed a greater mixture of materials—watercolor (or oil, on the few occasions he used the medium before 1928), graphite, colored pencils, and charcoal or chalk. He tended to work them with great vigor, taking full advantage of the specific characteristics of each medium and often using them in combination. In addition, he would often scratch into the surfaces of his sheets and canvases after they were worked, exposing jagged strokes of white that were every bit as crucial as the broadly painted areas.

One is almost always aware of the weather in Marin's Maine paintings. *Wind, Maine* (plate 187) truly suggests movement caused by the wind. In some paintings, the brilliance of the blue sky, the

°184. *Movement, Sea and Sun*, 1921. Watercolor and
charcoal on paper, 13½ × 17 in. Dorothy Norman. R.21.36.

°185. *Sunset*, 1922. Watercolor, graphite, and charcoal on paper, 17½ x 21½ in. The Eleanor and C. Thomas May, Jr., Collection, Dallas. R.22.105.

clarity of the green water, and the saturation of a patch of red-brown earth on a white sheet may suggest a sunny day. In others, such as *From Deer Isle, Maine* (plate 186), watercolor veils of grayed pinks, violets, and greens cover much of the sheet, suggesting that the landscape is being distilled by the fog. The major forces are linear, denoting tree branches and the peaked-roof boxy houses of the region, but the central subject is mist. The fogs that envelop the Stonington–Deer Isle region materialize suddenly, with an incredible density, and constitute an essential component of the place. *Sea Movement, Green and Blue* (plate 188) presents another set of conditions, more violent than atmospheric, with the distant island sandwiched by turbulence. Deep blues and grays, greens, and touches of browns were scrubbed and rubbed and washed and dry-brushed and then liberally marked with charcoal or chalk to emphasize the intensity of the movement.

Deer Isle (plate 189) of the same year, 1923, suggests a growing impatience with watercolor. The density of the forest and the strength of the trees' shapes seem to be of utmost interest, and the lyrical properties of the medium seem to have dissatisfied the artist, challenging him to find new ways of handling the paint. Having so thoroughly mastered his materials and methods, Marin was surely apt to feel a constant need to reinvent, to force, to do what he had not done before. Working in a medium traditionally associated with delicacy, Marin was creating what he and his colleagues and

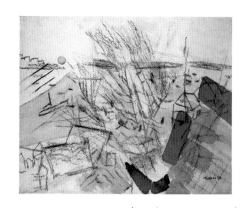

186. *From Deer Isle, Maine,* 1921. Watercolor and charcoal on paper, 13¾ × 17 in. National Gallery of Art, Washington, D.C.; Gift of John Marin, Jr. R.21.19.

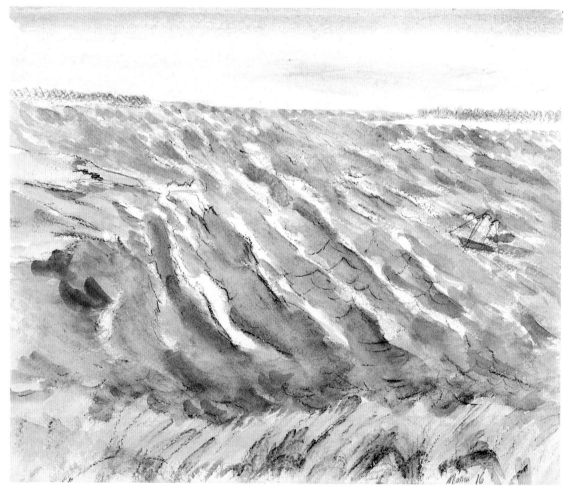

187. *Wind, Maine,* c. 1917. Watercolor and graphite on paper, 16 × 19¼ in. Fred L. Emerson Gallery, Hamilton College, Clinton, New York. R.16.146.

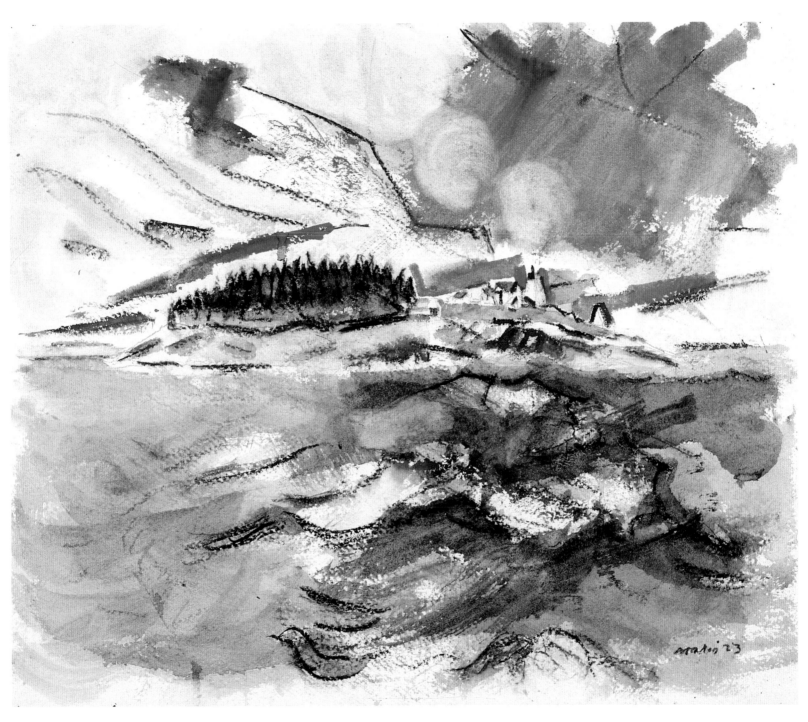

°188. *Sea Movement, Green and Blue,* 1923. Watercolor and
charcoal on paper, 17 × 20½ in. The Art Institute of
Chicago; Alfred Stieglitz Collection, 1949. R.23.63.

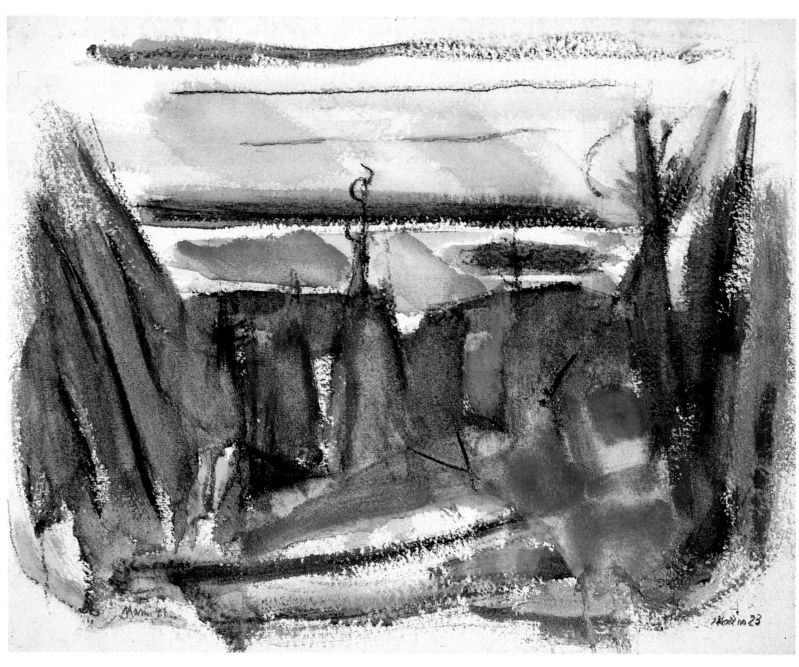

°189. *Deer Isle,* 1923. Watercolor and charcoal on paper,
13⅝ × 17⅜ in. National Gallery of Art, Washington, D.C.;
Gift of John Marin, Jr. R.23.16.

critics saw as a rugged American vision of landscape. His inelegant, "thundering"[36] works of the 1920s were a real breakthrough in this regard. The paint is scrubbed into the sheet, layer over opaque layer: subtle modulations no longer were seen as a primary measure of quality and success in watercolor.

In *Deer Isle,* Marin started rather gently, the evidence being in the gray-violet strokes in the lower register as well as in the delicate tonality visible in the diagonal blue-green and pale orange bands across the sky. Dryly brushed strokes of black in the sky add another charge to the vigorous suggestion of form. The heaviness of the blacks skipping across the sheet vibrates against the paint or the clear paper below. Brilliant strokes of yellow seem to have been applied directly from the tube, a method Marin certainly used later in his oils. Finally (or so it seems) slashes of black chalk were added to provide yet another layer of color, texture, direction, and delineation of stroke, as well as a stronger sense of speed and energy. The painting exemplifies a fusion of the motif and the method—of looking at the landscape and forming the painting. This balance was rarely achieved before Marin's very late work, and the range of his art suggests that most of the time his methodology was to consciously emphasize one aspect or another: now seeking new things to look at; now seeking new ways to capture their essence on paper or canvas.

On the basis of such recent paintings as *Deer Isle,* a prescient reviewer of his 1925 retrospective show at the Intimate Gallery queried "whether Marin might not be flirting with the idea of abandoning watercolor for oil."[37] Marin did indeed begin to concentrate more on oils in the late 1920s, but he never really abandoned anything. Just as he made etchings off and on until the last years of his life, so he continued to work in both watercolor and oil and to draw in a variety of media. His profusion of approaches to both form and materials yielded an art of rich complexity in both attitude and process. On both measures, Paul Rosenfeld wrote extensively. In 1922 he had remarked on the breadth of Marin's spirit; in 1930 he commented quite aptly on the richness of his technique:

> [Marin's] painting is full of daring transitions. The gamuts frequently progress in wild, quick leaps;
> color jumping boldly to its subtle complement. It passes with delightful precipitousness from one
> texture to another. It passes from shaggy surfaces spattered on the paper to satiny rivulets and
> streams; from sensations of roundness to sensations of flatness; from streaks ridged like minute
> mountain ranges to streaks smooth as pond-water on summer nights. The relatively large areas
> of white paper left unmarked add to the instantaneousness and heterogeneity of the color
> relations.... Marin actually scrubs on his paint in scudding rivulets, airy cascades and dithering
> flashes of running color, plotting the curve of quickest motion....[38]

In the early 1930s, as oil painting became an increasingly important medium for Marin's paintings of New York, he used it for many of his Maine landscapes as well. Among them is *Small Point, Maine* (plate 190), in which the artist included many of his favored motifs: islands at several levels of distance, establishing a sense of space; an active and varied sky structure; water that changes as it moves across the canvas, encompassing many colors that suggest changes of current; and trees and rocks painted and scratched into the foreground, represented by Marin's energetic handling of paint.

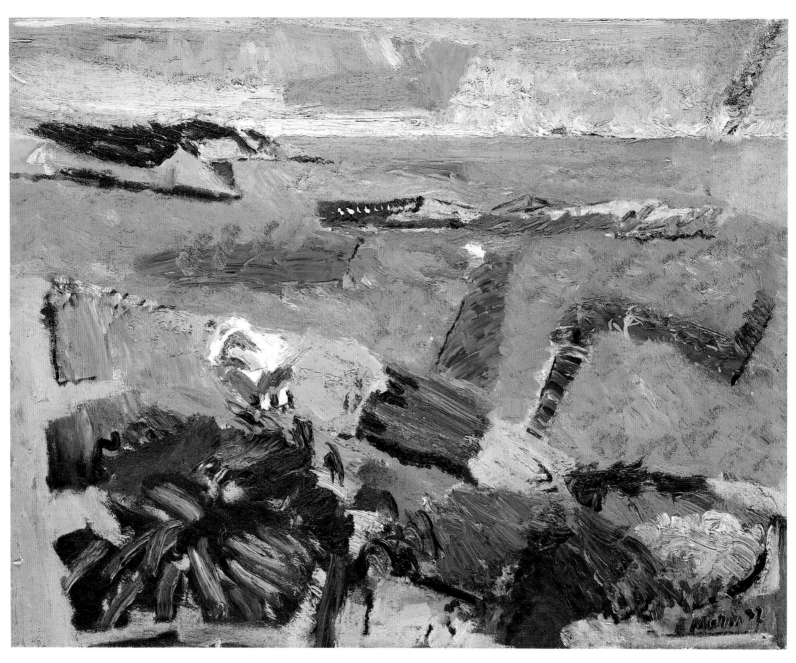

°190. *Small Point, Maine,* 1932. Oil on canvas, 22 x 28 in.
Mr. and Mrs. William duPont III. R.32.43.

191. *Looking out the Window, West Point, Maine,* 1914.
Watercolor and graphite on paper, 19½ x 15¾ in.
Dorothy Norman. R.14.38.

192. *Autumn*, 1923. Watercolor and charcoal on paper, 26 x
22 in. (with mount). Private collection. R.23.2.

193. *Deer Isle, Maine*, 1921. Watercolor and charcoal on paper, 13¹¹/₁₆ × 16¹¹/₁₆ in. Private collection. R.21.10.

One aspect of Marin's art that had become increasingly important beginning in the early 1920s was the artist's attention to the outer edges of his work, his enclosures and frames of various sorts.³⁹ His propensity to control the edges of his work can be traced back to his etchings; he not only emphasized plate edges by leaving a layer of ink on their bevels but also incorporated explicitly drawn margins, as in *Brooklyn Bridge and Lower New York* (plate 37). The 1914 watercolor *Looking out the Window, West Point, Maine* (plate 191) is the clearest example of a painted enclosure to that date. It was not until some years later that others followed in any number. The year 1923 seems crucial. Painted mounts of various sorts date from that year, and a few watercolors still in their original frames have moldings painted by Marin, which he used to extend to the outermost limits the activity generated by the painted mount; see, for example, two 1923 autumn scenes, *Movement Autumn* and *Autumn* (plates 153, 192).

Marin's frames can be divided into three categories: those that appear within the painting itself, those that are part of a mount, and those that are more or less traditional frames. Exemplary of the enclosure lines and designs that constitute a fundamental part of his painted compositions is *Deer Isle, Maine* (plate 193), in which the frame functions virtually as a window. Two less obvious examples may be seen in *Deer Isle, Islets* and *Maine Islands* (plates 194, 196), watercolors that illustrate Marin's notion "that Old Man God when he made this part of the Earth just took a shovel full of islands and let them drop."⁴⁰ In *Maine Islands* these outer strokes have little interaction with the central form—as if a "modern" device had been imposed on a picturesque scene. In *Deer Isle, Islets*, by contrast, the outer strokes work as part of the overall structure. Fascinating, too, is *Deer Isle, Maine, Movement No. 27, Pertaining to Deer Isle—The Harbor, No. II* (plate 199), in which a wavy charcoal line encloses the vignetted and very spare composition of lighthouse and ships.

In the second category, the main composition is attached to painted or other special mounts composed of marginal bands painted onto larger sheets of watercolor paper—for example, the soft gray to black margin in *White Mountain Country, Summer No. 29, Dixville Notch, No. 1* (plate 1). Some more elaborate painted margins on mount sheets clearly take cues for their form and color from the main subject, as is true of Marin's later painted frames as well. Other watercolors are mounted on sheets with painted schemes that seem arbitrary. For example, in *The Little Craft, Maine* (plate 197) a burlaplike woven texture is implied, perhaps a passing reference to a kind of Cubist collage element. Some mounts, either plain or with painted elements, are enhanced by a quarter-inch raised strip of silver board that serves as an inner liner. Another painted strip was often added between the raised one and the physical frame, as in *Movement, the Sea and Pertaining Thereto, Deer Isle, Maine Series, No. 23* (plate 198). Yet other works, starting with some painted as early as the teens, are mounted on wide gold- or silver-leafed mounts of great elegance, which were generally finished with matching half-inch frame moldings in gold or silver, as appropriate. "My gold mat," wrote Marin, "that's a wonder. Why? Because it fights and that within it has got to put up such a fight that neither

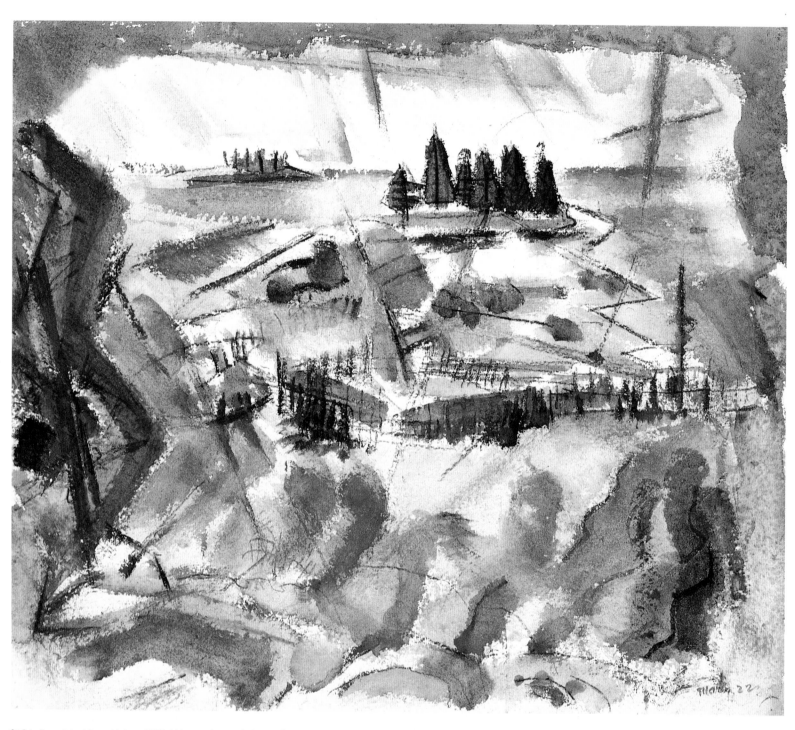

°194. *Deer Isle, Islets, Maine,* 1922. Watercolor and charcoal
on paper, 17⅛ × 20¼ in. Private collection. R.22.7.

one gets the best of it. Someday I'll get me a wall with glaring, hideous wallpaper and try and have my things so that they too will fight the things and not be worsted."[41]

And then there are Marin's frames. Most of these were commercially made and modified by the artist, but there also are many that he constructed himself from driftwood and other found or made elements. The cutout aluminum frame for *Dancing Figures at Seaside* (plate 195) makes clear the lengths to which he would go in presenting even a fairly brief watercolor sketch. Other frames—both red-toned wood, as in plates 153 and 192, and painted white—have painted segments. On several works from New Mexico there are original white frames that were modified either with blue-green or red-brown paint, roughly applied between two narrow, raised bands of the molding. Some frames—for example, those for the 1939 Marin Spring series—were modified by a paper strip laid onto the molding all around (plate 103).

By the mid-1930s Marin's frames were a notable enough aspect of his art to warrant mention by Herbert Seligmann in his note for Marin's December 1933–January 1934 show at An American Place. After commenting on the depths of Marin's response to his subject as he painted, Seligmann went on to say:

195. *Dancing Figures at Seaside,* 1937. Watercolor and graphite on paper with aluminum frame by Marin, 8 x 10⅛ in. Private collection. R.37.8.

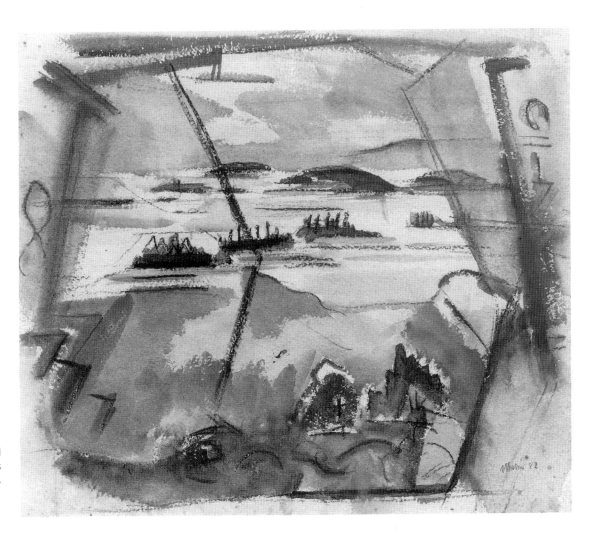

196. *Maine Islands,* 1922. Watercolor and charcoal on paper, 16⅞ x 19¾ in. The Phillips Collection, Washington, D.C. R.22.29.

197. *The Little Craft, Maine,* 1923. Watercolor and charcoal on paper, 11 x 13½ in. (sight, including mount). Dorothy Norman. R.23.70.

198. *Movement, the Sea and Pertaining Thereto, Deer Isle, Maine Series, No. 23,* 1927. Watercolor and charcoal on paper, 21 x 26⅜ in. Private collection. R.27.24.

°199. *Deer Isle, Maine, Movement No. 27, Pertaining to Deer Isle—The Harbor, No. II*, 1927. Watercolor, graphite, and charcoal on paper, 18 x 22 in. Alfred Stieglitz/Georgia O'Keeffe/Private collection. R.27.29.

200. *The Spirit of the Cape: Susie Thompson*, 1949. Oil on
canvas, 28 x 22 in.; with Marin frame. Private collection.
R.49.58.

And so, when at last he came to present these pictures, it was inevitable and a happy movement of genius that he should play in the frames in the same spirit of invention, daring and fertility that he had played with the forces of nature speaking through him in the water colors and oils. Gold and chromium, metals in shining lines and designs, designs of his own painting, even a gold star . . . seemed not alone to frame the pictures but to carry on their lyric illimitably beyond frame, beyond the room, into time and space.[42]

Other critics began to remark on the frames as well:

Marin's recent experiments in adjusting the tone and temper of his paintings to their boundaries have been of great interest, involving the use of materials and punctuations that only a rugged individualist of his type would dare attempt. He has done a neat trick in framing a still-life of a squash [presumably R.36.34] in an arrangement of weathered strips picked off the beach at Cape Split . . . a frame that will have its place in present-day Americana as sure as collectors are collectors.[43]

As the years passed, Marin's frames became increasingly complex. The later paintings became ever more explosive, more calligraphic, with the artist more attentive to an overall quality of surface as well as to the development of spatial activity. As these changes occurred, the frames came to match the canvases in the intensity of their facture. Marin constructed, carved, and painted his frames, including the one on *The Spirit of the Cape: Susie Thompson* (plate 200). In this way, he modified the edges of his images by extending them yet another level, into the world of the viewer. In an interview when the artist was in his eighties, Marin revealed an extraordinary desire to work three dimensionally: " 'If I were younger,' he said, 'I'd plunge into sculpture, but my frame-making will have to satisfy my sculptural urges.' "[44] Marin was doing much more than satisfying his sculptural urges, however. He was exploring yet one more way to satisfy his need for balance:

[A good picture will have] its boundaries as definite as the prow, the stern, the sides and bottom bound a boat. . . . My picture must not make one feel that it bursts its boundaries. The framing cannot remedy. That would be a delusion and I would have it that nothing must cut my picture off from its finalities. And, too, I am not to be destructive within. I can have things that clash. I can have a jolly good fight going on. There is always a fight going on where there are living things. But I must be able to control this fight at will with a Blessed Equilibrium.[45]

°201. *Entrance to Hondo Canyon,* 1930. Watercolor,
graphite, and charcoal on paper, 15½ × 21 in. Private
collection. R.30.11.

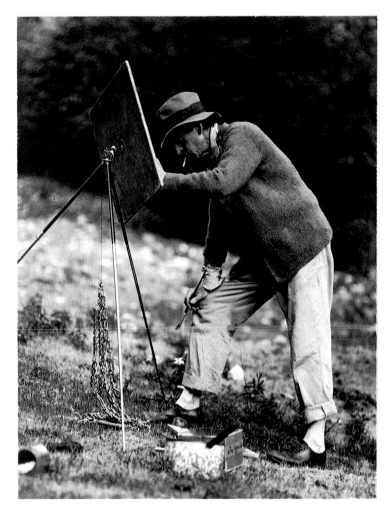

202. Paul Strand, *John Marin at Work, Twining Canyon, New Mexico*, 1930. Gelatin silver print, 4⅝ × 3⅝ in. Private collection.

NEW ENGLAND AND NEW MEXICO

Marin's readiness to grasp the pictorial potential of landscape was hardly confined to his summers in Maine. His work of 1916 at Echo Lake, Pennsylvania, had pushed forward what was at that time his move toward a greater abstraction. Two years later, when the Alliquippa House in Maine was too full to accommodate them, Marin, Marie, and John, Jr., went to the region of Rowe, Massachusetts, in the Berkshire Mountains, an area where Marin had painted before and where he would return several times, if only for brief stops en route to Maine.[1]

During this 1918 summer in the Berkshires, Marin produced a substantial body of watercolors, including some of his largest to date, approximately 21 by 26 inches.[2] Backing off from the hard-edge abstractions he had explored the previous season, in some of his paintings he described or clearly implied the details and nuances of the Rowe landscape. In others he built on the 1917 abstractions, radically modifying forms that signify land, trees, and sky, as in the spare and misty *Region, Rowe, Massachusetts* (plate 203). Sensitive as always to the weather, Marin produced a group of spare atmospheric works in response to the frequent thundershowers that summer. These move

°203. *Region Rowe, Massachusetts,* 1918. Watercolor and
charcoal on paper, 21¾ x 26½ in. John Marin Collection,
Colby College Museum of Art, Waterville, Maine; Gift of
Mr. and Mrs. John Marin, Jr. R.18.40.

204. *Shower*, 1918. Watercolor and charcoal on paper, 12¼ × 15¼ in. Pauline and Irving Brown. R.18.70

205. *Storm Weehawken*, c. 1916–18. Graphite on paper, 8½ × 11 in. Private collection.

to the opposite extreme from the tight shapes of, for example, *Abstraction* from the previous year (plate 167); they are marked instead by loose, often overlapping patches of color. Watercolor was placed over a spare underdrawing, and charcoal additions were made on top. Despite these differences, virtually every move toward abstraction in the 1918 paintings had already begun in some form the previous year.[3] Exemplary is *Shower* (plate 204), one of many works that suggest Marin must have leapt at the challenge to evoke on paper just how the frequent fog and rains and winds that year looked and felt. The sense of relative calm he conveyed in *Shower* is in great contrast to the violence of a storm in Weehawken, possibly rendered about this same year (plate 205).

The Rowe paintings as a group are generally pale in tone and closely modulated. Greens, blues, and oranges predominate, with occasional touches of red. Exceptional in this respect is the highly calligraphic *Rowe, Massachusetts* (plate 206). Given that charcoal is used so extensively in these paintings—far more, for example, than in the Maine seascapes of the previous year—the Rowe paintings function as a sort of watershed; from this point on, Marin's use of many linear media and of linear incising and scraping would be even more important. By pushing abstraction as far as he had the previous year, Marin apparently came to recognize the limits of his desire to separate his painterly interests from the visible world, and in the Rowe paintings he started to reintegrate elements he'd considered pushing aside.

Despite the range and beauty of that summer's work, Massachusetts wasn't where Marin would have chosen to be, at least not early in the season. "This isn't Maine," he wrote to Stieglitz; "I think Maine will see us before the summer's out."[4] This was not to be, but autumn found the artist much happier with his surroundings: "Huge carpetings of color cover the hills. . . . Where I painted yesterday, I was miles from a human. . . . The forests, here, in directions, are vast. Wood roads scarcely any, and those in existence grown over with bushes and alders scattered here and there. . . . Today everything looks fresh. The sky a deep blue with clouds." The artist went on to describe the previous night's "terrific thunder shower," his enjoyment at gathering mushrooms, how he could stay for the winter for just five dollars a month; then he gave an account of his paintings: "As for my work, many ups and downs, fighting out problems, making deductions and then being pulled up on after-thought, and after-sight. But if you do get a little something you like, why that's about all you are entitled to in this life. . . . Suppose I'll have to be trotting along soon. Hate the thought of it."[5] The season had turned out to be a good one for Marin and he craved to discuss his progress with Stieglitz: "I expect, when I get back, to have some long talks with you about art and things in general as, although I don't see things too clearly, I have never seen them as clearly as at present."[6] The Marins stayed in Massachusetts into November and planned to spend the winter in Brooklyn with Marie's sister. Marin took a room for working at 291 Fifth Avenue, though he "had looked to having a real—not exactly studio but a place where I could hang all my pictures and work too."[7] His economic plight put that out of the question.

206. *Rowe, Massachusetts,* 1918. Watercolor and charcoal on paper, 19⅜ × 16¼ in. Courtesy of Kennedy Galleries, Inc., New York. R.18.52.

207. *Bellows Falls, Vermont,* 1923. Graphite and colored pencil on paper, 10⅞ x 8½ in. Private collection.

The following summers were spent in Maine, and worries over where to spend the winter were resolved in 1920 when the family settled in Cliffside. Marin acquired his first automobile two years later, in 1922. Doing so may have been a statement of independence, given the fact that "automobiles and peregrination were not in the austere Stieglitzian picture. However, it shortly transpired that travel in the Ford was presenting Marin with new exciting visual experience...."[8] The artist loved to drive, but he did not enjoy maneuvering through the busy East Coast cities. To avoid them, each year he drove a long, circuitous route to Maine, passing through the Adirondack, Berkshire, and White Mountain ranges.[9] En route, he would stop at various points, on many occasions staying for a number of days in order to draw and paint.

Among Marin's paintings and drawings from these stops are several completed in Vermont in 1923 and in the White Mountains in 1927. The earlier group, completed in Bellows Falls, Vermont, includes dynamic sketches combining graphite and colored pencils in which the artist transformed trees into square boxes and captured the splash of the falls (plate 207). Marin's addition of colored pencils to his repertoire appears to date from this year, and from this point on, he used them in combination with watercolor as well.

The series of watercolors painted in the White Mountains includes dramatic mountain views such as *White Mountain Country, Summer No. 29, Dixville Notch, No. 1* (plate 1) and *Echo Lake, Franconia Range, White Mountain Country* (plate 208), both of which feature broad strokes of dense, dark

°208. *Echo Lake, Franconia Range, White Mountain Country,* 1927. Watercolor, graphite, and charcoal on paper, 18³⁄₁₆ x 21¹⁄₁₆ in. National Gallery of Art, Washington, D.C.; Alfred Stieglitz Collection. R.27.31.

°209. *White Mountain Country, Summer No. 31, the Rapids,*
New Hampshire, 1927. Watercolor, graphite, crayon, and
colored pencil on paper, 17⅛ × 21 in. Munson-Williams-
Proctor Institute Museum of Art, Utica, New York. R.27.51.

mountain stream lunging across the sheet, *White Mountain Country, Summer No. 31, the Rapids, New Hampshire* (plate 209). In it Marin's use of crayon and colored pencil lines to enhance his watercolor washes adds a crispness and clarity.

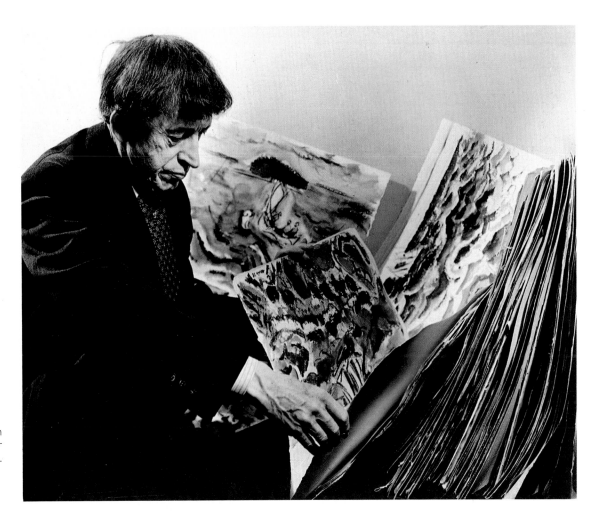

210. Robert Disraeli. *Untitled* (John Marin looking at his watercolors), n.d. Gelatin silver print, 7¼ x 8³⁄₁₆ in. Private collection.

Works based on views from these and other New England sites were among the "batches" that Marin took back with him to New York after most of his working seasons in Maine. There were, in addition, two seasons in the southwestern United States that were pointedly different, and they yielded a body of work of great distinction. During 1929 and 1930, with encouragement from Rebecca Strand, Georgia O'Keeffe, and Mabel Dodge Luhan (on whose estate he stayed), Marin spent several months painting in New Mexico. Driving daily out to one of a large number of sites that interested him, he was once again surprisingly and successfully prolific, even in alien new surroundings.[10] Writing to Stieglitz about his progress the first summer, Marin indicated, "The batch is growing, quite a batch in quantity. In between time I go trout fishing."[11] Describing the place, he continued:

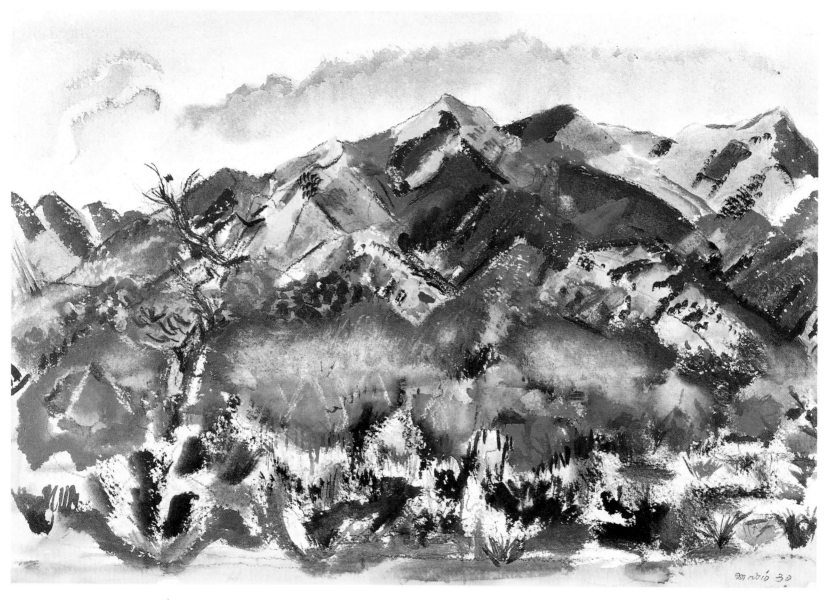

°211. *Autumn, New Mexico*, 1930. Watercolor and graphite
on paper, 15¼ × 22 in. Harvey and Françoise Rambach.
R.30.2.

°212. *The Mountain, Taos, New Mexico,* 1929. Watercolor
and graphite on paper, 14 x 20 in. Private collection.
R.29.67.

The *One* who made this country, this big level seeming desert table land cut out slices. They are the canyons. Then here and there he put mountains atop. Astanding here you can see six or seven thunder storms going on at the same time.

A Sun set seems to embrace the earth.

Big sun heat.

Big storm.

Big everything.

A leaving out that thing called *Man.*[12]

Marin completed approximately one hundred watercolors in the Taos area during his two stays there. As with the work of 1914 and 1915, the years he was first getting to know Maine, the work in New Mexico suggests that he got to know the place by seeking out views of every kind. By now, however, he was almost two decades more experienced than when he had first encountered Maine; in New Mexico he was able to select subjects immediately with a clear and responsive eye. "All my pictures this year will have labels tagged to them, as, this is so and so mountain I'd have you understand, and is, I'd have you understand, so and so feet high. Yes, all labeled with explanations like a *map.* . . . I am sort of laying out spots, places, points of observation, staking claims for future use in case I get my *second wind.* . . ."[13]

213. Paul Strand. *John Marin Fishing in His Hondo, New Mexico,* 1930. Gelatin silver print, 4¾ × 3⅝ in. Private collection.

There was a great variety in the distances of the views he selected and in the scale of the forms; there was also great range in the degree of specificity he used—for example, in describing plant life. Overall, the New Mexico watercolors seem rather meditative and calm; perhaps the heat of the sun slowed the artist's gestures. The colors are distinctive, dominated by certain browns and oranges and muted blues and greens, much deeper and richer than those of the Rowe series. While there is an evolution within the body of work, there are few characteristics that can be attributed solely to the works of one year or the other. Some of the 1930 paintings, such as *Autumn, New Mexico* (plate 211), do seem much more variously worked than any from the previous year, but most of Marin's main concerns spanned his two seasons in the region.

The Mountain, Taos, New Mexico (plate 212) is perhaps one of the earliest of the New Mexico watercolors. Embedded within it are memories of the dramatic White Mountain paintings of two years earlier. His recall of the mountains' shapes and scale reinforced the effect of the spaces and colors he was discovering in New Mexico. Marin discovered by working new ways of looking at the new place, rooted in what he already knew. *The Mountain, Taos, New Mexico* is among the most dramatic of all of Marin's frontal mountain landscapes, pressing itself to the surface of the sheet. It confirms one critic's delight in Marin's ability in general to grasp that "the chief artistic fact about mountains, next to their color, is their height—their loom, and the awe with which their loom impresses the eye of the beholder. So he makes them loom tremendously and one gets a glad, awed sense of height."[14]

Quite different from *The Mountain, Taos, New Mexico* is the frontal mountain autumn scene of the following year (plate 211), in which form is considerably more contained, the visual frame of

°214. *On the Road to Santa Fe, New Mexico,* 1929.
Watercolor and graphite on paper, 15 x 20 in.
Mr. and Mrs. Rollin W. King, Dallas. R.29.43.

°215. *Stream, Taos Canyon, New Mexico*, 1929. Watercolor and graphite on paper, 14 x 20 in. The Jan Perry Mayer Collection of American Works on Paper, Denver. Not in Reich.

216. *New Mexico*, 1930. Watercolor and graphite on paper, 13½ x 16⅝ in. The Michael and Dorothy Blankfort Collection. R.30.33.

reference is deeper, and the facture (as noted earlier) is far more complicated. Touches of brilliant color are evident throughout the mountains, in contrast to the patterning of dark and light neutral hues that dominates the foreground. In some places paint is quite opaque, scumbled on, scraped out, the surface being heavily worked; in others, transparent watercolor is freshly washed in. The depth of the place and the surface of the sheet are given equal attention simultaneously.

A work from Marin's first year in the region presents an entirely different sort of view from the two tightly constructed and fully painted mountain views. *On the Road to Santa Fe, New Mexico* (plate 214) is composed of dots of color loosely painted with great diversity, at times almost hurled across the surface to express the vastness of the region. Marin paid attention not only to the desert growth, but also to the distances leading back to the hills: "Miles upon miles of level stretches covered with sage brush—with here and there a drop of a few hundred feet that would be a canyon—After that you proceed with the levelness again."[15]

Suggesting both the vast scale and the enormous complexity of the landscape are many works such as *Stream, Taos Canyon, New Mexico* (plate 215). The lushness of the desert is beautifully conveyed by the subtle tonal washes, which create a multitude of spatial shifts. Attention is given to the details of the foreground as well as to the distant canyon walls, depth being established by a shift in the scale of the markings. Much of the surface activity results from Marin's use of a fairly dry brush, which allowed the white of the sheet to flicker through. The sense of enclosure, especially at the right, and the interaction of the enclosure with the shifting diagonals throughout exemplify the dynamism of Marin's work during this period at its most successful. *New Mexico* (plate 216) presents the equivalent of a detail of *Stream, Taos Canyon, New Mexico*. Its unusually compressed view of trees and bushes is visually squashed against the surface, with a plunge into deep space beyond. The rounded fingerprint-blobs establish a radical scale contrast to the larger circular foliage forms. It also features elements seen in many of the other New Mexico watercolors, especially the use of dots and dashes overall and the strokes zigzagging across the sky, which echo the zigzag enclosure along the bottom.

Marin's growing interest in the figure took form in a few of his New Mexico paintings, notably *Dance of the San Domingo Indians* (plate 217), painted from memory. He would drive as far as a hundred miles to observe these ceremonial events: "A big Indian dance I attended—I feel my greatest human Experience—the barbaric Splendor of it was magnificent. The movements within movements are swell—and it kept up for hours."[16] After seeing the "great San Domingo dance" the following year, Marin wrote to Stieglitz that he didn't feel like painting it at all; indeed, he was considering tearing up the painting based on the previous year's experience (fortunately for those who have come to admire it greatly, it was safely stored away).[17]

In *Dance of the San Domingo Indians* symbolic geometric patterning associated with the native American art of the region serves as an inner framing structure, enclosing figural activity of far greater complexity than in New York scenes of the period. Indeed, in terms of its large number of

217. *Dance of the San Domingo Indians,* 1929. Watercolor and charcoal on paper, 22 x 30¾ in. The Metropolitan Museum of Art, New York; The Alfred Stieglitz Collection, 1949. R.29.10.

participants, the painting is arguably the most complicated figure composition Marin was ever to undertake. Although the artist was somewhat more meticulous with the details of figures here than he tended to be with those of the foliage in the New Mexico landscapes, the bands of horizontal activity echo the landscape compositions: in its overall distribution of form in a receding space, the painting is not unlike many others of the season.

Several of Marin's letters speak of New Mexico storms, which inspired two of his most powerful storm paintings: "You can see six separate thunder storms taking place at the same time.... In wet weather you keep in the ruts or you'll slide all over the place—and contrary to the usual—this has happened often for it has rained 50 *some* days the past two months."[18] In *Storm over Taos* (plate 218) Marin employed weighty diagonal slabs to suggest the fierce rains and lightning. The other of the great storm paintings, *Storm, Taos Mountain, New Mexico* (plate 219), was probably done later; the forms are generally more schematic in conception, with a strong geometric pull. It moves further from its immediate source than *Storm over Taos,* and a movement away from the subject was often Marin's tendency when he made several related versions of a single theme.

By the time Marin arrived in New Mexico the unique beauty of the area had already attracted many artists.[19] John Sloan had traveled there from New York, as had Stuart Davis and Marsden Hartley. At the time of Marin's visits, there were many other artists working in the region, not only his friends Georgia O'Keeffe, the Strands, and Andrew Dasburg, but also B.J.O. Nordfeldt, Ward

Lockwood, Victor Higgins, and others. It is interesting to speculate why Marin never returned after 1930. For one thing, he clearly missed the sea: "Yes, back to the Atlantic—," he wrote to Stieglitz in the summer of 1929, "if this place and it were only 50–100 miles apart."[20] Another possibility is that the loner in him, that characteristic that pulled him away from the hubbub of New York each year, instinctively rejected participation in so large a community of artists outside the city. Yet another possibility is suggested by *Entrance to Hondo Canyon* (plate 201). Highly developed, both spatially and in its surface modulations, it conveys the varying light on the hills and the richness of the area's vegetation. Hovering patches of repetitive markings tell of angles and crevices and hillocks off in the distance. The sky is marked by Marin's schematic blocks suggesting areas of clouds. This incredibly beautiful but highly controlled watercolor, completed in 1930, points to the possibility that Marin may have found this particular sort of grandeur daunting and restrictive in comparison with what he'd found in Maine—certainly no less impressive, but very different in its forms.

The New Mexico watercolors were much admired in the region, according to Mabel Dodge Luhan, who reported to the artist, "Everyone stands in front of your picture and *all say* you are the only person who has ever done this country at all."[21] When they went on view at An American Place in 1931, critics admired them too. Ralph Flint wrote: "[Marin] is a master way beyond his time, possessing an almost sculptural solemnity and grandeur in his pictorial approach to the world about him, having a certain sumptuousness of outlook that is akin to that of an extraterrestrial patterning that has no other accounting for.... [The New Mexico watercolors] range in mood and manner from the tenderly lyric to the overwhelmingly torrential. Marin says they are the last watercolors he is going to do."[22]

Clearly he changed his mind. Marin painted watercolors for the rest of his life, showing them for the next two decades at An American Place. When this last of Stieglitz's exhibition spaces opened in December 1929, the very first exhibition was a retrospective of Marin's work, rather than a display of only his recent New Mexico paintings. While this may have reflected some lack of enthusiasm for the new work on Stieglitz's part, it more likely reflected his eagerness to celebrate this latest venture with an exhibition of the more familiar Marin: "The latest Marin show is doubly exciting, being hung perfectly in a gallery designed for him and O'Keeffe.... The visitor will, perforce, see only the pictures... you open the door and there before you are the forty-seven new Marins blazing in your eyes."[23]

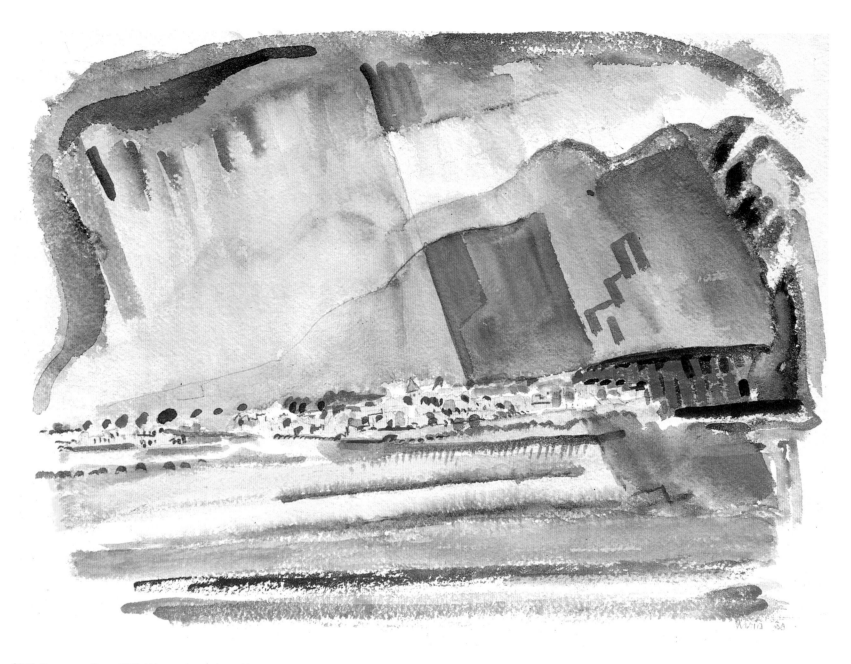

°218. *Storm over Taos*, 1930. Watercolor and graphite on paper, 15 x 20¹⁵/₁₆ in. National Gallery of Art, Washington, D.C.; Alfred Stieglitz Collection. R.30.57.

°219. *Storm, Taos Mountain, New Mexico,* 1930. Watercolor, graphite, and charcoal on paper, 16¾ x 21⅜ in. The Metropolitan Museum of Art, New York; The Alfred Stieglitz Collection, 1949. R.30.58.

°220. *Grey Sea,* 1938. Oil on canvas, 22 x 28 in. National
Gallery of Art, Washington, D.C.; Gift of Mr. and Mrs. John
Marin, Jr. R.38.14.

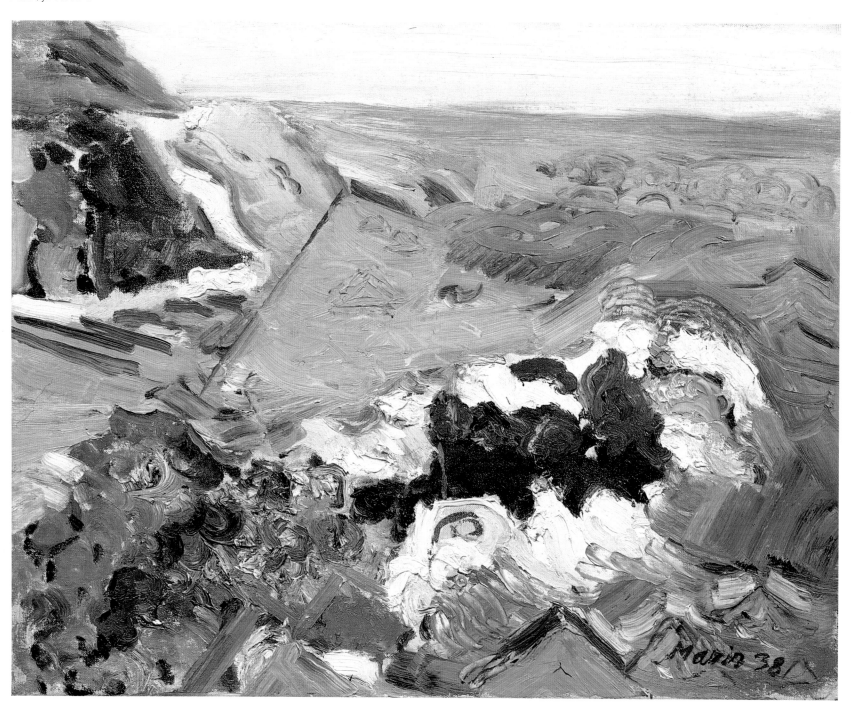

221. George Daniell. *John Marin on His Porch, Cape Split, Maine,* 1952. Gelatin silver print, 8 × 10 in. Collection of the photographer.

THE SEA

In 1933 Marin, then approaching the age of sixty-three, spent the summer at Cape Split, Maine, for the first time, at the urging of Herbert Seligmann. This site was farther north and east and required several more hours of travel to reach than his earlier stopping places. The paintings he did that year suggest that the artist must have felt an immediate surge of empathy—a sense of being at home again—similar to what he had experienced on his first visit to the Casco Bay area almost two decades earlier. Far less settled than either the West Point–Small Point or the Stonington–Deer Isle areas, Cape Split juts into Pleasant Bay. Even today the population of the region is sparse, and it is far off the routes normally traveled by tourists. Getting there requires some determination, and certainly in Marin's day, with many dirt roads, it must have imposed the demands of a pilgrimage.

On the strength of the success of that first summer, in 1934 the Marins bought a cottage at the cape; one senses from the work that ensued that Marin had found his spiritual home, one that affected him deeply even during his months spent in Cliffside. The Maine cottage was set out on the rocks, with the sea perhaps twenty-five feet from the doorstep. Sitting on the open porch where the artist often painted, one has the sense of being in a boat rather than on land. "Here the Sea is so damned insistent that houses and land things won't appear much in my pictures."¹ Sheep Island,

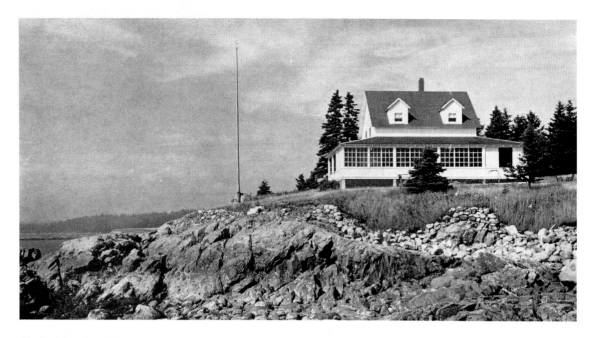

222. Herbert J. Seligmann. Marin's house at Cape Split, n.d. Private collection.

Eagle Island, and Norton's Island do dot the view, however, interrupting the horizon. On a clear day the Tunk Mountains are visible off in the distance.

Marin immersed himself in the life there:

> He loved to pick highland cranberries on the Maine islands nearby, Outer Sand Island, Flint Island, Nortons. He filled his hat with the ultramarine blueberries coloring the great blueberry barrens that undulate at the top of the world with only the distant blue mountains for the sky to rest on. Seals and porpoises swam past his door, fish hawks dived with a resounding splash in his oceanic dooryard and flapped out of the water to go lumbering to their nests, their talons clutching fat flounders. . . . Many a night he sat in the kitchens of neighbors, smoking, gossiping, swapping stories of storms, of deer and moose, of bears and partridges and wild duck. In his earlier years he walked long stretches through wild country in the mountains, he bathed in and rode over the sea in small boats and became part of his world in the way primitive men, old hunters and sailors do.[2]

Among the Marins' closest neighbors were Bill and Susie Thompson; as the summer approached, the artist would write to one or the other of them, requesting that they ready the house for his arrival. Sometimes he was quite specific with his instructions: "Will you have house cleaned as usual back house cleaned as usual spring house cleaned as usual Can you have boat fixed so she don't leak and put in water and have grass cut can you see to it that some loads of gravel be put on road if necessary. . . . p.s. try to get some wood."[3] At other times he was more lighthearted, and rather amusing: "If you will grab the place up and give her a hair cut—wash her face—hang her upon the line to dry—and such things as should be done for her I'll be—ever and plenty—obliged so here's to you—your dearly beloved—the Spirit of the Cape—"[4]

Marin's impassioned response to the sea didn't begin with his move to Cape Split, of course.[5] In 1917 he had done, among others, that extraordinary view of waves crashing against the rocks along the Casco Bay, *Study of the Sea* (plate 168), in which the rhythmic forces of nature are the primary subject. *Sea, Dark Green and Yellow* (plate 223), from four years later, is as abstract and explosive as

°223. *Sea, Dark Green and Yellow*, 1921. Watercolor and charcoal on paper, 16 × 19 in. (sight). Harvey and Françoise Rambach. R.21.46.

°224. *Off York Island, Maine,* 1922. Watercolor and charcoal on paper, 16¾ x 20¼ in. (sight). Williams College Museum of Art, Williamstown, Massachusetts; Gift of John H. Rhoades. R.22.86.

any seascape before the late calligraphic works from the end of Marin's life. Swirling black-green strokes rhythmically hug the surface while the energy of the sea—set out in grays and violets and greens—is aggressively channeled among them.

Throughout the 1920s Marin would periodically focus on the sea rather than on the rugged Maine landscape or its picturesque towns. In 1922 he completed several watercolors titled *Off York Island, Maine* (plate 224), in which a wave in upheaval takes on a mountainlike form, pressing against the rocks and framed by the sky and sea. A rich black-violet separates the white wave and dark rocks, emphasizing the impact of their collision. This version of the subject (formerly in the collection of painter Katharine Rhoades, a close associate of the Stieglitz circle) has a charcoal sketch on its verso, which reveals Marin's initial approach to his composition (plate 225).

225. Verso of *Off York Island, Maine*, c. 1922. Charcoal on paper.

Four years later, on one of those gray days along the coast, Marin painted *Deer Isle, Maine* (plate 226), a monochromatic view from the rocks that in its composition anticipates the format of Marin's later seascapes. Horizontal bands structure the piece, which also has a range of enclosing edges: zigzag at the bottom, clearly delineated at the left, hovering heavily at the top of the sheet, and softly holding in the forms off to the right. Most fascinating are the choppy, schematic diamonds that signify the patterns of light on the water—large ones in the foreground and smaller, more tightly structured ones above. In this way Marin suggested a variation in the currents of the sea. This kind of shorthand had been part of Marin's art for years, but it has an unusually powerful authority here.

Another gray sea is suggested in the watercolor *A Southwester* (plate 227), painted in 1928, the year Marin began working in oil again; perhaps that change in medium contributed to the use of broadly brushed areas of subtle color. It is as abbreviated as *Deer Isle, Maine,* but gentler, suggesting that the storm is just beginning.[6] Geometric divisions organize the composition and impose an unusually calm order: there are three broad strokes, virtually equal in length, suggesting islands on the horizon, with a land mass at left center that juts in just about halfway across the sheet and is echoed by the confined area of gray water below it. The bands across the bottom maintain the balance, filling a centralized space on the sheet. Its order puts it at the opposite pole from another work of the same year, *Related to Brooklyn Bridge* (plate 123), with its explosive composition. Fascinating is the bowl-shaped frame, with its angled neck at the left countered across the sheet by a straight edge. Whether Marin was actually painting a view from an enclosure, as in his 1914 *Looking out the Window, West Point, Maine* (plate 191), or more likely, arbitrarily enclosing a slice of the view, is unclear.

A more rugged handling of paint came into play in the watercolors after Marin renewed his interest in oil. In *Speed, Lake Champlain* (plate 228)—painted when the artist spent some weeks in the Lake Champlain region in 1931—there are strongly scratched and incised areas and others that are roughly rubbed and abraded. They suggest that Marin was working with a physical vigor even greater than his norm in this medium. This title is apt, for speed seems indeed to be the subject of

°226. *Deer Isle, Maine,* 1926. Watercolor and charcoal on
paper, 14¹⁵⁄₁₆ × 17½ in. National Gallery of Art,
Washington, D.C.; Gift of John Marin, Jr. R.26.15.

°227. *A Southwester*, 1928. Watercolor and charcoal on paper, 17¼ x 22½ in. Mr. and Mrs. Meredith J. Long, Houston. R.28.1.

°228. *Speed, Lake Champlain*, 1931. Watercolor, graphite,
charcoal, and ink on paper, 23⅞ x 28⅞ in. Munson-
Williams-Proctor Institute Museum of Art, Utica, New York.
R.31.42.

this work. "This *Inland Sea* can be quite a person—can kick up quite a rumpus . . . can misbehave quite some—can surely get up speed—."[7] It is among the first of Marin's watercolors in which an independent calligraphic scheme—swirling lines, especially in the sky but active in the water as well —is a highly developed component.

By the time Marin settled in Cape Split, the sea was paramount among his motifs. Moment by moment, day by day, season by season, year by year, he continued to chart the changes that took place in the bay outside his house and throughout the surrounding area. Portraying the sea in all of its moods—calm or violent, gray or filled with color, luminous or leaden—he created an extraordinary record of what must be one of the most beautiful places in the world.

Particularly somber, and emblematic of Marin's symbolic use of the sea, is *Dead Trees and Sea* (plate 229) of 1934, the year he purchased his Maine home. Against a flattened, framing sea are set the dead tree and an implication of a lone sailing vessel, composed of three short lines reaching toward the horizon (both meld with the sea). The outer frame is composed of sky above, schematic water at the sides (with a further tree implied at the right), and the land marked by a line of boxes below. To what extent the sea symbolized death—or the womb, as seems to be the case in many of Marin's later seascapes that incorporate groups of nude women—is not a subject the artist ever addressed directly in his letters or published writings. It seems clear, however, that part of his

229. *Dead Trees and Sea,* 1934. Watercolor and charcoal on paper, 15 × 20 in. Courtesy of Kennedy Galleries, Inc., New York. R.34.4.

immediate connection to Cape Split, where the surrounding bay became a central factor in his life, may have come from an intuitive sense of the symbolic possibilities these surroundings suggested for his paintings. Starting in the early 1930s several paintings address issues of symbolic fantasy—for example, *Young Man of the Sea (Maine Series, No. 10)* (plate 230) and *Women Forms and Sea* (plate 231). During his very first summer at Cape Split, Marin wrote: "The Country is filled with ANGELS. . . . Fall is upon us and I was thinking of painting a summer picture with real angels in it— females in there [their] altogether—as God or someone else made them. . . . My clothesless ladies are so camouflaged with the landscape or seascape—that before found by the Society of Angels —they can put their clothes on."[8]

Breaking Sea, Cape Split, Maine (plate 232) is perhaps a more typical response to the sea by Marin, though it is distinctive in its limited palette, relating closely to several sumptuous neutral gray-green oils from 1938 (for example, plate 220). As much as any watercolor of the period it shows the effects of Marin's investigation of oils. Worked throughout with a broad stroke, it conveys a sense of the weight apparent in the oils of the late 1930s. There is a feeling of scrubbedness in places, and the white sheet is active primarily in the waves, not flickering through overall as it often does in more transparent watercolors. In the even distribution of its composition, with no confining structure at the edges, *Breaking Sea, Cape Split, Maine* seems to have grown from the oils of the previous year.

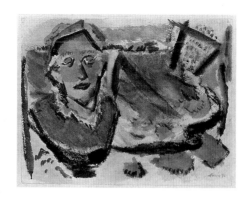

230. *Young Man of the Sea (Maine Series, No. 10)*, 1934. Watercolor and graphite on paper, 15⅜ × 20½ in. The Metropolitan Museum of Art, New York; The Alfred Stieglitz Collection, 1949. R.34.36.

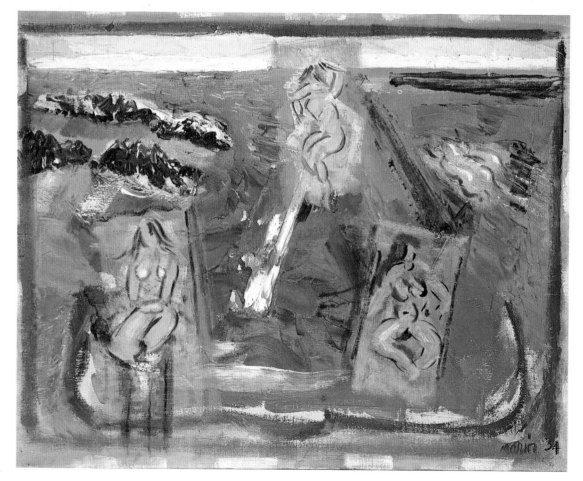

231. *Women Forms and Sea*, 1934. Oil on canvas, 23 × 28 in. Private collection. R.34.34.

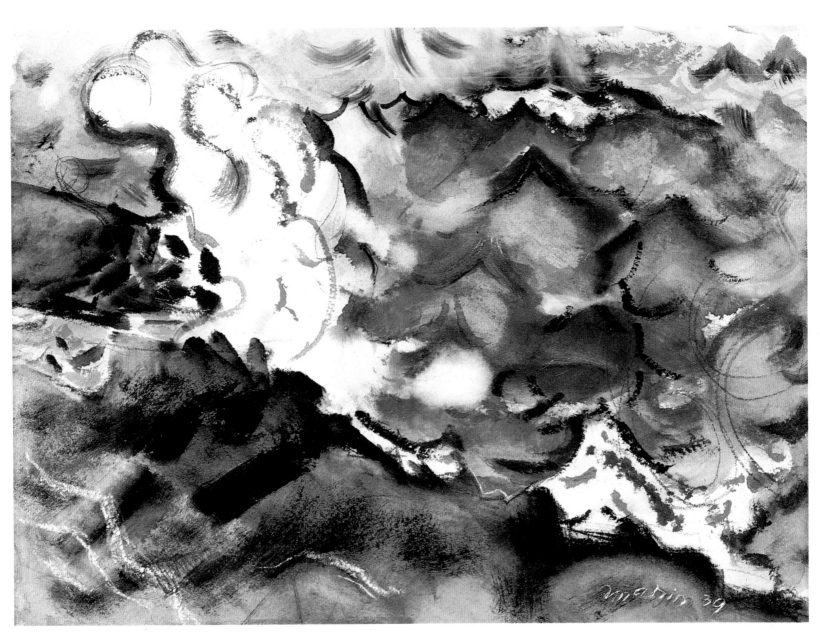

°232. *Breaking Sea, Cape Split, Maine,* 1939. Watercolor, graphite, and charcoal on paper, 15½ x 21¼ in. Sid Deutsch Gallery, New York. R.39.7.

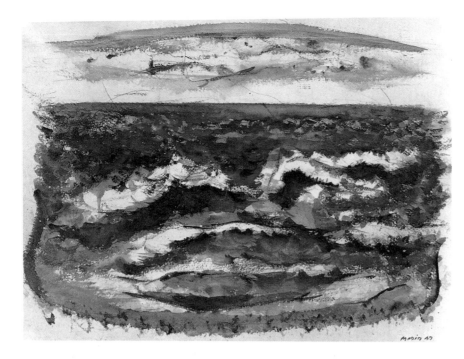

233. *From Flint Isle, Maine—No. 1*, 1947. Watercolor and graphite on paper, 15⅛ × 20⅜ in. Corcoran Gallery of Art, Washington, D.C.; Gift of the Women's Committee. R.47.10.

From Flint Isle, Maine—No. 1 (plate 233) exemplifies another shift in Marin's use of watercolor during the last decades of his life, when he was giving equal emphasis to working in watercolor and oil. It is composed of dabs of paint, broadly and often opaquely applied—layered, in fact, much as he had been doing in oil. During the late 1940s, when this was painted, many of Marin's seascapes incorporated an energetic calligraphy. However, he continued to work in other ways, painting seascapes such as this in which the potential for calm imposed by a strong horizontality is disrupted by the intense color activity across the plane. Here the vigorous handling of paint and the touches of warm color work in ways that recall an earlier oil, *Off Cape Split, Maine* (plate 238).

Marin's extremely seductive watercolors of the sea suggest the range of his formal interests during these years. But it is the oils of the 1930s that expand our understanding of Marin's painterly panache. Early in the decade many of the oils of Maine subjects, such as *Small Point, Maine* (plate 190), coordinated aspects of land and sea. As early as 1931, however, the lonely sea—that is, the sea if not alone then clearly dominant—had become one of Marin's major subjects, and it was to remain so for the rest of his life.

Small Point Harbor, Casco Bay, Maine (plate 234) is especially beautiful, showing Marin's enormous pleasure in the manipulation of paint, layered to build a dense impasto. It is a landmark image in other ways, too, as it is certainly among the earliest examples in oil of Marin's use of broad diagonal bands and rectangular boxes that hover in space—hovering that has been referred to as "cubist structure"[9] but seems to have nothing at all to do with Cubist ordering of form. Marin's use of these elements, which flatten painterly space and set up a rhythmic activity across the surface, seems to suggest a symbolic approach in which specific floating forms signify atmosphere, suggesting the weight, importance, and shifting activity of water and sky.

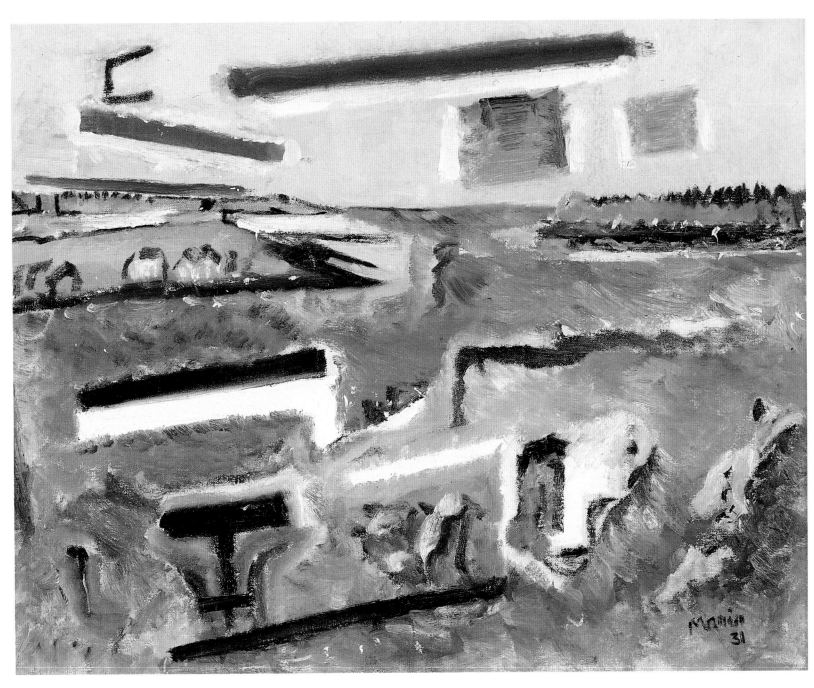

°234. *Small Point Harbor, Casco Bay, Maine*, 1931. Oil on canvas, 22 × 28 in. Montgomery Museum of Fine Arts, Montgomery, Alabama; The Blount Collection. R.31.41.

°235. *Wave on Rock,* 1937. Oil on canvas, 22¾ x 30 in.
Whitney Museum of American Art, New York; Purchase,
with funds from Charles Simon and the Painting and
Sculpture Committee. R.37.29.

It is not certain that *Small Point Harbor, Casco Bay, Maine* was among the paintings on view at An American Place in 1932; if so, it surely would have been among those that so affected a visitor to the show, as Henry McBride recounted in the *New York Sun:* "[A painter visiting An American Place] looked with compunction on the [oils] that defied successfully so many of the rules. 'If only I could have seen some of these last summer,' said he, 'I would have had the nerve to do something like this myself.'"[10] McBride himself was taken with the new work and added an amusing comment about modern composition:

> In the new Marin pictures . . . the artist takes a theme and plays it up so dancingly that you almost
> hear the air to which it moves, but the color tones are the tones that drip with sea moisture, if it
> be a sea picture, or with city tenseness if it happens to be a city picture . . . there are, it is true,
> some high-handed cryptograms in the way of foreground bluffs to the ocean pictures, but you
> know, if you have had any experience at all with modern art, that foregrounds are merely things
> to be looked over.[11]

236. *Untitled (Woman on the Beach with Sea Creatures),* c. 1940. Ink on paper, 7⅝ x 10¹¹⁄₁₆ in. Private collection.

In contradiction to McBride, Marin surely made it difficult to look over the foreground of *Wave on Rock* (plate 235), though it is difficult to determine and lock in its specific spatial locations. It is useful to compare *Wave on Rock* with Marin's *Off York Island, Maine* watercolor (plate 224) of fifteen years before. Such a comparison makes it readily apparent why Ralph Flint, writing the same year that *Wave on Rock* was painted, pointed out the essential interaction of Marin's oils and watercolors, while commenting as well on his introduction of figures into his work:

> His strokes in both mediums acquired a fresh intensity, a deeper thrust. His sense of mass and
> volume began to evoke a more vigorously ordered sense of pattern. Figures began to creep into
> his designs—human figures that were as individually ordered as strange hieroglyphics. . . . He has
> described to me the way he looks at objects when he paints, focusing on a central point and
> letting secondary objects glance off as best they may. . . .[12]

237. *The Sea, No. 3,* 1940. Graphite and black crayon on paper, 8½ x 10⅞ in. National Gallery of Art, Washington, D.C.; Gift of Frank and Jeanette Eyerly.

The sorts of human figures that crept into the work can be seen in *Untitled (Woman on the Beach with Sea Creatures)* (plate 236), along with a tortoise crawling away and birds staring head on (both in the shadows at left), plus a bird with an erect beak coming from the lower margin—a bit of covert sexual content. Another drawing of the same year shows women not only on land but also hovering as part of the sky's activity (plate 237).

Some critics were less enthusiastic about Marin's work of the 1930s. Edward Alden Jewell, writing in the *New York Times* early in 1938, commented:

> Marin's work has always been abstract but not in uniform degree. So long as there are definite
> objects—recognizable, even if indefinitely, as such—the moorings hold; but more and more
> often of late Marin goes off the deep end, in which case there may appear, except for him who
> is very adept in these matters, nothing left but the title. "Surf and Rocks" is followed by a potent
> word in parenthesis—"movement." This furnishes a sort of liaison clue, just as shifting from
> movement to a harmony of colors, we find the parenthetical "Grays and Black" after "Boat and
> Sea."[13]

While such negative responses surely weren't appreciated by Marin, they didn't slow him down,[14] and later that same year he completed a number of exceedingly beautiful seascapes. In two of them,

238. *Off Cape Split, Maine,* 1938. Oil on canvas, 22 × 28 in. Mr. and Mrs. Meredith J. Long, Houston. R.38.25.

Grey Sea and *Off Cape Split, Maine* (plates 220, 238), Marin's expressive use of the brush and his masterly manipulation of paint are extraordinary. The surface of *Grey Sea* varies from raw canvas to a rich impasto applied with brushes of many sizes. The horizontal bands slashing across the sky in *Off Cape Split, Maine* were to recur frequently in Marin's seascapes to the end of his life. The golden patterning evoking the reflection of sun on sea and the incredibly animated surface throughout the entire canvas aptly illustrate Jerome Mellquist's description of Marin's seascapes as compared with Ryder's:

> Ryder showed the sea dark with a kind of mystic moonlight upon it with boats and men deep in
> a golden haze; but Marin's sea is the sea of the daytime, the sea which hurtles on against the
> shore, the sea which churns and chops in its own restless center; and the very energy and
> movement of the force itself. In the movement is life, and the secret of life for him.[15]

Marin's *Movement—Sea and Sky* of 1946 and *The Fog Lifts* of 1949 (plates 239, 240) are two of the artist's most distinctive and important seascapes. The "movement" in the former takes Marin's painterly impulses as far as they were ever to go. It is extraordinarily lyrical in color and more varied in hue than most of Marin's seascapes in oil, with yellows and oranges and roses set off by grays, greens, and blues. Perhaps of all of the oil paintings thus far described, this is most varied in its facture. Some areas are so thinly painted that one is aware of the drips; others, especially in the sky, are washed out in a circular motion with turpentine; still others are dabbed and swiped with great vigor. Strokes of thin paint laden with medium are laid onto others already in place, dissolving the paint layer below and establishing a clear sense of stroke-over-stroke development of form and surface. By this time Marin's highly calligraphic line was in full force, but here the linear markings are in counterpoint to the jewellike patches of hue.

239. *Movement—Sea and Sky*, 1946. Oil on canvas, 22 x
28 in. The William H. Lane Collection; Courtesy of
the Museum of Fine Arts, Boston. R.46.22.

°240. *The Fog Lifts,* 1949. Oil on canvas, 21¾ x 27½ in.;
with Marin frame. Wichita Art Museum, Wichita, Kansas;
The Roland P. Murdock Collection. R.49.57.

In *The Fog Lifts*, Marin built on his use of specific forms to symbolize natural phenomena—in this instance fog surrounding the sea, as evident earlier in *Small Point Harbor, Casco Bay, Maine* (plate 234). The use of white in *The Fog Lifts* is intriguing, ranging from the hovering blocks of unpainted canvas to the thickly painted bands of white foam to the white painted into other colors to modify them and create new ones—for example, white into red to achieve a pink. *Movement* per se is not in the title, but *Lifts* carries similar implications. The distribution of forms blocks aspects of view, with areas disappearing and reappearing, and suggesting the weight of air and its importance in structuring vision.

The Fog Lifts, associated with a closely related sketch (plate 241), was painted the year after Marin was voted the best painter in America in the *Look* magazine poll. His empathy with the sea, apparent from almost the start of his celebrated career, had been so profound a force in his life that it seems eminently appropriate that his last painting, from a few months before he died, was a sea-dominated watercolor of Flint Island (plate 242). "I don't have to see the ocean anymore to paint," he mused in 1947. "I've been looking at it so long I can see it with my eyes closed. And so I try to put it on canvas as I see it, the colors and the movement as it appears to me. I'm not interested in how other artists paint the sea. I paint it as I see it."[16]

241. *Untitled (The Fog Lifts)*, 1949. Graphite on paper; 5¹⁵⁄₁₆ × 9 in. Private collection.

242. *Untitled (Flint Island)*, 1953. Watercolor and graphite on paper, 15¼ × 20¼ in. Private collection. R.53.8.

°243. *Autumn (On the Road to Deblois, Maine) Coloring No. 2,*
1952. Watercolor, graphite, and ink on paper, 12⅝ × 18 in.
(sight). Private collection. R.52.4.

LATE CALLIGRAPHIC WORKS

Marie, Marin's wife of more than three decades, died in February 1945. Alfred Stieglitz, his mentor for an even longer period, passed away the following year. The loss of the two of them in so brief a span left devastating gaps in Marin's support system, especially with John, Jr., at war in the South Pacific. Yet even in mourning Marin could express his affirmation of life, as evident in his acknowledgment of Susie Thompson's letter of condolence shortly after Marie's death:

> Letters arrive and for her to have known from these letters what she was thought of—
> wouldn't it have made her happy—She was mine and it gives one pride to read them
>
> But of all those letters—yours touches me most as it would have her—its such a dear letter
> —the little says so much
>
> The doctor said—hardening of the arteries of the brain the end has [come] by two paraletic
> [sic] strokes
>
> and if she had lived she would have been helpless and she would not have wanted that—
> How she would have delighted in this warm beautiful early spring
>
> What I will do I don't know my pleasure was having her beside me
> but one must carry on

May be I'll get to Maine—it being nearest my

heart than any other place—

later on—I hope to know better

 John is still in the Pacific Islands

My hope is that he will be home soon

 Now to you and Bill—Harry and Leo—the

young ones—and the rest Enjoy the beautiful

earth it's there to enjoy and its our resting place [1]

 John, Jr., returned from the front in 1946, and for the rest of his father's life he attended devotedly to his needs, organizing his work for exhibitions and accompanying him when he went out to paint. Shortly before Stieglitz's death Marin himself had suffered a heart attack from which he never fully recovered, and during the last few years of his life he was hospitalized on several occasions. He remained surprisingly energetic, however, making watercolors and drawings even from his bed in New York Hospital (plate 288) and adding the hospital syringe to his tools for making line drawings in ink. Marin continued painting in Maine, too, almost to the very end, his last watercolor painted there a few months before he died (plate 242).

245. *Portrait of John, Jr.,* 1936. Oil on canvas, 30 × 25 in. Private collection. R.36.25.

246. *Portrait of Roy Wass with Apologies,* 1949. Oil on canvas, 28 × 22 in. Private collection. R.49.40.

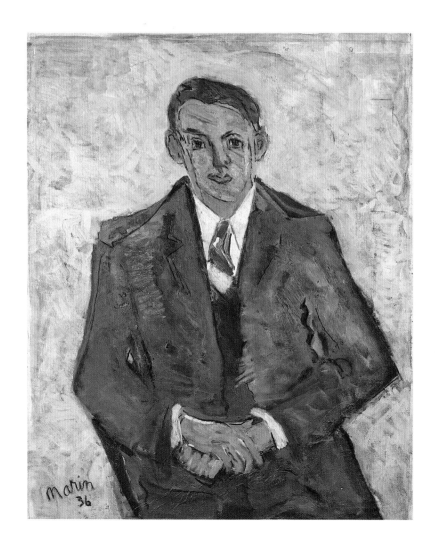

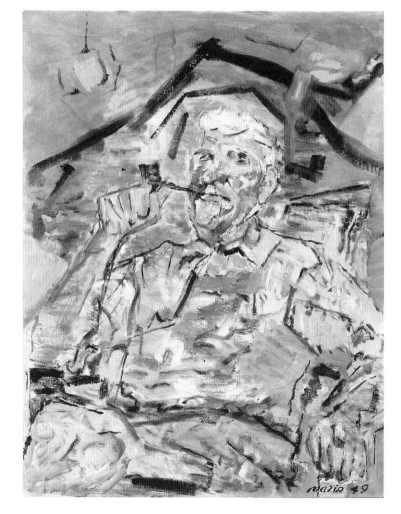

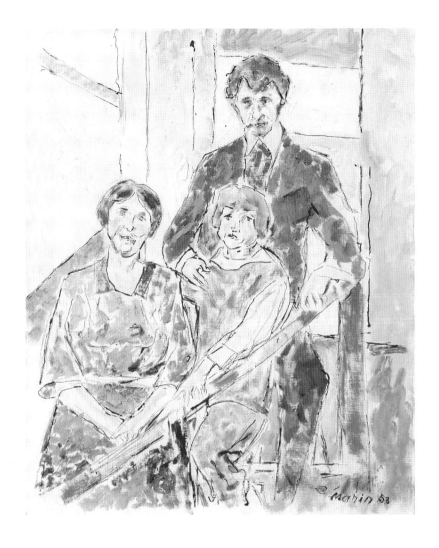

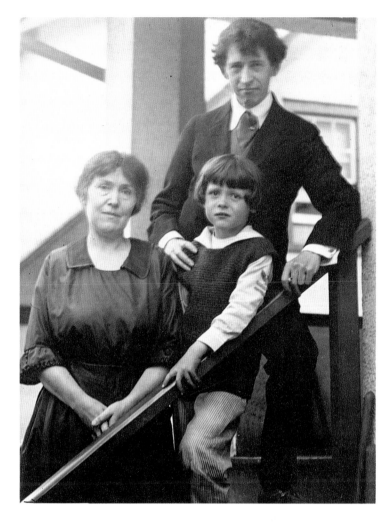

Perhaps it was the sense of personal loss that directed Marin to portraiture or perhaps an urge to establish a new link with tradition. There had been occasional portraits earlier of friends and family, like those of Mrs. Haviland and John, Jr. (plates 85, 95, 245). After Marie and Stieglitz died, however, Marin's attention to portraits was more concentrated. He wrote: "The painted portrait has held for a thousand years—I feel it will have Value in the years to come—that mankind will eventually—is now beginning to get tired and sick of the abstract—the nonobjective—that old subject object forms will come forth again."[2]

His portraits of Susie Thompson and Roy Wass (plates 200, 246) have painterly qualities very different from those of his other subjects from this period. Though not thickly worked, they have an overall brushiness, as if the artist were caressing the forms as he painted them. The portraits undoubtedly resemble the sitters, but the paintings reveal this to be less their aim than the integration of figure and environment. Susie, especially, is at one with nature, as much a part of her surroundings as Marin's schooners were with the sea. The use of driftwood in the frame he constructed reinforces this effect.

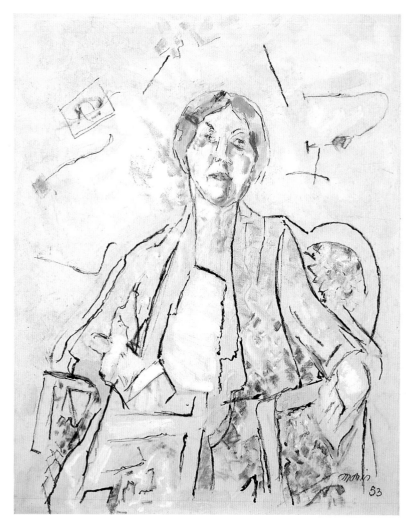

249. *Untitled (Mrs. Marin),* 1953. Oil and ink on canvas, 28 x 22 in. Private collection. R.53.3.

In the last year of his life some of Marin's portraits looked to the past. There are a few of his family based on photographs, worked sparely in oil with a pen line. One, of himself with Marie and John, Jr. (plate 247), stays close to its source in the Stieglitz original of 1921 (plate 248), taking few imaginative liberties. Another, a portrait of Marie (plate 249) after a photograph by Dorothy Norman, is far more expressive, and the calligraphic line serves many functions beyond description. What seems astounding in comparing these two portraits is that Marin, working from photographs at age eighty-two, was *still* exploring the same two parallel approaches to pictorial problems that he had established that long-ago summer of 1918 in Rowe, Massachusetts.

Not only did Marin's art never lose its vigor, in the last decades of his life it took on a cheerful liveliness that reflected his great pleasure in portraying the world around him. The continuing delight of his ever-appreciative public is expressed in an *Art Digest* review of the last of his major lifetime exhibitions: "In this new show—which Marin himself titles '1952 Paintings of Land, Sea and Circus' —an impression of extraordinary playfulness, a sense of joy, seems to reaffirm life all over again. . . . *The Written Sea* [plate 250], as its title suggests, reflects Marin's new attitude towards line that is symbolically expressive."[3]

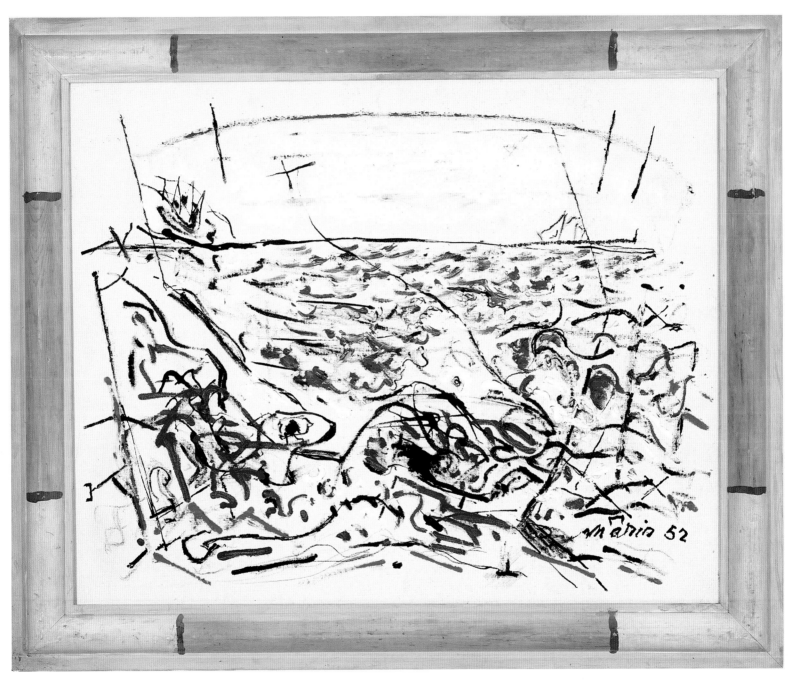

°250. *The Written Sea*, 1952. Oil on canvas, 22 × 28 in.;
with Marin frame. Private collection. R.52.50.

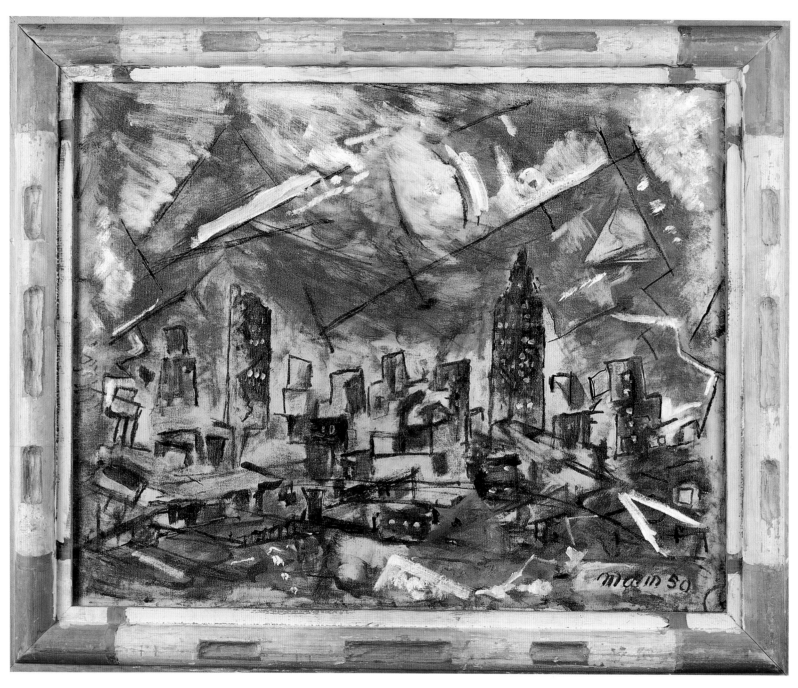

°251. *New York at Night, No. 3*, 1950. Oil on canvas, 22 × 28 in.; with Marin frame. Mr. and Mrs. Vincent A. Carrozza, Dallas. R.50.41.

The important role of line in almost all phases of Marin's art has been made evident in the preceding chapters. In the artist's last decade that role became even more crucial. Line activated the entire picture plane, possibly as an outgrowth of his attention to the overall surface in his Cape Split sea paintings. Suggestions of a metaphysically symbolic use of figuration, especially in the development of circus themes, were augmented by new physical ways of dealing with the canvas. Marin's addition of an active ink line to his repertoire, not only in drawings and watercolors but in his oil paintings as well, provided new ways of suggesting an expansive surface. In the works on view at An American Place in January 1937, Ralph Flint saw Marin as having traveled

> a step further along the line of technical experimentation, adding to his watercolors for the first time an inked line.... This sharp and brittle sort of outline, needless to say, gives a different quality to Marin's watercolors.... His color, too, is jacked up several degrees in intensity; and altogether the result, while definitely thrilling, makes for results that are a bit disquieting for even a Marin convert. These new Marins are decidedly "difficult" to get.... In this time of upset and swift advance along uncharted courses almost anything is liable to happen in society, government or art.[4]

Marin's introduction of a symbolic figurative component and a sense of fantasy to his sea paintings in the early 1930s had been paralleled at about the same time by his enthusiastic exploration of the

252. *New York at Night, No. 2,* 1950. Oil on canvas, 22 x 28 in.; with Marin frame. Private collection. R.50.40.

circus motif. Apart from some undated sketchbook drawings that may have been done a bit earlier, the circus subject did not enter his oeuvre until the artist was in his sixties: at this late stage of life, Marin clearly loved the extravagance of it all—the sounds, the color, the movement.[5] The circus undoubtedly served in some respects as a metaphor for the city, which had its own connotations and which held less of a place in Marin's work after the mid-1930s. (There were important exceptions to this, such as the dramatic New York at Night paintings [plates 251, 252] of 1950, in which the time of day has specific meaning, given that the artist was in his eightieth year.) The circus also would have signified the human condition in much the same way it did for other artists of the period, from Picasso to Walt Kuhn.

The circus may have introduced Marin to a variety of new spatial structures that he incorporated into his late work. The early circus oil paintings comprise highly architectonic forms, with none of Marin's later expansiveness and lyricism. Equally architectonic are his best-known circus watercolors —for example, Circus Elephants (plate 253), from the following decade—and his highly developed colored pencil drawings, such as Untitled (Trapeze Performers) (plate 256). Although both of these use line extensively, it is Marin's sketches of the circus—in graphite, sometimes combined with colored pencil or watercolor—that display the most extraordinary liveliness, reaching far beyond the city views or the landscapes in their suggestion of "movement."

The complexity of action in the circus and the way it framed Marin's field of vision must have made a vivid impression on him. A profound relationship certainly developed between what he saw and how he drew. Two of his sketches (plates 254, 255) suggest that one crucial influence may have been the movement of the trapeze and other high-flying apparatus as they would swing forward and back, slicing out sections of space to be glimpsed in isolation and establishing a network of visual paths. This structure of motion seems to have functioned much as the Brooklyn Bridge had decades earlier, framing schemes to be explored and suggesting various interactions and juxtapositions of

253. *Circus Elephants*, 1941. Watercolor, graphite, and crayon on paper, 19³⁄₁₆ x 24³⁄₄ in. The Art Institute of Chicago; Alfred Stieglitz Collection. R.41.10.

254. *The Circus*, c. 1945. Sketchbook page, graphite and colored pencil on paper, 9 x 12 in. National Gallery of Art, Washington, D.C.; Gift of John Marin, Jr.

255. *The Circus*, c. 1945. Sketchbook page, graphite and colored pencil on paper, 9 x 12 in. National Gallery of Art, Washington, D.C.; Gift of John Marin, Jr.

256. *Untitled (Trapeze Performers)*, c. 1948. Graphite and colored pencil on paper, 9¾ x 7¹¹⁄₁₆ in. Private collection.

°257. *Movement—Sea or Mountain—As You Will*, 1947. Oil
on canvas, 30 × 36¾ in. Museum of Fine Arts, Boston;
Arthur Gordon Tompkins Residuary Fund. R.47.24.

forms. Ladders, ropes, poles, rings; colorful spaces for elephants and for clowns and for spectators; as well as all of the animal and human performers themselves—everything would have been further visually activated by lighting that added its own suggestion of movement. Marin was so taken with all of this that he spent hours watching and drawing. The nature of the swiftly changing visual experience as manifested in the divisions and gestures in the circus sketches make more than plausible the notion that his hours at the circus had great impact on his late work. It is important, too, that the circus was on his mind even in Maine: "I brought up *the start*—the sort of layout to another circus picture—well I have been working on that—and it hangs over the mantle. . . ."[6]

It is pointless to try to establish a specific starting date for Marin's calligraphic works because calligraphic elements appear at various times in various forms throughout his career. Moreover, while making his late calligraphic works Marin continued to expand on ideas that he had been worrying over for years. However, this aspect of his work seemed to coalesce in the mid-1940s,

°258. *On the Road to Addison, Maine, No. 3,* 1946. Oil on canvas, 22 × 28 in. Charles Simon, New York. R.46.26.

°259. *Movement: Lead Mountains near Beddington*, 1950. Oil
on canvas, 25 × 30 in.; with Marin frame. Private collection.
R.50.31.

°260. *Tunk Mountains, Maine*, 1948. Oil on canvas, 25 x 30 in.; with Marin frame. Louisiana Arts and Science Center, Baton Rouge. R.48.37.

°261. *Jersey Hills*, 1949. Oil on canvas, 24 × 29 in. Private collection. R.49.13.

°262. *Snow, New Jersey*, 1933. Watercolor and charcoal on paper, 18⅝ × 21¹³⁄₁₆ in. (sight). Private collection. R.33.30.

and from then on a distinctively dancing line organizes the spatial structure in many of his works. His use of calligraphy pervaded all media and subjects, and it introduced into his oeuvre a greater sense of unity. Many of the landscapes and seascapes, for example, shared a closer formal relationship than they had in earlier years. One painting, in fact, *Movement—Sea or Mountain—As You Will* (plate 257), insists by its very title that the artist's responsiveness to the expressive nature of jagged forms —whether chopping seas or mountain peaks—was more important than the identification of any specific type of place.

While extending his use of calligraphy, Marin also added new motifs to his Maine repertoire. Traveling inland from his home on the sea, he encountered places very different from Stonington. In the mid-1940s he started exploring Addison, which he passed through en route to Cape Split; Machias, a bit farther north along the coastal route; and the town of Centerville. The artist often took a vantage point from above, emphasizing the integration of the buildings with their surrounding hills and valleys. At this time, too, *On the Road to* was added to *Pertaining to* in Marin's titles, and, to further suggest energy and motion, *Movement* was used in them more frequently. In *On the Road to Addison, Maine, No. 3* (plate 258) the town is encompassed by a suggestion of the roads passing through it, by the vegetation that dotted the region, by the action of the wind, and by the motion of the drive there—one that Marin would have taken countless times during his years at the cape. The artist would also drive considerable distances to reach his subjects. The tiny village of Deblois—in *Autumn (On the Road to Deblois, Maine) Coloring No. 2* (plate 243)—would have been traversed in the course of the two-hour drive from Cape Split to Beddington, the site of Lead Mountain. *Movement: Lead Mountains near Beddington* (plate 259), one of several oil paintings of that subject, was made almost without impasto. The paint was laid on and scraped off, resulting in a surface far different from those in the sumptuous works of the 1930s.

Frederick Wight's description of Marin's oils of the late 1940s, such as *Tunk Mountains, Maine* (plate 260), illuminates as well many that came later, such as the New York at Night and Lead Mountain paintings:

> Again he develops a theme from one canvas to the next, creating a fugue out of a series, each
> phase progressively more abstract and more concentrated around a central element of
> composition, with a wide margin about it that sets it off like silence. . . . His most recent canvases
> are . . . upended fields and hills in quilted patterns which can be tipped further back into the plane
> of painting. The whole surface is brittle with red, blue, black, and yellow notes. . . . It is the
> essence of his art to work out a balance between antitheses, setting them up in order to
> establish an equilibrium between them, playing one thing off against another.[7]

That Marin was also inspired by landscapes closer to his winter home is made clear by *Jersey Hills* (plate 261), one of his most expansive late oils. It was painted from memory the day following a drive through the hills when Marin had stopped to observe, not to draw, this particular scene.[8] The subject is a tracking of visual paths—a blue path, a tan path, and several alizarin paths. He seems to

°263. *Sea with Boat in Greys, Greens, and Red,* 1948. Oil on canvas, 25⅛ × 30 in. Private collection. R.48.29.

have been making reference to distances, as if measuring the spaces between various points. It calls to mind a much earlier, more compressed painting, *Snow, New Jersey* (plate 262). In its shadowy suggestion of the snow-covered forms of a hillside, while not calligraphic in the same sense, that work is equally about tracking a field, albeit a much more confined one. Similar in its spareness to both of these, but very different from *Jersey Hills* in its use of line as the primary expressive mode, is *Sea with Boat in Greys, Greens, and Red* (plate 263). It is closer to a fireworks display than a measuring device. The schooner chopping its way through the sea almost disappears in the turbulence, but a spirit of celebration, not menace, prevails. Large areas are unpainted, others are modulated by a gray wash. The strokes of green water slithering across the surface provide a weighty anchor to the explosion above.

Peach Trees in Blossom, Saddle River District, New Jersey, No. 2 and *Apple Tree in Blossom* (plates 264, 265) are among the many paintings in watercolor and oil of orchard motifs made during Marin's last decade. They are formed as much by dots as by line, both setting up a vibration across the surface of the sheet itself as it interacts with the paint. This vibration is more dramatic in Marin's autumn paintings of the period. In the watercolor *Little Maple in Swamp, Addison, Maine* and the oil *Trees in Autumn Foliage, Maine* (plates 266, 267), the brilliant reds and golds hug the surface while

264. *Peach Trees in Blossom, Saddle River District, New Jersey, No. 2*, 1953. Oil on canvas, 19 x 24¾ in. Mr. and Mrs. David Anderson. R.53.6

°265. *Apple Tree in Blossom*, 1948. Watercolor and graphite
on paper, 14¾ × 18¾ in. Duncan Vance Phillips. R.48.1.

Marin 45

°266. *Little Maple in Swamp, Addison, Maine*, 1945.
Watercolor and ink on paper, 14 x 17 in. Private collection.
R.45.11.

°267. *Trees in Autumn Foliage, Maine,* 1948. Oil on canvas,
22 × 28 in. Dr. and Mrs. Meyer Friedman. R.48.36.

°268. *Landscape*, 1951. Ink and watercolor on paper, 16¾ x 12⅜ in. James and Barbara Palmer. R.51.15.

°269. *Tunk Mountains, Maine*, 1952. Watercolor, graphite, and ink on paper, 14 x 19½ in. Courtesy of Kennedy Galleries, Inc., New York. R.52.53.

the calligraphic line suggests a deep landscape space. Both point to the expanded visual as well as physical role of the support in Marin's late paintings, coming close to that of the paper in his etchings, in their use of the white primed canvas or watercolor sheet as a primary formal element.

Marin's later art was celebratory, "as if in his late style Marin, paralleling Titian and Renoir, or even Beethoven in his last symphony, approaches the world with rapturous love and creates his image of it with almost triumphant freedom."[9] This triumph approached its climax in late watercolor-drawings such as *Landscape* and *Tunk Mountains, Maine* (plates 268, 269), many of which are as much, if not more, drawing than watercolor. It reached full tilt in his joyful calligraphic masterpiece, *The Written Sea* (plate 250). The year it was painted, the critic Gertrude Benson visited Marin and provided a wonderful description of the aging artist: "[He is] as full of wrinkles as a winter apple, his strong face is like weather-beaten parchment and his body is round from years of bending over his easel. His long grey hair and bangs still provide a picturesque frame for his deep blue eyes which are as sharp and alert as ever for 'the piercing seeing' of elemental forms which distinguishes everything he does."[10]

The range of this "piercing seeing" at the end of Marin's life can be seen in his 1952 sketchbook (plates 270–80), perhaps his last. It is filled with landscape studies, each one a small jewel, capturing the precise time, place, and atmosphere of each subject while infusing them with a knowledge of landscape distilled from the experience of a lifetime.

> I demand of [my paintings] that they are related to experiences—I demand of them that they
> have the story—embracing these with the all over demand that they have the music of
> themselves—so that they do stand of themselves as beautiful—forms—lines—and paint on
> beautiful paper or canvas—[11]

270. *Sunset, Maine,* 1952. Sketchbook page, watercolor and graphite on paper, 9 × 12 in. Private collection. Not in Reich.

271. *Sunset, Maine,* 1952. Sketchbook page, watercolor and graphite on paper, 9 × 12 in. Private collection. Not in Reich.

272. *Sunset, Maine,* 1952. Sketchbook page, watercolor and graphite on paper, 9 × 12 in. Private collection. Not in Reich.

273. *Shoreline*, 1952. Sketchbook page, watercolor and graphite on paper, 9 × 12 in. Private collection. Not in Reich.

274. *Yawl in Full Sail off Norton's Island, Maine,* 1952. Sketchbook page, watercolor and graphite on paper, 9 × 12 in. Private collection. Not in Reich.

275. *Prospect Harbor, Maine,* 1952. Sketchbook page, graphite on paper, 9 × 12 in. Private collection.

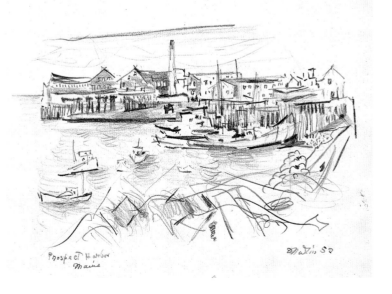

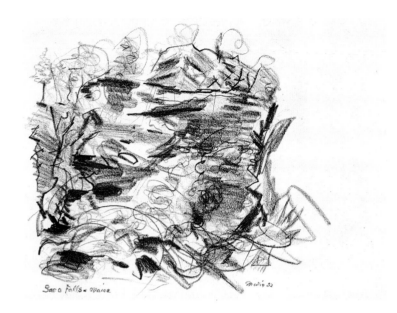

276. *Saco Falls, Maine,* 1952. Sketchbook page, graphite on paper, 9 x 12 in. Private collection.

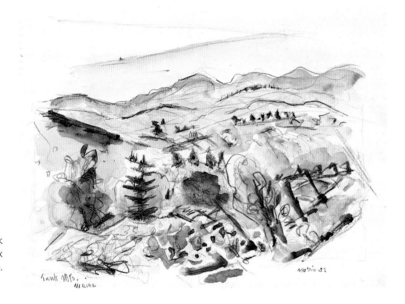

277. *Tunk Mountains, Maine,* 1952. Sketchbook page, watercolor and graphite on paper, 9 x 12 in. Private collection. Not in Reich.

278. *Machias, Maine,* 1952. Sketchbook page, watercolor and graphite on paper, 9 x 12 in. Private collection. Not in Reich.

279. *Autumn Color,* 1952. Sketchbook page, watercolor and graphite on paper, 9 × 12 in. Private collection. Not in Reich.

280. *Autumn Color,* 1952. Sketchbook page, watercolor and ink on paper, 9 × 12 in. Private collection. Not in Reich.

°281. *At Small Point, Maine*, 1914. Watercolor on paper, 14⅛ × 16½ in. Alfred Stieglitz/Georgia O'Keeffe/Private collection. R.14.1.

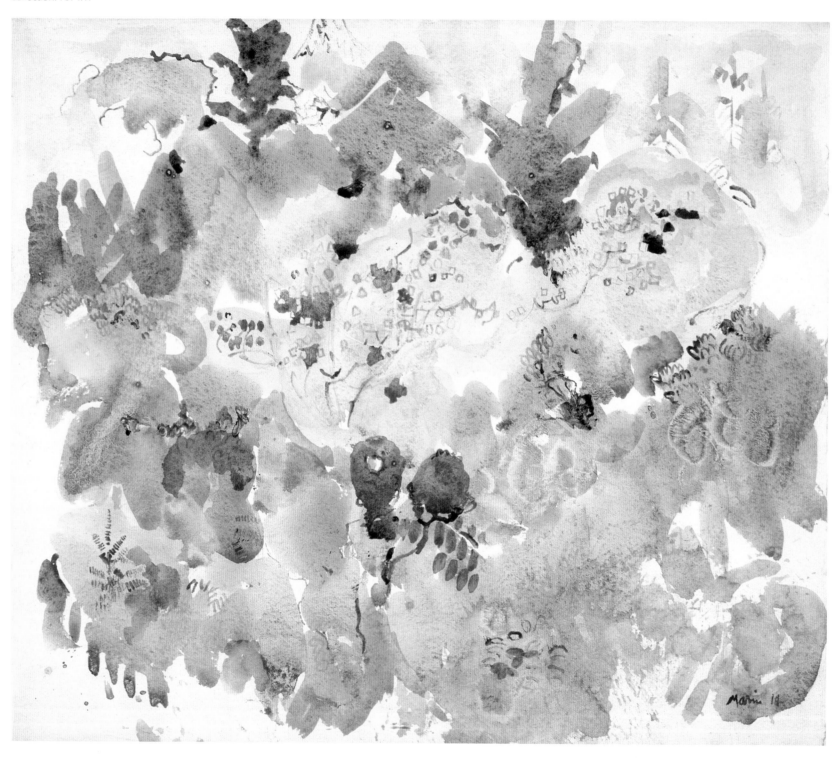

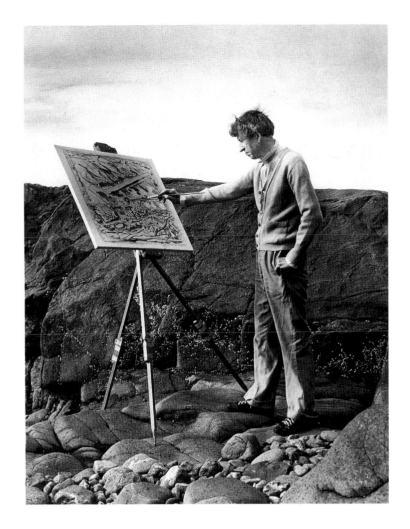

282. Sargent F. Collier (Collier and McCann Photography).
Marin in Maine, 1946. Private collection.

M A R I N A T W O R K

Marin's working methods varied greatly over the course of his career, but several constants seem to have remained throughout. One was his commitment to making drawings, many of which relate loosely and somewhat indirectly to works in other media. They suggest that Marin used sketching on site for information-gathering purposes and then took aspects from many different sketches to compose his more finished etchings, watercolors, and oils. Other drawings, mainly on tracing paper or other translucent sheets, are directly related to prints and paintings, having been used in developing details of their images. Still others seem to have been done for their own sake, bearing little relationship to anything else. They, too, may have been seen by Marin as part of his storehouse of visual data, to be called upon if and when needed.

Another constant in Marin's work, starting with his early European etchings, was his tendency to work repeatedly with a given subject, redoing it several times. One senses that sometimes he did this because he saw problems with a rendition and that other times he had more to say about the motif. The same came to be true for his watercolors and oils; many images are known in several

very close versions (plates 150, 151; and 251, 252). This practice of working a subject again and again, with the versions often being quite similar, suggests that, even though he usually seemed to have worked swiftly, Marin did not necessarily work spontaneously.

At certain times, however, he was both swift and spontaneous, making a number of variant views within a very compressed period, as evident in his reports to Stieglitz of various work sessions. Two such reports from the early 1920s are exemplary: "Take today for example," Marin wrote. "I was laying off in my boat, and there was a schooner under full sail coming toward me. I made about 20 drawings, none near perfect, but the sight as she loomed up, a thing of life changing with every second. . . . I couldn't begin to describe the wonder of it."[1] A few years later a similar group of related works was spontaneously drawn as Marin, Arthur B. Carles, and another friend "were racing home to get in ahead of the thunder storm. We were passing a lake, with the black mountains and black clouds. I happened to say that looked great. They stopped the car and I started to work."[2]

Marin painted Maine subjects in Cliffside and circus subjects in Maine. But when he worked directly on site, it was not only in the rush of inspiration, as recounted above, but sometimes with great deliberation. For example, he reported in 1925: "Rig up my tripod over the front seat of the car and proceed to play, seated in the back seat, with cigarettes and whiskey bottle (sometimes with water in it) handy. . . ."[3] More extraordinary is his report of 1940, as a man of seventy, how he "went to the Head of the Cape in the car—when I got there the thing to do was to get down to the foot of the Cape on the ledges—about 200 feet below. To get there—a tangle mess of fir trees —there's a path—the one who made it is a fool—or was a fool—I being of course the greater fool must needs make my own—with my (leetle hatchet)—then to lug the load—2 canvases an easel— a paint box—a pallette [sic]—also the hatchet for the chopping out—then a vast assortment— tobacco pouch—pipe matches & what not—also myself. . . ."[4] Such radically differing ways of setting himself up to work continued from day to day throughout his life.

There are close parallels among Marin's methods of working in the various media he used, most notably the consistent directness with which he handled materials, from manipulating tone on the surfaces of his etchings (plates 26, 47, 48) to pressing textures and scratching lines into his water-colors and oils (plates 152, 100). An early indication of this is Marin's beautiful watercolor *At Small Point, Maine* (plate 281), in which the stamp of the artist's hand can be seen in the lower right corner, contrasted with the delicate line his work featured at this time. The investigation of line was a mainstay of his art, starting with his early drawings and his etchings. As the years passed and he became increasingly involved in painting, he worked with a wider variety of linear means in both his watercolors and oils. He used line in many ways, most often combining several different materials. In his early watercolors he had depended mainly on graphite, then graphite and an incised line, then also a painted line; charcoal, black chalk, a wider selection of graphite grades, colored pencils, and ink all eventually came into play. The choice of material established and enhanced specific properties of the work—for example, the weight of forms or the softness of edges. Ambidextrous as he was,

Marin worked with his fingers, with matchsticks, and with surgical syringes in addition to the traditional brushes, pencils, and pens.

Marin's letters and other writings tell us much about the artist's subjects and his feelings at various times about the general progress of his work; but they offer little information about his actual technical processes. One 1933 letter is an important exception that provides a vivid overview of the artist's watercolor techniques, omitting, however, any mention of the importance of the linear aspect of his work. The letter is a response to an admirer wanting lessons from the master. Marin wrote that he couldn't possibly provide them, not having time enough to do what he had in mind for his own work, but he offered instead to write down a few hints:

You get your paper good but not too good—say Whatman's—and *don't be afraid of it*

Your colors—say Windsor & Newton's—and say just a few Green Viridian—Blue Cerulean and French ultramarine—Red—Light or Indian—and Rose Madder—Yellow Ochre & Aureolin —Black—Lamp—Other colors—Suit yourself

Brushes—don't be too particular in beginning for I am to presume that you are to heed what I say and go on a—watercolor—*debauch*—*it's quantity*—not quality—you are after—not to take this too literally—but what I mean is to get in front of any old landscape and spend reams of paper and paint on it—painting 3 or four a day—and then at the end of the season—you'll —if you are naturally gifted—have learned something about water color—then naturally you'll come to quality

In my case—in my early days I made stacks of them—gradually getting on to some tricks of the medium and taking advantage of them.

Use plenty of water)
Use less water) and watch the result of each
Use hardly any water)

If you want an edge to a set passage tilt the paper up a little and let the paint of its own accord run up to and dry at that edge

If you feel certain passages want to be scrubbed in scrub them in—if not don't

In painting water make the hand move the way the water moves—same with everything else —and don't cuss your *paint* or your paper—cuss yourself—and good luck [5]

Unfortunately, Marin left no similar lesson in oil painting. He did, however, send Stieglitz a brief account of the advantages of working both in watercolors and oils: "As to my doings—my makings —on canvas and on paper—of oil paint—of waterpaint—of a quiet realized recognition of—of a difference between—of a stretched canvas—as a burden bearer for to tenaciously grip and to hold and to bind its expressing oil paint—of a white paper—of itself—of a quality intrinsic—for to hold —for to show—of itself and its waterpaint talk There seems now to me a benefit found in the—in the working of these two—in the working of others than these two—of an one offsetting another —of a greater understanding of each—thereby of a seeing of each thereby." [6]

Marin was interested in the interaction between working in watercolor and working in oil and their properties in relation to different substrates on which they were placed. In oil paints he was

283. *Weehawken* (verso), c. 1916(?). Graphite on paper, 8½ x 11 in. Private collection.

284. *Weehawken* (recto), c. 1916(?). Graphite on paper, 8½ x 11 in. Private collection.

surely attracted also by the medium's extensive tactile possibilities. Although the kind of paint isn't mentioned, one senses that it was oils to which the artist was referring in expressing his glee at how "when I squeeze the red out of the tube and it's moulded onto its working surface to my moulding I have delight and when I squeeze the blue out of the tube and its [*sic*] moulded onto its working surface to my moulding—I have delight—and it's so when all others of my choosing are squeezed out and moulded to my mouldings that I have delight—"[7]

Marin's methods of exploring his variant versions of an image are not clearly documented. There is not much physical evidence to prove that he used tracing and other forms of transfer in the early years, but there is some. One fascinating sheet is in a private collection, an undated Weehawken drawing, possibly from the mid-teens; in it certain sections appear on the verso, in reverse, and in precisely the same positions as on the recto (plates 283, 284). Marin presumably held it to a light source to be able to see the drawing through the sheet and trace it onto the other side; he could then have laid his verso drawing onto a clean sheet and used it to transfer the image without reversing it. For anyone with Marin's experience in printmaking, this sort of thinking would have been natural. The possibility that he worked this way at least once during the early part of his career is fascinating, especially given his increasing exploration of several versions of his images as his work developed over the years. This early work certainly reinforces the notion that for Marin spontaneity in no way precluded meditative impulses.

There is ample evidence that Marin used tracings to develop the variant versions of his late work. Many of his drawings on clear plastic can be matched with specific works known to exist in more than one version, such as *Prospect Harbor, Maine* (plates 285, 286). And, as evident from two views of Machias that are in reverse of each other, he didn't require a literal fidelity to the scene. A similar method of working from a key drawing on plastic was undoubtedly used for compositions such as the varying versions of *New York at Night* (plates 251, 252). There are tracings for drawings and watercolors as well as for paintings—for example, for some of the scenes from New York Hospital. Since the various versions are never identical, the tracings evidently enabled Marin to set down on

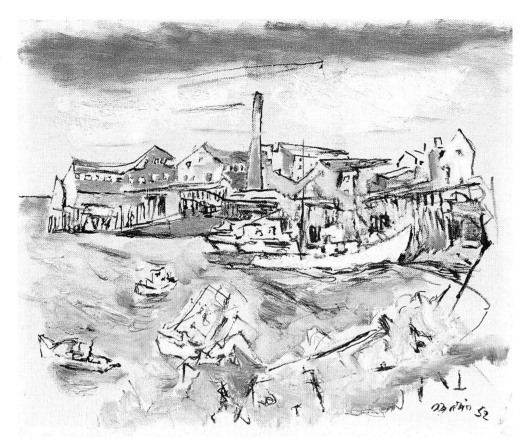

285. *Prospect Harbor, Maine*, 1952. Oil on canvas board, 12 × 15⅛ in. Pauline and Irving Brown. R.52.38.

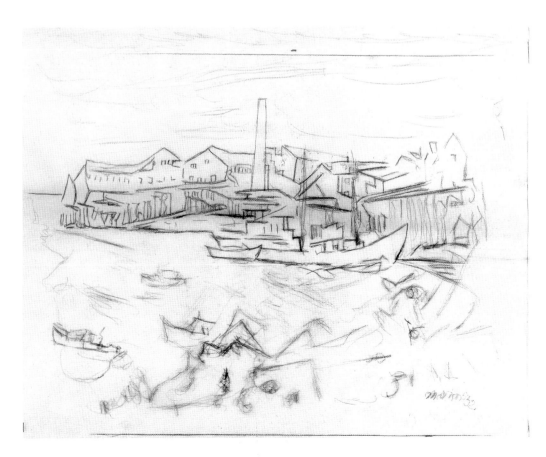

286. *Prospect Harbor, Maine*, c. 1952. Graphite on plastic, 15⅜ × 19⅞ in. Private collection.

canvas or paper basic generalities of a scene—a "movement" from which he then "spontaneously" developed his variants. In addition, some drawings explore the abstract schemes of *movement* in isolation from an image of a site. Related to this way of working is the linear scheme titled *Black Angular Lines* of 1942 (plate 287) and its use ten years later to establish a movement in *From New York Hospital* (plate 288).

Fascinating, too, is a canvas with four views of a seascape, undated, but presumably from the mid-1940s (plate 289). Although no drawing on plastic for it has turned up, it is safe to say that one did exist and was used to lay in the essential linear dynamics of the piece—the plane at the right and the various diagonal lines. Once the four drawings of the composition were laid down, Marin painted each one individually, shifting the rhythms of the sea, the scale of his markings, and his color. Each of the four is "framed" with a different hue—green, blue, gold, red—reflecting the main accent color of the particular version.

Marin's tracings and his explorations of process in general were amazingly prescient of ideas that were to come later, representing an aspect of his work that makes it of particular interest today. Late in his own lifetime, however, he was clearly feeling some sense of alienation: "You Surrealists —you moderns? do you like my painting?—as one voice they answer—NO—what do you like— we like what comes from within say they—Oh I knew that say I—but you mistake—Since your upper story cannot give out what isn't there—what comes from you is quite different. . . ."[8]

In 1950 Marin was the main representative of the United States at the Venice Biennale and was given the major portion of space to fill, while the rest was shared by a number of his younger contemporaries: Hyman Bloom, Willem de Kooning, Lee Gatch, Arshile Gorky, Jackson Pollock, and Rico Lebrun. His feelings about the younger generation were tempered not only by his sense of rejection by some, but also by his own bright vision. His enthusiasm for life and for painting never flagged, and he seemed a bit put off by the Existential angst expressed by many of the younger painters. A comment he made in a 1947 interview best summarizes his high-spirited artistic views: "[Shakespeare] didn't give us tragedies only; he gave us comedies as well. I'd like the modern artists to think about that—there's room in life for both and I'd like to see them restore the balance and give us something a little cheerful. The sun is still shining and there's a lot of color in the world. Let's see some of it on canvas."[9]

287. *Black Angular Lines,* 1942. Ink on paper, 15 × 19¾ in. Courtesy of Kennedy Galleries, Inc., New York.

288. *From New York Hospital,* 1952. Watercolor, graphite, and ink on paper, 10½ × 14 in. Mr. and Mrs. David Mayer. R.52.17.

289. *Untitled (Four Views of a Seascape)*, c. 1945. Oil and charcoal on canvas, 22¼ x 24 in. Private collection. R.49.5.

N O T E S

INTRODUCTION pages 9–19

Epigraph: John Marin, "Marin Writes," in MacKinley Helm and Frederick S. Wight, *John Marin: A Retrospective Exhibition* (Boston: Institute of Modern Art, 1947), p. 12.

1. John O'Brian, ed., *Clement Greenberg: The Collected Essays and Criticism*, vol. 2 (Chicago: University of Chicago Press, 1986), p. 268.

2. "Are These Men the Best Painters in America Today?" *Look*, February 3, 1948, p. 44. Other winners were Max Weber, second; Yasuo Kuniyoshi, third; Stuart Davis, fourth; Ben Shahn, fifth; Edward Hopper, sixth; Charles Burchfield, seventh; George Grosz, eighth; Franklin Watkins, ninth; and Lyonel Feininger and Jack Levine, tied for tenth place.

3. The Ferdinand Howald Collection is now at the Columbus Museum of Art, Columbus, Ohio. Mr. and Mrs. Duncan Phillips's collection is part of the Phillips Collection, Washington, D.C. After Stieglitz's death, Georgia O'Keeffe distributed most of his paintings by Marin to the Metropolitan Museum of Art, the Art Institute of Chicago, the Philadelphia Museum of Art, and the Fisk University Museum of Art, Nashville; three watercolors went to the National Gallery of Art. The bulk of A. E. Gallatin's collection is now at the Philadelphia Museum of Art, but in 1921 he gave to the Metropolitan Museum of Art the first work by Marin ever presented to a public collection.

4. Sheldon Reich, *John Marin: A Stylistic Analysis and Catalogue Raisonné*, 2 vols. (Tucson: University of Arizona Press, 1970). Some of the titles and dates I have used here differ from Reich's.

5. See Carl Zigrosser, *The Complete Etchings of John Marin* (Philadelphia: Philadelphia Museum of Art, 1969).

6. On Marin's drawings see Sheldon Reich, *John Marin: Drawings, 1886–1951* (Salt Lake City: University of Utah Press, 1969). On a single late sketchbook, see Cleve Gray and Dorothy Norman, "John Marin's Sketchbook—Summer 1951," *Art in America* 55 (September–October 1967): 44–53.

7. Marin to Stieglitz, Cliffside, N.J., December 1, 1923; in Dorothy Norman, ed., *The Selected Writings of John Marin* (New York: Pellegrini and Cudahy, 1949), p. 94: "I am still working on that Maine stuff."

8. Three volumes of Marin's writings have been published: Herbert J. Seligmann, ed., *Letters of John Marin* (New York: An American Place, 1931); Dorothy Norman. ed., *The Selected Writings of John Marin* (New York: Pellegrini and Cudahy, 1949); and Cleve Gray, ed., *John Marin by John Marin* (New York: Holt, Rinehart and Winston, 1970).

9. I would like to thank Dorothy Norman for sharing my knowledge of Stieglitz and Marin in several conversations with me; and Sarah Greenough for answering my countless queries regarding Stieglitz. There is an enormous body of literature on Alfred Stieglitz, his galleries, and his associations. Useful bibliographies appear in Sarah Greenough and Juan Hamilton, *Alfred Stieglitz: Photographs and Writings* (Washington, D.C.: National Gallery of Art; New York: Callaway Editions, 1983); Sue Davidson Lowe, *Stieglitz: A Memoir/Biography* (New York: Farrar Straus Giroux, 1983); and Dorothy Norman, *Alfred Stieglitz: An American Seer* (New York: Aperture, 1973).

10. Press release from the Downtown Gallery, November 17, 1950, on file in the John Marin Archive, National Gallery of Art (hereafter cited as JMA/NGA). The John Marin Room apparently was phased out shortly after Marin's death in October 1953.

11. Thornton Wilder, introduction to *John Marin: 1870–1953* (New York: American Academy of Arts and Letters and National Institute of Arts and Letters, 1954); and MacKinley Helm et al., *John Marin Memorial Exhibition* (Los Angeles: Art Galleries, University of California, 1955).

12. Robert Rosenblum, "Marin's Dynamism," *Art Digest* 28 (February 1, 1954): 13. Artists, too, admired Marin. For example, Dorothy Norman recounts a conversation with Jackson Pollock in which the painter indicated, "I admired Marin greatly and for a while was even influenced by him." In Dorothy Norman, *Encounters: A Memoir* (San Diego: Harcourt Brace Jovanovich, 1987), p. 288.

13. Marin, "Marin Writes," p. 12. See also Louis Finkelstein, "Marin and de Kooning," *Magazine of Art* 43 (October 1950): 202–6.

MARIN'S YOUTH pages 21–29

1. Marin to Egmont Arens, managing editor of *Creative Arts* magazine, Stonington, Maine, August 26, 1928; in Norman, *Writings*, p. 122. MacKinley Helm suggested that while this heritage makes for amusing reading, "only the Vermouth and ale, with perhaps a dash of old Spanish Sherry" can be accounted for (*John Marin* [New York: Pellegrini and Cudahy in association with the Institute of Modern Art, Boston, 1948], p. 4).

2. Helm (*Marin*, p. 4) described the elder Marin as an investor and public accountant, whereas he was described as a textile merchant by Matthew Josephson, "Leprechaun on the Palisades," *New Yorker*, March 14, 1942, p. 29. On file in a scrapbook in the JMA/NGA is a card announcing the dissolution as of April 15, 1906, of the Certified Public Accountant's firm of Bragg and Marin, located at 253 Broadway (New York).

3. Eliza Currey to "My Dear Children," February 25, 1875, private collection.

4. Jennie Currey's obituary, with the name of the newspaper and the date removed, gives an indication of her popularity. See Helm, *Marin*, p. 8, on Aunt Lelia's teaching piano. Letters from Jennie (not "Jenny," as in Helm, *Marin*) Currey to Lelia Currey, dated March 4, 1872, and July 30, 1899, respectively, refer to a music teacher and to going with John to the Metropolitan Museum of Art. On Marin's later years, a yearbook, dated 1951, covers many Marin family events from 1945 to 1962; written mainly by Marin's cousin Retta, there are entries by his cousin Lyda, too. According to Helm (*Marin*, p. 58), the cousins moved to Cliffside to the house adjoining the Marins' a few years after the death of their Aunt Lelia in 1926. Given the time span, the cousins' yearbook seems to have been written retrospectively, although it is marked by a sense of true immediacy and may be composed of miscellaneous notes that were later compiled in this form. All of this material is in a private collection. In addition to this and other manuscript material, the biographical information cited here is based on E. M. Benson, *John Marin: The Man and His Work*

(New York: J. J. Little and Ives Company; Washington D.C.: American Federation of Arts, 1935); on Helm, *Marin*; and on scores of articles on Marin with comments about his life.

5. Herbert J. Seligmann, "Close Friend Recalls Life of John Marin," *Bangor Sunday Commercial*, October 4, 1953, p. A5.

6. Jennie Currey to Lelia Currey, September 19, 1886, private collection.

7. Jennie Currey to Lelia Currey, September 26, 1886, and October 11, 1886, private collection.

8. Information from the "Course of Instruction" for 1889–90. For information concerning Marin's years at the Stevens Academy and Institute of Technology, I thank Jane G. Hartye, associate curator at the school.

9. Samuel Swift, *New York Sun*; reprinted in *Camera Work* 42–43 (April–July 1913): 23.

10. Marin, "Notes (Autobiographical)"; in Norman, *Writings*, p. 78.

11. "Agreement for Building," February 16, 1892, private collection.

12. Charles Caffin, *New York American*; reprinted in *Camera Work* 48 (October 1916): 37.

13. Guy Eglington, John Marin, "Colorist and Painter of Sea Moods," *Arts and Decoration* 79 (August 1924): 14.

14. Helm (*Marin*, p. 10) reports that a body of work was destroyed while Marin was in Europe. Only a few of these early drawings have dates; others with subject annotations provide clues as to when they were done. For example, the many scenes of Germantown and various streets in Philadelphia and its environs probably date from 1899–1901, Marin's student years at the Pennsylvania Academy of the Fine Arts.

15. An Academy registration card indicates that during his first year he took "Beginners' Classes Day" and "Drawing from Cast, 2d Section," the latter of which would have been conducted by Thomas P. Anshutz. It is possible that Beginners' Classes Day refers to sections of the "Antique Drawing" and "Still Life Painting" classes, described in the school's catalog as "preparatory ones, intended as a suitable introduction to the higher study of art in the Academy's courses." In both of these classes the instructor would have been Hugh Breckenridge, the other of the two faculty members with whom Marin reportedly studied. Marin again signed up for "Cast Drawing" during his second year at the school and took "Men's Night Life Drawing," both taught by Anshutz. The register of students for the 1900–1901 season shows that Marin also signed up for "Draw. 2, Ptg. 1." It is difficult to connect these brief notations with specific instructors, but others on the staff at the time included William Merritt Chase, the school's dominant force; Cecilia Beaux, who taught "Drawing and Painting from Head"; Henry J. Thouron, who offered a course in "Composition"; and Charles Grafly, who offered "Modelling from Figure." See *Circular of Committee on Instruction: Schools of the Pennsylvania Academy of the Fine Arts for the Seasons of 1899–1900 and 1900–1901*. For assistance in obtaining these sources, I thank Cheryl Leibold, archivist, Pennsylvania Academy of the Fine Arts.

16. Marin to E. M. Benson, August 17, 1935, E. M. Benson Papers, Archives of American Art, Smithsonian Institution, Washington, D.C. (hereafter cited as AAA).

17. Among the paintings in the collection at the time would have been Thomas Doughty's *On the Susquehanna*; Frank Duveneck's *The Turkish Page*; Thomas Eakins's *The Pathetic Song*; Edmund C. Tarbell's *The Golden Screen*; John Vanderlyn's *Ariadne Asleep on the Island of Naxos*; and Benjamin West's *Death on a Pale Horse*. Among the special exhibitions that Marin might have seen were a collection of nineteenth-century European paintings that included works by Jean-Baptiste-Camille Corot, Charles-François Daubigny, and Jean-François Millet; two Philadelphia photographic salons in which works by Edward Steichen and Alfred Stieglitz were on view; a show of paintings, drypoints, and etchings printed in color by Jean-François Raffaëlli; pastels by Everett Shinn; and American paintings that had been exhibited at the Paris Salon of 1901, including works by Chase, Eakins, William Glackens, Homer, George Inness, and Tarbell. Catalogs for these exhibitions are on file in the archives of the Pennsylvania Academy of the Fine Arts.

18. For information on Marin's time at the Art Students League, I thank Mr. Lawrence Campbell, curator at the League. Mr. Campbell has suggested that, despite the records, Marin actually attended the school from 1903 to 1904.

19. Jennie Currey to Lyda Currey, August 3, 1905, and August 24, 1905, private collection.

20. Herbert J. Seligmann, "Marin at Cape Split: A Reminiscence of One of Maine's Greatest Painters," *Down East* 1 (Winter 1955): 24. See also Cleve Gray, "Marin and Music," *Art in America* 58 (July–August 1970): 72–81. Herbert J. Seligmann, a member of the Stieglitz circle, was a writer, poet, and photographer. His works include *D. H. Lawrence: An American Interpretation* (Thomas Seltzer, 1924), the first serious criticism of Lawrence's work in America; and *Alfred Stieglitz Talking* (New Haven, Conn.: Yale University Library, 1966). Seligmann died in 1983. His papers are in the J. Pierpont Morgan Library, New York.

OVERTURE: THE ETCHINGS pages 31–73

1. The first catalog of Marin's etchings, compiled by E. M. Benson and listing 132 subjects, was published in E. M. Benson, Marsden Hartley, and Henry McBride, *John Marin: Watercolors, Oil Paintings, Etchings* (New York: Museum of Modern Art, 1936). This was superceded by Carl Zigrosser, *The Complete Etchings of John Marin* (Philadelphia: Philadelphia Museum of Art, 1969), which lists 180 subjects. The catalog accompanied an exhibition celebrating the acquisition by the museum of the master set of Marin's etchings. The museum also houses the matrices for more than sixty of the artist's etchings, a few of which are aluminum, the rest copper. Zigrosser's catalog provided the basis for all subsequent research on Marin's prints, and I am indebted to him for his ground-breaking work. Since the time of his publication, however, several new images have been discovered, and additional states of known subjects have been discovered as well.

In addition to the master set at the Philadelphia Museum of Art, other important collections of Marin's etchings can be found at the Metropolitan Museum of Art (including many of the etchings acquired by Alfred Stieglitz, among them several unique images and proofs with hand-drawn additions); the Achenbach Foundation for Graphic Arts, San Francisco, and the Cleveland Museum of Art (both having strong concentrations of the early European subjects); the Art Institute of Chicago; and the Museum of Modern Art, New York. In the course of this research I also studied Marin's etchings at the Columbus Museum of Art, Columbus, Ohio; Detroit Institute of Arts; Fisk University Museum of Art, Nashville; Los Angeles County Museum of Art; Marion Koogler McNay Art Museum, San Antonio, Tex.; Minneapolis Institute of Arts; National Gallery of Art, Washington, D.C.; Phillips Collection, Washington, D.C.; Smith College Museum of Art, Northampton, Mass.; Toledo Museum of Art, Toledo, Ohio; Vassar College Art Gallery, Poughkeepsie, N.Y. and Yale University Art Gallery, New Haven, Conn.; as well as in several private collections.

2. The earliest published article I have found devoted solely to Marin's art is Charles Saunier, "John Marin—Peintre-Graveur," *L'Art décoratif* 18 (January 1908): 17–24. However, Marin is mentioned in earlier articles that discuss group exhibitions in Paris.

3. Charles Blanc, *L'Oeuvre de Rembrandt, décrit et commenté par M. Charles Blanc: Catalogue raisonné de toutes les estampes du maître et ses peintures, orné de bois gravé, de quarante eaux-fortes de Flameng, et de trente-cinq heliogravures d'Amand Durard* (Paris: A. Lévy, 1873). Jay M. Fisher, curator of prints, drawings, and photographs at the Baltimore Museum of Art, has edited an edition of Lalanne's *Treatise* and written a useful introduction to it, published

by Dover Publications in 1981. The text provides a technical background on etchings as practiced in Marin's time. The artist's ownership of it is cited in Helm, *Marin*, p. 13, and in Jerome Mellquist, "John Marin: Rhapsodist of Nature (1870–1953)," *College Art Journal* 13 (Summer 1954): 311.

4. See Helm, *Marin*, pp. 13–14, and Zigrosser, *Etchings*, pp. 7–8. According to Helm's account, written during Marin's lifetime, Bittinger "supervised the purchase of etching equipment"; according to Zigrosser, Bittinger gave Marin his own equipment, which he no longer used.

5. Academy records show that as early as 1876 three prints by Whistler were in the collection: two etchings, *Sketching, No. 1* (Kennedy 86) and *Alderney Street* (K.238); and one lithograph, *Smith's Yard* (Levy 126). That students were encouraged to view the print collection is recorded in the *Circular of Committee on Instruction: Schools of the Pennsylvania Academy of the Fine Arts* for both 1899–1900 and 1900–1901, the years Marin was enrolled. In addition, interest in Whistler at the school during this period is recorded in *The Pennsylvania Academy of the Fine Arts Annual Report*, February 1899, p. 19: Arthur J. Eddy had spoken to a large audience of artists and students on *Days with Whistler* the previous year. For a general discussion of interest in Whistler's prints during this period, including mention of Philadelphia collections, see M. Lee Wiehl, *A Cultivated Taste: Whistler and American Print Collectors* (Middletown, Conn.: Wesleyan University, 1983).

6. Marin to his Aunt Jennie, April 4, 1907, on stationery from the Pension Gregory, Venice, JMA/NGA. Marin's fascination with a visual movement, the "leaning this way and that" he perceived in Saint Mark's, suggests the approach he was to take five years later to the forms of New York City, especially in his etchings and watercolors of the Woolworth Building and the Brooklyn Bridge.

7. Zigrosser (*Etchings*, p. 11) recounted Charles and Edith Bittinger's report that while in Venice, Marin refused to go with the rest of his family to see an exhibition of Whistler's Venice etchings, fearing that he might be influenced by their style and subject.

8. Marin to his father, September 24, 1906, on stationery from the Hôtel Pension Internationale, Amsterdam, JMA/NGA.

9. Marin to his father, August 28, 1905, on stationery from the Hôtel l'Océan, Knocke sur Mer, Belgium, JMA/NGA.

10. Marin to his father, August 26, 1906, on stationery from the Hôtel l'Océan, Knocke sur Mer, JMA/NGA. On other occasions, too, Marin referred to the Rijksmuseum as the Rix Gallery, JMA/NGA.

11. Marin to his father, September 24, 1906, on stationery from the Hôtel Pension Internationale, Amsterdam, JMA/NGA.

12. Gertrude Benson used the phrase "scraped the sky" in "82-Year-Old Marin Tells Artist's Credo," *Philadelphia Inquirer*, July 6, 1952.

13. Elizabeth Luther Cary, *New York Times*; reprinted in *Camera Work* 30 (April 1910): 45–46.

14. Zigrosser, *Etchings*, p. 13.

15. Ibid., p. 11.

16. Zigrosser (*Etchings*, p. 9) also suggested that "Marin's figure drawing was always rather weak," perhaps because "architects never had sufficient training in free figure drawing and were not apt to treat the figure as an integral part of the composition." The notion that Marin's figures are weak seems very off the mark to me. His early sketches of figures in action, made before he went to Europe, are extremely skillful. In addition, the figures in many of the European scenes are perfectly in keeping with the style of the rest of the work. Zigrosser did concede that "in time, he mastered the art of suggesting the movement of pedestrians and crowds." It is impossible to know what he meant by "in time," but in any event, Zigrosser's lack of enthusiasm certainly seems surprising given the lively sense of specific gesture in the tiny figures that people even Marin's earliest etchings. Quite remarkable, for example, are the figures in *Notre Dame, Seen from the Quai Celestins, Paris* (plate 28).

17. For background on the painter-etcher movement in America, see Judith Goldman, *American Prints: Process and Proofs* (New York: Whitney Museum of American Art, 1981), pp. 34–39; C. F. Mandel, *The American Painter-Etcher Movement* (Southampton, N.Y.: Parrish Art Museum, 1984); and Thomas P. Bruhn, *American Etching: The 1880s* (Storrs, Conn.: William Benton Museum of Art, University of Connecticut, 1985).

18. Throughout the text, a *Z* followed by a number is a reference to the appropriate entry in Carl Zigrosser's *Complete Etchings of John Marin*. Benson recorded Marin as telling him that *Hansom Cab, Paris,*

1905, was his first etching. Zigrosser interpreted this to mean that it was the first etching Marin considered successful. Zigrosser records *Street Corner* of the same year as Marin's first etching, pointing out its obvious lack of technical agility.

19. I thank Ray Lewis of San Rafael, Calif., for bringing this impression to my attention.

20. Zigrosser's organization of Marin's etchings within each year is not explained, and it may well be arbitrary. We do not know, then, how his day-by-day development progressed during this crucial period—for example, what are the relationships in time between *Old House, Rue des Arpents, Rouen, I* (plate 32) and other prints of 1909.

21. Marin, in Norman, *Writings*, p. 11.

22. Marin to his father, September 1, 11, and 24, and October 10 and 25, 1906, JMA/NGA. The majority of Marin's etchings that were in Stieglitz's collection are now at the Metropolitan Museum of Art, New York. For this division of the paintings he owned, see Introduction, n. 3.

23. The collections formed by Charles T. Brooks and Moore Achenbach, which are now in the Cleveland Museum of Art and the Achenbach Foundation for Graphic Arts, San Francisco, respectively, seem to reflect this conservative impulse. In both instances only the detailed European views were acquired.

24. Seligmann, "Friend Recalls Life of John Marin," p. A5.

25. Jerome Mellquist, "John Marin: Painter from the Palisades," *Tricolor* 3 (May 1945): 62, 64.

26. Attention to the edges of the printed sheet, outside the image on the plate, was an important aspect of Whistler's prints as well, though it took a very different form. He habitually trimmed the edges of his sheets to the plate marks, explaining this practice in a list of eleven "Propositions" first published in 1886 to accompany *A Set of Twenty-six Etchings*, Whistler's second Venice set. Among his reasons, stated in the last three propositions, were the following: "IX. That the habit of margin, again, dates from the outsider, and continues with the collector in his unreasoning connoisseurship—taking curious pleasure in the quantity of paper. X. That the picture ending where the frame begins, and, in the case of the etching, the white mount, being inevitably, because of its colour, the frame, the picture thus extends itself irrelevantly through the margin to the mount. XI. That we of this kind should leave six inches of raw canvas between the painting and its gold frame, to delight the purchaser with the quality of the cloth." Marin may well have taken all of this into consideration, developing over time his own personal solutions to the problem of establishing a relationship between a print or a painting and its environment. One further note on Marin's prints—subjects that were "framed" by the working of ink during the printing process are not consistently printed; the various impressions of any given subject will not necessarily all show evidence of this strategy.

27. The impression reproduced here is one of at least two that are printed in a warm brown ink that I have not seen in any other impressions of Marin's images and in a manner that does not "feel" like Marin's. I have been unable to obtain firm information about them.

28. Zigrosser (*Etchings*, p. 110) recorded a rejected plate for *Brooklyn Bridge, No. 4*, which, in a sense, may be seen as an even earlier study for *Brooklyn Bridge, No. 6 (Swaying)* (plate 41).

29. Zigrosser (*Etchings*, p. 18) noted Marin's use of rubber pads. The surfaces of some impressions clearly look sponged, and Mrs. John Marin, Jr., confirmed that little pieces of ink-covered sponge were among the materials found in Marin's studio after his death.

30. I thank Denise Thomas, paper conservator at the Philadelphia Museum of Art, for examining prints in the museum's collection and confirming that they are etchings.

31. Marin to his father, September 24, 1906, JMA/NGA. Further support for the fact that some plates were worked on site is given by Zigrosser in *The Artist in America: Twenty-four Close-ups of Contemporary Printmakers* (New York: Alfred A. Knopf, 1942), p. 5. He quoted a letter from Marin published earlier by Lena M. McCauley, *The Print Collector's Bulletin: An Illustrated Catalogue of Painter-Etchings: John Marin* (Chicago: Albert Roullier, 1909): "These personalities (etchings) were put down at places in Paris and Venice during my wanderings about, of things that appealed and impressed me to such an extent that something had to be said, things that were seen in passage, and of an impression deeply felt. The hour demanded them to be stamped and to be done in a manner easiest seen and easiest understood. So the needle was picked up and these etchings made."

32. Marin to his father, October 6 and 25, and November 6, 1906, Paris, JMA/NGA; in Zigrosser, *Etchings*, p. 10.

33. Zigrosser, *Etchings*, p. 5. Ernest Haskell died suddenly in an automobile accident in 1925. The following year, to accompany a Haskell exhibition at the Macbeth Gallery, Marin wrote "A Tribute" to him that was later published in Nathaniel Pousette-Dart, *Ernest Haskell: His Life and Work* (New York: T. S. Hutson, 1931).

34. Pierre Hepp, "La Salon d'Automne," *Gazette des Beaux-Arts* 2 (1908): 398.

35. All information about printers is based on Zigrosser's catalog entries. Zigrosser (*Etchings*, p. 6) also noted fourteen plates that may have been printed by Ernest Roth and indicated that small numbers of all of these plates were printed by Marin, on different papers, prior to the larger editions. It is interesting to note that most of Marin's late prints were done in several versions before the artist arrived at his final image. Among these are *The Sailboat* and *The Lobster Fisherman*; for the latter there were four preliminary plates.

36. See, for example, the letter of September 24, 1906, cited in n. 31.

37. Marin to his father, October 25, and November 6, 1906; JMA/ NGA.

38. Zigrosser, *Etchings*, p. 12; pp. 10–11 carry a mention of Marin's plans to visit a London dealer.

39. Information cited in Kenneth Shopen, "Exhibit Marin Water Colors at Art Institute," *Chicago Daily News*, n.d., Downtown Gallery Papers, AAA, included in a scrapbook in the JMA/NGA. The article is annotated by John Marin, Jr.

40. H. H. Tolerton, *Illustrated Catalogue of Etchings by American Artists: John Marin* (Chicago: Albert Roullier's Art Galleries, 1913).

41. See *Catalogue of an Exhibition of Etchings by John Marin* (New York: Kennedy and Co., 1911).

42. Zigrosser, *Etchings*, p. 17.

43. "Another Side of John Marin," *New York Herald Tribune*, October 31, 1948, JMA/NGA.

44. The announcement and listing of the American Place exhibition, the announcement of the Adele Lawson Galleries exhibition, and the list of venues and exhibited works for the American Federation of Arts show are all on file in the Downtown Gallery Papers, AAA. In addition to the Speed Art Museum, the itinerary for the A.F.A. exhibition, which traveled from April 1953 through January 1955, included showings at the Scarborough School, Scarborough, N.Y.; Winona State Teachers College, Winona, Minn.; Massachusetts Institute of Technology, Cambridge; Willimantic State Teachers College, Willimantic, Conn.; Hotchkiss School, Lakeville, Conn.; Dartmouth College, Hanover, N.H.; Chikurin Gallery, Detroit; Cedar Rapids Association, Cedar Rapids, Iowa; and the North Carolina State Art Gallery, Raleigh, N.C.

45. Justus Bier, "Art in Kentuckiana: Etchings by John Marin Are Shown at Speed," *Courier Journal* (Louisville), April 19, 1953, JMA/ NGA.

46. E. A. Taylor, "The American Colony of Artists in Paris," *Studio* 53 (July 1911): 112–15; in Zigrosser, *Etchings*, p. 14.

EUROPE AND THE RETURN TO AMERICA pages 75–107

1. Mellquist, "John Marin: Rhapsodist of Nature," p. 311.

2. A book on billiards, inscribed with Carles's name, was in Marin's library after his death. His interest in the game seems to have lasted his lifetime; in a letter dated November 23, 1950 (JMA/NGA), Paul Strand wrote from Paris to Marin: "What I miss most is not having any 'Marins' on my wall as daily companions. And also a game of billiards with their 'father.'" For Marin's view of Carles, see "On My Friend Carles," *Artnews* 52 (April 1953): 67. See also Barbara Wolanin, "Carles and Marin: Kindred Spirits," *Archives of American Art Journal* 27 (1987): 2–11.

3. Ernest Haskell, "John Marin," *Arts* 2 (January 1922): 201.

4. Marin, "Notes (Autobiographical)," *Manuscripts* 2 (March 1922): 5.

5. See, for example, Paul Rosenfeld, "John Marin's Career," *New Republic*, April 14, 1937, pp. 289–90.

6. Benson, *Marin*, p. 31.

7. Helm, *Marin*, p. 42. Seligmann, "Marin at Cape Split," p. 23. Marin to Benson, August 17, 1935, E. M. Benson Papers, AAA.

8. Seligmann, "Marin at Cape Split," pp. 23–24.

9. See, for example, Reich, *Marin*, vol. 1, pp. 13–16, 24–31.

10. Rainer Maria Rilke, ed., Clara Rilke and Joel Agee, trans., *Letters on Cézanne* (New York: Fromm International Publishing Corporation, 1985), p. 36.

11. Benson (*Marin*, p. 36) has him traveling home in December; by mid-May of 1910, "Old England [was] in sight" and Marin was anticipating seeing "Paris again & Steichen and Carls' [sic] and the rest"; in Gray, *John Marin by John Marin*, p. 21.

12. Seven of Marin's pastels are in the collection of the National Gallery of Art, Washington, D.C. When they were received, several were titled descriptively [*Street Scene, Paris?*]. It seems clear, however, that all of them are actually Venetian scenes.

13. Marin to his father, September 24, 1906, on stationery from the Hôtel Pension Internationale, Amsterdam, JMA/NGA.

14. On William Merritt Chase and the Pennsylvania Academy of the Fine Arts, see Ronald G. Pisano, *A Leading Spirit in American Art: William Merritt Chase, 1849–1916* (Seattle: University of Washington, Henry Art Gallery, 1983), pp. 105–11.

15. Benson, *Marin*, p. 60.

16. Benson more than any other author tends to stress the equal importance of all aspects of Marin's work; see *Marin*, pp. 47–48. The first major study of Marin's oil paintings is Klaus Kertess, *Marin in Oil* (Southampton, N.Y.: Parrish Art Museum, 1987).

17. Benson, *Marin*, p. 56.

18. Norman, *Writings*, p. xi. *The Mills at Meaux* seems to be lost. Benson (*Marin*, p. 27) indicated that the painting dated from 1906, and Reich maintained that date. I see no reason to suggest a date earlier than 1907, the year Marin completed several other paintings of similar size, subject, and style, and the year the painting is said to have been sold. Helm (*Marin*, pp. 15–16) indicated that the purchase was arranged by the American painter George Oberteuffer and noted that the painting was "somewhere in a provincial museum," countering the notion that it had been sold to "the Luxembourg," noted in Norman, *Writings*, p. xi.

19. On the American watercolor tradition, see Theodore E. Stebbins, Jr., *American Master Drawings and Watercolors* (New York: Harper and Row, Publishers, 1976); Donelson F. Hoopes, *American Watercolor Painting* (New York: Watson-Guptill Publications, 1977); and Christopher Finch, *American Watercolors* (New York: Abbeville Press, 1987). On Whistler's watercolors, see Ruth E. Fine, "Notes and Notices: Whistler's Watercolors," in John Wilmerding, ed., *Essays in Honor of Paul Mellon, Collector and Benefactor* (Washington, D.C.: National Gallery of Art, 1986), pp. 111–33; on Sargent's watercolors, see Carter Ratcliff, *John Singer Sargent* (New York: Abbeville Press, 1982); and on Homer's watercolors, see Helen A. Cooper, *Winslow Homer Watercolors* (Washington, D.C.: National Gallery of Art, 1986).

20. Charles Caffin, *New York American*; reprinted in *Camera Work* 48 (October 1916): 37.

21. Charles Caffin, *New York American*, January 27, 1913; reprinted in *Camera Work* 42–43 (April–July 1913): 42.

22. Margery Austen Ryerson, "John Marin's Watercolors," *Art in America* 9 (February 1921): 91.

23. Paul Haviland was an associate of both Stieglitz and Marin. A graduate of Harvard, he was the heir to his family's porcelain-manufacturing business in France and seems to have traveled frequently between Paris and New York. Haviland, a photographer himself, assisted Stieglitz's efforts to promote modern art in America by becoming an associate editor of *Camera Work* and a cofounder of the periodical *291*, and by providing financial assistance to Stieglitz's 291 Gallery. Reich ascribes a few portraits of women to Marin's years in Paris, specifically, *Girl Sewing* (R.10.27) and *Woman in an Interior* (R.10.93).

24. This painting has been titled *Berkshire Landscape*, but it is precisely the same view as another painting of the same year, *Hudson River, Hook Mountain*, 1925, the title of which was inscribed on the verso by Marin. See Ruth E. Fine, *John Marin's Autumn* (New York: Kennedy Galleries, 1988), no. 14.

25. J. Nilsen Laurvik, *Boston Transcript*; reprinted in *Camera Work* 42–43 (April–July 1913): 42.

26. Jennie Currey to her sister, Lelia, and to her nieces Lyda and Retta, July 11, 1913; to "Dear Everybody," July 20, 1913; and to Retta, August 3, 1913; all in a private collection. Although the place from which the last letter was written is not noted, it presumably is again from Castorland, given the references to the scarcity of mutton,

which is also mentioned in other letters, and despite the curious comment that there were few chances to paint, since Marin, in fact, made a good number of paintings that summer.

27. For Marin's views of photography, see "Can a Photograph Have the Significance of Art"; in Norman, *Writings*, pp. 86–88.

28. Rosenfeld, "John Marin's Career," p. 291.

29. James Huneker, *New York Sun*, April 7, 1909; reprinted in *Camera Work* 27 (July 1909): 42.

30. Charles H. Caffin, from the catalog for the exhibition; reprinted in *Camera Work* 27 (July 1909): 46.

31. [?] Harrington, *New York Herald*, April 5, 1909; reprinted in *Camera Work* 27 (July 1909): 44.

32. The numbers for the various media come from *Camera Work* 27 (July 1909): 44. Helm (*Marin*, p. 23) cited eight etchings rather than ten.

33. William D. MacColl, "Exhibition of Water-Colors, Pastels and Etchings by John Marin"; reprinted in *Camera Work* 30 (April 1910): 43.

34. Elizabeth Luther Cary, *New York Times*; reprinted in *Camera Work* 30 (April 1910): 45.

35. J. Nilsen Laurvik, *Camera Work* 39 (July 1912): 38.

36. Ralph Flint, "Recent Work by Marin Seen at American Place," *Artnews* 30 (October 17, 1931): 3.

37. Paul Rosenfeld, "American Painting," *Dial* 71 (December 1921): 668–69.

38. Jerome Mellquist, "John Marin, An Affirmative American Painter," unpublished article, dated January 1934, JMA/NGA.

39. Forbes Watson in the *World*, December 20, 1925; reprinted in an Intimate Gallery brochure, *John Marin at the Intimate Gallery*, 1925, William Dove Papers, AAA.

40. There is an extensive body of literature on the Armory Show. The standard text has been Milton W. Brown, *The Story of the Armory Show* (New York: Abbeville Press, 1988). See also *The Armory Show —50th Anniversary Exhibition* (Utica, N.Y.: Munson-Williams-Proctor Institute, 1963).

41. Henry McBride, writing about an exhibition of children's drawings at 291 for the *New York Sun* (reprinted in *Camera Work* 48 [October 1916]: p. 38), made the amusing observation that "as everybody knows, we are born Cubists and it is only after years of arduous and expensive study that we learn how not to be Cubists."

42. See M. E. Chevreul, *The Principles of Harmony and Contrast of Colors and Their Applications to the Arts*, with an introduction and explanatory notes by Faber Birren (1839, first French edition; 1854, first English translation; New York: Reinhold Publishing Corporation, 1967).

43. Paul Rosenfeld, "The Water-Colours of John Marin," *Vanity Fair*, April 1922, p. 54. Rosenfeld, in particular, seems to be writing about the importance of the unconscious.

44. Willard Huntington Wright, "John Marin's Watercolors," *International Studio* 58 (March 1916); reprinted in *Camera Work* 48 (October 1916): 54.

45. John Marin, "What Is 291?" *Camera Work* 47 (July 1914): 74.

THE URBAN LANDSCAPE pages 109–63

1. Helm, *Marin*, p. 32.

2. Marie Marin to Lelia Currey, n.d., private collection. Elements in this letter correspond with one from Marin to Stieglitz, Cyrus, Mass., October 5, 1918; in Norman, *Writings*, pp. 37–40. Therefore, Marie's letter probably dates from 1918, the year after Stieglitz closed 291.

3. "Noted Artist Abhors All 'Isms' Except Real 'ism' in Art," *Palisadian*, December 11, 1947.

4. Benson, "Marin Tells Artist's Credo."

5. J.W.L., "J. Marin's Best Paintings in Oil to Date," *Artnews* 38 (December 30, 1939): 12.

6. *John Marin: The Weehawken Sequence*, an exhibition devoted solely to the series, was held in 1985 at the Jersey City Museum, Jersey City, N.J.

7. Dorothy Seckler, "Marin," *Artnews* 49 (April 1950): 44.

8. The Weehawken Sequence paintings were exhibited at the 1950 American Place show with a date of 1903–4; but 1903 has been the date most consistently attached to them from that exhibition until

Reich's redating of them to 1916 in 1970 (*Marin*, vol. 1, pp. 97–98). In the introduction to *John Marin, 1870–1953* (Los Angeles: Los Angeles County Museum of Art, 1970), Larry Curry questioned Reich's 1916 date, leaning in favor of Marin's own, and in his entries for the Weehawken Sequence paintings he listed the dates as "1903–04?" Reviews of that exhibition vary on the subject. Robert Rosenblum ("Marin's Dynamism," *Art Digest* 28 [February 1, 1954]: 13) tends to assume Curry's date; Abraham A. Davidson ("John Marin: Dynamism Codified," *Artforum* 9 [April 1971]: 41) ignores the dating issue entirely; and Patrick McCaughey ("Where Paleface Meets Redskin," *Artnews* 70 [May 1971]: 30–33, 77–78) finds Reich's later date convincing. Presumably Marin's son, John C. Marin, Jr., never fully accepted Reich's date. A catalog of a 1977 exhibition, *John Marin: Paintings, 1903–1953*, at Marlborough Gallery, New York, which was then handling the Marin estate, continued to attach the 1903–4 date to the Weehawken Sequence; that date was also used in the 1980 exhibition *John Marin: The Etchings and Related Oils, Drawings and Watercolors*, organized in 1980 by Cape Split Place, a gallery run for several years by Mr. and Mrs. John C. Marin, Jr.

9. Benson, *Marin*, p. 35.

10. The JMA/NGA includes sixteen sketchbooks worked from before Martin went to art school through the last years of his life. On the drawings in the archive see Ruth E. Fine, "The John Marin Archive at the National Gallery of Art," *Drawing* 9 (September–October 1987): 54–57.

11. Despite Reich's comment (in *John Marin: Drawings, 1886–1951*, p. 9) that the drawings were "never intended for public view," Marin exhibited them frequently, for example: in his one-man show at 291 during January and February 1916; at a one-man show at the Metropolitan Museum of Art in 1924; in selected one-man exhibitions at An American Place from 1935 to 1946; in two one-man exhibitions at the Downtown Gallery in 1948 and 1950; in the New Jersey State Museum's exhibition, *John Marin: A Retrospective Exhibition, 1921–1949*, December 1950–January 1951; and in *John Marin: Water Colors, Oils, Prints and Drawings* at the Munson-Williams-Proctor Institute Art Gallery, December 1951. Many were given elaborate presentation mountings.

12. On the Woolworth Building, see Robert A. M. Stern, Gregory Gilmartin, and John Montague Missengale, *New York 1900: Metropolitan Architecture and Urbanism, 1890–1915* (New York: Rizzoli International Publications, 1983), pp. 175, 176–77.

13. Four of Marin's Woolworth Building watercolors were given to the National Gallery of Art by Agnes and Eugene Meyer in 1967.

14. This work entered the National Gallery's collection with a date of c. 1913. Dealing with Marin's dates can be an enormous problem. He signed and dated his works many years after the fact, perhaps at the time they were sold. Evidence for this is found in a letter from Stieglitz cited in Reich, *Marin*, vol. 2, p. 408 (R.15.29 has an inscription on the back of the watercolor itself), pertaining to a watercolor in a private collection: "This Marin is not signed. Marin is ill and I don't want to keep you waiting. Marin is written all over the watercolor. Signatures are easily forged. The watercolor not. . . ." In addition, a letter from Edith Halpert to Albert Chris-Janer, March 13, 1947, states, "[We] are trying to get young John to go through the material with his father, marking dates and titles on any of the undated and untitled pictures. . . ." Another, of May 9, 1947, indicates that Marin "seems pretty much lost without Stieglitz and cannot make up his mind about anything at anytime." Both letters are in the Institute of Contemporary Art, Boston, Papers, AAA.

15. Marin, in the 291 catalog; reprinted in *Camera Work* 42–43 (April–July 1913): 18. The artist further elaborated on his views on architecture in "The Living Architecture of the Future," *New York American*, February 16, 1913, p. 4.

16. Ryerson, "John Marin's Watercolors," p. 88.

17. Mellquist, "Marin: Painter from the Palisades," p. 61.

18. W. B. McCormick (in the *New York Press*) and Royal Cortissoz (in the *New York Tribune*), in Sheldon Reich, "John Marin: Paintings of New York, 1912," *American Art Journal* 1 (Spring 1969): 45.

19. Charles Caffin, *New York American*, January 27, 1913; reprinted in *Camera Work* 42–43 (April–July 1913): 43.

20. See John Oliver Hand, "Futurism in America: 1909–14," *Art Journal* 41 (Winter 1981): 337–42; and Reich, "Paintings of New York," pp. 43–52.

21. See Reich, "Paintings of New York," pp. 49–52.

22. In the scrapbooks in the JMA/NGA are a number of images the artist clipped from various newspapers and magazines. Among them

are images of the Brooklyn Bridge, as well as Maine landscapes and sailboats (plate 175). Just as Delaunay's Eiffel Towers have been associated with Marin's Woolworth Buildings, so have similar associations been made between the former's 1909 series on Saint-Séverin and the latter's Brooklyn Bridges; see Reich, *Marin*, vol. 1, pp. 58–60.

23. Lewis Mumford, "Sticks and Stones," in Waldo Frank, introduction to *The Collected Poems of Hart Crane* (New York: Liveright Publishing Corporation, 1946), p. xviii.

24. On the Brooklyn Bridge, see *The Great East River Bridge, 1883–1983* (Brooklyn: Brooklyn Museum, 1983).

25. Ibid., pp. 64, 66.

26. The critic Waldo Frank, in his introduction to *The Collected Poems of Hart Crane* (p. xxviii), said of Crane's *Bridge* that "a cosmic content has given beauty to the Bridge; now it must give it a poetic function. From being a machine of body, it becomes an instrument of spirit. The Bridge is matter made into human action."

27. Illustrations are scattered throughout *The Great East River Bridge*, but concentrated selections are found on pp. 108–22 and 153–71.

28. For accounts of these buildings see Stern, Gilmartin, and Missengale, *New York 1900*: on the Telephone Building, pp. 162, 165; and on the Singer Building, pp. 170–71.

29. Rosenfeld, "American Painting," p. 653.

30. "Skyscrapersoup" was applied to Marin's work by William Carlos Williams in a poem titled *Young Love*; in Marjorie Perloff, "William Carlos Williams," in *Voices and Visions*, Helen Vendler, ed. (New York: Random House, 1987), pp. 183–84.

31. Marin to Stieglitz, Stonington, Maine, September 24, 1924; in Norman, *Writings*, p. 100.

32. Ralph Flint, "Marin Exhibits New Landscapes Done in Taos," *Artnews* 29 (November 8, 1930): 5.

33. Marin to Elizabeth S. Navas, September 31, 1951, Elizabeth S. Navas Papers, AAA.

34. "Current Marin Exhibition Is Concentrated on Oils," *Springfield Republican*, November 24, 1932.

35. Ralph Flint, "John Marin Blazes New Trails," *New York Sun*, January 16, 1937.

36. Paul Rosenfeld, "John Marin," in *Port of New York* (New York: Harcourt, Brace and Company, 1924), pp. 162–63.

MAINE: WHERE LAND AND WATER MEET pages 165–207

1. Marin to Stieglitz, Small Point, Maine, July 31, 1917; in Norman, *Writings*, p. 35.

2. On the American landscape tradition, see Kynaston McShine, ed., *The Natural Paradise: Painting in America, 1800–1950* (New York: Metropolitan Museum of Art, 1976); Barbara Novak, *Nature and Culture: American Landscape Painting, 1825–1875* (New York: Oxford University Press, 1980); and John K. Howat, *American Paradise: The World of the Hudson River School* (New York: Metropolitan Museum of Art, distributed by Harry N. Abrams, 1987). All have useful bibliographies.

3. Ryerson, "John Marin's Watercolors," pp. 87–88.

4. See *The Short Stories of Ernest Hemingway* (New York: Modern Library, 1942), pp. 307–30.

5. I am grateful to Josephine Haskell Aldridge, Ernest Haskell's daughter, and her husband, Richard Aldridge, for welcoming me to their home, showing me the barn from which Marin carried his daily pail of milk, and allowing me to wander on their land looking for Marin-like sights.

6. Haskell, "Marin," p. 201.

7. Rosenfeld, "John Marin's Career," p. 291. Jerome Mellquist ("Marin: Painter from the Palisades") gave a slightly different account. In his version Marin had two years' worth of support money; he reported his purchase to Stieglitz in the autumn, presumably after his return from Maine; and the cost of the island, acquired at Marie's urging, was one thousand dollars. Helm (*Marin*, p. 36) reported that the island was purchased in 1915.

8. Marin to Stieglitz, West Point, Maine, August 7, 1914; in Norman, *Writings*, p. 14.

9. Charles Caffin, *New York American*; reprinted in *Camera Work* 48 (October 1916): 37.

10. Henry Tyrell, *Christian Science Monitor*; reprinted in *Camera Work* 48 (October 1916): 53.

11. Jennie Currey to Retta Currey, postmarked July 20, 1915, private collection.

12. Jennie Currey to her sister-in-law Mary Coupland, undated letters in envelopes postmarked July 29, 1915, and August 1, 1915, private collection.

13. Wright, "Marin's Watercolors"; reprinted in *Camera Work* 48 (October 1916): 54.

14. Forbes Watson, *New York Evening Post*; reprinted in *Camera Work* 48 (October 1916): 38.

15. Henry McBride, *New York Sun*; reprinted in *Camera Work* 48 (October 1916): 46. The comment that "the whole world is feeling its age" is presumably a reference to the war.

16. Marin to Stieglitz, Echo Lake, Pa., September 6, 1916; in Norman, *Writings*, p. 28.

17. *The Forum Exhibition of Modern American Painters* (1916; reprint, New York: Arno Press, 1968).

18. Marin to Stieglitz, West Point, Maine, September 16, 1914; in Norman, *Writings*, p. 16.

19. Dorothy Norman, "John Marin: Conversations and Notes," *Art Journal* 14 (Summer 1955): 324–25.

20. Arthur Wesley Dow, in Judith Katy Zilczer, "The Aesthetic Struggle in America, 1910–1918, Abstract Art and Theory in the Stieglitz Circle," Ph.D. diss., University of Delaware, 1975, p. 33.

21. For a discussion of musical analogy and theories of abstract art in America, see Zilczer, "Aesthetic Struggle," pp. 43–110. See also Chapter 4 in Donna M. Cassidy, "The Painted Music of America in the Works of Arthur G. Dove, John Marin, and Joseph Stella: An Aspect of Cultural Naturalism," Ph.D. diss., Boston University, 1988, pp. 171–228.

22. Marin to Stieglitz, Small Point, Maine, September 19 and 26, 1915; in Norman, *Writings*, p. 26.

23. Paul Strand, "John Marin," *Art Review* 1 (January 22, 1922): 22–23.

24. Helm, *Marin*, p. 41.

25. Marin to Stieglitz, Stonington, Maine, July 1, 1919; in Norman, *Writings*, p. 42; and Marin to Stieglitz, Stonington, Maine, August 21, 1927; ibid., p. 115.

26. Marin, in Norman, "Conversations and Notes," pp. 326–27.

27. Marin to Stieglitz, Stonington, Maine, August 13, 1919; in Norman, *Writings*, p. 46.

28. Marin to Stieglitz, Stonington, Maine, August 22, 1920; ibid., p. 58.

29. Marin to Stieglitz, Stonington, Maine, September 14, 1920; ibid., p. 59.

30. John C. Marin, Jr. (in conversation with the author, August 24, 1987), provided the information about his father's reading habits. Haskell, "John Marin," p. 201.

31. Rosenfeld, "John Marin's Career," p. 292.

32. Mellquist, "Affirmative American Painter."

33. Paul Strand, "American Water Colors at the Brooklyn Museum," *Arts* 1–2 (December 1921): 152.

34. Elizabeth Luther Cary, "Modern American Painting," *International Studio* 80 (December 19, 1924): 214.

35. Rosenfeld, "American Painting," pp. 664–65.

36. The word "thundering" had been used in comparing Homer's rugged Maine watercolors to Marin's delicate ones of 1914–15. In 1923 the term was used by Alexander Brook (*Arts* [April 1923]: 272) in reference to Marin's recent works.

37. Guy Eglington, *American Art News* (December 12, 1925); reprinted in *John Marin at the Intimate Gallery*, 1925. William Dove Papers, AAA.

38. Rosenfeld, "The Water-Colours of John Marin," p. 88; and Paul Rosenfeld, "The Marin Show," *New Republic*, February 26, 1930, p. 49.

39. A scrapbook in the JMA/NGA includes an article titled "New Styles in Picture Frames," from the *New York Herald Tribune*, bearing an inscribed date of January 14, 1935. Marin's concern with frames was not unique. In the generation preceding his, similar attention had been paid by Georges Seurat, Whistler, and a number of the Pre-Raphaelites. Among Marin's contemporaries, Marsden Hartley and

especially Maurice Prendergast (in collaboration with his brother Charles) shared Marin's interest in this aspect of art.

40. Marin to Stieglitz, Stonington, Maine, July 1, 1919; in Norman, *Writings*, p. 42. On Cubism and *Maine Island*, see McCaughey, "Where Paleface Meets Redskin," p. 33.

41. Marin to Stieglitz, Stonington, Maine, July 27, 1919; in Norman, *Writings*, p. 44.

42. Herbert J. Seligmann, "Frames: With Reference to Marin," *It Must Be Said* 3 (January 8, 1934), JMA/NGA.

43. Flint, "Marin Blazes New Trails."

44. Benson, "Marin Tells Artist's Credo." Among various catalogs in Marin's scrapbooks is one from Hammacher, Schlemmer and Co. for wood-carving tools.

45. Norman, "Conversations and Notes," p. 327. It has been noted that Marin's frames sometimes extended the elements and colors of the paintings "so forcefully and assiduously that the coloring and patterns on the frame became too dominant for the painting in it. Many owners have replaced his frames with more restrained, more neutral moldings." (See Henry Heydenryk, *Art and History of Frames* [New York: James H. Heineman, 1963], p. 110.) Reflecting a serious misunderstanding of the importance of the frame to Marin, such alterations are equivalent to cutting off the outer three inches or so of the painting.

NEW ENGLAND AND NEW MEXICO pages 209–27

1. See Debra Bricker Balken, *John Marin's Berkshire Landscapes* (Pittsfield, Mass.: Berkshire Museum, 1985).

2. The Rowe, Massachusetts, paintings number more than seventy-five.

3. Helm (*Marin*, p. 41) found the Rowe paintings less exciting than many of Marin's other works, suggesting that Marin worked so abstractly because he didn't find the landscape very interesting. Reich (*Marin*, vol. 1, pp. 114–21), on the other hand, found them among Marin's most abstract and far-reaching works, and as such, a body of work of crucial importance. Balken (*Berkshire Landscapes*, n.p.) suggested that these works inaugurated a "quasi-abstract style which was to inform Marin's work from 1918 onwards." I believe that 1917 was the crucial year in Marin's move toward abstraction and that in the 1918 Rowe, Massachusetts, paintings he solidified the process of moving his work in two directions simultaneously—toward a greater abstraction and toward a close fidelity to picturesque visual detail—parallel interests that were to mark his work for the rest of his career. That, rather than any far-reaching exploration of abstract form, made the season a crucial one in Marin's career.

4. Marin to Stieglitz, Rowe, Mass., July 26, 1918; in Norman, *Writings*, p. 36.

5. Marin to Stieglitz, Cyrus, Mass., October 5, 1918; ibid., pp. 37–40.

6. Marin to Stieglitz, Cyrus, Mass., November 2, 1918; ibid., p. 40.

7. Marin to Stieglitz, Cyrus, Mass., November 2, 1918; ibid., p. 41.

8. Rosenfeld, "Marin's Career," p. 291.

9. This information was supplied by John C. Marin, Jr., in a conversation with the author, August 25, 1987.

10. On the New Mexico paintings, see Van Deren Coke, *Marin in New Mexico: 1929 and 1930* (Albuquerque: University Art Museum, University of New Mexico, 1968).

11. Marin to Stieglitz, Taos, N. Mex., July 21, 1929; in Norman, *Writings*, p. 129.

12. Ibid.

13. Marin to Paul Strand, Taos, N. Mex., June 22, 23, 25 ("one of these, I don't know which"), 1929; in Norman, *Writings*, p. 128.

14. The quotation is from a review clipped without citation included in a scrapbook in JMA/NGA.

15. Marin to Emil C. Zoler, Taos, N. Mex., August 25, 1929; in Norman, *Writings*, p. 132.

16. Ibid.

17. Marin to Stieglitz, Taos, N. Mex., August 4, 10, and 14, 1930; in Norman, *Writings*, pp. 134–135.

18. Marin to Zoler, Taos, N. Mex., August 25, 1929; ibid., p. 132.

19. See Sharyn Rohlfsen Udall, *Modernist Painting in New Mexico, 1913–1935* (Albuquerque: University of New Mexico Press, 1984); and Charles C. Eldredge, Julie Schimmel, and William H. Truettner, *Art in New Mexico, 1900–1945: Paths to Taos and Santa Fe*

(Washington, D.C.: Smithsonian Institution; New York: Abbeville Press, 1986).

20. Marin to Stieglitz, Taos, N. Mex., August 25, 1929; in Norman, *Writings*, p. 131.

21. Mabel Dodge Luhan to Marin, n.d., JMA/NGA.

22. Flint, "Recent Work by Marin," p. 5.

23. Murdock Pemberton, "The Art Galleries," *New Yorker*, January 11, 1930, p. 73.

THE SEA pages 229–47

1. Marin to Stieglitz, Addison, Maine, September 10, 1936; in Norman, *Writings*, p. 171.

2. Seligmann, "Marin at Cape Split," p. 23.

3. Marin to Bill Thompson, July 14, 1947, private collection.

4. Ibid., July 7, 1948, private collection. "The Spirit of the Cape" refers to Susie Thompson; see plate 200.

5. See John I. H. Baur, *John Marin and the Sea* (New York: Kennedy Galleries, 1982), n.p.

6. Years earlier Marin had described such storms: "Today it is blowing up what they call a 'Souwester' and you want to have a good stout rope to moor your boat—otherwise you won't have any boat—and the Seas are piling up on the rocks—and the wind moans, howls, and whistles." Marin to Stieglitz, Small Point, Maine, September 19 and 26, 1915; in Norman, *Writings*, p. 23.

7. Marin to Stieglitz, North Hero, Vt., August 28, 1931; ibid., pp. 142–43.

8. Marin to Zoler, Addison, Maine, September 14, 1933; ibid., pp. 153, 155.

9. Baur, *Marin and the Sea*, n.p.

10. Henry McBride, "John Marin Exhibits Oils," *New York Sun*, November 19, 1932.

11. Ibid.

12. Flint, "Marin Blazes New Trails."

13. Edward Alden Jewell, "Art by John Marin Is Displayed Here," *New York Times*, February 2, 1938.

14. Over the years, Marin's letters and other writings include numerous references, both direct and indirect, to critics and the critical response to his work, for example: " 'Tell 'em to go to Hell.' I find that a beautiful answer to all things if one is really busy doing things that give one an exaltation. In the doing you don't really care for opinions, for they were not with you, were not you, at the time, can never rob you of memories, of exaltation." (Marin to Stieglitz, Stonington, Maine, September 11, 1921; in Norman, *Writings*, p. 71); or "One of my wife's nephews . . . was all *het up* over an article in Sunday's *Times*—belittling his *Wonder Uncle's* efforts . . . that my line or form didn't mean anything. . . . Good thing I am getting to be—*A real hardboiled*." (Marin to Stieglitz, Cliffside, N.J., October 19, 1924; in Norman, *Writings*, p. 101); or "For one worker, the seer, is apt to damn all terms applied by the discussionists." ("John Marin, by Himself," in Norman, *Writings*, p. 1); or "To you my Oil Kids . . . there are those who have said. . . . You should never have been born—give them not a thought. . . ." ("To My Paint Children," in Norman, *Writings*, p. 179).

15. Mellquist, "Affirmative American Painter."

16. "Noted Artist Abhors All 'Isms,' " *Palisadian*.

LATE CALLIGRAPHIC WORKS pages 249–75

1. Marin to Susie Thompson, April 6, 1946, private collection.

2. Marin to Louis Kalonyme, Cape Split, Maine, July 7, 1953, JMA/NGA.

3. Al Newbill, "New Marin Signatures," *Art Digest* 27 (January 15, 1953): 13.

4. Flint, "Marin Blazes New Trails."

5. Marin's love for the circus was cited by both John C. Marin, Jr. (conversation with the author, August 25, 1987), and Dorothy Norman (telephone conversation, December 22, 1988).

6. Marin to Stieglitz, Addison, Maine, August 30, 1936; in Norman, *Writings*, p. 169.

7. Frederick S. Wight, "Marin, Late View of a U.S. Master in Boston's Retrospective," *Artnews* 45 (January 1947): 41.

8. John C. Marin, Jr., conversation with the author, August 25, 1987.

9. "Marin: New Stature in Oils," *Artnews* 44 (December 1945): 21.

10. Benson, "Marin Tells Artist's Credo."

11. Marin to Stieglitz, Addison, Maine, August 31, 1940; in Norman, *Writings*, p. 194.

MARIN AT WORK pages 277–83

1. Marin to Stieglitz, Stonington, Maine, October 7 to October 12, 1920; in Norman, *Writings*, p. 62.

2. Marin to Stieglitz, Stonington, Maine, October 1, 1922; ibid., p. 83.

3. Marin to Stieglitz, Cliffside, N.J., October 18, 1925; ibid., p. 105.

4. Marin to Stieglitz, Addison, Maine, August 31, 1940; ibid., p. 192.

5. Marin to Mr. Lustberg, Cliffside, N.J., April 24, 1933; ibid., pp. 148–49.

6. Marin to Stieglitz, Sebasco, Small Point, Maine, August 28, 1932; ibid., p. 146.

7. Marin to Stieglitz, Cliffside, N.J., September 23, 1937; ibid., p. 175.

8. Marin to Stieglitz, Addison, Maine, July 12, 1939; ibid., p. 192.

9. "Noted Artist Abhors All 'Isms,' " *Palisadian*.

290. Alfred Stieglitz. *John Marin*, 1922. Palladium print, 9⅜ x 7⅝ in. National Gallery of Art, Washington, D.C.; Gift of Georgia O'Keeffe.

CHRONOLOGY BY BEN GLENN II

1870　December 23—John Currey Marin is born in Rutherford, New Jersey. His mother dies within days of his birth, and he is raised by his maternal grandparents and two maiden aunts, Jennie and Lelia Currey, first in Weehawken and then Union Hill (now Union City), New Jersey. He also has a married uncle, Richard Currey, with whose daughters, Retta and Lyda, Marin is closely associated.

1880–86　Attends school in New Jersey: Union Hill Public School; Hoboken Academy; Stevens Academy (1882–86); and Stevens Institute of Technology (September–December 1886).

1886　Makes his earliest dated drawing, a Catskill Mountains scene.

1888　Executes his earliest dated watercolors—views of White Lake, Sullivan County, New York. Travels and sketches in the Midwest, including Cleveland, Detroit, Chicago, Milwaukee, Minneapolis, and Saint Paul.

1888–92　Works for a wholesale notion house and then in various architects' offices.

c. 1892　Begins working independently as an architect and designs six residences in Union Hill, New Jersey (until about 1897).

1899–1901　Studies with Thomas P. Anshutz and Hugh Breckenridge at the Pennsylvania Academy of the Fine Arts, Philadelphia.

1900　Wins Pennsylvania Academy prize for outdoor sketches made in Weehawken of wild fowl and riverboats.

1902–3 or 1903–4　Attends Art Students League, New York, studying under Frank Vincent DuMond.

1905　September—travels to Paris, where he briefly attends the Delecluse Academy and the Académie Julian. Executes first etchings of European street scenes. Travels to Amsterdam and the Belgian coast. November—Alfred Stieglitz's Little Galleries of the Photo-Secession (known as 291) opens at 291 Fifth Avenue, New York.

291. Marin and his aunt Jennie Currey, c. 1900.
Private collection.

1907 Meets Chicago print dealer Albert Roullier in Paris. April
—travels to Italy; spends six weeks in Venice, where he
meets the critic Henry McBride, and also makes brief
stops in Florence, Rome, and Genoa. Marin's oil, *Mills at
Meaux,* is acquired by the French government.

EXHIBITIONS
Salon des Artistes Indépendants, 23e Exposition, Serres du
Cours, Paris, March 20–April 30.
Salon d'Automne, 5e Exposition, Grand Palais, Paris,
October 1–22.

1908 First article on Marin is published: Charles Saunier, "John
Marin: Peintre-Graveur," *L'Art décoratif* 18 (January
1908): 17–24. February—becomes part of the New
Society of American Artists in Paris; other members are
Patrick Henry Bruce, Jo Davidson, Richard Duffy,
Maximilien Fischer, J. Kunz, Alfred Maurer, Donald Shaw
MacLaughlin, E. Sparks, Max Weber, and Albert
Worcester. February 3–15—exhibition of "The Eight" at
Macbeth Galleries, New York, showing the work of
Arthur B. Davies, William Glackens, Robert Henri, Ernest
Lawson, George Luks, Maurice Prendergast, Everett
Shinn, and John Sloan. Spring–summer—visits
Amsterdam, Bruges, Antwerp, and Brussels. Autumn—
Edward Steichen sees Marin's watercolors for the first
time at the Salon d'Automne; shortly thereafter Steichen
meets Marin through Arthur B. Carles and then sends his
work to Alfred Stieglitz in New York. November—an
etching, *Meaux Cathedral II,* is reproduced in *Gazette des*

Beaux Arts (as *Cathedral of St. Stephen*). December—
travels to London.
EXHIBITIONS
Salon des Artistes Indépendants, 24e Exposition, Serres du
Cours, March 20–May 2.
Salon d'Automne, 6e Exposition, Grand Palais, October 1–
November 8.

1909 June—Marin and Stieglitz meet for the first time, in
Marin's Paris studio. Probably December—Marin returns
to the United States.
EXHIBITIONS
John Marin, American Etcher, Albert Roullier's Art Gallery,
Chicago, January 4–18 (with checklist). 36 European
etchings.
*Watercolors by John Marin and Sketches in Oil by Alfred
Maurer,* 291, New York, March 30–April 17. Marin's first
appearance at 291, with 25 watercolors of his shown
with 15 oil paintings by Alfred Maurer.
Salon d'Automne, 7e Exposition, Grand Palais, October 1–
November 8. Includes oil paintings by Marin.

1910 May—returns to Paris. Spends six weeks in the town of
Kufstein in the Austrian Tyrol; stops in Munich,
Nuremberg, and Strasbourg. Autumn—returns to New
York.
EXHIBITIONS
John Marin, 291, February 7–25. 43 watercolors, 20
pastels, 8 etchings. Marin's first one-man exhibition at
291.

292. Photograph of the painting *Mills at Meaux*
(purchased by the French government in 1907, now
lost), n.d. Private collection.

The Younger American Painters, 291, March 21–April 15. Includes Daniel Putnam Brinley, Arthur B. Carles, Arthur G. Dove, Marsden Hartley, Marin, Maurer, Steichen, and Weber.
Salon d'Automne, 8e Exposition, Grand Palais, October 1–November 8. Includes 10 watercolors by Marin.

1911 Summer—spends a month with his aunts at Egremont Plains, Massachusetts, in the Berkshire Mountains. Paints along the Hudson River and on Long Island.
EXHIBITIONS
John Marin, 291, February 2–22. Focuses on Marin's paintings of the Austrian Tyrol.
Exhibition of Etchings by John Marin, Kennedy and Co., New York, May (with checklist). 33 European etchings.

1912 Summer—visits Adirondack and Berkshire Mountains with his aunts and fiancée, Marie Jane Hughes. December 7—marries Marie Hughes; they take honeymoon trip to Washington, D.C. Winter—the Marins stay with Sarah Hughes Shaw, Marie's widowed sister, in Brooklyn's Flatbush section.
EXHIBITIONS
Annual Exhibition, Pennsylvania Academy of the Fine Arts, Philadelphia. Includes 15 watercolors by Marin.

1913 February 16—*New York American* publishes Marin's theory of "living" art and architecture. Summer—lives in Castorland, Lewis County, New York, on the Black River. Fall—lives and works in New York at Twenty-eighth Street and Fourth Avenue. December 17—Charles Daniel opens the Daniel Gallery at 2 West Forty-seventh Street, New York.
EXHIBITIONS
Watercolors and Oils by John Marin, 291, January 20–February 15. 28 works.
International Exhibition of Modern Art (the Armory Show), New York, February 17–March 15. Over 1,000 paintings and sculptures by 300 artists; includes 10 watercolors by Marin.
John Marin, Albert Roullier's Art Gallery. 49 European etchings.

1914 Marin's *Fifth Avenue* is on the cover of *Puck* magazine's March 21 issue. Visits West Point, Maine. This year, Marin's first in Maine, is one of his most prolific to date, resulting in some 100 paintings. November 22—only son, John Currey Marin, Jr., is born.

1914 or 1915 Purchases "Marin Island" off Small Point Harbor, Maine; a lack of water makes it uninhabitable, but Marin camps, fishes, and paints there.

1915 Summer—stays at the Alliquippa House, near Small Point Beach, Maine.
EXHIBITIONS
John Marin: Water Colors, Oils, Etchings, Drawings, Recent and Old, 291, February 23–March 26.

1916 Spends summer and fall at Echo Lake, Pennsylvania, in the Kittatinny Mountains near the Delaware Water Gap. Jennie Currey dies.
EXHIBITIONS
One-man exhibition of watercolors, 291, January 18–February 12.
American Art of Today, Daniel Gallery, New York. Includes Davies, Childe Hassam, Henri, Lawson, Marin, Man Ray, Albert Pinkham Ryder, and Julian Alden Weir, among others.
The Forum Exhibition of Modern American Painters, Anderson Galleries, New York, March 13–28.

1917 June—291 closes. Over the next several years Stieglitz arranges for Marin exhibitions at the Daniel, Montross, and Ardsley galleries. Marin spends summer in Small Point, Maine.
EXHIBITIONS
John Marin Exhibition—The Country of the Delaware, and Other Exercises, 291, February 14–March 3.
One-man exhibition, Ardsley Gallery, New York.
One-man exhibition, Daniel Gallery.

1918 Spends summer and autumn in Rowe, Massachusetts.

1918–19 Spends winter at sister-in-law's house in Brooklyn.

1919 Summer–late December—first spends time in Stonington–Deer Isle area of Maine, on Penobscot Bay.

1919–20 Spends winter in Union Hill, with Lelia Currey.

1920 May—his father dies. While spending summer in Stonington, Maine, Marin develops a rotating easel, which makes it easier for him to paint outside. Autumn—purchases house at 243 Clark Terrace, Cliffside, New Jersey.
EXHIBITIONS
Exhibition of Watercolors by John Marin, Daniel Gallery, March–April 10 (with checklist). This 10-year retrospective of 50 watercolors attracts Marin's first important patron, Ferdinand Howald, an engineer from Columbus, Ohio.

1920–21 Winter—suffers frequent attacks of lumbago.

1921 Spends summer in Stonington. A. E. Gallatin gives a watercolor, *Landscape, Delaware County*, to the

Metropolitan Museum of Art, New York; it is the first work by Marin to enter a museum collection.
EXHIBITIONS
Etchings by John Marin, E. Weyhe Gallery, New York, March 13–31 (with checklist). 31 etchings, 6 pastels, 5 watercolors.
Watercolors Pertaining to the Sea by John Marin, Daniel Gallery.
Watercolor Paintings by American Artists, Brooklyn Museum, November 7–December 18. Includes 14 watercolors by Marin.

1922 February 23—an auction of nearly 200 works of art by 40 American moderns, organized by Stieglitz, takes place at the Anderson Galleries. Artists represented are Thomas Hart Benton, Charles Demuth, Samuel Halpert, Hartley, Yasuo Kuniyoshi, Gaston Lachaise, Marin, Maurer, George F. Of, Georgia O'Keeffe, Charles Sheeler, and William and Marguerite Zorach, among others. Summer—drives his first car to Stonington.
EXHIBITIONS
Exhibition—Water Colors, Oil Paintings and Etchings: John Marin, Montross Gallery, New York, January 24–February 11 (with checklist). 110 watercolors, 4 oils, 31 etchings.

1923 Spends summer in Stonington.
EXHIBITIONS
Recent Pictures by John Marin: 1922–23, Montross Gallery, March 6–24 (with checklist). 31 watercolors.

1924 Serves as a witness at the wedding of Alfred Stieglitz and Georgia O'Keeffe in New York. A portfolio published by the *New Republic* includes a Marin etching; some include *Brooklyn Bridge and Lower New York,* others include *Downtown the El.* Spends summer in Stonington.
EXHIBITIONS
Recent Watercolors by John Marin, Montross Gallery, February 16–March 8 (with checklist). 54 watercolors. One-man exhibition of etchings, J. B. Neumann's Print Room, New York, April.

1925 Stomach problems prevent annual trip to Maine; instead, paints along Hudson River and makes weekend visits to cousins Lyda and Retta Currey in the Berkshires. A 1925 Berkshire landscape by Marin is purchased by the Brooklyn Museum. December 7—Stieglitz opens The Intimate Gallery at 489 Park Avenue, room 303, New York.
EXHIBITIONS
John Marin, Intimate Gallery, New York, December 7–

January 11, 1926. The inaugural exhibition at Stieglitz's new gallery.

1926 Lelia Currey dies. Marin spends summer in Stonington. November 6—Edith Gregor Halpert opens Our Gallery at 113 West Thirteenth Street, New York, dedicated to modernist American art.
EXHIBITIONS
Sixth International Watercolor Exhibition, Art Institute of Chicago, May 3–30. Features a separate Marin gallery with 30 watercolors, the first major exhibition of his work outside New York.
Marin Exhibition, Intimate Gallery, November 9–January 9, 1927. Watercolors, all dated 1925.

293. Charles Demuth. *Poster Portrait: Marin,* 1926. Tempera on illustration board, 26¾ x 33 in. Beinecke Rare Book and Manuscript Library, Yale University, New Haven, Connecticut.

1927 Spends summer in Stonington. Fall—stops in the White Mountains on return to Cliffside. Lachaise executes bronze portrait of Marin. Edith Halpert renames her gallery The Downtown Gallery. A. E. Gallatin opens Gallery of Living Art, at New York University.
EXHIBITIONS
Marin Exhibition, Intimate Gallery, November 9–December 11. Features 38 watercolors dated 1926.

1928 Spends summer in Stonington, with stop in Small Point en route to Georgetown to see Hartley, Lachaise, and Paul Strand. Fall—visits Stieglitz at Lake George, New York. Returns to painting in oil after a hiatus of several years. October—E. Weyhe Gallery announces that it is the sole agent for the sale of Marin's etchings.

EXHIBITIONS

American Landscapes, Downtown Gallery, New York, January 24–February 11. Marin's first appearance at the Downtown Gallery. Also includes Albert Blakelock, Winslow Homer, and George Inness, among others.

Marin Exhibition, Intimate Gallery, November 14– December 29 (with checklist). 47 watercolors.

1929 Summer—visits Taos, New Mexico. November— Museum of Modern Art, New York, opens. November– December—Stieglitz closes Intimate Gallery because the Anderson Building is being torn down. He opens An American Place at 509 Madison Avenue, room 1710, New York, specifically to show work by Demuth, Dove, Hartley, Marin, O'Keeffe, Strand, and himself.

EXHIBITIONS

Paintings by Nineteen Living Americans, Museum of Modern Art, New York, December 13–January 12, 1930. Includes 6 watercolors by Marin.

John Marin: Fifty New Watercolors, An American Place, New York, December–January 1930. Opening exhibition of An American Place. All watercolors are dated 1928 and framed by Marin.

1930 Spends summer in Taos. *Modern American Painters* by Samuel M. Kootz is published; Marin, O'Keeffe, and Dove are among the eleven artists mentioned.

EXHIBITIONS

John Marin—Recent Watercolors: New Mexico and New York, An American Place, November (with checklist). 8 New York paintings, 35 New Mexico works.

1931 Spends summer in Small Point and along Lake Champlain in Vermont. A selection of Marin's letters, mainly to Stieglitz, edited and with an introduction by Herbert J. Seligmann, is privately printed for An American Place.

EXHIBITIONS

One-man exhibition, Phillips Memorial Gallery, Washington, D.C.

John Marin, An American Place, October 11–November 27. 14 oils from Maine, 30 watercolors from New Mexico, 4 etchings from New York.

1932 Spends summer in Small Point. Daniel Gallery closes because of the Depression. November—Gallatin buys a Marin oil for New York University. American Artists Group publishes Marin's etching *Sailboat* in an edition of approximately 200.

EXHIBITIONS

John Marin: Exhibition of Watercolors and Oils, An American Place, November–December.

294. *Two Sketches of Figures,* c. 1932. Ink and watercolor on paper, 7⅛ × 5 in. Private collection. Not in Reich.

1933 At the suggestion of Seligmann, Marin spends his first summer at Cape Split, Maine. There he stays at the Crandon house and rents a "peapod"-style rowboat.

EXHIBITIONS

Paintings by John Marin and Georgia O'Keeffe, Society of the Arts and Crafts, Detroit, January 17–February 9, 1934 (with checklist). Organized by Edith Halpert. 13 watercolors by Marin, 12 oils by O'Keeffe.

Twenty-five Years of John Marin—1908–1932— Watercolors, An American Place, October–November (with checklist). 33 watercolors.

First Biennial Exhibition of Contemporary American Sculpture, Watercolors and Prints, Whitney Museum of American Art, New York, December 5–January 11, 1934.

John Marin—New Watercolors, New Oils, New Etchings, An American Place, December 20–February 1, 1934. 15 watercolors from 1908–32, recent oils, etchings.

1934 Summer—buys the Henry Prentiss house on Pleasant Bay, Cape Split. Spends summers there for the rest of his life. Buys a lobster boat and travels in it to paint on surrounding islands.
EXHIBITIONS
A painting each by Marin and O'Keeffe featured at the Downtown Gallery in the fall.
John Marin: New Oil Paintings—Water Colors—Drawings, An American Place, November–December (with checklist). 15 watercolors, 10 oils, 2 etchings.

1935 November—enlarges studio at Cliffside Park home by combining two small rooms. *John Marin: The Man and His Work* by E. M. Benson published.
EXHIBITIONS
John Marin—Exhibition of Watercolors, Drawings, Oils (1934–1935), An American Place, October 27–December 15 (with checklist). 13 watercolors, 6 oils, figural drawings in pencil and watercolor. A letter from Marin to Stieglitz is published in the checklist.

1936 EXHIBITIONS
Second Biennial Exhibition: Part II, Contemporary Watercolors and Pastels, Whitney Museum of American Art, February–March.
John Marin: Watercolors, Oil Paintings, Etchings, Museum of Modern Art, October 21–November 22. This major exhibition—which includes 160 watercolors, 21 oils, and 44 etchings selected by Stieglitz—is accompanied by an important catalog and attracts over 20,000 people. A portion of the exhibition travels to the Phillips Memorial Gallery in February 1937.
Exhibition of Paintings: Charles Demuth, Arthur G. Dove, Marsden Hartley, John Marin, Georgia O'Keeffe and New Paintings on Glass by Rebecca S. Strand, An American Place, November 27–December 31.

1937 American Abstract Artists founded to promote abstraction in American art.
EXHIBITIONS
John Marin: New Watercolors, Oils and Drawings, An American Place, January 5–February 3 (with checklist). 5 drawings, 16 watercolors, 6 oils.
John Marin: Water Colors, Oils, Etchings, Studio House (an exhibition space at the Phillips Memorial Gallery), Washington, D.C., February 3–21 (with checklist). 15 watercolors, 3 oils, 13 etchings.

1938 EXHIBITIONS
John Marin: Recent Paintings, Watercolors and Oils, An American Place, February 22–March 27 (with brochure).

Also includes drawings. A poem by Marin, "To My Paint Children," is published in the brochure.
Picasso and Marin, Phillips Memorial Gallery, April 10–May 11 (with checklist). Includes 17 watercolors and 4 oils by Marin.
The 1938 International Exhibition of Paintings, Carnegie Institute, Pittsburgh, October 13–December 4.
John Marin: Exhibition of Oils and Water Colors, An American Place, November 7–December 27 (with checklist). 17 watercolors, 7 oils.

1939 EXHIBITIONS
Simultaneous one-man shows of work by Marin and Demuth at Philadelphia Art Alliance, February 14–March 5.
Beyond All "Isms," An American Place, October 15–November 21. 20 watercolors dated 1908–37.
20 Watercolors by John Marin, Downtown Gallery, October 19–November 4. Retrospective of 29 variations on the theme of New York. All works priced at $500.
New Oils/New Watercolors by John Marin, An American Place, December 3–January 17, 1940 (with checklist). 12 watercolors, 19 oils.

1940 With Charles Burchfield and Eliot O'Hara, Marin juries a watercolor competition in Carville, Louisiana, for the Smithsonian Institution.
EXHIBITIONS
John Marin—12 New Watercolors—1940; 9 New Oils—1940; Some New Drawings/1940, An American Place, December 11–January 21, 1941 (with checklist).

295. The Marins and Thompsons at Cape Split, Maine, c. 1940. Private collection.

1941 May—Marin is on jury at Syracuse, New York, for an exhibition of works by 200 American artists organized by the Section of Fine Arts, New York Public Buildings Administration. The show is the first exhibition of contemporary art at the new National Gallery of Art, Washington, D.C., and then travels to several other venues. Marin juries the Pennsylvania Academy of the Fine Arts' *35th Annual Watercolor Exhibition*.

EXHIBITIONS

A Study on Sand Island, Dudley Peter Allen Memorial Art Museum, Oberlin College, Oberlin, Ohio, opens January (with checklist). 15 watercolors.

Group Exhibition, An American Place, October 17–November 27 (with checklist). Includes Dove, Marin, O'Keeffe, Picasso, and Stieglitz.

Exhibition: John Marin (Vintage—1941), An American Place, December 9–January 27, 1942 (with checklist). 12 oils, 15 watercolors. "A Letter from John Marin" to Stieglitz is published in the checklist.

1942 Marin is elected to the National Institute of Arts and Letters. A $10,000 bid from the Saint Louis Art Museum for *Seascape*, an oil by Marin, tops all others at an auction of the State Department's collection of American art.

EXHIBITIONS

A History of American Watercolor Painting, Whitney Museum of American Art, January 27–February 25.

Pertaining to New York—Circus and Pink Ladies, An American Place, March 12–April 12 (with checklist). 37 works. Paintings in this one-man exhibition, installed by O'Keeffe, are grouped by subject; works include 7 studies of Nassau Street and a group incorporating female nudes.

John Marin: Exhibition of Recent Paintings, 1942: Oils and Watercolors, An American Place, November 17–January 11, 1943 (with checklist). 12 watercolors, 16 oils.

New Frontiers in American Painting, Downtown Gallery.

1943 March 27—elected to life membership, American Academy of Arts and Letters.

EXHIBITIONS

John Marin, Phillips Memorial Gallery, August 1–September 30. A retrospective loan exhibition (with checklist). 3 oils, 17 watercolors.

John Marin, Paintings—1943, An American Place, November 5–January 9, 1944 (with checklist). 5 oils, 9 watercolors, 6 drawings. A letter from Marin is published in the checklist.

1944 November—Columbus Gallery of Fine Arts opens a special room devoted to twenty-five Marin watercolors from its collection.

EXHIBITIONS

John Marin, Paintings—1944, An American Place, November 27–January 10, 1945 (with checklist). 11 oils, 13 watercolors.

1945 February 12—Marie Marin dies.

EXHIBITIONS

American Watercolor and Winslow Homer, Walker Art Center, Minneapolis, February 27–March 23. Includes 10 Marin watercolors. Travels to Detroit Institute of Arts, April 3–May 1; Brooklyn Museum, May 15–June 12.

John Marin, Paintings—1945, An American Place, November 30–January 17, 1946 (with checklist). 9 oils, 21 watercolors.

1946 Spring—Marin suffers heart attack. July 13—Stieglitz dies at age eighty-two; Marin is too sick to attend funeral. July—Paul Rosenberg approaches Marin about becoming his dealer. December—Charles Daniel, now associated with M. Knoedler and Co., tries unsuccessfully to secure Marin as one of the gallery's artists.

EXHIBITIONS

John Marin: 160 Drawings: Mostly New York, 1930–1946, An American Place, April 7–30.

1947 Marin and O'Keeffe renew the lease of An American Place with financial assistance from Dorothy Norman. The gallery remains open for occasional exhibitions through 1950.

EXHIBITIONS

John Marin: A Retrospective Exhibition, Institute of Modern Art, Boston, January 7–February 15. 50 watercolors, 20 oils, and selected prints and drawings, all from the artist's collection. Travels to Phillips Memorial Gallery, March 2–April 15; Walker Art Center, May 1–June 15.

John Marin Exhibition: New Watercolors and Oils, An American Place, April 1–May 2 (with checklist). 15 watercolors, 14 oils; installed by Marin and John Marin, Jr., as are most shows at An American Place from this year until the gallery closes.

Thirteen Marins from the Keith Warner Collection, Walker Art Center, September 30–October 19.

John Marin's New Paintings in Oil and Watercolor, An American Place, December 8–January 31, 1948 (with checklist). 10 oils, called Movements in Paint, and 14 watercolors.

Advancing American Art, U.S. Information Service, Prague. Includes 1 oil by Marin.

February—*Look* magazine poll declares Marin America's "Artist No. 1." *John Marin* by MacKinley Helm is published, with a foreword by Marin.

EXHIBITIONS

John Marin Water Color Exhibition, organized by the University of Michigan, with loans from the Columbus Gallery of Fine Arts. Travels to Cranbrook Academy of Art, Bloomfield Hills, Michigan, January 7–28; Grand Rapids Art Museum, February 4–25; Hackley Art Museum, Muskegon, Michigan, March 3–24; Michigan State University, East Lansing, April 1–22; University of Michigan, Ann Arbor, May 4–25; Flint Institute of Arts, Flint, Michigan, June 1–26.

Paintings and Drawings by John Marin: New York—1910–1944, Downtown Gallery, August 10–September 8 (with checklist). 43 watercolors, 3 oils, 1 pen-and-ink drawing, and a group of pencil-and-crayon drawings. In honor of New York City's Golden Jubilee.

John Marin: Etchings, 1906–1948, An American Place, October 26–November 27. The gallery's first exhibition exclusively of prints. Travels to Detroit Institute of Arts, February 16–March 27, 1949.

The 46th Annual Watercolor and Print Exhibition, Pennsylvania Academy of the Fine Arts, November 7–December 12. Includes 20 works by Marin. During the course of this exhibition Marin is awarded the Philadelphia Watercolor Club Medal of Award and the Dawson Memorial Prize.

John Marin: New Paintings in Oil and Water-Color, An American Place, December 7–January 31, 1949 (with checklist). 16 oils, 23 watercolors.

June 26—O'Keeffe announces that the Alfred Stieglitz Collection is to be divided among five institutions, with the bulk of it, including more than sixty watercolors by Marin, going to the Metropolitan Museum of Art. Other recipients of the collection are the Art Institute of Chicago; National Gallery of Art; Philadelphia Museum of Art; and Fisk University, Nashville.

EXHIBITIONS

John Marin: Oils, Watercolors, Etchings, M. H. de Young Memorial Museum, San Francisco, February 15–March 22. A retrospective exhibition and the first comprehensive showing of Marin's work on the West Coast. Travels to Santa Barbara Museum of Art, Santa Barbara, California, April 1–30; Los Angeles County Museum of Art, May 12–June 12.

Aquamedia, Downtown Gallery, ends March 11. Includes

Demuth, Dove, Marin, George L. K. Morris, Sheeler, and Joseph Stella, among others.

Watercolors by John Marin, Phillips Collection (formerly the Phillips Memorial Gallery), April 3–May 4.

Painting in the United States, Carnegie Institute, October 14–December 12.

John Marin: New Mexico Watercolors, An American Place, November 19–December 17.

John Marin Exhibition: New Watercolors and Oils, An American Place, December 19–February 4, 1950 (with checklist). 15 watercolors, 15 oils, all dated 1949.

June—awarded honorary doctorate from Yale University. August—awarded honorary doctorate from the University of Maine. August 15–Downtown Gallery, now located at 32 East Fifty-first Street, becomes Marin's dealer and opens a John Marin Room devoted solely to his works. September—*John Marin: Drawings and Watercolors,* a portfolio designed by Marin. is published by Twin Editions.

EXHIBITIONS

John Marin: Oils—1903–1950, An American Place, March 20–May 6 (with checklist). The gallery's final show, and Marin's first exhibition devoted exclusively to oils, with 27 works dating (according to the checklist) from as early as winter 1903–4. Weehawken Cliff Sequence shown for first time.

Marin is the featured artist at the 25th Venice Biennale, June–September. His work fills a large section of the American Pavilion; the rest is devoted to the work of

296. Marin's final exhibition at An American Place, 1950. Private collection.

297. James E. Davis. Marin's paint box, c. 1950–51. Private collection.

Hyman Bloom, Willem de Kooning, Lee Gatch, Arshile Gorky, Rico Lebrun, and Jackson Pollock.

John Marin: Drawings and Watercolors, Downtown Gallery, September 12–23. The 38 original works reproduced in the Twin Editions Portfolio, exhibited to celebrate its publication. Marin's first show as a member of the Downtown Gallery.

John Marin: A Retrospective Exhibition, 1921–1949, New Jersey State Museum, Trenton, December 27–January 1, 1951. 14 oils, 20 watercolors, 28 drawings. State reception for Marin on December 2, with a tribute to the artist delivered by Governor Alfred E. Driscoll.

John Marin: Exhibition—Oils and Watercolors, 1950, Being Movements in Paint, Downtown Gallery, December 27–January 27, 1951 (with checklist). 10 oils, 12 watercolors.

Twentieth Century Painters—U.S.A., Metropolitan Museum of Art, New York. Includes William Baziotes, John Steuart Curry, Stuart Davis, Thomas Eakins, Lyonel Feininger, Marin, Ryder, John Singer Sargent, and James McNeill Whistler.

1951 Travels to New Brunswick, Canada. Hospitalized for prostate gland trouble; completes numerous drawings and watercolors of the view from his hospital window and starts using a syringe to draw lines.

EXHIBITIONS

American–Japanese Exhibition, Mitsukoshi Department Store, Tokyo, February 3–13. Includes a seascape oil by Marin.

John Marin, American Federation of Arts, New York, May–June.

John Marin, Exhibition of Oils and Watercolors, 1946–1950, Frank Perls Gallery, Beverly Hills, California, May 31–July 3 (with checklist). 6 oils, 14 watercolors.

John Marin, University of Miami, Coral Gables, Florida, October 2–23 (with catalog). 31 paintings.

First Biennial, Museu de Arte Moderna de São Paulo, Brazil, October–December (with checklist). Includes 2 watercolors and 1 oil by Marin.

John Marin, Institute of Contemporary Art, Washington, D.C., November 24–December 31.

Les Peintres Graveurs actuels aux Etats-Unis, Bibliothèque Nationale, Paris, December (with checklist). Includes 2 etchings by Marin.

298. Charles Sheeler. *Edward Steichen and John Marin Celebrating Marin's 81st Birthday,* 1951. Gelatin silver print, 6¹³⁄₁₆ × 6¹³⁄₁₆ in. Private collection.

John Marin: Watercolors, Oils, Prints and Drawings, Munson-Williams-Proctor Institute Art Gallery, Utica, New York, December 2–30 (with checklist). 30 watercolors, 13 oils, 5 etchings, 5 drawings.

1952 December—Marin's *Tunk Mountain Series, No. 3* is one of eighteen winners at the Metropolitan Museum of Art's American Watercolors, Drawings and Prints Contest of 1952. Ivan Le Lorraine Albright is another winner.

EXHIBITIONS

John Marin: Exhibition—Oils and Watercolors, Downtown Gallery, January 2–26 (with checklist). 10 oils, 10 watercolors, all dated 1951.

Expressionism in American Painting, Albright Art Gallery, Buffalo, May 10–June 29 (with checklist). Includes 1 oil by Marin.

299. George Daniell. *John Marin at Cape Split*, 1952. Gelatin silver print, 8 × 10 in. Collection of the photographer.

The 1952 Pittsburgh International Exhibition of Contemporary Painting, Carnegie Institute, October 16–December 14. Includes 1 oil by Marin.
John Marin Exhibition—1952 Paintings in Oil and Watercolor Being Composed of Movements Related to Sea, Land, and Circus, Downtown Gallery, December 30–January 24, 1953 (with checklist). 11 oils, 13 watercolors.
An Exhibition of 22 Watercolors by Marin, Evansville Public Museum, Evansville, Indiana.
Etchings of New York by John Marin, Stanford University, Palo Alto, California.

1953 October 1—John Marin dies at Cape Split. MacKinley Helm, a retired Episcopal priest as well as Marin's biographer, conducts his funeral service. The artist is buried in Cliffside, New Jersey.
EXHIBITIONS
John Marin: Prints and Drawings, Adele Lawson Galleries, Chicago, January 7–31.
One-man exhibition, Martha Jackson Gallery, New York, March.
John Marin Etchings, circulated by the American Federation of Arts. Travels from April 1953 through January 1955: J. B. Speed Art Museum, Louisville, Kentucky; Scarborough School, Scarborough, New York; Winona State Teachers College, Winona, Minnesota; Massachusetts Institute of Technology, Cambridge; Willimantic State Teachers College, Willimantic,

Connecticut; Hotchkiss School, Lakeville, Connecticut; Dartmouth College, Hanover, New Hampshire; Chikurin Gallery, Detroit; Cedar Rapids Association, Cedar Rapids, Iowa; and the North Carolina State Art Gallery, Raleigh.
International Contemporary Art Exhibition, New Delhi, India, opens May 5. Includes Milton Avery, Demuth, Feininger, Marin, and Ben Shahn.
Thirteen Paintings, Museum of Modern Art, October.
John Marin Memorial Exhibition, Museum of Fine Arts, Houston, November 29–January 3, 1954 (with catalog).
One-man exhibition, Phillips Collection, opens December 13. Paintings by Marin from the gallery's permanent collection.
John Marin—Paintings of the 1950s, Downtown Gallery, December 29–January 30, 1954 (with checklist). 15 oils, 8 watercolors.
One-man exhibition, Art Institute of Chicago, opens December 31. Watercolors by Marin, many of which O'Keeffe donated to the Art Institute from the Stieglitz collection, are displayed in their own gallery.

1954 MEMORIAL EXHIBITIONS
John Marin: 1870–1953, American Academy of Arts and Letters and National Institute of Arts and Letters, New York. 97 oils, watercolors, and etchings.
John Marin Memorial Exhibition, Art Galleries, University of California, Los Angeles. Travels to Cleveland Museum of Art; Museum of Fine Arts, Boston; Phillips Collection; and San Francisco Museum of Art.

300. Jim Herron. *Map of Marin Land*, in the *Cleveland Press*, November 19, 1955. From a scrapbook in the John Marin Archive, National Gallery of Art, Washington, D.C.; Gift of John Marin, Jr.

ACKNOWLEDGMENTS

As with most publications, especially those that accompany exhibitions, the realization of *John Marin* has depended upon help from large numbers of colleagues and friends. For the wonderful gift to the National Gallery of Art of John Marin's paintings, watercolors, drawings, etchings, and personal reference materials—all central to this undertaking—as well as for their subsequent assistance and hospitality, I would like to express my gratitude to the late John Marin, Jr.; his widow, Norma Boom Marin; and their daughter, Lisa Marie Marin. For his role in the donation of this John Marin Archive to the National Gallery and for his assistance and encouragement since then, I thank Lawrence A. Fleischman, president of Kennedy Galleries, Inc. Mrs. Dorothy Norman, who knew John Marin well and who loves his art as I do, has been a special friend. E. M. Benson, Marin's earliest biographer and one of the first art professionals I knew, has been an important, haunting presence. Sheldon Reich's catalogue raisonné of John Marin's paintings and watercolors greatly facilitated our task.

Second only to the artist in making this exhibition possible are the lenders, who are listed elsewhere. I am enormously grateful for their generosity in parting temporarily with their treasures and for their hospitality at their homes and offices during the course of my research. I am equally grateful to the many collectors and gallery owners who allowed permission to reproduce works in this book; to those who offered assistance to our project and whose paintings, also of great beauty, are not included here due to limitations of space; and to those with whom we were in communication by mail and telephone but could not, in the end, visit in person due to the constraints of time.

Museum colleagues and other professionals were helpful beyond the ordinary, not only providing information on works in their own care but also introducing me to collectors in their regions and providing room, board, and transportation as I traveled from city to city. Special thanks go to Anselmo Carini, Verna Curtiss, Douglas Druick, Richard Field, Elizabeth Glassman, Hugh J. Gourley III, Juan Hamilton, Ray and Mike Lewis, Suzanne Folds McCullagh, Barbara Shapiro, and Peter

Zegers. I also am grateful to paper conservators Denise Thomas, Roy Perkinson, and Elizabeth Lunning—the first for examining Marin's etchings in the collection of the Philadelphia Museum of Art and the latter two for discussing the particular properties of watercolors with me while we examined the Marins at the Museum of Fine Arts, Boston. Mr. and Mrs. Richard Aldridge kindly let me explore their land, where, during his early years in Maine, Marin had visited with Mrs. Aldridge's father, Ernest Haskell. The staff at Kennedy Galleries, Inc., which handles the Marin estate, was repeatedly helpful, especially F. Frederick Bernaski, Lynn Bettman, Lillian Brenwasser, and Martha Fleischman.

At the National Gallery I would like to thank J. Carter Brown, our Director; the former and current Deputy Directors, John Wilmerding and Roger Mandle, respectively; Andrew Robison, Senior Curator of Prints and Drawings; Ben Glenn II, my assistant on this project, whose help has been invaluable to all phases of the undertaking; D. Dodge Thompson, Debbie Shepherd, Cameran Castiel, and Trish Waters in the Exhibitions Office; Gaillard Ravenel, Mark Leithauser, Gordon Anson, William Bowser, and the design and installation staff, whose precise attention adds significantly to the beauty of the exhibition; Editor-in-Chief Frances Smyth, who provided advice and coordinated all aspects of this publication, and Jane Sweeney of her staff; Richard Amt, Chief of Photographic Services, Ira Bartfield, Coordinator of Photography, Dean Beasom, and James Locke, who provided much of the photography used in this book; Anne Halpern and Mary Suzor of our Registrar's Office, who coordinated the original Marin Archive Gift and many exhibition-related matters; our capable staff of art handlers, especially Daniel Shay; Lamia Doumato, Ted Dalziel, and Thomas McGill in the library; Nicolai Cikovsky, Jr., Curator of American Art, for his interest during the early stages of the project; Nan Rosenthal, Curator of Twentieth-Century Art, who has a long-standing interest in Marin; Elizabeth Croog, Associate Secretary General Counsel, for assistance with contractual matters; Genevra Higginson, Assistant to the Director for Special Events, who has graciously coordinated several lovely occasions related to the John Marin Archive and exhibition; Joseph Krakora and Elizabeth Weil of our External Affairs Office; Ruth Kaplan and Deborah Ziska of our Information Office; Paper Conservators Shelley Fletcher, Pia Di Santis, and former staff member Sarah Bertalan; Sarah Greenough, Research Curator, for discussing the relationship between Marin and Stieglitz with me; Carlotta J. Owens and Charles M. Ritchie, Assistant Curators of Prints and Drawings; Hugh Phibbs, Virginia Ritchie, and Jamie Stout in our matting and framing department; Suzan B. Harris, Jennifer Kahane, and Michael Godfrey for assistance when the deadline was bearing down; Susanne L. Cook, Tom Coolsen, and Lisa M. Shovers, departmental secretaries; and former staff member Laurie Weitzenkorn, who prepared a preliminary draft for the chronology and helped with the early stages of the exhibition.

In addition I would like to thank: Bill Adair, Renée Alter-Roberts, Ruth Appelhof, Elizabeth Armstrong, Linda Ayres, Ida Balboul, Kay Bearman, Elaine Benson, Elizabeth Boone, David Cadigan, Lawrence Campbell, Richard Campbell, Victor Carlson, Donna M. Cassidy, Riva Castleman, Nan

Chisholm, Carol Clark, Sylvan Cole, Elizabeth M. Collier, Mrs. Sargent Collier, E. Jane Connell, Francesca Consagra, Pearl Creswell, George Daniell, Daphne Deeds, Denise Donahue, Kathleen A. Erwin, Judith C. Eurich, Larry Feinberg, Norris Ferguson, James L. Fisher, Jay Fisher, Valerie R. Foradas, David C. Freese, Kinney Freylinghuysen, Jane Fudge, Frank Gettings, Carol Gikas, Vicky Gilmer, Jane Glaubinger, Mrs. Walter S. Greathouse, Alison de Lima Greene, Roslyn Halper, James Harris, Jane Hartye, Carl Hecker, Lisa Hodermarsky, Joseph Holbach, Jan Howard, Colta Feller Ives, Barbara Johns, Renee Kay, David W. Kiehl, Judith Russi Kirshner, Joanne Klein, Trudy Kramer, Sadajiro Kubo, Rebecca Lawton, John Palmer Leeper, Cheryl Leibold, Lisa Levy, Jenny Long, Karen Lovaas, Nanette Maciejunes, Terence L. Marvel, Sarah Melching, Christopher S. Middendorf, Michael Miller, Shirley H. Milligan, Linda Mills, Nicholas Mingiurch, Ahmad Moghbel, Kirk F. Mohney, Mary Moran, Jane Myers, Barbara Odevseff, Danelle O'Neill, I. Erik Orav, Kathleen Orillion, Cindy Ott, Vivian Patterson, Martin E. Petersen, Ann Percy, Marla Price, Michael Quick, Eliza Rathbone, Kevin Robbins, Steven Rosen, Amy Rule, Jennifer Saville, Douglas G. Schultz, Paul D. Schweizer, Kyoko Selden, Mrs. Herbert J. Seligmann, Patricia L. Serafini, Nancy Shawcross, Innis Shoemaker, Ann Sievers, Elizabeth Simon, Ann Slimmon, Theodore E. Stebbins, Jr., Hanna Szczepanowska, Miriam Stewart, Anne Stricker, Inga Christine Swenson, Marilyn Symmes, Martha Tedeschi, Gloria Teplitz, James Tottis, Julia Brown Turrell, Jill Waltrous Walsh, Joan Washburn, Wendy M. Watson, Wendy Weitman, Susan Wilkerson, Sandra Wilson, Amy Wolf, Paula Wolf, Howard E. Wooden, Judith Zilczer, and others too numerous to mention who provided us with information and photographs.

At Abbeville Press, Nancy Grubb has shared my enthusiasm for this project from its start, and her insightful editorial skills were most welcome. So, too, is Alex Castro's handsome design. Larry Day, undoubtedly the most patient man in the world, I thank, as always, for his intelligent contributions to the process and his understanding support.

R.E.F.

LIST OF LENDERS

Amon Carter Museum, Fort Worth

The Art Institute of Chicago

Mr. and Mrs. Vincent A. Carrozza, Dallas

Cleveland Museum of Art

Colby College Museum of Art, Waterville, Maine

Columbus Museum of Art, Columbus, Ohio

The Des Moines Art Center

The Detroit Institute of Arts

Sid Deutsch Gallery, New York

Mr. and Mrs. William duPont III

The Farber Collection, New York

Dr. and Mrs. Meyer Friedman

Harvard University Art Museums, Cambridge, Massachusetts

Hirshhorn Museum and Sculpture Garden, Smithsonian Institution, Washington, D.C.

Mr. and Mrs. William Janss, Sun Valley, Idaho

Kennedy Galleries, Inc., New York

Mr. and Mrs. Rollin W. King, Dallas

Mr. and Mrs. Frank A. Ladd, Amarillo, Texas

Mr. and Mrs. Meredith J. Long, Houston

Louisiana Arts and Science Center, Baton Rouge

Lisa Marie Marin

Mrs. John C. Marin, Jr.

The Eleanor and C. Thomas May, Jr., Collection, Dallas

The Jan Perry Mayer Collection of American Works on Paper, Denver

The Metropolitan Museum of Art, New York

Montgomery Museum of Fine Arts, Montgomery, Alabama

Munson-Williams-Proctor Institute Museum of Art, Utica, New York

Museum of Fine Arts, Boston

The Museum of Modern Art, New York

National Gallery of Art, Washington, D.C.

Dorothy Norman

James and Barbara Palmer

Philadelphia Museum of Art

Duncan Vance Phillips

The Phillips Collection, Washington, D.C.

Private collections

Harvey and Françoise Rambach

The Regis Collection, Minneapolis

Charles Simon, New York

Jean and Alvin Snowiss

Terra Museum of American Art, Chicago

Vassar College Art Gallery, Poughkeepsie, New York

Whitney Museum of American Art, New York

Wichita Art Museum, Wichita, Kansas

Williams College Museum of Art, Williamstown, Massachusetts

The most comprehensive bibliography for Marin is found in volume one of Sheldon Reich's *John Marin: A Stylistic Analysis and Catalogue Raisonné* (see below), a revised and updated version of which will appear in Reich's forthcoming second edition. It is not useful for the etchings, but a brief bibliography for them is included in Carl Zigrosser's *Complete Etchings of John Marin* (see below). The following selected and annotated bibliography includes only the works that have been the most useful to the present author. Additional exhibition checklists are noted in the chronology.

SELECTED BIBLIOGRAPHY

PUBLISHED WRITINGS BY MARIN

COLLECTED WRITINGS

Seligmann, Herbert J., ed. *Letters of John Marin.* New York: privately printed for An American Place, 1931. Reprint. Westport, Conn.: Greenwood Press, 1970. A fascinating compilation that offers a suggestion of Marin's intensity and wit while providing authoritative biographical and philosophical data. It spans 1910–30 and includes some of Marin's writings as well as his letters, with an introduction by Seligmann.

Norman, Dorothy, ed. *The Selected Writings of John Marin.* New York: Pellegrini and Cudahy, 1949. Includes additional letters and writings from the same period covered by Seligmann plus new material to 1948. It has an extensive and informative introduction by Norman.

Gray, Cleve. *John Marin by John Marin.* New York: Holt, Rinehart and Winston, 1970. A large-format volume of excerpts from Marin's writings, with numerous illustrations including documentary photographs, oils, watercolors, drawings, and prints. The illustrations provide a vivid overview of Marin's art; the excerpts are less satisfying and informative than Norman's *Selected Writings.*

MISCELLANEOUS WRITINGS

Marin, John. "The Living Architecture of the Future." *New York American,* February 16, 1913, .p. 4. In this previously uncited article, found in a scrapbook in the John Marin Archives, National Gallery of Art, Washington, D.C., Marin wrote about his vision of the modern city.

————. Untitled note. In *The Forum Exhibition of Modern American Painters.* New York: Anderson Galleries, 1916. Reprint. New York: Arno Press, Arno Series of Contemporary Art No. 19, 1968. A brief note on the interrelationship of seeing and feeling as the painter responds to experience. Oscar Bluemner, Andrew Dasburg, Arthur G. Dove, Marsden Hartley, George F. Of, Man Ray, and Charles Sheeler are among the other artists included, all of whom have notes in the catalog.

————. "The Man and the Place." In Dorothy Norman, et al. *America and Alfred Stieglitz: A Collective Portrait.* New York: Literary Guild, 1934, pp. 233–35. A brief homage to the unique spirit and importance of Alfred Stieglitz—"the place was where this man was"—that makes clear Marin's respect and affection for his friend.

————. *John Marin: Drawings and Watercolors.* New York: Twin Editions, 1950. A facsimile portfolio of 40 works, issued in two editions totaling 425 copies (Edition I, numbered I–CXXV, was to be issued with an original etching—although I am not certain that many were, in fact, issued this way; Edition II, numbered 1–300). The artist's ideas about observation, order, movement, etc., are accompanied by a statement that even the briefest sketches were not just "jottings" but "made to purpose a living completeness."

————. "To The University of Miami." In *John Marin.* Coral Gables, Fla.: University of Miami, 1951. Having been asked to write about his paintings that were to be exhibited at the university, Marin suggested

comparisons between painting and both music and architecture: "The whole a piece of music written with line and paint. . . . As is the good dwelling constructed. . . . So the picture." Also includes a listing of the 31 etchings, watercolors, and oils from 1909 to 1950 that constituted the show.

For additional brief notes by Marin on a variety of subjects see: "Letter to the Editor," *Nation* 118 (May 14, 1924): 562; "Notes on a Few of the Watercolors," *Phillips Collection Bulletin*, 1927, pp. 35–38; "Writings: Notes—Summer 1935," *Twice a Year*, tenth anniversary issue, 1948, p. 319.

MONOGRAPHS

Benson, E. M. *John Marin: The Man and His Work*. New York: J. J. Little and Ives Company; Washington, D.C.: American Federation of Arts, 1935. A sympathetically written introduction to Marin, divided into two distinct parts—one devoted to the man, the other to his work. Includes a selection of Marin's writings and numerous illustrations. Marin designed the dust jacket.

Helm, MacKinley. Foreword by John Marin. *John Marin*. New York: Pellegrini and Cudahy in association with the Institute of Modern Art, Boston, 1948. The first full-scale biography of Marin, written during the artist's lifetime with extensive input from him. Although there are inaccuracies, it is a sound study.

Reich, Sheldon. *John Marin: A Stylistic Analysis and Catalogue Raisonné*. 2 vols. Tucson: University of Arizona Press, 1970. An invaluable aid to the study of Marin's vast oeuvre, despite numerous omissions, the lack of hundreds of illustrations for the paintings listed, and the fact that virtually all of the illustrations are cropped on all sides. It is planned that these problems will be rectified in a revised and updated one-volume edition forthcoming from the University of Missouri Press.

Zigrosser, Carl. *The Complete Etchings of John Marin*. Philadelphia: Philadelphia Museum of Art, 1969. A beautifully produced volume with extremely useful illustrations of all of Marin's prints known at the time. New images as well as new states of known images and other data have been discovered since its publication. A revision is underway. See also Carl Zigrosser, "Errata in the Catalogue of the Etchings by John Marin," *Print Collector's Newsletter* 1 (September–October 1970): 82–83.

SOLO-EXHIBITION CATALOGS

Balken, Debra Bricker. *John Marin's Berkshire Landscapes*. Pittsfield, Mass.: Berkshire Museum, 1985. Catalog for an exhibition of about 40 watercolors painted in the Berkshires, 1912–25. Selectively illustrated.

Benson, E. M., Marsden Hartley, and Henry McBride. *John Marin: Watercolors, Oil Paintings, Etchings*. New York: Museum of Modern Art,

1936. Catalog for the first major retrospective of Marin's art; includes the first checklist of his etchings. Selectively illustrated.

Buckley, Charles E. *John Marin in Retrospect*. Washington, D.C.: Corcoran Gallery of Art; Manchester, N.H.: Currier Gallery of Art, 1962. Catalog for a retrospective exhibition of 91 oils and watercolors, with an introductory overview. Selectively illustrated.

Catalogo: XXV Biennale di Venezia. Venice, 1950. Marin was the featured artist in the American Pavilion; this catalog lists 55 of his watercolors and oils. Unillustrated.

Catalogue of an Exhibition of Etchings by John Marin. New York: Kennedy and Co., 1911. Not cited by Zigrosser. Includes a brief biographical statement followed by a listing of 33 European etchings. Unillustrated.

Coke, Van Deren. *Marin in New Mexico: 1929 and 1930*. Albuquerque: University Art Museum, University of New Mexico, 1968. Study of Marin's work in this region, documenting the sites of many specific paintings and listing 64 of them. It attempts completeness but more works than this date from Marin's summers in New Mexico. Selectively illustrated.

Curry, Larry. *John Marin, 1870–1953*. Los Angeles: Los Angeles County Museum of Art, 1970. Catalog for a traveling exhibition that celebrated the centennial of Marin's birth; includes an introductory essay and a list of 157 works. Selectively illustrated.

Etchings by John Marin. New York: E. Weyhe Gallery, 1921. Despite its title, this checklist lists 31 etchings, 6 pastels, and 5 watercolors. It has a very brief introduction, which comments that Marin has left behind "all but a few daring connoisseurs [and] has created things that will arouse questions as to the fundamentals of the art." Unillustrated.

Ferguson, Robert. *John Marin: The Weehawken Sequence*. Jersey City, N.J.: Jersey City Museum, 1985. Brochure reviewing earlier accounts of the Weehawken paintings but lacking documentation of the specific works on view. Selectively illustrated.

Fine, Ruth E. *John Marin's Autumn*. New York: Kennedy Galleries, Inc., 1988. Catalog of 24 watercolors and oils executed between 1912 and 1952 during the colorful season that inspired some of Marin's most beautiful works. Fully illustrated.

———. *John Marin Watercolors*. Amarillo, Tex.: Amarillo Art Center, 1989. Catalog for an exhibition of 44 works that featured a group from New Mexico. Fully illustrated.

Helm, MacKinley, and Sheldon Reich. *John Marin, 1870–1953*. Tucson: University of Arizona Art Gallery, 1963. Catalog for an exhibition of 106 watercolors, oils, and drawings; includes a brief memoir by Helm and an overview by Reich. Selectively illustrated.

Helm, MacKinley, and Frederick S. Wight. Foreword by John Marin. *John Marin: A Retrospective Exhibition*. Boston: Institute of Modern Art,

1947. Catalog for an exhibition of approximately 100 oils, watercolors, etchings, and drawings. Selectively illustrated.

Helm, MacKinley, Frederick S. Wight, Dorothy Norman, William Carlos Williams, and Duncan Phillips. *John Marin Memorial Exhibition.* Los Angeles: Art Galleries, University of California, 1955. Catalog for a major memorial exhibition that traveled to several U.S. cities. Includes several tributes by friends and admirers, a note by Marin's biographer, and a useful overview of his art by Wight. Selectively illustrated.

John Marin: 1870–1953. Introduction by Thornton Wilder. New York: American Academy of Arts and Letters and National Institute of Arts and Letters, 1954. Checklist of 97 oils, watercolors, and etchings, as well as an unspecified number of drawings. Unillustrated.

John Marin (1870–1953): Retrospective Exhibition of Watercolours. London: Waddington Galleries, 1963. Catalog for an exhibition of 42 watercolors and 3 drawings (1 each in pastel, colored pencil, and crayon) dating from 1888 to 1952. Includes a brief chronology and a listing of works in public collections. Fully illustrated.

John Marin: Exhibition—Oils and Watercolors, 1950, Being Movements in Paint. New York: Downtown Gallery, 1950–51. Checklist of 10 oils and 12 watercolors. Announces that a retrospective selection of Marin's paintings is always on view in the gallery's Marin Room. Unillustrated.

John Marin: Oils—1903–1950. New York: An American Place, 1950. Checklist of the last exhibition at An American Place. Documents the first public showing of the Weehawken Cliff Sequence oil paintings, dating them 1903–4. Unillustrated.

John Marin: A Retrospective Exhibition, 1921–1949. Trenton: New Jersey State Museum, 1950. Brochure including 64 entries for oils, watercolors, drawings, and letters. The brief introduction by James E. Davis includes a quotation from a letter to him from Marin. Unillustrated.

Kennedy Galleries, Inc., New York, which currently handles the Marin Estate, has issued several fully illustrated catalogs with introductions by John I. H. Baur featuring Marin's oils, watercolors, and drawings. These include *John Marin's New York* (1981); *John Marin and the Sea* (1982); *John Marin's Mountains* (1983); *John Marin's Oils* (1984); *John Marin: Watercolors of the 1920s, Drawings from 1917 to 1931* (1986); *John Marin Watercolors* (1987); *John Marin in Miniature: Watercolors and Drawings, 1908–1950* (1986); *John Marin Watercolors, 1929–1939* (1987); and *John Marin—1930s* (1988). See also Fine and *Master Prints 10.*

Kertess, Klaus. *Marin in Oil.* Southampton, N.Y.: Parrish Art Museum, 1987. The first study of Marin's work in oil and a catalog for an exhibition of 55 works. Fully illustrated (many in color).

Marin Exhibition. New York: Intimate Gallery, 1928. Checklist of 47 watercolors, with an autobiographical note, "The Recent Paintings of John Marin" by Marsden Hartley, and notes by Julius Meier-Graefe and Murdock Pemberton reprinted from *Vanity Fair* and the *New Yorker,* respectively. Unillustrated.

Marlborough Gallery, New York, handled the Marin estate between 1971 and 1978 and produced several publications on him. The most sumptuous is Sheldon Reich's *John Marin: 1870–1953* (1972–73), which documents an exhibition of 74 oils and watercolors, about one-third of which are illustrated, many in color, with a brief introduction. The others are selectively illustrated checklists, often with quotations from the artist's writings; they include *John Marin Etchings: 1905–1951* (1971); *John Marin's Maine, 1914–1952* (1976); *John Marin: Paintings, 1903–1953* (1977); and *John Marin: New York Drawings* (1978).

Master Prints 10: John Marin Prints, A Retrospective. New York: Kennedy Galleries, Inc., 1982. Divided into the categories "Europe," "New York," and "Maine," the catalog has useful entries for each of the 48 etchings included. Fully illustrated.

McCauley, Lena M. "John Marin: Painter-Etcher." In *The Print Collector's Bulletin: An Illustrated Catalogue of Painter-Etchings, John Marin.* Chicago: Albert Roullier [1909]. Sales catalog of 36 European etchings. Prices range from $5 to $18. Selectively illustrated.

Norman, Dorothy. "John Marin, Painter-Poet." In *John Marin Memorial Exhibition.* Houston: Museum of Fine Arts, 1953. A brochure listing 43 works; medium is not specified, so identifying many of them is difficult. 2 illustrations.

———. *John Marin: America's Modern Pioneer.* Montclair, N.J.: Montclair Art Museum, 1964. Brochure for an exhibition of 61 oils and watercolors spanning Marin's career. Includes an affectionate introduction with many quotations from Marin. Selectively illustrated.

Phillips, Duncan. *John Marin: Paintings, Watercolors, Drawings and Etchings.* London: Arts Council Gallery, 1956. Brochure for an exhibition of 101 oils, watercolors, etchings, and drawings. Includes an appreciative introduction. Selectively illustrated.

Reich, Sheldon. "John Marin: Painter-Etcher." In *John Marin: Oils, Watercolors, and Drawings Which Relate to His Etchings.* Philadelphia: Philadelphia Museum of Art, 1969. Catalog for an exhibition of 52 works that accompanied an exhibition of Marin's etchings heralding the publication of Zigrosser's catalogue raisonné (see Monographs). Fully illustrated.

———. *John Marin: Drawings, 1886–1951.* Salt Lake City: University of Utah Press, 1969. Catalog for an exhibition of 94 drawings, which traveled longer than a year, going to ten venues. Provides the only overview to date of Marin's drawings. Fully illustrated.

Thorn, Megan. *John Marin in Maine.* Portland, Maine: Portland Museum of Art, 1985. Brochure listing 93 works. The introduction provides a brief overview of Marin's work in this region, peppered with quotations from the artist. Selectively illustrated.

Tolerton, H. H. *Illustrated Catalogue of Etchings by American Artists: John Marin.* Chicago: Albert Roullier's Art Galleries, 1913. Sales catalog of 49 European etchings, with a brief biographical introduction that suggests Marin "is soon to take up his etching needle once more." Prices range from $5 through $24. 2 illustrations.

ARTICLES AND SOLO-EXHIBITION REVIEWS

Baur, John I. H. "John Marin's 'Warring, Pushing, Pulling' New York." *Artnews* 80 (November 1981): 106–10. An admiring overview of Marin's career, suggesting that his pioneering role in American modernism was of unique importance.

Benson, Gertrude. "82-Year-Old Marin Tells Artist's Credo." *Philadelphia Inquirer,* July 6, 1952. A wonderful article presenting a brief history of Marin's career and filled with quotations from statements Marin made a little more than a year before he died.

Caffin, Charles H. "Chance to See Paintings by Marin." *New York American;* reprinted in *Camera Work* 42–43 (April–July 1913): 42–43. An enthusiastic discussion of Marin's 1912–13 New York watercolors, with comparative illustrations of New York views by Joseph Pennell (cited as John) and Herman A. Webster.

Craven, Thomas Jewell. "John Marin." *Shadowland* 5 (October 1921): 11, 75. A generalized overview, as much biographical as philosophical or critical, that praises Marin for his directness; written before Craven shifted to a more conservative stance.

Davidson, Abraham A. "John Marin: Dynamism Codified." *Artforum* 9 (April 1971): 37–42. A discussion of Marin's art within the context of American modernism, emphasizing aspects of Cubism and moving into Abstract Expressionism.

Fine, Ruth E. "The John Marin Archive at the National Gallery of Art." *Drawing* 9 (September–October 1987): 54–58. A report on the several hundred drawings, watercolors, and sketchbooks in a major gift from John Marin, Jr., to the National Gallery.

Finkelstein, Louis. "Marin and de Kooning." *Magazine of Art* 43 (October 1950): 202–6. A fascinating discussion by the painter-critic of spiritual affinities evident in Marin's late oils and de Kooning's recent work, suggesting that both artists were seeking "organic synthesis" through immersion in the painting experience.

Flint, Ralph. "John Marin Blazes New Trails." *New York Sun,* January 16, 1937. A sympathetic review of Marin's first American Place exhibition following his 1936 retrospective at the Museum of Modern Art, with some discussion of that earlier exhibition.

Genauer, Emily. "A Visit with Marin, Celebrating 81st Birthday with a New Exhibition." *New York Herald Tribune,* January 6, 1952. An affectionate article, with many statements by the artist, focusing on Marin's late work and thoughts.

Gray, Cleve. "Marin and Music." *Art in America* 58 (July–August 1970): 72–81. A handsomely illustrated article celebrating the publication of Gray's *John Marin by John Marin* and featuring quotations from Marin's writings on music.

———. "John Marin: Graphic and Calligraphic." *Artnews* 5 (September 1972): 48–53. Focuses on the calligraphic aspects of Marin's work, especially evident in the artist's last decades, with a lament that the 1970–71 retrospective organized by the Los Angeles County Museum of Art had not generated significant interest in Marin.

Gray, Cleve, and Dorothy Norman. "John Marin's Sketchbook—Summer 1951." *Art in America* 55 (September–October 1967): 44–53. Reminiscences by Gray and Norman accompanying selections from one of Marin's spectacular last sketchbooks. Featured are views from Maine and Saint John, New Brunswick.

Haskell, Ernest. "John Marin." *Arts* 2 (January 1922): 201–2. A brief firsthand account of Marin's immediate empathy for Maine, by an artist about whom Marin later wrote a posthumous appreciation, "A Tribute," in Nathaniel Pousette-Dart, *Ernest Haskell: His Life and Work* (New York: T. Spencer Hutson, 1931), p. 11.

Josephson, Matthew. "Leprechaun on the Palisades." *New Yorker* 18 (March 14, 1942): 26–35. A splendid conflation of much that had previously been written about Marin as well as by him, providing a biographical overview with emphasis on Marin's relationship with Stieglitz, art collectors, and the art market.

Kitagawa, Tamiji. "John Marin: A Painter Who Rediscovered America." *Bijutsu Techo* 76 (December 1953): 1–12. Previously uncited. Appreciation and an introduction of Marin's work to a Japanese audience, written soon after the artist's death by an admiring Japanese painter who had worked in America during the early decades of the twentieth century. In Japanese.

McBride, Henry. "Modern Art." *Dial* 72 (March 1922): 330–31. Review of Marin's Montross Gallery show in which McBride applauds the artist for his tendency to be daring even if this leads to occasional failure.

McCaughey, Patrick. "Where Paleface Meets Redskin." *Artnews* 70 (May 1971): 30–39, 77–78. Inspired by the 1970 retrospective organized by the Los Angeles County Museum of Art, the author suggests the superiority of Marin's oils over his watercolors and expresses the opinion that Cubism was of little direct consequence to Marin's achievements. Provides a useful discussion of the complexity of Marin's modernism and the distinctiveness of his ambition.

Mellquist, Jerome. "John Marin, an Affirmative American Painter." 19-page manuscript, dated January 1934, in John Marin scrapbooks, John Marin Archives, National Gallery of Art, Washington, D.C. An appreciation, especially of Marin's responses to nature, built around specific paintings.

————. "John Marin: Painter from the Palisades." *Tricolor* 3 (May 1945): 58–64. A somewhat glib article focusing on Marin's early years as an artist.

————. "Pan among Our Painters." *Theatre Arts* 34 (June 1950): 35–39. Focuses on Marin's early years, closing with a summary of Marin's popularity and the changes in his work after the deaths of Stieglitz and Marie Marin.

Newhall, Beaumont. "A Day with John Marin." *Art in America* 2 (1961): 48–55. A brief account suggesting Marin's warmth toward friends and passion toward his art, accompanied by splendid photographs by Ansel Adams of Marin.

Norman, Dorothy. "Conversations with Marin." *Artnews* 52 (December 1953): 38–39, 57–59. Published within months of the artist's death, this is composed mainly of quotations from Marin, including many remarks on painting.

————. "John Marin: Conversations and Notes." *Art Journal* 14 (Summer 1955): 320–31. This article contains explanatory comments by Norman interspersed with quotations from several of Marin's letters not included in Norman's *Selected Writings of John Marin*, as well as other notes.

Phillips, Duncan. "John Marin." *Phillips Collection Bulletin,* 1927, pp. 22–24. Includes excerpts from several press comments and brief notes by Marin on a few watercolors in the Phillips Collection.

Porter, Fairfield. "The Nature of John Marin." *Artnews* 54 (March 1955): 24–27, 63. A review of the traveling Marin memorial exhibition at the time of its Museum of Fine Arts, Boston, venue, this is an appreciative overview by a painter of the following generation who, like Marin, loved Maine.

Rosenblum, Robert. "Marin's Dynamism." *Art Digest* 28 (February 1, 1954): 13. An enthusiastic review of the memorial exhibition at the American Academy of Arts and Letters by a young critic who was able to bring a fresh eye to Marin's work.

Rosenfeld, Paul. "The Water-Colours of John Marin." *Vanity Fair* 18 (April 1922): 48, 88, 92, 110. A generalized appreciation, with Rosenfeld's ardent prose conveying his missionarylike zeal on the artist's behalf.

————. "John Marin's Career." *New Republic,* April 14, 1937, pp. 289–92. More of an appreciation than a fact-filled account of Marin's career, this provides a responsible and authoritative overview.

Saunier, Charles. "John Marin: Peintre-Graveur." *L'Art décoratif* 18 (January 1908): 1.7–24. The first published article devoted solely to Marin's art, this mentions the paintings and pastels but emphasizes the etchings, illustrating 8 of them (including 5 scenes of Venice).

Seligmann, Herbert J. "John Marin and the Real America." *It Must Be Said,* no. 1 (November 3, 1932): n.p. The first of several brief essays in pamphlet form published by An American Place.

————. "Frames: With Reference to Marin." *It Must Be Said,* no. 3 (January 1934): n.p.

————. "Marin at Cape Split: A Reminiscence of One of Maine's Greatest Painters." *Down East* 1 (Winter 1955): 23–26. A firsthand account of Marin's life in Maine by the man who encouraged his move to Cape Split. It ranges from Marin's love of blueberries and his eccentric renditions of Beethoven's piano music to his painting trips into the countryside.

Strand, Paul, "John Marin." *Art Review* 1 (January 22, 1922): 22–23. An appreciation of Marin's watercolors inspired by a group exhibition at the Brooklyn Museum. It is a pleasure to read Strand's admiration of Marin's work, expressed with a direct clarity that is unrivaled by the writings of any other critic of the period.

GENERAL REFERENCES

BOOKS, DISSERTATIONS, AND GROUP-EXHIBITION CATALOGS

Avant-Garde Painting and Sculpture in America, 1910–1925. Wilmington: Delaware Art Museum, 1975. The introduction to this catalog includes brief introductory material on topics including "The Rise of the Avant-Garde in America: Issues and Aesthetics"; "The Stieglitz Circle"; "The Armory Show and Its Aftermath"; and "Changing Patterns in the Avant-Garde, 1917–1925." Includes more than fifty artists, with several illustrations and brief texts for each.

Baur, John I. H., ed. *New Art in America.* Greenwich, Conn.: New York Graphic Society, 1957. Very brief essays on fifty artists are divided into three sections. The essay on Marin, by Frederick S. Wight, is included in the section "The Native Scene (1920–1940)."

Brandfon, Robert, Kermit S. Champa, et al. *Over Here! Modernism, the First Exile, 1914–1919.* Providence, R.I.: David Winton Bell Gallery, Brown University, 1989. This exhibition catalog (received after the present study was completed) includes 9 essays on the social history of the period as well as the art. Extensive entries for 94 objects (including 3 watercolors by Marin), covering paintings, sculpture, drawings, and photographs by Alfred Stieglitz and his circle, Marcel Duchamp, Stanton MacDonald-Wright, Man Ray, and John Storrs, among others.

Brown, Milton W. *The Story of the Armory Show.* New York: Joseph H. Hirshhorn Foundation, [1963]. Revised edition. New York: Abbeville Press, 1988. Written fifty years after the exhibition, this remains a standard reference on the show that irreversibly altered American art.

Cassidy, Donna M. "The Painted Music of America in the Works of Arthur G. Dove, John Marin, and Joseph Stella: An Aspect of Cultural Nationalism." Ph.D. diss., Boston University, 1988. Starts with an examination of the cultural and aesthetic climate of the early twentieth century. Includes individual chapters on Dove, Marin, and Stella and their various relationships to music.

Davidson, Abraham A. *Early American Modernist Painting: 1910–1935.* New York: Harper and Row, 1981. Includes chapters titled "The Stieglitz Group" and "Some Early Exhibitions, Collectors, and Galleries," as well as a useful bibliography.

Dijkstra, Bram. *Cubism, Stieglitz and the Early Poetry of William Carlos Williams.* Princeton, N.J.: Princeton University Press, 1969. A fascinating study of some of the intellectual currents that mark the era.

Finch, Christopher. *American Watercolors.* New York: Abbeville Press, 1986. An excellent overview in an introduction and thirteen chapters, one of which is devoted solely to Marin.

Frank, Waldo, ed. *America and Alfred Stieglitz: A Collective Portrait.* New York: Literary Guild, 1934. Revised edition, New York: Aperture, 1979, with a preface by Dorothy Norman. This remains a seminal study of Stieglitz's contribution to an era. Marin contributed an essay titled "The Man and The Place"; other contributors include Charles Demuth, Gertrude Stein, and Paul Strand.

Hartley, Marsden. *Adventures in the Arts.* New York: Boni and Liveright, 1921. Dedicated to Alfred Stieglitz, the book presents an overview of one painter-writer's concerns, ranging from the work of individual artists (Winslow Homer, Arthur B. Davies, Odilon Redon) to general issues such as "American Values in Painting" and "The Appeal of Photography," ending with an afterword titled "The Importance of Being 'Dada.'"

Homer, William Innes. *Alfred Stieglitz and the American Avant-Garde.* Boston: New York Graphic Society, 1977. Focuses on Stieglitz's early development, his role in the Photo-Secession, the artistic climate before the Armory Show, and the important period of artistic growth between that exhibition and 1917, when 291 was closed.

Kootz, Samuel M. *Modern American Painters.* New York: Brewer and Warren, 1930. Written with great enthusiasm for the Mexican muralists and emphasizing the importance of political and social forces on American modernism. The painters that Kootz considered important enough to warrant individual chapters are Peter Blume, Charles Demuth, Preston Dickinson, Arthur G. Dove, Marsden Hartley, Yasuo Kuniyoshi, Marin, Georgia O'Keeffe, Charles Sheeler, Maurice Sterne, and Max Weber.

Norman, Dorothy. *Alfred Stieglitz: An American Seer.* New York: Random House, 1960. Reprint. New York: Aperture, 1973. An informative and warmly written illustrated biography by a member of Stieglitz's inner circle; includes an appendix of the exhibitions organized by Stieglitz at 291, the Anderson Galleries, the Intimate Gallery, and An American Place between 1905 and 1946.

Platt, Susan Noyes. *Modernism in the 1920s: Interpretations of Modern Art in New York from Expressionism to Constructivism.* Ann Arbor, Mich.: UMI Research Press, 1985. The chapter "The Critics and Their Premises" is especially interesting, given the enormous critical attention paid to Marin during this period.

Rosenfeld, Paul. *Port of New York.* New York: Harcourt, Brace and Company, 1924. Written in Rosenfeld's flowery manner, with chapters on fourteen artists, writers, and musicians that offer a portrait of a time and a place. Chapters are devoted to Van Wyck Brooks, Marsden Hartley, Marin, Carl Sandberg, Roger Sessions, and Alfred Stieglitz, among others.

Seligmann, Herbert J. *Alfred Stieglitz Talking.* New Haven, Conn.: Yale University Library, 1966. Organized in the form of a diary or journal, the book presents a record of Seligmann's notes and memories of Stieglitz's conversations on a wide variety of subjects between 1925 and 1931. Considerable attention is given to Marin, Georgia O'Keeffe, and Arthur G. Dove.

Udall, Sharyn Rohlfsen. *Modernist Painting in New Mexico, 1913–1935.* Albuquerque: University of New Mexico Press, 1984. A well-documented study of the rich southwestern artistic tradition. Chapters are devoted to Marsden Hartley, Marin, and Georgia O'Keeffe, among others.

Zilczer, Judith Katy. "The Aesthetic Struggle in America, 1910–1918: Abstract Art and Theory in the Stieglitz Circle." Ph.D. diss., University of Delaware, 1975. Of special interest in relation to Marin is the chapter "Musical Analogy and Theories in Abstract Art in America."

Zigrosser, Carl. *The Artist in America.* New York: Alfred A. Knopf, 1942. Chapters on twenty-four contemporary printmakers, including John Taylor Arms, Thomas Hart Benton, Mabel Dwight, Rockwell Kent, and Marin. The chapter on Marin provided the groundwork for Zigrosser's 1969 catalogue raisonné of his etchings.

ARTICLES AND GROUP-EXHIBITION REVIEWS

"Are These Men the Best Painters in America Today?" *Look,* February 3, 1948, p. 44. A brief article documenting the results of a survey of 68 museum directors, painting curators, and critics across America, as well as the findings of a similar survey of the winning painters.

Benson, E. M. "The American Scene." *American Magazine of Art* 27 (February 1934): 57–58. Starts with Thomas Eakins; moves to John Sloan, George Luks, and Robert Henri; and goes on to discuss a number of other Americans while touching on aspects of the European influence. Among those discussed are Glenn D. Coleman, Morris Kantor, Marin, and Georgia O'Keeffe.

Phillips, Duncan, "Original American Painting of Today." *Formes* 21 (January 1932): 197–201. Includes several unnumbered pages of illustrations. Arguing for the importance and originality of American modernists, while acknowledging the importance of the European heritage to Americans, Phillips also suggests that Europeans emigrating to America would do well to absorb aspects of what they found in the art of their new land.

Rosenfeld, Paul. "American Painting." *Dial* 71 (December 1921): 649–70. Starts with Albert Pinkham Ryder, whom he deeply admires, then

glosses over William Merritt Chase and Winslow Homer to Arthur B. Davies, Kenneth Hayes Miller, Max Weber, and others. His greatest appreciation is reserved for Arthur G. Dove, Marin, and Georgia O'Keeffe.

Strand, Paul. "American Water Colors at the Brooklyn Museum." *Arts* 1–2 (December 1921): 148–52. An enthusiastic review of an exhibition that opened with the work of Winslow Homer. Written with Strand's characteristic clarity, the article ends with strong praise for Marin as the most important force among his contemporaries.

Taylor, E. A. "The American Colony of Artists in Paris." *Studio* 53 (July 1911: 103–18. Brief accounts of several artists' work, among them such now-forgotten figures as Mary R. Hamilton and Charles Lasar, as well as Marin. Acknowledging that Marin is known chiefly for his etchings, the article praises his watercolors for their excellence.

INDEX

Photography Credits